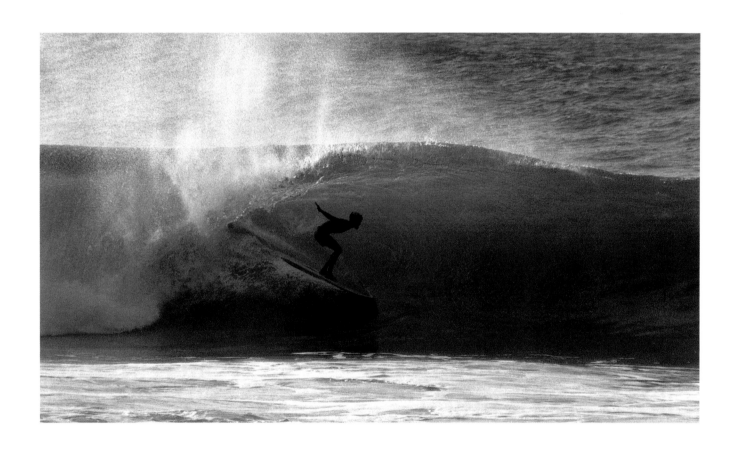

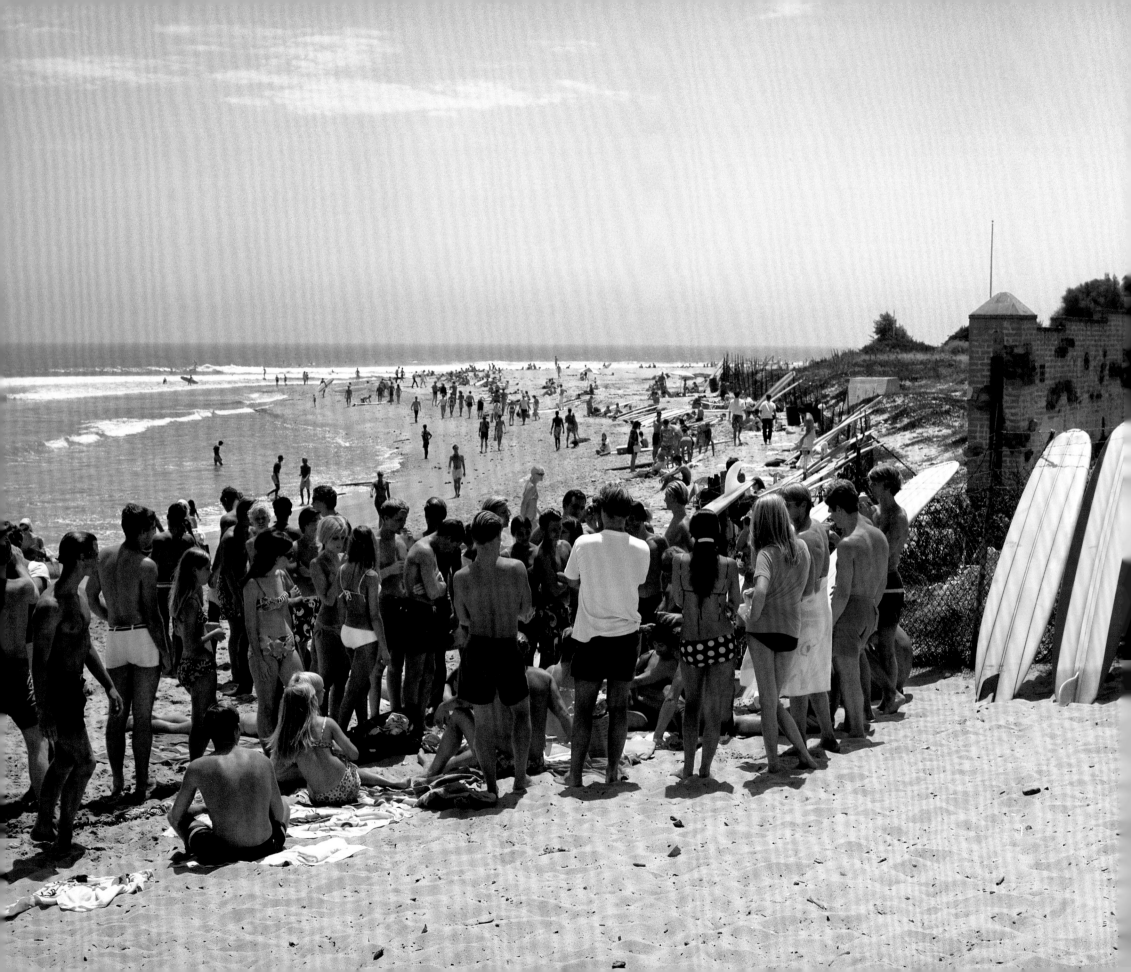

LEROY GRANNIS

SURF PHOTOGRAPHY OF THE 1960s AND 1970s

Edited by Jim Heimann

Essay by Steve Barilotti

TASCHEN

HONG KONG KÖLN LONDON LOS ANGELES MADRID PARIS TOKYO

Dedicated to my wife, Katie, for being behind me all those years, making it easy for me to shoot pictures, and waiting patiently for me on the beach.

To stay informed about upcoming TASCHEN titles, please request our magazine at
www.taschen.com/magazine or write to TASCHEN, Hohenzollernring 53, D-50672 Cologne,
Germany, contact@taschen.com, Fax: +49-221-254919. We will be happy to send you a free
copy of our magazine, which is filled with information about all of our books.

© 2007 TASCHEN GmbH
Hohenzollernring 53, D-50672 Köln
www.taschen.com

Editor: Jim Heimann, Los Angeles
Cover & interior design: Paul Mussa, San Francisco
Production: Morgan Slade, Los Angeles, and Stefan Klatte, Cologne
Project management: Nina Wiener, Los Angeles, and Florian Kobler, Cologne
Collaboration: Kate Soto and Janet Duckworth, Los Angeles
German translation: Anke Burger, Berlin
French translation: Arnaud Briand, Paris

Printed in Italy
ISBN: 978-3-8228-4859-3

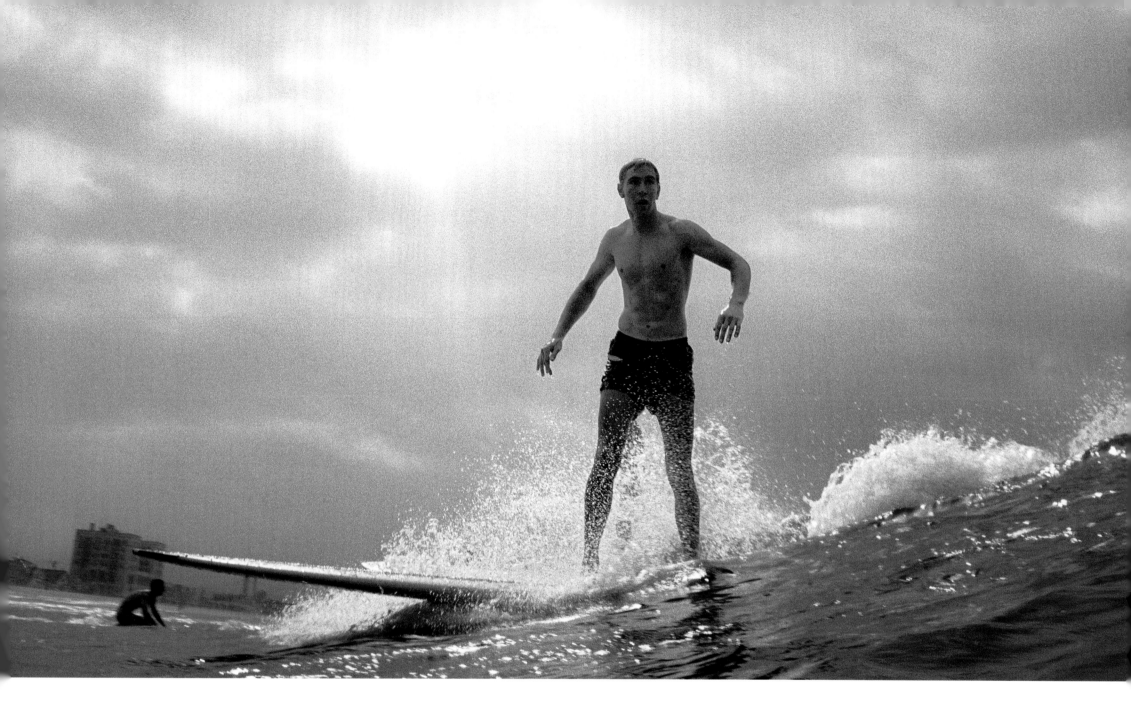

Contents

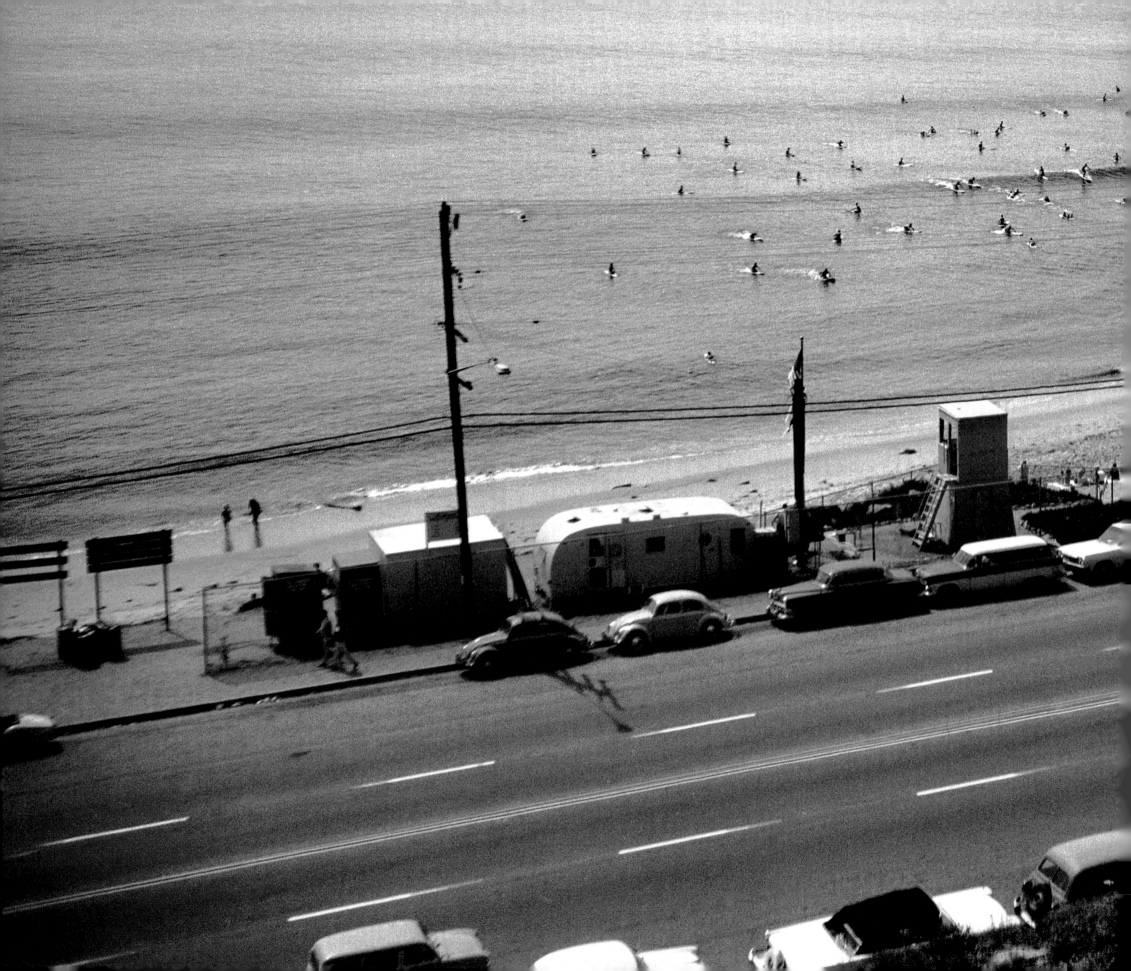

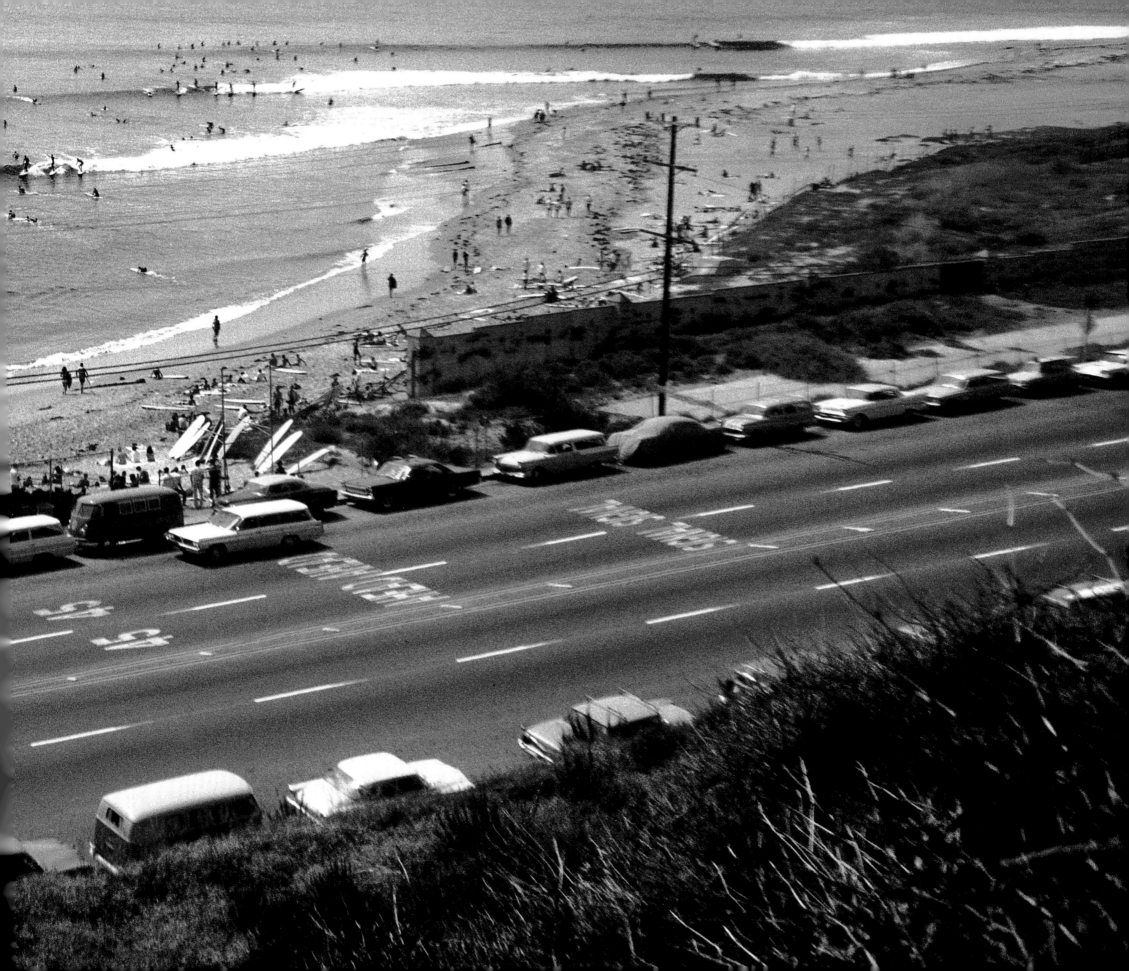

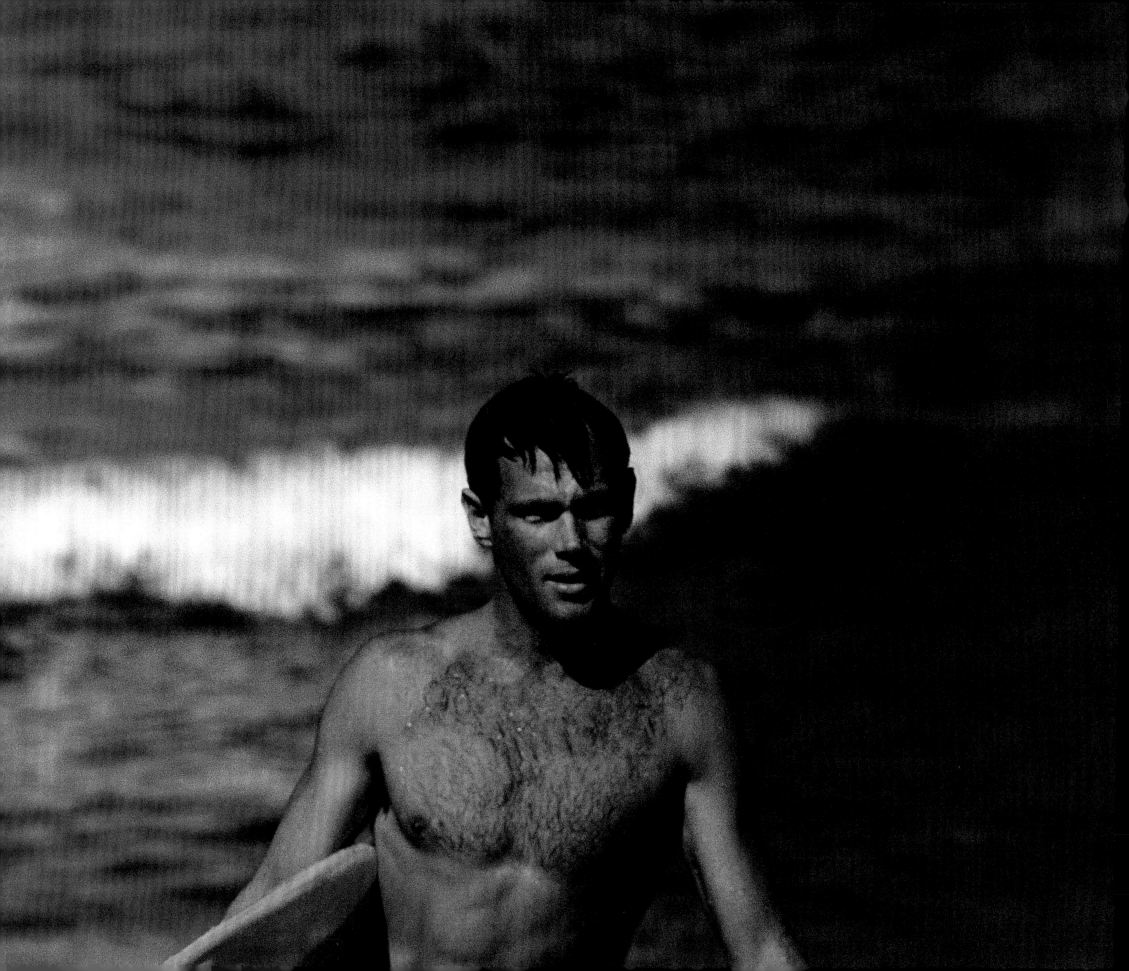

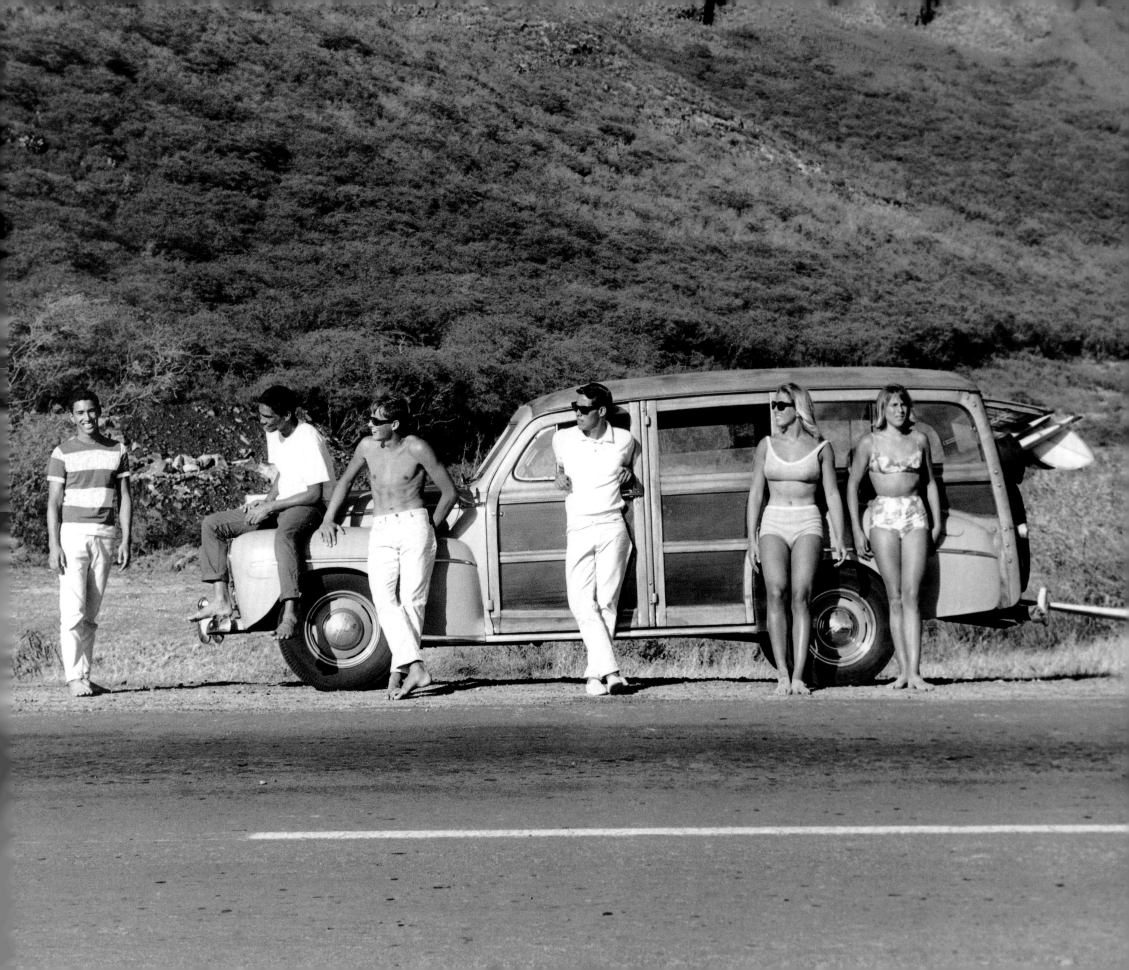

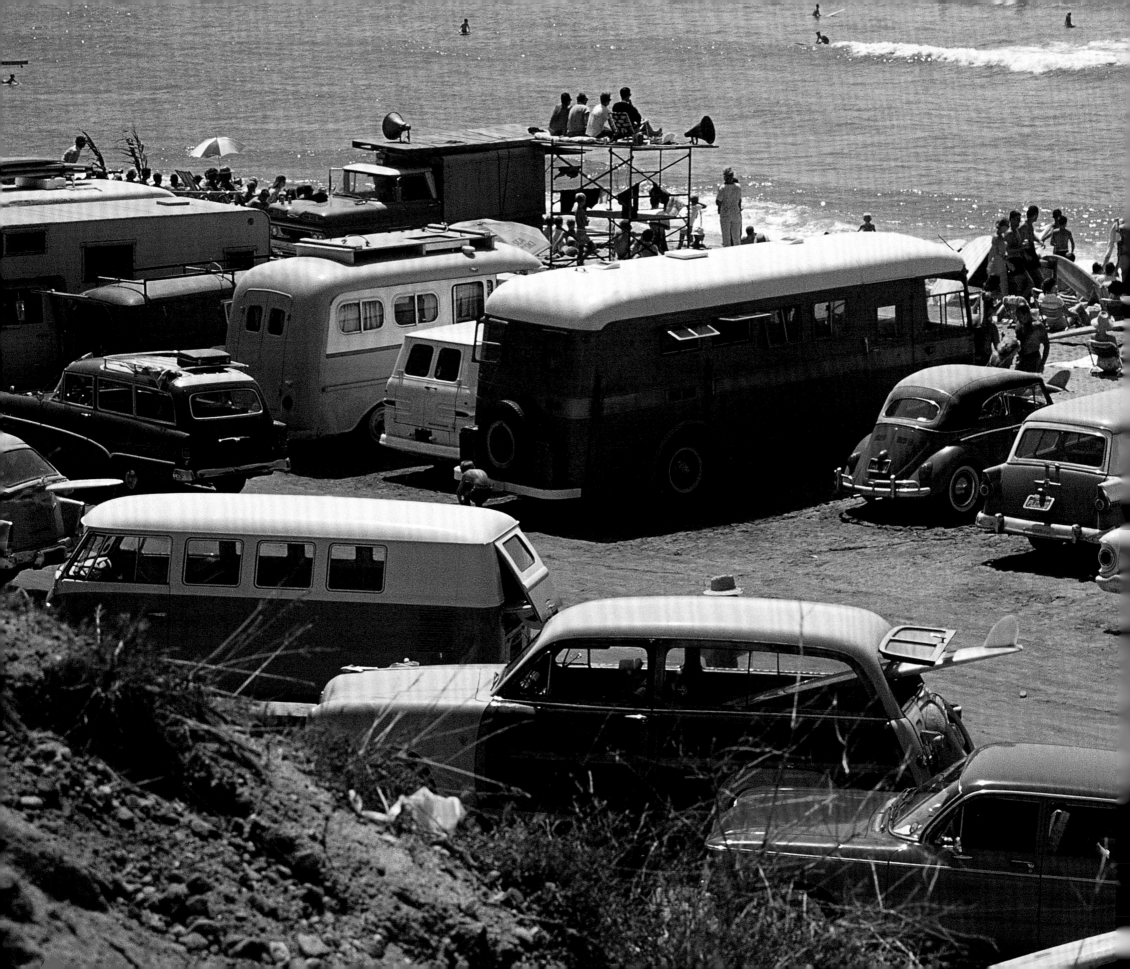

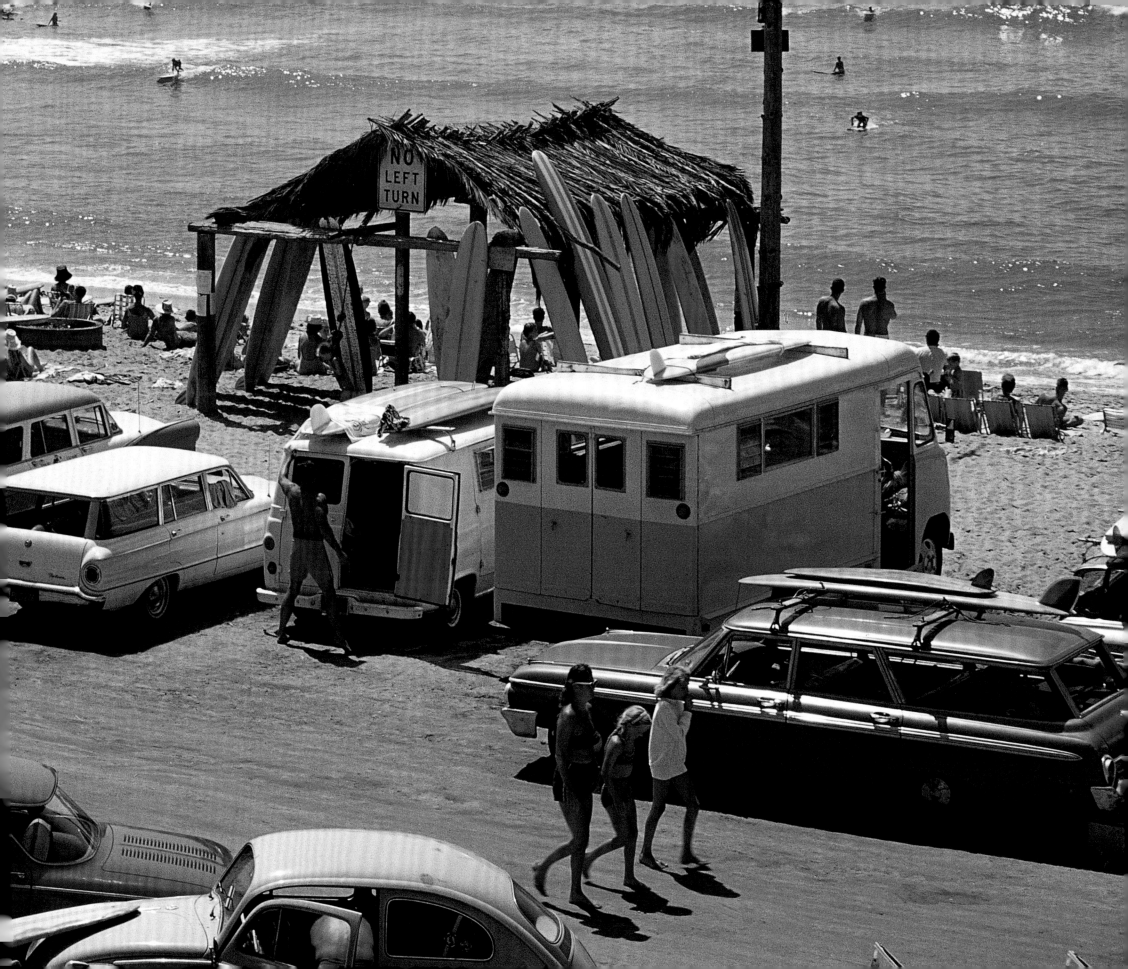

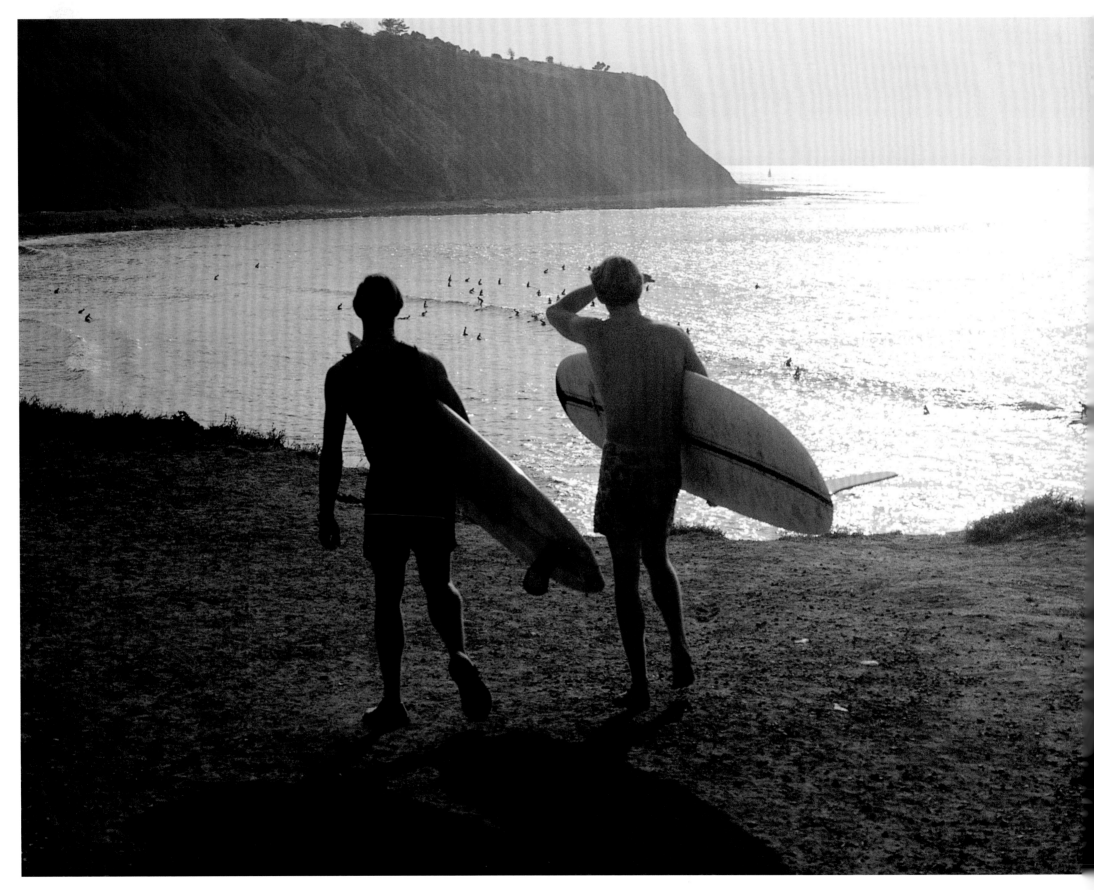

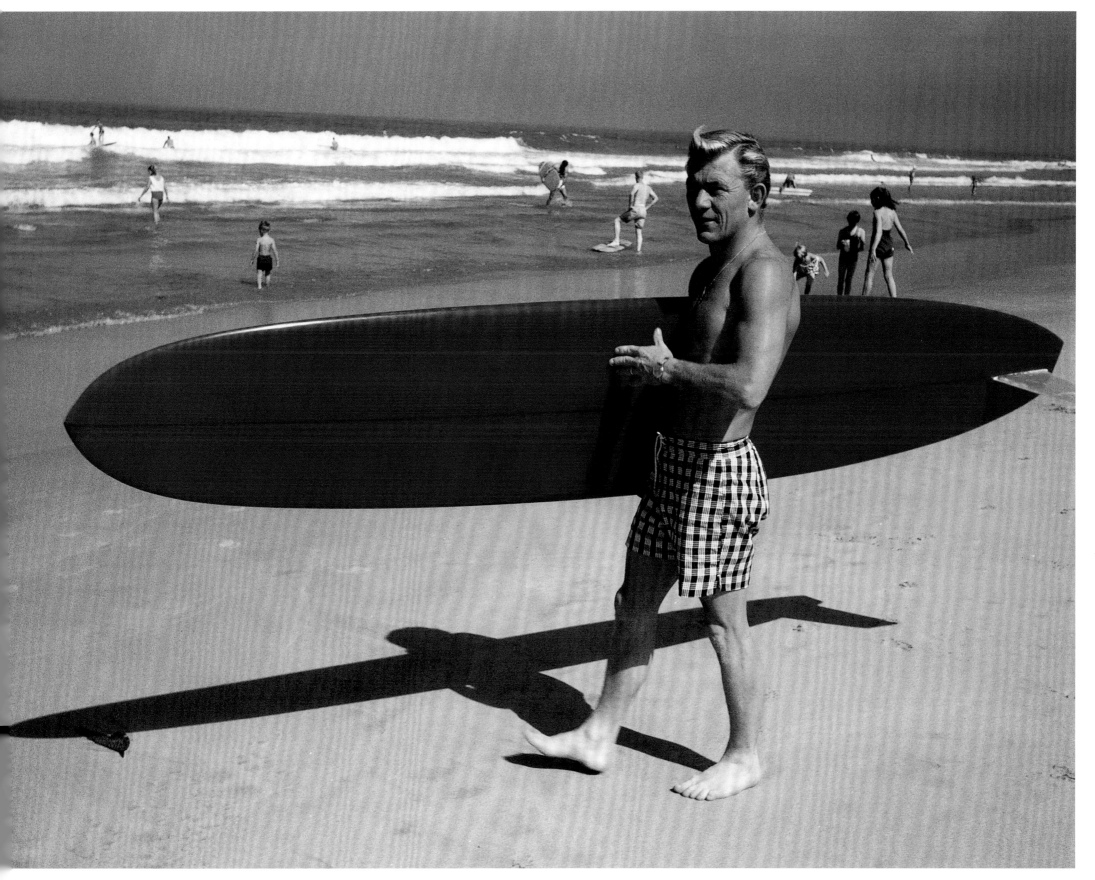

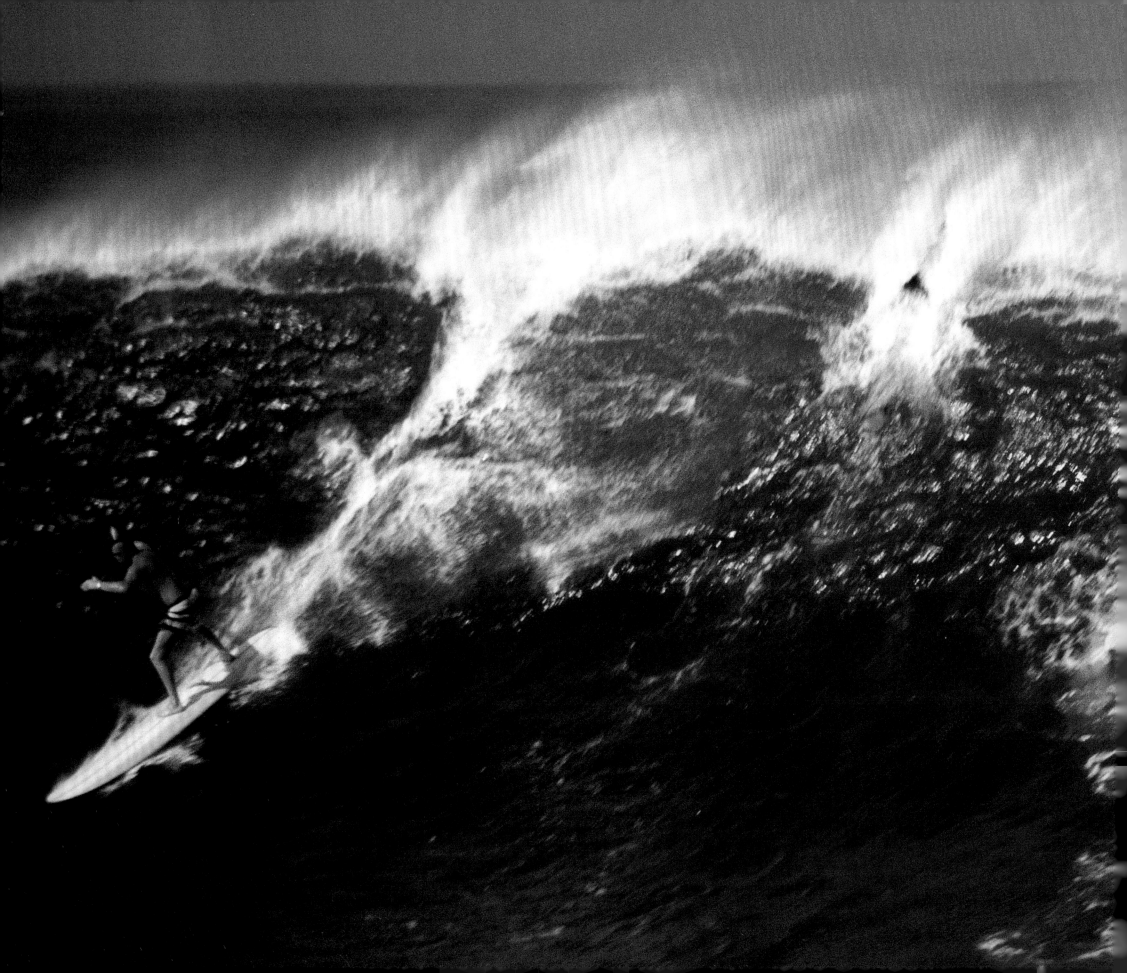

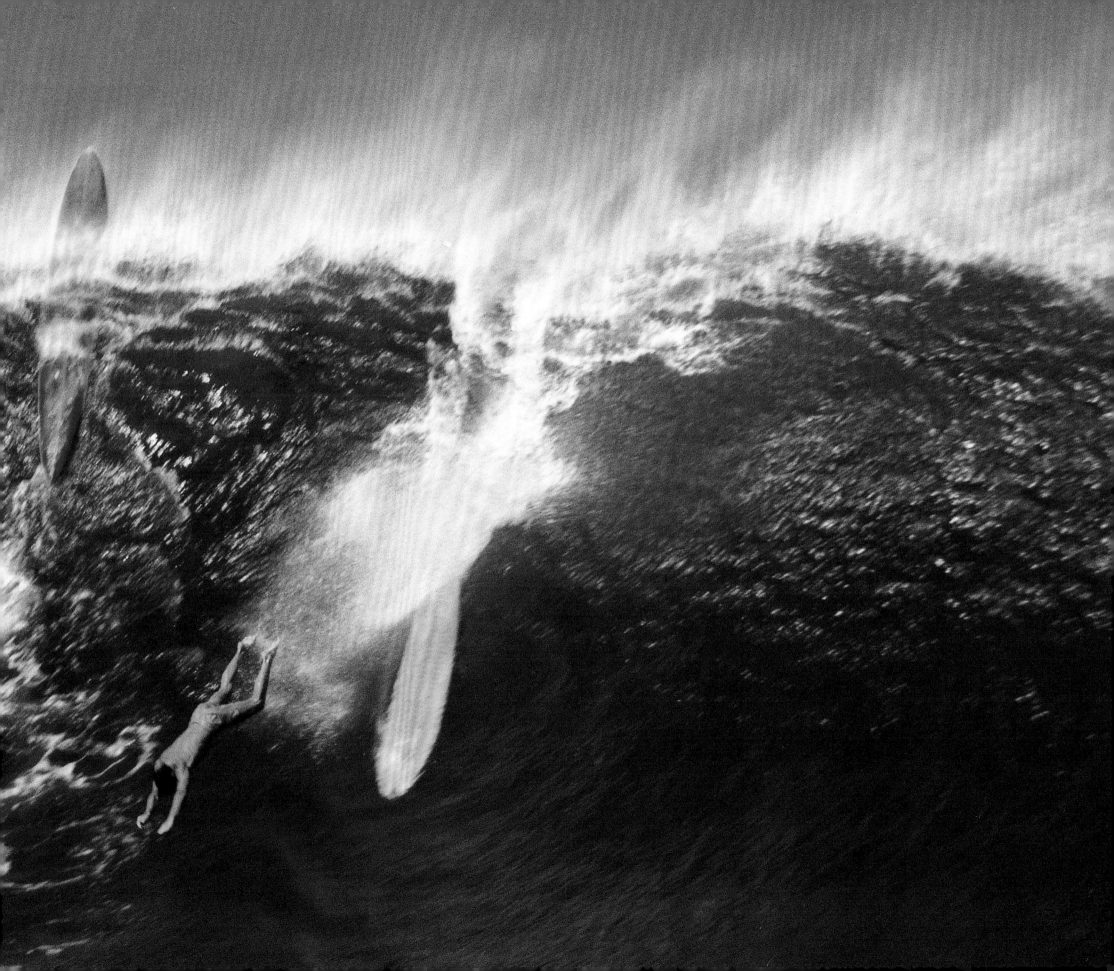

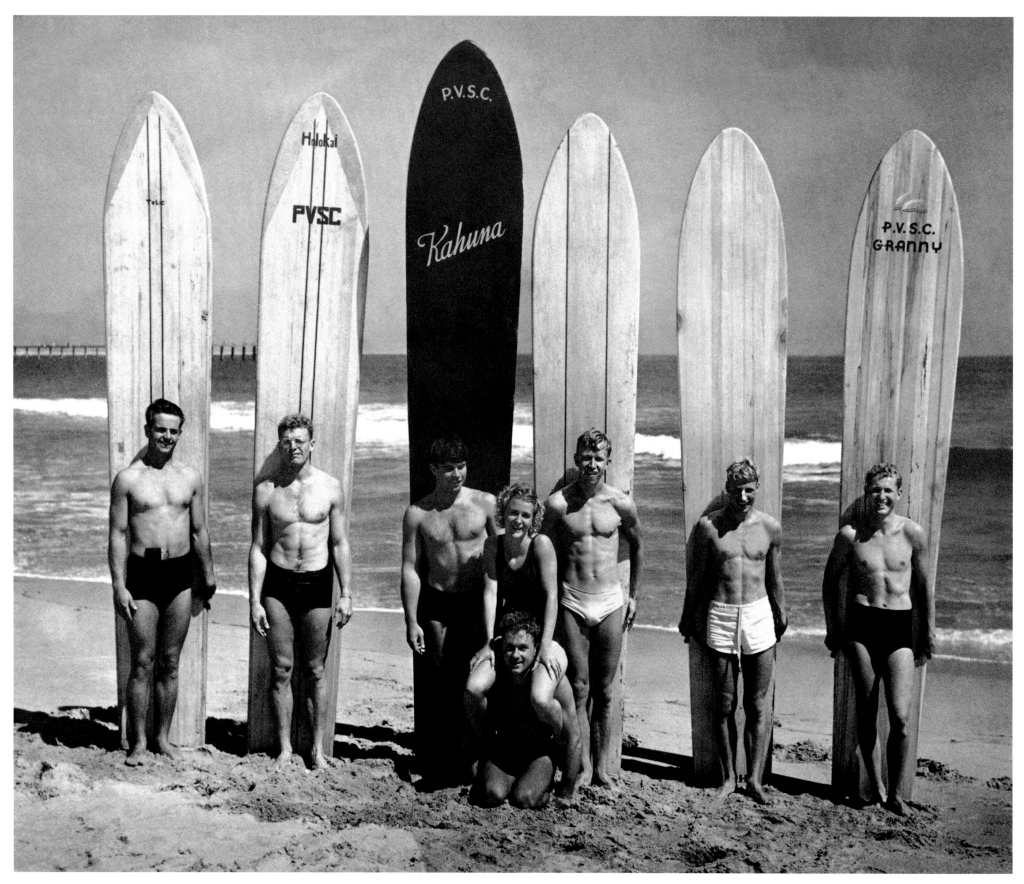

CAPTURING THE PERFECT WAVE: The Surf Photography of LeRoy Grannis

By Steve Barilotti

Palos Verdes Surfing Club, Hollywood by the Sea, California, 1938

Left to right, Jim Reynolds, Hoppy Swarts, Tulie Clark, Mary Ann Hawkins on E. J. Oshier's shoulders, Chuck Allen, Hal Pearson, LeRoy Grannis.

Von links nach rechts: Jim Reynolds, Hoppy Swarts, Tulie Clark, Mary Ann Hawkins auf den Schultern von E. J. Oshier, Chuck Allen, Hal Pearson, LeRoy Grannis.

De gauche à droite : Jim Reynolds, Hoppy Swarts, Tulie Clark, Mary Ann Hawkins sur les épaules de E. J. Oshier, Chuck Allen, Hal Pearson et LeRoy Grannis.

Down through the ages, references to surf riding have survived; first via the chant, later in writing, and now most eloquently by the medium of the camera.
—Tom Blake, pioneer surfer and surf photographer

The revolution was shot in black in white, on a Sunday afternoon, at 250th of a second. October 2, 1966. World Surfing Championships, Ocean Beach, San Diego. Forty thousand spectators jammed the beach and the newly opened Ocean Beach pier. At the exact moment that eighteen-year-old Robert "Nat" Young hoisted an awkward California–shaped trophy over his head, there were more than three hundred and forty thousand U.S. troops in Vietnam, Brian Wilson was on the verge of releasing his masterpiece, "Good Vibrations," and LSD would remain legal for three more months. Surfboards averaged ten and a half feet in length and weighed thirty pounds. Nat Young was now world champion. And the surfing world had quietly tilted ninety degrees off its axis.

A tall, brash Australian, Young was flanked on the victory dais by the soft-spoken Hawaiian Jock Sutherland and California small-wave whiz kid Corky Carroll. A small group of local and national media, among them *Newsweek* and *The New York Times*, jostled to get close to the winners. LeRoy Grannis, *International Surfing* magazine's sole staff photographer, roamed the fringes of the crowd, methodically snapping off trophy shots with his salt-corroded Pentax S camera. At a key instant in the ceremony he focused and framed the jubilant Young cheering, "I feel jazzed!"

Despite the palpable buzz on the beach, Grannis remained stoically detached. For him, the event was simply the culmination of a year of weekends shooting club contests up and down the Southern California coast. Grannis, then forty-nine, was in his sixth year of surf photography and thirty-fifth as a surfer. The next weekend he would likely be back up at Malibu or Huntington Beach for another small regional contest, and the World Surfing Championships qualifying process would start anew.

LeRoy Grannis came to surf photography in late 1959, not as a professional or an artist, but as a middle-aged family man looking for a hobby to reduce the stress of his job. Luckily, he happened to pick up his camera at a pivotal point in surfing history. Born in Hermosa Beach, California, in 1917, Grannis was a holdover from the redwood era of West Coast surfing, when a scant two hundred California surfers rode massive eleven-foot boards on the slow rollers off San Onofre and Palos Verdes Cove with a dignified, gentlemanly esprit. They were the first generation of mainland surfers to take up the ancient sport, newly exported by Hawaiians George Freeth and Duke Kahanamoku. They were also part of surfing's renaissance, which grew from a handful of Hawaiian beach boys in Waikiki during the late nineteenth century.

Raised a block from the ocean in Hermosa Beach, Grannis began surfing at age fourteen on a borrowed redwood plank that weighed close to a hundred pounds. It was there, bobbing in the gentle swells beneath the Hermosa Beach Pier, that he met fellow surfers Lewis "Hoppy" Swarts, another Hermosa beach native, and John "Doc" Ball, an affable University of Southern California dental student who was ten years older than Grannis. The three became lifelong friends.

Ball was an expert surfer, and soon talked the teenage Grannis and Swarts into tackling the better-formed waves of Palos Verdes Cove, five miles to the south. The cove was a second home to a zealous crew of dedicated surfers, mostly jobless young men in their twenties who were waiting out the Depression in grand low-budget style. A self-reliant group, they built their own surfboards, sewed their own surf trunks, and pooled their meager cash resources to buy gasoline (and the occasional jug of cheap wine) for trips to Malibu or San Onofre. Many were also expert divers and would often harvest free feasts of lobster and abalone from the surrounding tide pools. In 1935 Ball organized the Palos Verdes Surfing Club and inducted Swarts and Grannis (by now nicknamed "Granny") in 1936.

Surfers made for natural subjects for photographers, and the image of bronzed Hawaiian watermen poised majestically against Diamond Head quickly became a postcard cliché. Surf imagery has always been created primarily by the surfers themselves. The surf photographers were all self-taught hobbyists; none made a living from the sales of their photos. Tom Blake, the pioneering surfer/designer, built a waterproof box for his Graflex camera in 1929 and began shooting Hawaiian beach boys from his board as they hurtled past on twelve-foot *alaia* boards in the long, rolling waves off Waikiki. He taught Doc Ball, who in turn had a big influence on Don James and, later, LeRoy Grannis. Ball was a talented photographer with a natural eye, constantly experimenting with novel angles and building prototype waterproof housings so he could take his cameras out into the waves. His candid snapshots of his buddies and their girlfriends captured the brief, halcyon era of pure surfing that vanished shortly after the Japanese attack on Pearl Harbor, Hawaii, in 1941.

With the onset of World War II, California surfing went into steep decline as most able-bodied young watermen over eighteen either enlisted or were drafted

into military service. Many never returned. Although Grannis was newly married and had a baby daughter by 1941, he enlisted in the U.S. Army Air Forces two years later. By the time he graduated from flight school, however, the war had ended, and he was discharged in 1946. Back home in Hermosa Beach, Grannis became a communications engineer, and found a steady job as a switchboard installer with Pacific Bell Telephone (Grannis remained on active reserve with the U.S. Air Force, retiring as a major in 1977).

In the years following the war, Grannis surfed sporadically, but became increasingly absorbed in the demands of his job and raising four children. In late 1959 he was diagnosed with a stress-related stomach ulcer, and his doctor recommended a relaxing pastime. Surf photography appeared a logical choice, as Grannis lived a few blocks from the ocean and his teenage son Frank had recently begun surfing. By June 1960 Grannis had built a darkroom in his garage and developed a few rudimentary photos, their style influenced by Doc Ball.

That summer, with an East German 35mm camera, he began shooting 22nd Street in Hermosa Beach, a stretch of undistinguished South Bay beach break that attracted a crew of young surfers eager to show off for his lens. The undisputed leader of the 22nd Street gang was Dewey Weber, who at twenty-three had already starred in several surf films and had just opened his own surfboard shop in nearby Venice Beach. The small (five-foot-three) but powerful Weber surfed aggressively and pushed the rest of the crew, which included Henry Ford, Freddie Pfahler, and Mike Zuetell, to perform their best. By the end of 1960 Grannis had shot and developed more than twenty-five hundred frames.

Grannis's darkroom was the closest thing to a one-hour photo lab in the South Bay, and at a time when surf magazines came out bimonthly, surfers were ravenous for current shots of themselves. "Sometimes I'd go right from shooting at 22nd Street to the darkroom, and before I knew it there'd be half a dozen guys waiting to see what I'd shot," Grannis recalls. "And then I'd get them in the darkroom and the body heat would become terrible. There were a couple of kids, Tom and Don

spiffy business suit for Jacobs Surfboards is considered a surf-photography classic. In 1963 Grannis bought a Calypso water camera (invented by Jacques Cousteau, and the precursor to the Nikonos), and produced a touchstone shot of Henry Ford executing a perfect bottom turn at 22nd Street.

Grannis found out early on, however, that surf photography could be dangerous for even the most experienced waterman. While shooting Hawaii's Sunset Beach with his Nikonos from the water one day, a massive "West Peak Bowl" swung unexpectedly toward the channel, breaking far outside and trapping Grannis directly in its path. He looked up to see a twenty-foot wall of whitewater and three thickset eleven-foot surfboards hurtling toward his unprotected head. He dove beneath the maelstrom but managed to keep his precious camera safe. Later, with help from his old friend Doc Ball, Grannis designed and built his first rubber-lined, suction-cupped waterproof box, which allowed him to change film and shoot from the water with longer lenses and sit in the relative safety of Sunset Beach or the Waimea Bay channel for hours without returning to shore.

On land, Grannis loved the clean, cool remove provided by the Century 1000 telephoto lens. Viewed from a half-mile away, artfully framed surfers appeared as heroic figures within a vast arena such as Sunset Beach. But it was his dedication to the rest of the beach scene that fills a large gap in surfing's collective memory today. Grannis's photography, especially from 1960 to 1965, caught surfing at a critical juncture between cult and culture. Upon first glance, his photos may evoke nostalgia for a simpler, more naive era, but closer inspection reveals that he was documenting surfing's rapid evolution into an iconic lifestyle. His photos captured the real thing, providing a bridge between the world of Beach Boy lyrics and the reality of the Southern California beach scene. Surf language, surf music, surf art, surf media, surf fashion—all the basic elements of what are now considered essential to modern surf culture were either conceived or codified within this brief window of time. Grannis was one of the few surf photographers to swing his camera off the wave action and record it all.

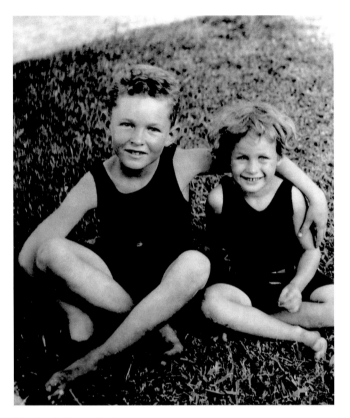

LeRoy Grannis, Hermosa Beach, California, 1926

LeRoy, age nine, with sister Vera, age seven, at their parents' house on Monterey Boulevard. In 1926, Hermosa's population was just 6,500. Photograph by Blanche Grannis.

LeRoy im Alter von neun Jahren mit seiner siebenjährigen Schwester Vera vor dem Haus der Eltern auf dem Monterey Boulevard. 1926 hatte Hermosa nur 6.500 Einwohner. Fotografiert von Blanche Grannis.

LeRoy à l'âge de neuf ans et sa soeur Vera, âgée de sept ans, devant la maison familiale sur Monterey Boulevard. En 1926, Hermosa ne comptait que 6 500 habitants. Photo : Blanche Grannis.

Raised a block from the ocean in Hermosa Beach, Grannis began surfing at age fourteen on a borrowed redwood plank that weighed close to a hundred pounds.

Craig, who lived nearby who would go through my trash to see if I threw anything away that they wanted." From his house it was only a forty-minute drive up the then two-lane Pacific Coast Highway to Malibu, an obscure point break when Grannis surfed it in the thirties, which by 1960 was world-famous. With its perfect, tapering waves and proximity to Hollywood, "the 'Bu" had become a bona fide scene that drew surfing's elite each summer. Although extremely crowded even then, the break featured surf stars such as Lance Carson, Johnny Fain, Mike Hynson, and the legendary Miki Dora dancing across the face of the swells with a quick, theatrical style that came to be known as "hotdogging." Grannis's photographic skills were improving, and he sold his early Malibu shots to the short-lived Reef magazine, initiating his career in print.

In November 1961 Grannis made his first trip to Hawaii, the epicenter of the surfing frontier at the time. After photographing small waves in Waikiki and Makaha for two weeks, he headed for the fabled North Shore of Oahu. By then a large swell had filled in, and Grannis was stunned by the sheer magnitude and power of Hawaiian waves. Using a 650mm telephoto lens, he captured the likes of Rick Grigg, Peter Cole, and Phil Edwards racing down the massive concave faces of the infamous "West Bowl" at Sunset Beach.

Grannis returned to California with renewed fervor. Over the next few years, he tripled his output and began shooting more color, lifestyle, contest, and advertising photos. Insular and budget-minded, early surf marketers looked to their own for graphic design and photos. Grannis had no experience as a commercial photographer, nonetheless he acquitted himself with simple, clever concepts. His photo of Hermosa Beach surfer Ricky Hatch deftly stepping to the tip in shoes and a

In 1964, after a highly successful winter trip to Hawaii, Grannis teamed with future surfwear tycoon Dick Graham to start *International Surfing* magazine (later shortened to *Surfing*, and still the second oldest surf magazine in the world). Grannis became its founding photo editor, associate editor, and primary photographer, in addition to his full-time job with Pacific Bell Telephone. Each weekend, he dutifully covered the endless series of amateur and club contests. In doing so he caught a generation of now legendary surfers in their gawky adolescence. As many were the same age as his teenage son, he turned an often paternal lens on his subjects, capturing candid portraits that belie the reticence of a middle-aged man approaching strangers to pose for pictures. Among his photographic mentors and peers, Grannis struck a clear middle note between art and photojournalism. His photos were well framed, focused, and gifted with a generous depth of field that allowed a viewer time to pore over the ecology of the moment. His use of slow, fine-grained film, exposed by the book and painstakingly processed, allowed for highly detailed enlargements. "There was a texture about Grannis's shots that for me took them into another realm," says Brad Barrett, a staff photographer and photo editor at *Surfer* magazine from 1968 to 1973.

In the early sixties there were fewer than half a dozen published surf photographers in the U.S., and with the exception of John Severson, all shot purely as a sideline hobby. Each, however, had a clearly defined style and agenda. Severson, a former art teacher, brought a raw, bebop aesthetic to his shots. Ron Stoner

favored warm, burnished tones and a lush, romanticized view. Ron Church was a professional industrial photographer with advanced technical expertise and state-of-the-art underwater cameras. His black-and-white photographs were heroic but often cold renderings of the reigning surf gods. As a surfer and coastal native, Grannis, on the other hand, shot the local scene with an unfiltered sense of verité.

Surf filmmaker and publisher John Severson was one of the first to expand surf photography into surf media. In 1960 he published *The Surfer*, a thirty-six-page booklet of his photography and art to be sold for extra cash at screenings of his documentary *Surf Fever*. The booklet was hugely popular, and the first printing of 5,000 sold out quickly. He followed up in 1961 with a quarterly, and a year later went bimonthly. Severson hired a small staff and became a full-time editor and publisher. Soon Grannis was contributing to *Surfer* magazine, as well as the short-lived *Surfing Illustrated*.

The early surf 'zines had been kitchen-table projects, created and distributed by the sport's devotees. When *Surfer* emerged, print as a mass medium was becoming accessible to low-budget publishers such as Severson, and media leaders had begun to exploit this niche sport in movies such as *Gidget* (1959) and *Ride the Wild Surf* (1964). In Southern California, action shots and colorful graphics of surfing had become eye candy for Hollywood's film and television industries. "Suddenly there was an opportunity to get unprecedented distribution

The opening volley of the "Shortboard Revolution"—and the disintegration of the simpler years of the early sixties surf scene—was served on October 2, 1966, in Ocean Beach, San Diego. It was there, under overcast skies in small, soft surf, that Nat Young won the World Surfing Championships with a radical, hard-turning approach that stunned the ruling elite. When David Nuuhiwa, the lithe Hawaiian favorite famed for long, elegant noserides, insisted, "You must try to blend into the wave," the cocky Young retorted, "I don't want to blend in with anything!" Young's rhetoric was as inflammatory as his equipment. He won the contest on "Magic Sam," a self-made surfboard, measuring nine feet four inches—a full foot shorter than the standard of the day. Designed with fellow Aussie Bob McTavish, it featured a tall, scimitar-like fin created by the eccentric American surf savant George Greenough. Virtually overnight a generation of powerful, state-of-the-art surfboards were pushed to the edge of the scrap heap by a drastic, forced evolution in technology, maneuvers, and mind-set. With Nat Young's victory, surfing veered away from mainstreaming for more than a decade. Big Nat, nicknamed "the Animal" for his gutsy approach to wave riding, had shown the surfing world the future. Before 1966 the gold-standard maneuver was to "hang ten" (balance stylishly on the end of the board with ten toes hanging over the nose). Now, anything was possible. It was called "mind surfing." And it was, as *Surfer* magazine journalist Paul Gross wrote, "a mass desertion from everything that had gone on before." Yet, at the time, nobody seemed to notice.

"There was a texture about Grannis's shots that for me took them into another realm," says Brad Barrett.

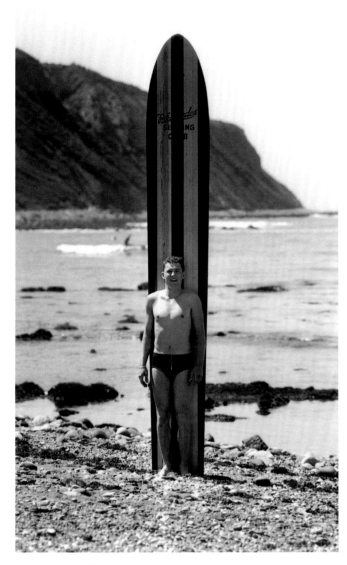

LeRoy Grannis, Palos Verdes Cove, California, 1946

Grannis showing off his twelve-foot hand-shaped redwood-and-balsa square-tail plank. The rare Ecuadorean balsa had been stored for the duration of World War II. Photograph by Doc Ball.

Grannis präsentiert stolz sein selbst gefertigtes zwölf Fuß langes Square-Tail-Brett aus Redwood und Balsa. Das seltene Balsaholz aus Ecuador war während des gesamten Zweiten Weltkrieges eingelagert gewesen. Fotografiert von Doc Ball.

LeRoy Grannis posant fièrement devant son *square tail* de douze pieds taillé à la main dans le séquoia et le balsa. Les stocks du précieux balsa équatorien avaient été mis à l'abri pendant la Seconde Guerre mondiale. Photo : Doc Ball.

for an image that you hand made," says John Van Hamersveld, a one-time *Surfer* magazine art director and creator of the legendary Day-Glo *The Endless Summer* poster. "It was the taking of this small isolated culture by the media, through the magazines or through the surf movies, up to the producers of mass culture."

By 1966 the surfing "fad" of five years earlier had become an authentic youth culture, complete with its own language, music, fashion, media, cars, and code of honor. Mainstream interest in the scene was at an all-time high, and fortunes were being made by a small Southern California cartel of surf-related manufacturers known fan a weekend pastime—had gotten a huge mainstream media push in July with the 1966 coast-to-coast release of Bruce Brown's *The Endless Summer*. An inventive, easygoing documentary, it gave the non-surfing world (the "Legions of the Unjazzed," as maestro surfer Phil Edwards put it) its first legitimate view of the insular surfing culture, and the world wanted more. A new gold rush was on.

Back in San Diego, city fathers and World Surfing Championships organizers stumbled over themselves to congratulate one another on surfing's newfound respectability. With the upcoming championships, contest officials hoped to reverse a tide of "surfing hooliganism" and bad publicity that had dogged the sport during its first great boom following the release of *Gidget*. The San Diego Chamber of Commerce saw a huge increase in tourism as the sexy, fast-growing beach sport captivated the nation's free-spending youth, seemingly overnight.

A surge of conservatism was encroaching upon the once bohemian lifestyle as well. An ongoing campaign conducted primarily by John Severson's *Surfer* magazine was attempting to purge the surfing scene of "undesirable" elements. The magazine's editorial tone skewed toward self-righteousness, as guest editors and carefully selected reader letters gloated over organized surfing's defeat of the surf punks, or "hodads," who had blackened surfing's name with lowbrow pranks and a generally rotten attitude toward authority figures. "[Surfing] no longer just appeals to the oddball type," declared John Hannon, a leading East Coast surfboard manufacturer, in an interview with *Newsweek*. "These kids have haircuts and their fingernails are clean; they won't tolerate the troublemakers."

Simultaneously, psychedelic drugs raged through the surf culture like a wildfire, expanding some minds, blowing others. Surfing became introverted and underground as former Jantzen-wearing hotdoggers morphed into bearded Zen-spouting mystics. Contests were no longer cool; nobody cared who came in first. Nobody cared, period. Suddenly, surfing wasn't about tricks and trophies, but about balancing one's karmic flow within "crystalline cathedrals of molten glass," in the words of a *Surfer* magazine reader. As early as 1966, Rick Griffin was slipping sly drug references into his cartoons for *Surfer*, which enraged many of the magazine's prominent advertisers. The adventurous, free-ranging lifestyle also led many surfers into part-time careers as international drug smugglers. "You were on the bus or you were off the bus," wrote Drew Kampion, *Surfer* magazine's editor from 1968 to 1972. "You got it or you didn't. You believed in gravity or you believed in space. You were rigid or you flowed, and there was a whole lot of flowin' goin' on."

After a brief fling with mainstream respectability the culture was reclaiming its antiestablishment roots, a move that did not go unnoticed by the outside world. In his widely published 1966 essay "The Pump House Gang," pop culture critic Tom Wolfe reported that many surfers "were shifting from the surfing life to the advance guard of something else—the psychedelic head world of California." Where corporate America once saw a generation of compliant young consumers, they now saw long hair, pot smoke, and a defiant middle finger extended toward unchecked materialism.

The economic fallout was profound. Over the next few years most of the major board shops downsized or went out of business. At *Surfer*, advertising revenues plunged, the magazine shrank, and the editorial gestalt shifted markedly left of center. Under Kampion's new, radicalized regime, *Surfer* became a vector of the burgeoning counterculture, celebrating peace, free love, tuberides, and every surfer's right to drop out and get really, really stoned. Kampion, who publicly railed against most organized competitive surfing with articles such as "Bad Karma at Huntington Beach" and "The Death of All Contests," sought to promote surfing as a metaphor for cosmic balance rather than a crass marketing ego trip. He was also openly critical of the escalation of the Vietnam War, which was snatching surfers off the beach at an alarming rate, and declared open season on incoming U.S.

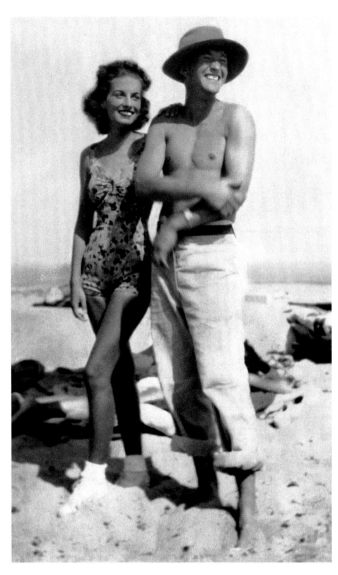

Katie Tracy, LeRoy Grannis, San Onofre, California, 1939

Pioneering surf fashion at "Sano" in the halcyon years just before World War II. Grannis and Tracy were married a month after this photo was taken. Photograph by Dorothy Hacket.

Die Vorreiter der Surfmode in „Sano" in den unbeschwerten Jahren vor Ausbruch des Zweiten Weltkrieges. Grannis und Tracy heirateten einen Monat, nachdem dieses Foto aufgenommen wurde. Fotografiert von Dorothy Hacket.

Les débuts de la mode du surf à San Onofre dans les années dorées qui ont précédé la Seconde Guerre mondiale. Grannis et Tracy se marient un mois après cette prise de vue. Photo : Dorothy Hacket.

president Richard Nixon for moving next door to Trestles Beach in San Clemente and closing off the premier surf break whenever he visited the "Western White House."

Grannis was, by virtue of his generational bias, out of step with surfing's new antiestablishment establishment, and frankly, he could not have cared less. A World War II veteran who had helped his good friend Hop Swarts run contests for his newly formed United States Surfing Association, Grannis held steadfast to the idea that competitive surfing advanced the sport and promoted its more socially acceptable side. In 1968 Grannis published an editorial in defense of good, clean surfing competition, dismissing the critics as "bellyachers" who had no right to complain. "The last few years have seen a rash of sick articles knocking competition by surfing has-beens, nonsurfing Hawaiian columnists, trunk salesmen and frustrated would-be editors," he wrote. "The reason they are all downgrading competition is that they can't meet the competition themselves."

By the end of the sixties, however, most contests, and even *Surfer* magazine's once prestigious Surfer Poll Awards, were passé. The nearest thing to professional-level competitive surfing was a groovy anti-contest contest called an "Expression Session," in which the top surfers showcased their prowess free of judges, points, and trophies. "This has been the year of the development, if not the invention, of many things: shortboards, V-bottoms, baby guns, flexible fins, short fins, radical board design in general," wrote Kampion in 1968. "It is the rare surfer who surfs in the same style that he did last year." Nevertheless, Grannis wrote a follow-up editorial accurately predicting a return to longboards and noseriding one day. Through it all, Grannis continued to aim his camera at a sport he was devoted to, recording image after image of both longboarders and shortboarders, in spite of surf-world politics.

In early December 1969, Hawaii and California were rocked by what was called "the swell of the century." Mountainous thirty-foot waves lashed the North Shore of Oahu, destroying sixty homes and tossing large boats one hundred yards inland.

Although the entire North Shore proved too huge to ride, Greg Noll and a small crew of surfers tackled the slightly diminished waves at Makaha on the island's west side. It was there that Noll caught what was arguably the largest wave ever ridden up to that date. He barely survived the resulting wipeout. "In a sport racked by change, hype and revolution, a no-bullshit fifties-dinosaur caught the last great wave of 1969," reported Drew Kampion.

The Swell of 1969 has come to be viewed by the surfing world as a geo-physical finale to surfing's most divisive and turbulent decade. "What we went through in December '69," sixties legend Skip Frye recalled many years later, "…in a way marked the transition from the whole sixties longboard thing to the shortboard era. It was kind of a wash-through, and we were playing a whole different ball game afterward." Grannis felt that board size was merely a logistic and was able to bridge the divide between the two generations with his photography. "I was shooting surfers, not boards," he says. "The way of life didn't change that much for me."

LeRoy Grannis's last surf photo for *International Surfing* was published in 1971. By the end of the seventies, he had retired from Pacific Bell Telephone and moved from Hermosa Beach to Carlsbad, California. Continuing to surf and shoot images, his prints and negatives remained neatly filed in three-ring binders in his home for more than twenty years. While a small, fringe culture of passionate surfers developed their lifestyle into a global industry, a primal decade of surfing's history was nearly forgotten.

A pioneer in the sport and its photography, Grannis captured surfing history at the brink of its evolution and iconography. This retrospective of his photographs—from the classics of the catalog to never-before-published material unearthed from his archive—grants viewers access to a lifestyle that has transitioned from a handful of practitioners to a $4 billion-a-year industry. Today, as endless images from professional surf photographers flood the market, the elegant simplicity of Grannis's photos and the period he captured provide a critical window into the birth of a culture. "I was a surfer and I shot what I liked to see," Grannis shrugs modestly. "I suppose you could say I was lucky."

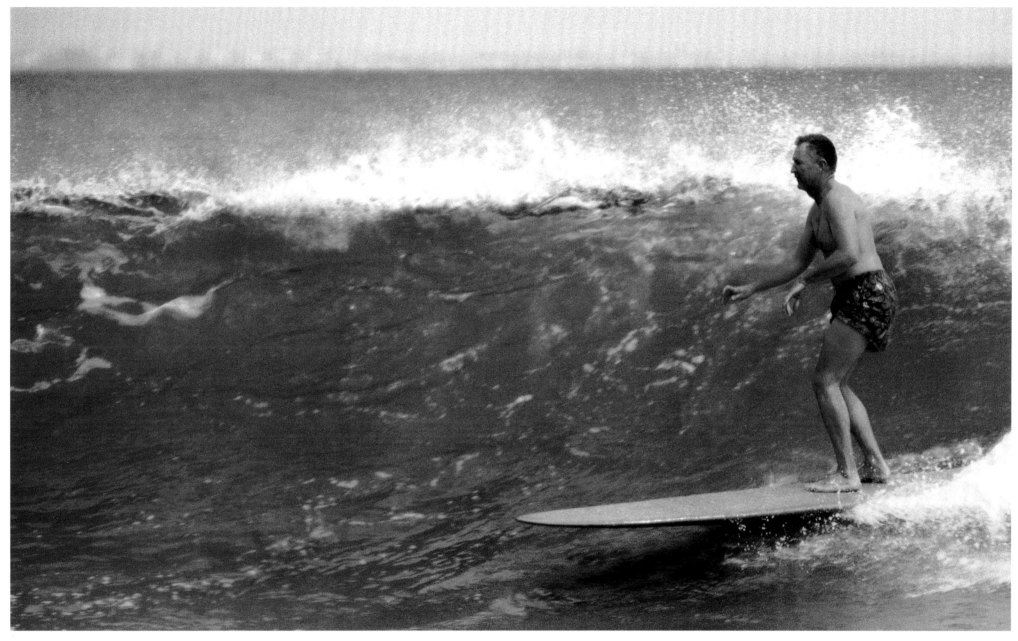

LeRoy Grannis, Malibu, California, 1962

First law of professional surf photography: "When it's good, you shoot." Grannis, who was always a surfer first, didn't mind breaking the rules occasionally. Photograph by Frank Grannis.

Die erste Regel der professionellen Surf-fotografie: „Man drückt ab, wenn es gut ist." Grannis, der immer zuerst ein Surfer war, brach hin und wieder auch gerne die Regeln. Fotografiert von Frank Grannis.

Règle numéro 1 de la photographie professionnelle : « Si c'est bon, appuie sur le bouton ! » Grannis, qui est toute sa vie resté surfeur avant d'être photographe, bravait parfois les règles établies Photo : Frank Grannis.

AUF DER JAGD NACH DER PERFEKTEN WELLE: Die Surffotografie von LeRoy Grannis

Von Steve Barilotti

Swami's, California, 1966

Swami's, one of Southern California's best point breaks, was named after Swami Paramahansa Yogananda, who established an ashram in 1937 above the Encinitas surf break.

Swami's, einer der besten Point Breaks in Südkalifornien, wurde nach Swami Paramahansa Yogananda benannt, der 1937 einen Ashram über dem Encinitas Surf Break einrichtete.

Swami's, l'un des meilleurs *point breaks* du sud de la Californie, doit son nom au moine Swami Paramahansa Yogananda qui fonda un ashram au-dessus du *surf break* d'Encinitas en 1937.

Seit Urzeiten haben Zeugnisse vom Wellenreiten überlebt; anfangs in Liedern, später in Worten und jetzt am schönsten durch das Medium der Kamera.
—Tom Blake, Pionier des Wellenreitens und Surffotograf

Die Revolution fand an einem Sonntagnachmittag statt, fotografiert in Schwarz-Weiß mit einem Zweihundertfünfzigstel. Es war am 2. Oktober 1966. Weltmeisterschaft im Wellenreiten, Ocean Beach, San Diego. Vierzigtausend Zuschauer standen wie die Heringe am Strand und auf dem neuen Ocean Beach Pier. In genau dem Augenblick, in dem der achtzehnjährige Robert „Nat" Young eine merkwürdige Trophäe in der Form des Staates Kalifornien in die Luft stemmte, befanden sich über 340.000 US-Soldaten in Vietnam, Brian Wilson stand kurz vor der Veröffentlichung seines Meisterwerks „Good Vibrations" und LSD sollte noch drei Monate lang legal bleiben. Surfbretter waren durchschnittlich zehneinhalb Fuß lang und wogen fünfzehn Kilo. Nat Young war jetzt Weltmeister. Und die Welt des Wellenreitens war gerade unbemerkt komplett aus ihrer Achse gekippt.

Young, ein großer, vorlauter Australier, wurde auf dem Siegertreppchen von dem stillen Hawaiianer Jock Sutherland und dem kalifornischen Wunderkind der kleinen Welle Corky Carroll flankiert. Ein Kontingent von Journalisten der regionalen und überregionalen Presse, darunter *Newsweek* und *The New York Times*, kämpfte um die besten Plätze bei den Siegern. LeRoy Grannis, einziger fester Fotograf des *International Surfing* Magazins, trieb sich an den Rändern der Menschenmenge herum und machte Schnappschüsse mit seiner rostigen Pentax S Kamera. Im entscheidenden Augenblick der Feierlichkeiten stellte er auf den jubelnden Young scharf, als der brüllte: „Ich fühle mich spitze!"

Trotz der spürbaren Aufregung am Strand blieb Grannis stoisch und hielt sich abseits. Für ihn war es nichts weiter als der Endpunkt eines Jahres, in dem er jedes Wochenende landauf, landab an der südkalifornischen Küste Clubwettbewerbe fotografiert hatte. Grannis war damals neunundvierzig, seit sechs Jahren Surffotograf und seit fünfunddreißig Jahren Surfer. Am nächsten Wochenende würde er wahrscheinlich schon wieder in Malibu oder Huntington Beach bei einem kleinen Regionalwettbewerb sein, wo der Qualifizierungswettkampf für die World Surfing Championships wieder von vorne anfing.

LeRoy Grannis kam Ende 1959 weder mit professionellem noch künstlerischem Anspruch zur Surffotografie, sondern als Familienvater in den besten Jahren, der nach einem Hobby suchte, um den Stress in seinem Berufsleben auszugleichen.

Glücklicherweise griff er an einem Wendepunkt der Surfgeschichte zur Kamera. Der 1917 in Hermosa Beach, Kalifornien, geborene Grannis war ein Überbleibsel der Redwoodplanken-Ära des West Coast Surfing, als gerade mal zweihundert kalifornische Surfer auf massiven Elf-Fuß-Brettern die langsamen Wellen von San Onofre und Palos Verdes Cove mit der Würde wahrer Gentlemen ritten. Sie waren die erste Generation amerikanischer Surfer, die den uralten, gerade von den Hawaiianern George Freeth und Duke Kahanamoku eingeführten Sport dort ausübten. Sie waren Teil der Wiedergeburt des Wellenreitens, die von einer Hand voll hawaiianischer Beach Boys in Waikiki am Ende des neunzehnten Jahrhunderts eingeleitet worden war.

Einen Steinwurf vom Meer entfernt in Hermosa Beach aufgewachsen, begann Grannis als Vierzehnjähriger mit dem Surfen, auf einer geborgten Redwoodplanke, die fast hundert Pfund wog. Dort, in den sanften Wellen unter dem Hermosa Beach Pier, lernte er zwei andere Surfer kennen, Lewis „Hoppy" Swarts, ebenfalls aus Hermosa Beach stammend, und John „Doc" Ball, einen leutseligen Zahnmedizinstudenten der University of Southern California, der zehn Jahre älter war als Grannis. Die drei blieben für den Rest ihres Lebens Freunde.

Ball war ein hervorragender Surfer und überredete die Teenager Grannis und Swarts bald dazu, es mit den sauberer laufenden Wellen im Palos Verdes Cove acht Kilometer weiter südlich aufzunehmen. Die Bucht war bereits einer begeisterten Crew ernsthafter Surfer ein zweites Zuhause, die meisten davon arbeitslose junge Männer um die zwanzig, die sich bis zum Ende der Weltwirtschaftskrise in großartigem, aber billigem Stil die Zeit vertrieben. Die Männer brauchten nicht viel, bauten ihre eigenen Surfbretter, nähten ihre Surfshorts selbst und warfen ihre knappen Barschaften zusammen, um den Sprit für Ausflüge nach Malibu oder San Onofre bezahlen zu können (und gelegentlich eine billige Flasche Wein). Etliche waren gleichzeitig erfahrene Taucher und fingen sich kostenlose Hummer-Festmahle und Seeohren in den Gezeitenpools. 1935 rief Ball den Palos Verdes Surfing Club ins Leben, in den Swarts und Grannis (jetzt bereits unter seinem Spitznamen „Granny") 1936 aufgenommen wurden.

Wellenreiter boten sich als Motive für Fotografen an, und das Bild vom hawaiianischen Wellenbezwinger, der majestätisch vor Diamond Head stand, wurde schnell zum Postkartenklischee. Surfbilder wurden immer in erster Linie von Surfern selbst gemacht. Sämtliche Surffotografen hatten sich das Fotografieren selbst beigebracht und betrieben es als Hobby, nicht, um ihren Lebensunterhalt damit zu

**LeRoy Grannis, Ocean Beach,
California, 1963**

A salt-crusted tripod and a hundred-yard
squint—the hallmarks of a die-hard
surf photographer. Grannis shooting the
Western Surfing Association contest.
Photograph by Frank Grannis.

Ein salzverkrustetes Stativ und ein zuge-
kniffenes Auge – die Markenzeichen eines
passionierten Surffotografen. Grannis bei
Aufnahmen während des Wettbewerbs der
Western Surfing Association. Fotografiert
von Frank Grannis.

L'apanage du photographe de surf invé-
téré: un trépied rongé par le sel et ... des
yeux de lynx. LeRoy Grannis en pleine
séance photo lors du championnat de la
Western Surfing Association. Photo: Frank
Grannis.

verdienen. Tom Blake, der große Surfpionier und Erfinder, baute 1929 eine wasser-
dichte Box für seine Graflex-Kamera und begann, die hawaiianischen Wasserrat-
ten abzulichten, die auf zwölf Fuß langen *alaia*-Brettern durch die lang laufenden
Wellen vor Waikiki glitten. Er brachte Doc Ball das Handwerk bei, und Ball hatte
wiederum großen Einfluss auf Don James und später auf LeRoy Grannis. Ball war
ein echtes Fototalent mit gutem Blick, probierte ständig neue Blickwinkel aus und
baute wasserdichte Gehäuseprototypen, in denen er seinen Apparat mit hinaus
in die Wellen nehmen konnte. Die Schnappschüsse seiner Kumpels und deren
Freundinnen fangen den Geist der kurzen, glücklichen Tage des reinen Surfens
ein, die mit dem Angriff der Japaner auf Pearl Harbor, Hawaii, 1941 endeten.

Seit Kriegseintritt der Amerikaner ging es mit dem fröhlichen kalifornischen
Wellenreiterleben steil bergab, da die meisten jungen, gesunden Männer über
achtzehn sich entweder freiwillig zum Militär meldeten oder eingezogen wurden.
Viele kehrten nie zurück. Obwohl Grannis gerade erst geheiratet und 1941 eine
Tochter bekommen hatte, meldete er sich zwei Jahre später zur Luftwaffe der
U.S. Army. Als er die Fliegerausbildung abgeschlossen hatte, war der Krieg jedoch
bereits vorbei, er wurde 1946 entlassen. Nach Hermosa Beach zurückgekehrt,
wurde Grannis Fernmeldetechniker und fand eine Anstellung als Telefonzentra-
leninstallateur bei Pacific Bell Telephone. (Grannis blieb aktiver Reservist der U.S.
Air Force und wurde 1977 als Major außer Dienst gestellt.)

In den Jahren nach dem Krieg surfte Grannis nur noch sporadisch, die Arbeit
und seine vier Kinder beanspruchten ihn mehr und mehr. Ende 1959 wurde bei
ihm ein stressbedingtes Magengeschwür festgestellt, und der Arzt empfahl ihm
ein entspannendes Hobby. Seine Wahl fiel auf die Surffotografie, da Grannis nur
ein paar Straßen vom Meer entfernt wohnte und sein halbwüchsiger Sohn Frank
gerade mit dem Wellenreiten angefangen hatte. Im Juni 1960 hatte Grannis sich

bereits in der Garage eine Dunkelkammer eingerichtet und entwickelte einige erste
simple Fotos, deren Stil von Doc Ball beeinflusst war.

In jenem Sommer begann er, ausgerüstet mit einer DDR-Kleinbildkamera,
am 22nd Street Beach in Hermosa Beach zu fotografieren, einem unauffälligen
Strandabschnitt in der South Bay, an dem eine Gruppe junger Surfer aktiv war,
die ihr Können gern vor seiner Linse zeigen wollte. Unangefochtener Anführer der
22nd-Street-Gang war Dewey Weber, der mit dreiundzwanzig bereits in mehreren
Surffilmen mitgespielt und gerade einen eigenen Surfshop im nahe gelegenen
Venice Beach eröffnet hatte. Der kleine (158 cm), aber kräftige Weber surfte
aggressiv und trieb den Rest der Crew (u. a. Henry Ford, Freddie Pfahler und Mike
Zuetell) dazu an, ebenfalls ihr Bestes zu geben. Als das Jahr 1960 sich dem Ende
zuneigte, hatte Grannis schon über 2.500 Bilder geknipst und entwickelt.

Grannis' Dunkelkammer wurde sozusagen zum Ein-Stunden-Fotoservice der
South Bay; zu einer Zeit, in der die Surfmagazine nur alle zwei Monate erschie-
nen, waren die Wellenreiter sehr interessiert an aktuellen Bildern von sich selbst.
„Manchmal ging ich geradewegs vom Fotografieren an der 22nd Street in die Dun-
kelkammer, und bevor ich mich versah, stand draußen ein halbes Dutzend Typen
herum und wollte sehen, was ich fotografiert hatte", erinnert Grannis sich. „Und
dann ließ ich sie in die Dunkelkammer rein, bis es wegen der vielen Menschen
unerträglich heiß wurde. Da gab es zwei Brüder, Tom und Don Craig, die wohnten
in der Nähe und durchwühlten meinen Abfall, ob ich irgendetwas weggeworfen
hatte, was sie vielleicht haben wollten." Von seinem Haus waren es nur vierzig
Autominuten den damals zweispurigen Pacific Coast Highway hoch nach Malibu,
ein ehemals unbekannter Point Break, wo Grannis in den Dreißigern gesurft war
und der mittlerweile weltberühmt geworden war. Mit seinen perfekt auslaufenden
Wellen und der Nähe zu Hollywood war „the 'Bu" zu einem Anziehungspunkt

27

LeRoy Grannis, Bettina Brenna, Don James, Hermosa Beach, California, 1965

Thanks to Jacques Cousteau's innovations, surf photographers were now able to paddle out to the action with lightweight waterproof camera housings. Photograph by Frank Grannis.

Dank der Neuentwicklungen von Jacques Cousteau konnten Surffotografen jetzt mit leichten, wasserfesten Kameragehäusen rauspaddeln und das Geschehen direkt verfolgen. Fotografiert von Frank Grannis.

Grâce aux innovations de Jacques-Yves Cousteau, les photographes de surf peuvent aujourd'hui s'approcher au plus près de l'action équipés d'appareils photos logés dans des boîtiers étanches et légers. Photo: Frank Grannis.

geworden, der jeden Sommer die Surferelite anzog. Obwohl es auch damals bereits hoffnungslos überlaufen war, gab es an diesem Spot Surfstars wie Lance Carson, Johnny Fain, Mike Hynson und den legendären Miki Dora, die mit einem schnellen, theatralischen Stil an der Wellenwand entlangtanzten – dieser Stil wurde als „Hotdogging" bekannt. Grannis' fotografisches Können verbesserte sich ständig, und er verkaufte seine frühen Malibu-Bilder an das kurzlebige *Reef Magazine*, womit seine Karriere in den Printmedien begann.

Im November 1961 unternahm Grannis seine erste Reise nach Hawaii, damals die vorderste Front der Surfrevolution. Nachdem er zwei Wochen lang kleine Wellen in Waikiki und Makaha fotografiert hatte, fuhr er an den legendenumwobenen North Shore Oahus. Zu diesem Zeitpunkt erreichte ein großer Swell die Inseln, und Grannis war von der schieren Größe und Wucht der hawaiianischen Wellen zutiefst beeindruckt. Mit einem 650mm-Teleobjektiv fing er Cracks wie Rick Grigg, Peter Cole und Phil Edwards ein, die in der riesigen, hohlen „West Bowl" am Sunset Beach surften.

Grannis kehrte mit neu erwachter Begeisterung nach Kalifornien zurück. Im Laufe der nächsten Jahre verdreifachte er seinen Ausstoß an Bildern und begann zudem, auch mehr Farbbilder und Lifestyle-, Wettbewerbs- und Werbefotos zu machen. Die frühen Anbieter von Surfprodukten waren eher isoliert und sparsam und suchten in den eigenen Reihen nach ihrem Design und Fotomaterial. Als kommerzieller Fotograf hatte Grannis keinerlei Erfahrung, schlug sich jedoch mit einfachen, cleveren Konzepten wacker. Sein Bild des Hermosa-Beach-Surfers Ricky Hatch, der in Schuhen und geschniegeltem Anzug vorne auf dem Brett steht, eine Anzeige für Jacobs Surfboards, ist ein Klassiker der Surffotografie. 1963 kaufte Grannis eine Calypso Unterwasserkamera (entwickelt von Jacques Cousteau und Vorläufer der Nikonos) und produzierte damit eine bahnbrechende Aufnahme von Henry Ford, der an der 22nd Street einen perfekten Bottom Turn demonstrierte.

Grannis musste schon früh feststellen, dass die Surffotografie selbst für den erfahrensten Ozeanschwimmer gefährlich sein konnte. Als er einmal den hawaiianischen Sunset Beach vom Wasser aus mit seiner Nikonos fotografierte, wurde er von einer riesigen Welle überrascht, die auf den Kanal der West Peak Bowl zurollte und sich weit draußen brach. Grannis saß fest, blickte auf und sah eine sieben

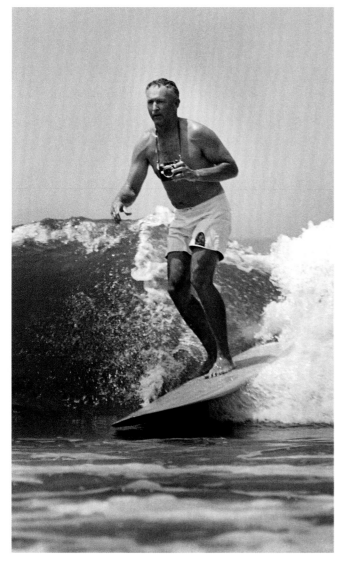

LeRoy Grannis, Hermosa Beach, California, 1969

Grannis in trim with another Cousteau invention—the Calypso amphibious camera. Photograph by John Grannis.

Grannis in Aktion mit einer weiteren Erfindung von Cousteau – der Calypso Amphibienkamera. Fotografiert von John Grannis.

Grannis se familiarisant avec une autre invention de Cousteau, l'appareil photo amphibie Calypso. Photo: John Grannis.

Meter hohe Wand aus Weißwasser und drei dicke, elf Fuß lange Surfbretter, die auf seinen ungeschützten Kopf zurasten. Er schaffte es, unter den Wassermassen durchzutauchen und seine kostbare Kamera zu retten. Später entwarf und baute Grannis mit Hilfe seines alten Freundes Doc Ball seine erste, mit Gummi ausgekleidete und mit Saugnäpfen versehene wasserdichte Box, die es ihm ermöglichte, den Film zu wechseln, auch vom Wasser aus mit längeren Brennweiten zu fotografieren und stundenlang in der relativen Sicherheit des Sunset Beach oder Waimea Bay Kanals zu sitzen, ohne an Land zurückkehren zu müssen.

Auf dem Festland liebte Grannis die klare, coole Distanz, die ihm das Century 1000 Superteleobjektiv ermöglichte. Aus 800 Metern Entfernung konnte er die Surfer als heroische Gestalten vor einem riesigen Hintergrund wie dem *Sunset Beach* künstlerisch komponieren. Seiner tiefen Verbundenheit mit der Surfszene verdanken wir es, dass eine große Lücke im kollektiven Gedächtnis heute geschlossen werden kann. Grannis' Fotos, besonders die von 1960 bis 1965, zeigen das Wellenreiten an dem wichtigen Wendepunkt von Kult zu (Sub-)Kultur. Auf den ersten Blick mögen seine Fotos Wehmut nach einer einfacheren, naiveren Zeit auslösen, aber bei näherem Hinschauen wird deutlich, dass er die rasend schnelle Entwicklung des Surfsports zum symbolhaften Lebensstil dokumentierte. Seine Bilder zeigen, wie es wirklich war; ihm gelang der Brückenschlag zwischen den Songtexten der Beach Boys und der Realität der südkalifornischen Strandszene. Surfjargon, Surfmusik, Surfkunst, Surfzeitschriften, Surfmode – alle Elemente, die heute als Grundlage der modernen Surfkultur gelten, wurden innerhalb dieser

Bebop-Ästhetik. Ron Stoner bevorzugte warme, goldbraune Töne und romantische, schöne Ansichten. Ron Church war professioneller Industriefotograf mit fortgeschrittenen technischen Kenntnissen und den neuesten Unterwasserkameras. Seine Schwarz-Weiß-Bilder waren heroische, aber oft unpersönliche Darstellungen der herrschenden Surfgötter. Als am Meer aufgewachsener Surfer fing Grannis hingegen die lokale Szene mit unmittelbarer Direktheit ein.

Der Surffilmer und Herausgeber John Severson war einer der ersten, der von der Surffotografie in andere Medien expandierte. 1960 brachte er *The Surfer* heraus, ein sechsunddreißig Seiten starkes Heftchen mit Fotos und Zeichnungen von ihm selbst, mit dem er bei den Vorstellungen seines Dokumentarfilms *Surf Fever* etwas Geld dazu zu verdienen hoffte. Das Heftchen war unglaublich begehrt und die erste Auflage von 5.000 Stück schnell ausverkauft. 1961 folgte ein Vierteljahresblatt, das ein Jahr später dann alle zwei Monate herauskam. Severson stellte ein paar Mitarbeiter ein und wurde hauptberuflicher Chefredakteur und Herausgeber. Schon bald fotografierte Grannis für die Zeitschrift *Surfer* und für die kurzlebige *Surfing Illustrated*.

Die frühen Surfmagazine waren hausgemachte Projekte, die von den Sportbegeisterten selbst am Küchentisch geschaffen und unters Volk gebracht wurden. Als *Surfer* herauskam, wurden Druckerzeugnisse erstmals für Herausgeber wie Severson mit niedrigem Budget bezahlbar; außerdem hatte die Verwertung der Nischensportart in den Medien bereits begonnen, z. B. in Filmen wie *Gidget* (1959) und *Ride the Wild Surf* (1964). In Südkalifornien hatte die Film- und

Einen Steinwurf vom Meer entfernt in Hermosa Beach aufgewachsen, begann Grannis als Vierzehnjähriger mit dem Surfen, auf einer geborgten Redwoodplanke, die fast hundert Pfund wog.

paar Jahre entweder erfunden oder definiert. Grannis war einer der wenigen Surffotografen, die die Kamera nicht nur auf die Action in den Wellen hielten, sondern auch das Drumherum dokumentierten.

Nach einem äußerst erfolgreichen Winteraufenthalt auf Hawaii tat Grannis sich 1964 mit dem späteren Surfbekleidungsmagnaten Dick Graham zusammen und hob das *International Surfing Magazine* aus der Taufe (es wurde später umbenannt in *Surfing* und besteht als zweitältestes Surfmagazin der Welt heute noch). Grannis wurde zum ersten Bildredakteur, Mitherausgeber und Hauptfotograf, und das alles neben seinem Vollzeitjob bei Pacific Bell Telephone. Jedes Wochenende fotografierte er pflichtbewusst die endlose Reihe der Amateur- und Clubwettbewerbe. Dabei schaffte er es, eine Generation heute legendärer Surfer als linkische Jugendliche für die Nachwelt festzuhalten. Da viele von ihnen so alt waren wie sein Sohn, betrachtete er seine Motive oft mit väterlichem Blick und erzielte so völlig natürlich wirkende Porträts, die über die Zurückhaltung des Mannes im mittleren Alter hinwegtäuschten, der Fremde bat, für seine Kamera zu posieren. Unter seinen fotografischen Vorbildern und Kollegen nahm Grannis eine klare Mittelposition zwischen Kunst und Fotojournalismus ein. Seine Bilder waren wohl komponiert, fokussiert und mit einem großzügigen Tiefenschärfebereich ausgestattet, die dem Betrachter Zeit gaben, sich in die Stimmung der Zeit hineinversetzen zu lassen. Weil er feinkörnige Filme mit geringer Empfindlichkeit verwendete, konnte er sehr detailreiche Vergrößerungen anfertigen. „Grannis' Aufnahmen hatten das gewisse Etwas, das sie für mich zu etwas ganz Besonderem machte", sagt Brad Barrett, von 1968 bis 1973 Hausfotograf und Fotoredakteur der Zeitschrift *Surfer*.

In den frühen Sechzigern gab es nicht mal ein halbes Dutzend Surffotografen in den USA, die bereits etwas veröffentlicht hatten, und mit der Ausnahme von John Severson betrieben alle die Fotografie nur nebenbei als Hobby. Jeder von ihnen besaß jedoch einen eindeutig definierten Stil und ein bestimmtes Anliegen. Severson, ehemaliger Kunstlehrer, vermittelte mit seinen Bildern eine ungeglättete

Fernsehindustrie von Hollywood actiongeladene, bunte Bilder vom Surfen als Blickfang entdeckt. „Plötzlich war die Möglichkeit da, ein Bild, das man gemacht hatte, auf ungeahnte Weise zu vermarkten", erzählt John Van Hamersveld, ehemaliger Artdirector beim *Surfer* und Schöpfer des legendären Leuchtfarbenplakats für *The Endless Summer*. „Diese kleine, isolierte Subkultur wurde jetzt von den Medien aufgegriffen und durch die Zeitschriften und die Surffilme hinauf zu den Produzenten der Massenkultur transportiert."

1966 hatte sich das, was fünf Jahre zuvor noch eine aufgesetzte „Surfmode" gewesen war, zu einer authentischen Jugendbewegung entwickelt, die ihre eigene Sprache, ihre Musik, Mode, Medien, Autos und Verhaltenskodizes hatte. Das Interesse des Mainstreams an dieser Szene befand sich auf dem absoluten Höhepunkt, und ein kleines südkalifornisches Herstellerkartell von Surfprodukten, auch „Dana Point Mafia" genannt, verdiente sich dumm und dämlich. Der noch in den Kinderschuhen steckende Sport – eher eine Glaubensrichtung als eine Wochenendbeschäftigung – bekam im Juli 1966 enormen Auftrieb, als im ganzen Land Bruce Browns Film *The Endless Summer* in die Kinos kam. Dieser einfallsreiche, lässige Dokumentarfilm gab der Welt der Nichtsurfer (den „*Legions of the Unjazzed*", wie Meistersurfer Phil Edwards es auszudrücken beliebte) den ersten realistischen Einblick in die eher abgeschlossene Surfszene, und die Welt wollte mehr davon. Eine Art Goldrauschstimmung breitete sich aus.

In San Diego beglückwünschten sich die Stadtväter und die Ausrichter der Surfweltmeisterschaft gegenseitig zum neu gewonnenen Ansehen des Wellenreitens. Die Wettbewerbsrepräsentanten hofften, bei der bevorstehenden Meisterschaft die immer zahlreicher werdenden „Surf-Hooligans" und die negativen Schlagzeilen loswerden zu können, die den Sport seit dem Kinostart von *Gidget* in der ersten großen Boomzeit verfolgt hatten. Die Handelskammer von San Diego freute sich über einen enormen Anstieg der Touristenzahlen, als diese sexy Strandsportart scheinbar über Nacht die Jugend des Landes mit ihrem lose sitzenden Geldbeutel im Sturm eroberte.

Gleichzeitig wurde das lockere Surferleben von einer konservativen Welle überrollt. John Severson führte in seiner Zeitschrift *Surfer* eine Kampagne durch,

mit der die Surfszene von „unerwünschten Elementen" gereinigt werden sollte. Das Magazin schlug in seinen Beiträgen einen selbstgerechten Ton an, und in Gastbeiträgen und sorgfältig ausgewählten Leserbriefen ließ man sich hämisch über die Niederlage der Surfpunks oder „hodads" aus, die das Ansehen des Surfens angeblich mit geschmacklosen Streichen und einer allgemein negativen Einstellung gegenüber Autoritätsfiguren beschmutzt hätten. „[Das Wellenreiten] spricht nicht mehr nur Außenseiter an", verkündete John Hannon, ein führender Surfboardhersteller von der Ostküste, in einem *Newsweek*-Interview. „Diese Jungs haben einen ordentlichen Haarschnitt und saubere Fingernägel; sie werden diese Unruhestifter auf ihre Plätze verweisen."

Die Eröffnungsrunde der „Shortboard Revolution" – und damit das Ende der unkomplizierten frühen Sechzigerjahre – wurde am 2. Oktober 1966 in Ocean Beach, San Diego, eingeläutet. Dort, bei bedecktem Himmel mit kleinen, sanften Wellen, überraschte Nat Young die amtierende Surfelite mit einem bis dahin unbekannt radikalen Stil. Mit seinen harten und kraftvoll gefahrenen Manövern gewann er die World Surfing Championships im Handumdrehen. Als David Nuuhiwa, der geschmeidige Hawaiianer, der für seine langen, eleganten Noserides berühmt war, auf ihn einredete: „Du musst versuchen, mit der Welle eins zu werden", erwiderte Young frech: „Ich will mit gar nichts eins werden!" Youngs Sprüche waren nicht minder provozierend als seine Ausrüstung. Er gewann den Contest auf „Magic Sam", einem selbst gebauten Surfbrett, das neun Fuß vier Zoll lang war – einen

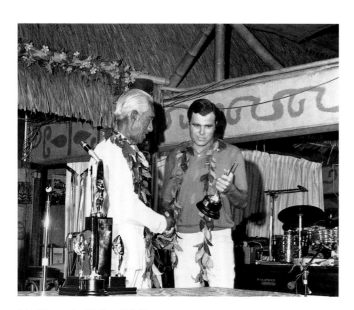

Duke Kahanamoku, Miki Dora, Waikiki, Hawaii, 1967

The Duke and the Cat—Dora, surfing's enfant terrible, graciously accepts a runner-up award from Kahanamoku, the seventy-six-year-old father of modern surfing.

The Duke and the Cat – Dora, Enfant terrible des Surfens, nimmt gnädig den Preis für den zweiten Platz von Kahanamoku, dem sechsundsiebzigjährigen Vater des modernen Surfens, entgegen.

Le Duke et « The Cat » : Miki Dora, l'enfant terrible du surf, accepte gracieusement un second prix des mains de Duke Kahanamoku, le père du surf moderne, alors âgé de 76 ans.

glaubte an Schwerelosigkeit. Man war verklemmt oder man ließ sich fallen. Alles befand sich so ziemlich im freien Fall damals."

Nach dem kurzen Liebäugeln mit der Mainstream-Respektabilität besann sich die Subkultur auf ihre Wurzeln als Protestbewegung gegen die angepasste Gesellschaft, was in der Welt draußen nicht unbemerkt blieb. In seinem weithin bekannten Essay „The Pump House Gang" berichtete Popkulturkritiker Tom Wolfe 1966, dass viele Surfer „sich vom Wellenreiten hin zu einer Vorhut ganz anderer Art entwickeln – der abgedrifteten psychedelischen Welt Kaliforniens". Wo die amerikanische Industrie einst eine Generation williger Jungkonsumenten gesehen hatte, erblickte sie jetzt nur noch lange Haare, Haschischrauch und einen ablehnend hochgestreckten Mittelfinger.

Die wirtschaftlichen Folgen waren weitreichend. Innerhalb der nächsten Jahre mussten die großen Bretthersteller sich entweder verkleinern oder dichtmachen. Beim *Surfer* gingen die Werbeeinnahmen in den Keller, die Zeitschrift wurde immer kleiner und die Redaktion immer linkslastiger. Unter der neuen radikaleren Führung von Kampion wurde *Surfer* zum Multiplikator der immer größer werdenden Gegenkultur, die sich für Frieden, freie Liebe, Tuberides und das Recht jedes Surfers stark machte, auszusteigen und sich die Birne so richtig vollzuknallen. Kampion, der öffentlich gegen die meisten organisierten Surfwettbewerbe mit Artikeln wie „Schlechtes Karma am Huntington Beach" oder „Tod allen Wettbewerben" hetzte, wollte das Wellenreiten als Metapher für kosmische Ausgewogenheit verstanden wissen, nicht als kapitalistischen Egotrip. Auch der Eskalation des Vietnamkrieges, der die Surfer in alarmierenden Zahlen vom Strand wegriss, stand er sehr kritisch gegenüber. Er eröffnete die Jagd auf den neuen amerikanischen

„Grannis' Aufnahmen hatten das gewisse Etwas, das sie für mich zu etwas ganz Besonderem machte", sagt Brad Barrett.

ganzen Fuß weniger als der damalige Standard. Er hatte es zusammen mit seinem australischen Landsmann Bob McTavish entwickelt; es besaß eine lange, krummsäbelartige Finne, die sich der exzentrische amerikanische Bord-Shaper George Greenough ausgedacht hatte. Durch diesen drastischen Evolutionssprung in Technologie und Mentalität wurde praktisch über Nacht eine ganze Generation von Wettkampfboards reif für den Müllhaufen. Mit Nat Youngs Sieg sollte sich das Wellenreiten die nächsten zehn oder mehr Jahre lang vom Mainstream wegbewegen. Big Nat, wegen seines aggressiv-radikalen Stils „The Animal" genannt, hatte der Welt einen Blick in die Zukunft eröffnet. Bis 1966 war das schwierigste Manöver der „Hang Ten" gewesen (elegant auf dem vordersten Ende des Bretts balancieren und die Zehenspitzen beider Füße über die Nose hinaushängen lassen). Von jetzt an war alles möglich – man nannte es „Mind Surfing". Und es war, wie *Surfer*-Journalist Paul Gross schrieb, „eine Massenflucht weg von allem, was vorher da gewesen war". Doch niemand schien es damals so recht zu bemerken.

Gleichzeitig breiteten sich die psychedelischen Drogen wie ein Steppenbrand in der Surfszene aus; bei manchen führten sie zur Erweiterung des Bewusstseins, bei anderen zum totalen Aussetzen des Denkvermögens. Das Wellenreiten wurde zu einer introvertierten, esoterischen Angelegenheit, als ehemals Jantzen-Sportswear tragende „Hotdogger" zu bärtigen Zen-Anhängern mutierten. Wettbewerbe waren nicht mehr cool, niemanden interessierte es, wer Erster wurde. Es kümmerte einfach niemanden mehr. Beim Surfen ging es jetzt nicht mehr um Tricks und Trophäen, sondern um die Ausbalancierung des persönlichen Karmaflusses in „Kristallkathedralen aus geschmolzenem Glas", wie im *Surfer* nachzulesen war. Rick Griffin machte schon 1966 in seinen Cartoons für *Surfer* versteckte Anspielungen auf Drogen, was viele der Werbekunden der Zeitschriften verärgerte. Ihr nomadenhafter Lebensstil veranlasste nicht wenige Surfabenteurer zu einer Zweitkarriere als internationale Drogenschmuggler. „Man war entweder dabei oder nicht", schrieb Drew Kampion, Herausgeber des *Surfer* von 1968 bis 1972. „Man kapierte es oder man kapierte es nicht. Man glaubte an Schwerkraft oder man

Präsidenten Richard Nixon, weil der es gewagt hatte, in die Nähe von Trestles Beach in San Clemente zu ziehen und dort den besten Surfspot zu blockieren, wann immer er im „Western White House" residierte.

Grannis entstammte einer ganz anderen Generation und konnte nicht viel mit dem neuen Antiestablishment-Dogma des Wellenreitens anfangen. Als jemand, der den Zweiten Weltkrieg erlebt hatte und seinem guten Freund Hop Swarts bei der Durchführung von Wettbewerben in der neu gegründeten United States Surfing Association geholfen hatte, hielt Grannis standhaft an der Idee fest, dass das Wettbewerbs-Wellenreiten dem Sport zugute kam und seine gesellschaftlich akzeptable Seite betonte. 1968 veröffentlichte Grannis einen Beitrag, in dem er gute, saubere Surfwettbewerbe verteidigte und ihre Kritiker als „ewige Nörgler" bezeichnete, die kein Recht hätten, sich zu beschweren. „In den letzten Jahren hat es eine Flut unsinniger Artikel gegeben, in denen die Wellenreiter von vorgestern, nicht surfende hawaiianische Journalisten, windige Handelsvertreter und frustrierte Möchtegern-Redakteure auf den Wettbewerben herumhacken", schrieb er. „Allesamt haben sie nur deswegen etwas gegen Wettbewerbe, weil sie selbst keine Chance hätten."

Dennoch gehörten Ende der Sechziger die meisten Wettbewerbe, sogar die einstmals so angesehenen Surfer Poll Awards des *Surfer*-Magazins, der Vergangenheit an. Das Ereignis, das einem professionellen Wettkampf am ehesten nahe kam, war ein durchgeknallter Antiwettbewerb, der sich „Expression Session" nannte, bei dem die Topsurfer ohne alle Preisrichter, Punkte und Trophäen ihre Künste zur Schau stellten. „In diesem Jahr wurde vieles entwickelt oder sogar neu erfunden: Shortboards, V-Bottoms, Mini-Guns, flexible Finnen, kurze Finnen – insgesamt radikales Board-Design", schrieb Kampion 1968. „Es gibt nur wenige Wellenreiter, die jetzt noch so surfen wie vor einem Jahr." Nichtsdestotrotz schrieb Grannis einen weiteren Gastbeitrag, in dem er sehr richtig voraussagte, dass es eines Tages eine Rückkehr zu Longboards und zum Noseriding geben würde. Und während all dieser Umwälzungen hielt Grannis immer weiter seine Kamera auf

**LeRoy Grannis, Hermosa Beach,
California, 1969**

On a lunch break from his day job as a
supervisor with Pacific Bell Telephone.

Während einer Mittagspause des hauptberuflichen Abteilungsleiters bei Pacific Bell
Telephone.

Au cours d'une pause déjeuner à l'époque
où il occupait un poste de direction chez
Pacific Bell Telephone.

einen Sport gerichtet, den er von ganzem Herzen liebte, und schoss unendlich viele Bilder von Longboardern wie von Shortboardern, trotz aller Grabenkämpfe zwischen den so unterschiedlichen Surfphilosophien.

Anfang Dezember 1969 wurden Hawaii und Kalifornien von einer Jahrhundertflut heimgesucht. Wie Berge türmten sich die zehn Meter hohen Wellen am North Shore von Oahu auf, zerstörten sechzig Häuser und schleuderten große Boote hundert Meter weit ins Landesinnere. Auch wenn die Wellen am gesamten North Shore zu riesig waren, um sie bezwingen zu können, nahmen es Greg Noll und eine kleine Gruppe von Surfern mit den etwas kleineren Wellen in Makaha auf der Westseite der Insel auf. Dort erwischte Noll die vermutlich größte Welle, die bis zu diesem Zeitpunkt jemals gesurft worden war. Den resultierenden Wipeout überlebte er nur knapp. „In einem Sport, der mit rapiden Veränderungen, Hype und Revolution zu kämpfen hat, erwischte ein knallharter Dinosaurier aus den Fünfzigern die letzte große Welle von 1969", schrieb Drew Kampion.

Der Swell von 1969 wird in der Surfwelt allgemein als grandioses geophysikalisches Finale für die zerstrittenste und turbulenteste Dekade des Wellenreitens angesehen. „Was wir im Dezember '69 erlebten", erinnerte sich der in den Sechzigerjahren legendäre Skip Frye viel später, „... war in gewisser Weise der Wechsel vom Sixties-Longboard-Ding zur Shortboard-Ära. Es war wie einmal groß Reinemachen, und danach war nichts mehr wie vorher." Grannis war überzeugt,

dass die Brettgröße nur eine Frage der Logistik war, und konnte die Kluft zwischen den beiden Generationen mit seinen Fotografien überbrücken. „Ich habe Surfer fotografiert, keine Bretter", sagt er. „Für mich veränderte sich im Grunde nicht so viel."

LeRoy Grannis' letztes Surffoto wurde 1971 in *International Surfing* veröffentlicht. Ende der Siebzigerjahre ließ er sich von seinem Beruf bei Pacific Bell Telephone pensionieren und zog von Hermosa Beach nach Carlsbad, Kalifornien. Über zwanzig Jahre lang surfte und fotografierte er dort noch weiter; seine Abzüge und Negative bewahrte er ordentlich in Ringordnern zu Hause auf. Das entscheidende Jahrzehnt in der Geschichte des Wellenreitens, als eine kleine Randgruppe passionierter Wellenreiter aus ihrem Lebensstil eine weltumspannende Industrie machte, wäre beinahe dem Vergessen anheim gefallen.

Grannis, ein Pionier des Surfsports und dessen Fotografie, fing die Surfgeschichte am Wendepunkt ihrer Evolution ein. Diese Retrospektive seiner Bilder von den Klassikern des Katalogs bis zu noch nie veröffentlichten, in seinem Archiv entdeckten Aufnahmen – gewährt dem Betrachter Zugang zu einem Lebensstil, der sich von einer Hand voll Begeisterten zu einem Wirtschaftszweig mit 4 Mrd. Dollar Umsatz im Jahr entwickelt hat. Heute, da zahllose Bilder professioneller Surffotografen den Markt überschwemmen, bieten Grannis' Fotos in ihrer eleganten Einfachheit und als Zeugen einer vergangenen Zeit einen wichtigen Einblick in die Entstehung einer Subkultur. „Ich war Wellenreiter und fotografierte das, was ich mir gerne ansah", wehrt Grannis bescheiden ab. „Wahrscheinlich habe ich eine Menge Glück gehabt."

LA VAGUE PARFAITE capturée par l'objectif de LeRoy Grannis

Par Steve Barilotti

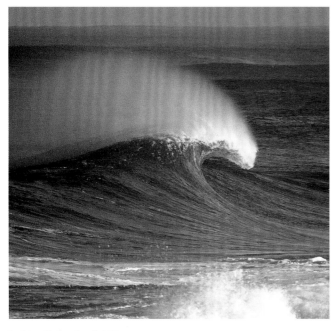

Backdoor Pipeline, Hawaii, 1971

Pipeline, which pitches over a shallow, unforgiving coral reef, has claimed dozens of boards and a few lives since it was first ridden in 1960.

Die „Pipeline", die sich über einem flachen, gnadenlosen Korallenriff erhebt, hat schon viele Bretter und einigen Menschen das Leben gekostet, seit sie 1960 zum ersten Mal gesurft wurde.

Les vagues de Pipeline, qui s'écrasent sur un impitoyable récif de corail aux fonds plats, ont broyé des dizaines de planches – et quelques vies humaines – depuis la première fois où elles ont été surfées, en 1960.

Depuis des temps immémoriaux, les nombreux témoignages relatant la chevauchée des vagues par les hommes nous sont livrés sous des formes multiples, depuis les mélopées des anciens et les premiers écrits jusqu'aux images actuelles sublimées par l'œil du photographe.
— Tom Blake, surfer de la première heure et photographe de surf

La révolution fut immortalisée en noir et blanc par un dimanche après-midi, en l'espace de 1/250ᵉ de seconde. Ce 2 octobre 1966, Ocean Beach, près de San Diego, accueille les championnats du monde de surf. Quarante mille spectateurs sont agglutinés sur la plage et sur l'embarcadère flambant neuf. Au moment même où le jeune Robert « Nat » Young, du haut de ses dix-huit ans, soulève au-dessus de sa tête le lourd trophée en forme de Californie, quelque trois cent quarante mille G. I. s'enlisent dans les rizières du Vietnam, Brian Wilson est sur le point de sortir son album mythique *Good Vibrations* et le LSD vit ses trois derniers mois de légalité. Les planches mesurent en moyenne dix pieds et demi et pèsent plus de treize kilos. Nat Young est sacré champion du monde, et l'univers du surf vient d'opérer un virage à 180 degrés.

Sur le podium des vainqueurs, le jeune Australien – imposant par sa taille et par son tempérament fougueux – est flanqué ce jour-là de Jock Sutherland, un Hawaïen à la voix douce, et du Californien Corky Carroll, l'enfant prodige de la petite vague. Un petit groupe de reporters locaux et nationaux, représentant entre autres *Newsweek* et *The New York Times*, se bouscule pour être au plus près des héros du jour. LeRoy Grannis, photographe exclusif du magazine *International Surfing*, rôde dans les derniers rangs de la foule, capturant méthodiquement les images du trophée avec son Pentax S rongé par le sel. Au moment crucial de la cérémonie, il met l'image au point et cadre le jeune Young en train de jubiler : « Je suis sur un nuage ! »

Malgré l'agitation palpable qui règne sur la plage, Grannis reste stoïque et impassible. Pour lui, tout cela n'est finalement que l'apogée d'une saison passée à sillonner la Californie du Sud et à immortaliser les week-ends de compétition inter-clubs. Alors âgé de quarante-neuf ans, Grannis compte à son actif trente-cinq années de pratique du surf et cinq années de photographie consacrée à la discipline. Le week-end suivant, son boulot le conduira sans doute vers le nord, à Malibu ou à Huntington Beach, pour couvrir une nouvelle compétition locale, et les qualifications pour les prochains championnats du monde de surf reprenant bientôt.

LeRoy Grannis s'est lancé dans la photographie de surf à la fin de l'année 1959, non pas en tant que professionnel ou artiste, mais comme un bon père de famille en quête d'un passe-temps qui lui permettrait d'évacuer le stress de la vie professionnelle. La chance a voulu qu'il ressorte son appareil photo à un tournant crucial de l'histoire du surf. Né en 1917 à Hermosa Beach en Californie, Grannis était un rescapé de l'époque où la Côte Ouest ne comptait que quelque deux cents surfeurs californiens qui, dans un esprit de gentlemen, flirtaient avec les vagues lentes de San Onofre et de Palos Verdes Cove sur des planches massives de onze pieds taillées dans le séquoia. Ils incarnaient la première génération de surfeurs californiens à avoir adopté cette vieille discipline importée sur le continent par les Hawaïens George Freeth et Duke Kahanamoku et ont ainsi contribué à la renaissance du surf, cette pratique introduite à la fin du XIXᵉ siècle par une poignée de « beach boys » hawaïens.

Grannis, qui a grandi à quelques pas de la plage de Hermosa Beach, a commencé à surfer à l'âge de quatorze ans sur une planche d'emprunt en séquoia qui pesait près de quarante-cinq kilos. C'est là, tandis qu'il taquinait les petites vagues qui venaient s'écraser sous la jetée, qu'il a rencontré les trois camarades de surf qui deviendront ses amis pour la vie : le premier est Lewis « Hoppy » Swarts, le second est un garçon natif de Hermosa Beach et le troisième, John « Doc » Ball, un sympathique gaillard de dix ans son aîné, étudiant en dentisterie à l'Université de Californie du Sud.

Ball est un surfer confirmé et ne tarde pas à convaincre ses jeunes camarades Grannis et Swarts d'aller se mesurer aux belles vagues de Palos Verdes Cove, à huit kilomètres au sud. La baie de Palos Verdes était devenue la résidence secondaire d'une escouade de surfeurs passionnés, pour la plupart de jeunes garçons désœuvrés d'une vingtaine d'années qui attendaient la fin de la Grande Dépression en déployant des trésors d'ingéniosité pour boucler leur budget. Ne comptant que sur eux-mêmes, ils construisaient leurs planches de leurs propres mains, cousaient leurs shorts de surf eux-mêmes et alimentaient de leurs maigres économies la cagnotte commune pour acheter le carburant – et parfois une bouteille de vin bon marché – qui leur permettait d'organiser des sorties à Malibu ou à San Onofre. Beaucoup parmi eux étaient des plongeurs chevronnés et régalaient la troupe de festins de homards et d'ormeaux pêchés au fond des bassins de marée environnants. En 1935, Ball crée le Palos Verdes Surfing Club et y introduit en 1936 ses camarades Swarts et Grannis (lequel prend dès lors le surnom de « Granny »).

Les photographes trouvaient dans les surfeurs des sujets naturels, à l'image de ces majestueux Hawaïens au teint cuivré immortalisés en équilibre sur leur planche avec en toile de fond la silhouette impressionnante du volcan Diamond Head – un décor de carte postale devenu mythique. L'iconographie du surf était essentiellement due aux surfeurs eux-mêmes. Les photographes de surf étaient tous des amateurs autodidactes ; aucun d'entre eux ne vivait de la vente de ses photos. Tom Blake, à la fois surfer et *shaper* d'avant-garde, a fabriqué en 1929 un boîtier étanche pour son appareil photo Graflex et commencé à photographier depuis sa planche les « beach boys » de Hawaï qui dévalaient sous l'œil de son objectif les longues déferlantes de Waikiki sur leurs *alaia* de douze pieds. Il fut le précepteur de Doc Ball, lequel à son tour exerça une grande influence sur Don James et, plus tard, sur LeRoy Grannis. Ball était un photographe talentueux doté d'un œil vif et toujours en quête d'angles nouveaux ; il a mis au point des prototypes de boîtiers étanches pour pouvoir emporter son appareil photo au cœur de l'action. Ses clichés d'un naturel saisissant, avec pour modèles sa bande d'amis et leurs petites copines, ont immortalisé l'époque dorée, mais éphémère, du surf « pur » qui s'est éteinte peu après l'attaque de Pearl Harbor par les Japonais en 1941.

Avec le déclenchement de la Seconde Guerre mondiale, l'enrôlement de la plupart des jeunes surfeurs de plus de dix-huit ans aptes au service militaire marque le déclin brutal du surf californien. Beaucoup ne revirent jamais leur terre natale. Bien que jeune marié et malgré la naissance de sa fille en 1941, Grannis s'enrôle deux ans plus tard dans la U.S. Air Force. Mais lorsqu'il obtient son

je les avais laissés entrer, c'était la fièvre assurée dans le labo. Je me souviens de deux gamins, Tom et Don Craig, qui habitaient juste à côté ; ils n'hésitaient pas à fouiller dans mes ordures pour voir si je n'avais pas jeté des photos qu'ils voulaient récupérer à tout prix. » Sa maison n'était qu'à trois quarts d'heure de voiture de Malibu par la Pacific Coast Highway – qui n'avait alors que deux voies. À l'époque où Grannis surfait à Malibu, dans les années 1930, cet endroit n'était qu'un obscur *point break*, loin de devenir le *spot* mondialement couru des années 1960. Grâce à sa houle idéale, ses crêtes de vagues parfaitement formées et la proximité de Hollywood, « The 'Bu » devient alors un rendez-vous estival respecté de l'élite du surf. Bien que déjà extrêmement fréquenté à cette époque, le *break* accueille aussi des stars de la planche comme Lance Carson, Johnny Fain, Mike Hynson et le légendaire Miki Dora, lequel dansait sur les grosses vagues dans un style vif et théâtral qui prendrait bientôt le nom de « hotdogging ». Les talents de photographe de Grannis se confirment rapidement et la vente de ses premiers clichés de Malibu à l'éphémère magazine *Reef* marque le début de sa longue carrière de photojournaliste.

En novembre 1961, Grannis entreprend son premier voyage à Hawaï, l'avant-poste du surf de l'époque. Après deux semaines passées à photographier les petites vagues de Waikiki et de Makaha, il pousse vers le mythique North Shore, la côte nord de l'île d'Oahu. Devant le spectacle d'un *swell* de circonstance, Grannis reste captivé par la puissance et la magnitude des déferlantes de Hawaï. Équipé d'un téléobjectif de 650 mm, il fixe sur sa pellicule des surfeurs de la trempe de

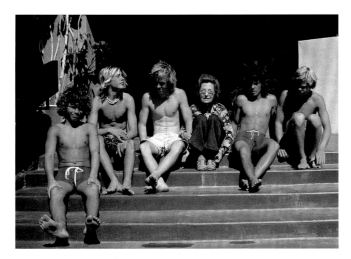

Nancy Katin, North Shore, Hawaii, 1972

Katin (center) was the feisty grande dame of early surf fashion with her colorfully rugged Kanvas by Katin trunks. Left to right, Eddie Gay, John Grannis, Tom Witt, Katin, Mark Sosa, Scotty Houghtby.

Katin (in der Mitte) war die energische Grande Dame der frühen Surfmode. Die farbenfrohen, robusten Hosen von Kanvas by Katin waren allgegenwärtig. Von links nach rechts: Eddie Gay, John Grannis, Tom Witt, Katin, Mark Sosa, Scotty Houghtby.

La fringante Nancy Katin (au centre), grande dame des premières heures de la mode du surf. Les shorts en toile hauts en couleur de sa marque légendaire, Kanvas by Katin, étaient devenus incontournables. De gauche à droite : Eddie Gay, John Grannis, Tom Witt, Nancy Katin, Mark Sosa et Scotty Houghtby.

Grannis, qui a grandi à quelques pas de la plage de Hermosa Beach, a commencé à surfer à l'âge de quatorze ans sur une planche d'emprunt en séquoia qui pesait près de quarante-cinq kilos.

diplôme d'aviateur, la guerre est finie et il est libéré en 1946. De retour à Hermosa Beach, Grannis devient ingénieur en télécommunications et décroche un emploi stable d'installateur de standards téléphoniques chez Pacific Bell Telephone. (Il reste cependant en réserve active au service de la U.S. Air Force, dont il prendra sa retraite en 1977 avec le grade de commandant.)

Au cours des années qui suivent la guerre, Grannis surfe de manière sporadique, mais son travail et sa famille – il est alors père de quatre enfants – ne lui laissent que peu de répit. Vers la fin de l'année 1959, on lui diagnostique un ulcère de l'estomac dû au stress et son médecin lui recommande la pratique d'une activité de détente. Grannis s'oriente tout naturellement vers la photographie aquatique – il habite à quelques rues de l'océan et son jeune fils Franck vient de commencer à pratiquer le surf. En juin 1960, Grannis aménage une chambre noire dans son garage et développe lui-même, de façon encore rudimentaire, quelques clichés au style fortement influencé par Doc Ball.

L'été 1960, équipé d'un appareil photo est-allemand de 35 mm, Grannis commence à photographier les surfeurs de 22nd Street sur Hermosa Beach, une portion relativement quelconque du *beach break* de Sunset Beach où une troupe de jeunes surfeurs se bousculent pour prendre la pose devant son objectif. Le leader incontesté de la bande de 22nd Street est un certain Dewey Weber, un jeune prodige de vingt-trois ans qui a déjà tourné dans plusieurs films consacrés au surf et qui vient d'ouvrir sa propre boutique de planches tout près de là, à Venice Beach. Bien que de petite taille – il ne mesure qu'un mètre soixante – Weber est un surfer puissant dont le style agressif encourage le reste de l'équipe, constituée notamment de Henry Ford, Freddie Pfahler et Mike Zuetell, à repousser les limites. À la fin de l'année 1960, Grannis a pris et développé plus de deux mille cinq cents photos.

La chambre noire de Grannis était devenue un véritable laboratoire de développement rapide à South Bay, et à une époque où les magazines de surf étaient bimensuels, les surfeurs étaient friands de clichés de leurs propres exploits sans cesse renouvelés. « Parfois, je me rendais directement de 22nd Street à ma chambre noire et, le temps de me retourner, j'avais une demi-douzaine de gars qui attendaient devant pour voir le résultat », se souvient Grannis. « Et une fois que

Rick Grigg, Peter Cole ou Phil Edwards en train de dévaler les gigantesques creux du redoutable *spot* de « West Bowl » à Sunset Beach.

Grannis rentre en Californie avec une ferveur redoublée. Au cours des années qui suivent, il développe trois fois plus de clichés et s'oriente résolument vers la couleur, le style de vie des surfeurs, la compétition et la publicité. L'industrie naissante du surf, repliée sur elle-même et soucieuse de son budget, est peu encline à se tourner vers l'extérieur et préfère réaliser elle-même ses illustrations et ses photos. Alors qu'il n'a aucune expérience de commercial, Grannis se débrouille donc pour vendre ses clichés grâce à quelques idées simples et convaincantes. C'est ainsi que la photo publicitaire qu'il réalise pour les planches Jacobs Surfboards entre dans les annales de la photographie de surf. On y voit Ricky Hatch, une figure locale de Hermosa Beach, chaussures aux pieds et affublé d'un costume noir impeccablement taillé, en train d'exécuter un habile exercice d'équilibre sur le nez de sa planche. En 1963 Grannis dégotte un appareil photo amphibie Calypso (ancêtre du Nikonos et invention de Jacques-Yves Cousteau) et réalise un cliché modèle de Henry Ford en train d'exécuter un *bottom turn* parfait à 22nd Street.

Grannis découvre bientôt que la photographie aquatique consacrée au surf est une discipline particulièrement périlleuse, y compris pour les sportifs les plus chevronnés. Un jour qu'il photographie Sunset Beach depuis le large avec son Nikonos, il est surpris par une gigantesque lame qui s'engouffre dans la passe de West Peak Bowl avant de se briser à distance du rivage et de piéger le photographe dans son sillage. Lorsqu'il relève la tête, Grannis aperçoit un mur d'écume de sept mètres de haut et trois lourdes planches de onze pieds lancées à toute vitesse en direction de sa tête dépourvue de toute protection. Dans un réflexe salutaire, il plonge sous le maelström et réussit même à sauver son précieux appareil photo. Plus tard, avec le concours de son vieil ami Doc Ball, Grannis conçoit et construit son premier boîtier étanche recouvert d'une enveloppe en caoutchouc et doté de mini-ventouses. Grâce à cet ingénieux montage, il peut rester sur l'eau pendant des heures, assis sur sa planche dans les passes relativement sûres de Sunset Beach et de Waimea Bay, à capturer les prouesses des surfeurs avec des objectifs longs, sans avoir à retourner sur le rivage pour changer de pellicule.

Sur la terre ferme, Grannis appréciait l'effet de recul, efficace et fort plaisant, que procuraient les téléobjectifs Century 1000. Cadrés de manière artistique à une distance d'environ huit cents mètres, les surfeurs ressemblaient à des figures héroïques livrant combat dans les arènes de Sunset Beach. Mais c'est d'abord son intérêt pour les coulisses du surf – les scènes de plage – qui permet aujourd'hui de combler des pans entiers de la mémoire collective des grandes heures du surf. L'objectif de Grannis, particulièrement de 1960 à 1965, a su saisir l'esprit d'un sport qui, à cette époque charnière, est passé d'une simple discipline *culte* à un mode de *culture* à part entière. À première vue, ses clichés peuvent évoquer une certaine nostalgie d'une époque insouciante où tout était plus simple et plus facile, mais un examen plus détaillé nous révèle un vrai travail de documentaliste sur la rapide transformation de la pratique du surf en un style de vie au statut mythique. Ses photos d'un réalisme saisissant ont contribué à jeter un pont entre le monde virtuel chanté par les Beach Boy et la réalité de la culture de plage du sud de la Californie. Le langage et la musique des surfeurs, les arts, les magazines et la mode dédiés au surf et à ses adeptes – bref tous les ingrédients de la « culture du surf » telle qu'on la connaît aujourd'hui – ont été imaginés sinon codifiés dans ce bref intervalle de temps. Et l'œil de Grannis est précisément l'un des rares à avoir fixé sur la pellicule, dans son intégralité, la vague du changement et les témoins vivants des événements qui l'ont accompagnée.

En 1964, de retour d'un voyage à Hawaï particulièrement fructueux, Grannis s'associe au magnat du vêtement de surf Dick Graham avec lequel il lance le magazine *International Surfing* (rebaptisé *« Surfing »*, c'est aujourd'hui le deuxième plus ancien magazine de surf du monde). Parallèlement à son poste à plein temps

dernier cri. Ses portraits en noir et blanc des dieux du surf mêlaient souvent héroïsme et froideur impersonnelle. Quant à Grannis, surfeur invétéré et enfant de l'océan, il capturait les scènes de la vie locale sans aucun filtre et avec un réalisme saisissant.

Éditeur et réalisateur de films consacrés au surf, John Severson fut l'un des premiers à ouvrir les portes des médias à l'iconographie du surf. En 1960, il publie *The Surfer*, un fascicule de trente-six pages consacré à son art photographique et vendu en marge des projections de son documentaire *Surf Fever*. L'ouvrage connaît un succès retentissant et les 5 000 premiers exemplaires s'écoulent comme des petits pains. En 1961, il sort un trimestriel, qui devint bimensuel un an plus tard. Severson s'attache le concours d'une petite équipe et s'installe comme directeur de la publication et éditeur à temps plein. Grannis en vient bientôt à contribuer au magazine *Surfer*, ainsi qu'à l'éphémère *Surfing Illustrated*.

Les premiers magazines de surf étaient nés dans les « arrière-cuisines » d'une poignée de passionnés qui les fabriquaient et les distribuaient eux-mêmes. Lorsque *Surfer* est lancé, la presse grand public est devenue accessible aux éditeurs à petit budget comme Severson, et les grands noms des médias ont commencé à exploiter le créneau du surf en portant cette nouvelle discipline à l'écran avec *Un amour de vacances* (*Gidget*, 1959) et *Ride the Wild Surf* (1964). En Californie du Sud, les clichés et les illustrations hautes en couleur immortalisant les prouesses des surfeurs ont tôt fait de taper dans l'œil des industriels du cinéma et de la télévision hollywoodiens. « Soudain, nous avions une occasion inespérée de monnayer nos propres créations photographiques », témoigne John Van Hamersveld, ancien directeur artistique de *Surfer* et créateur de la légendaire

« La texture même des tirages de Grannis en faisait des photos d'un autre monde », confia un jour Brad Barret.

LeRoy Grannis, Carlsbad, California, 2001

Forty years as a shooter, seventy as a surfer—octogenarian Grannis bridges the eras and the millennium. Promotional photo from an ad shoot for Hang Ten. Photograph by James Cassimus.

Vierzig Jahre als Fotograf, siebzig als Surfer – als über Achtzigjähriger überbrückt Grannis die Zeitalter und die Jahrtausendwende. Werbefoto für eine Anzeige von Hang Ten. Fotografiert von James Cassimus.

Quarante ans de photographie, soixantedix ans de surf : l'octogénaire LeRoy Grannis a traversé les époques et franchi le millénaire. Photo promotionnelle tirée d'une publicité pour Hang Ten. Photo : James Cassimus.

chez Pacific Bell Telephone, Grannis cumule les fonctions de premier rédacteur photo, de rédacteur en chef adjoint et de photographe en chef. Chaque week-end, en professionnel consciencieux, il couvre une pléthore de compétitions amateurs et interclubs. C'est ainsi qu'il fixe sur la pellicule les premiers pas encore hésitants d'une génération d'ados qui laisseront plus tard leur marque dans l'histoire du surf. Comme beaucoup d'entre eux avaient l'âge de son propre fils, il posait sur ces jeunes sujets un œil souvent paternel, saisissant au passage une candeur et un naturel en total contraste avec la pudeur que pouvait éprouver un homme d'âge mûr comme Grannis lorsqu'il s'agissait de demander à des inconnus de poser pour lui. Grannis se distingue de ses mentors et de ses confrères photographes par un statut à part que l'on peut situer à mi-chemin entre l'art et le photojournalisme. Ses cadrages parfaits, ses mises au point irréprochables et ses champs profonds et généreux livrent une foule de détails « naturalistes » fort instructifs, propres à titiller l'œil de tout observateur attentif. Ses films lents à grain fin, exposés dans les règles de l'art et développés avec une minutie extrême, permettent d'agrandir les détails avec une précision époustouflante. « La texture même des tirages de Grannis en faisait des photos d'un autre monde », confia un jour Brad Barrett, photographe attitré et rédacteur photo de *Surfer* de 1968 à 1973.

Au début des années 1960, les États-Unis comptaient moins d'une demi-douzaine de photographes de surf publiant leurs propres clichés et, à l'exception de John Severson, aucun d'entre eux n'en avait fait son activité principale. Mais chacun avait son style propre et ses compétitions favorites. Severson, ancien professeur d'arts graphiques, avait un faible pour l'esthétique brute et le style be-bop. Ron Stoner, quant à lui, préférait la chaleur des tons mordorés et l'exubérance des décors romantiques. Ron Church, en photographe industriel professionnel, maîtrisait à la perfection les technologies de pointe et les appareils photos sous-marins

affiche fluorescente du film *The Endless Summer*. « Au travers des magazines et du grand écran, les mass media et l'industrie de la culture se sont emparés de ce microcosme jusque-là confidentiel. »

Cette « marotte » du surf partagée par une poignée d'initiés en 1961 allait devenir cinq ans plus tard une authentique culture de la jeunesse avec ses codes linguistiques, sa musique, sa mode vestimentaire, ses médias, ses voitures et son code de l'honneur. En 1966, l'intérêt du grand public pour le surf atteint des sommets, faisant la fortune d'un petit cartel d'industriels de Californie du Sud surnommé avec humour « Dana Point Mafia ». Cette nouvelle discipline à part entière – qui relevait davantage d'un système de croyance que d'un passe-temps dominical – bénéficie d'une forte poussée médiatique en juillet 1966 avec la sortie dans toutes les salles du pays de *The Endless Summer*, un film de Bruce Brown. Ce documentaire imaginatif et décontracté accorde pour la première fois aux masses de non-surfeurs (les « légions de frustrés », comme les qualifiait le virtuose des vagues Phil Edwards) un ticket d'entrée dans le cercle très fermé du surf. Le grand public réclame sa part de rêve. C'est le début d'une nouvelle ruée vers l'or.

Lorsque San Diego se voit attribuer pour la deuxième fois la tenue des championnats du monde du surf, les édiles locaux et les organisateurs de l'événement, comblés par le retour de la discipline vers plus de respectabilité, se tombent littéralement dans les bras. Les organisateurs officiels espèrent ainsi tordre le cou au « hooliganisme du surf » et à la mauvaise presse qui avait entaché la réputation de ce sport pendant toute la période d'euphorie qui avait suivi la sortie de la comédie *Un amour de vacances*. En l'espace de quelques jours, la chambre de commerce de San Diego enregistre une forte augmentation des chiffres du tourisme, stimulés par une jeunesse consumériste captivée par ce nouveau sport de plage à la fois sexy et symbole de liberté.

Parallèlement, une vague conservatrice s'évertue à bousculer le style de vie bohème qui s'est installé dans le milieu du surf. À l'initiative du magazine *Surfer* de John Severson, une inlassable campagne de respectabilité tente de redonner

au surf ses lettres de noblesses en expurgeant de la scène ses éléments « indési-rables ». La ligne éditoriale du magazine adopte un ton plus péremptoire, réserve ses colonnes à des chroniqueurs et à des courriers de lecteurs se réjouissant de la défaite organisée des « hodads », ces voyous décérébrés qui avaient entaché la réputation du surf par leurs frasques et leur attitude puante à l'égard des représen-tants de l'autorité. « [Le surf] n'attirait plus seulement les excentriques », a déclaré un jour John Hannon, un des principaux fabricants de planches de la Côte Est, dans une interview donnée à *Newsweek*. « La nouvelle génération est propre sur elle ; elle se coupe les cheveux et les ongles, et ne tolère pas les trublions. »

Les premiers soubresauts de la « révolution du *shortboard* » – qui annoncent la disparition des années d'insouciance du début des Sixties – se font sentir à Ocean Beach, près de San Diego, le 2 octobre 1966. Ce jour-là, sous un ciel couvert, le jeune Nat Young est sacré champion du monde après avoir médusé l'élite régnante du surf par son style radical et ses virages extrêmement serrés sur des vagues de faible amplitude. Lorsque David Nuuhiwa, le Hawaïen donné favori et réputé pour sa souplesse et ses longs *noserides* élégants, affirme doctement qu'il faut « se fondre dans la vague », Young lui rétorque, sûr de lui : « Pas question pour moi de me fondre dans quoi que ce soit ! » Le ton proprement iconoclaste du jeune Young est tout à l'image de sa « Magic Sam » gagnante, une planche de neuf pieds et quatre pouces – un pied plus court que la longueur standard – qu'il a fabriquée de ses propres mains. Conçue avec le concours de l'Australien Bob McTavish, la Magic Sam se distingue par un aileron proéminent en forme de cimeterre dû à un génie américain de la planche de surf, l'excentrique George Greenough. Du jour au lendemain, c'est toute une génération de planches de compétition dernier cri qui est reléguée au rang de pièces de musée. Une révolution technologique est en marche, qui entraîne dans son sillage un bouleversement des mentalités et des techniques. Après la victoire de Nat Young, le monde du surf s'écarte des conventions pendant plus d'une décennie. Surnommé « The Animal » en raison de son style de surf impétueux, le jeune prodige vient de montrer la voie à la future génération de surfeurs. Avant 1966, la figure phare de la discipline était le « hang ten » (élégant exercice d'équilibre consistant à joindre les deux pieds à l'avant, les dix orteils retombant sur le « nez » de la planche). Désormais tout est permis. On a appelé cela le « mind surfing » ou le surf cérébral. Comme l'a fait remarquer Paul Gross, journaliste à *Surfer*, « on assistait à un abandon massif de tout ce qui avait eu cours jusque-là ». Même si, à cette époque, personne ne semblait en avoir encore pris conscience.

Pendant ce temps-la, les drogues psychédéliques faisaient rage dans le monde du surf. Avec un effet dynamisant pour certains, abrutissant pour d'autres. L'esprit du surf était à l'introversion, et le style underground de la nouvelle génération barbue explorant les bienfaits du zen dans des figures quasi mystiques avait supplanté la grâce conventionnelle des *hotdoggers* en Jantzen. Les compétitions avaient perdu leur aura. Peu importait la première place : finis les manœuvres sophistiquées et les trophées ! Seul comptait désormais l'équilibre « karmique » du surfeur glissant sur les « cathédrales de cristal en fusion », pour reprendre les termes d'un lecteur de *Surfer*. Au grand dam de certains annonceurs prestigieux, Rick Griffin glissait quant à lui quelques clins d'œil subreptices aux substances psychotropes dans les cartoons qu'il dessinait pour le même magazine. Le mode de vie vagabond et libertaire de la nouvelle génération poussa bon nombre de surfeurs vers une carrière parallèle de trafiquants de drogues. « Soit vous preniez le train en marche, soit vous restiez sur le quai », a écrit un jour Drew Kampion, directeur de la publication de *Surfer* entre 1968 et 1972. « Soit vous aviez pigé le truc, soit vous étiez en dehors du coup. Soit vous croyiez en la force gravitation-nelle, soit vous croyiez en l'espace tridimensionnel. Soit vous étiez figé [sur votre planche], soit vous étiez fluide. Et y'en a un bon paquet qui préféraient la fluidité. »

À peine remis d'un flirt peu concluant avec la respectabilité et les conventions établies, la culture du surf revendique de plus belle ses racines anticonformistes, ce qui ne passe pas inaperçu. Dans son essai à succès publié en 1966, *The*

Pump House Gang, le critique Tom Wolfe, spécialiste de la culture pop, constatait que de nombreux surfeurs, « auparavant simples représentants d'un style de vie lié au surf, incarnaient désormais l'avant-garde du mouvement psychédélique californien ». À la place des jeunes consommateurs dociles autrefois courtisés par l'industrie américaine, on avait désormais affaire à une génération de contestatai-res chevelus, fumant la marijuana et affichant, un doigt en l'air, toute leur haine pour le matérialisme débridé.

L'industrie du surf traverse alors une crise sévère. Au cours des quelques années qui suivent, la plupart des boutiques de surf doivent réduire leur activité sinon mettre la clé sous la porte. Les recettes publicitaires du magazine *Surfer* plongent, son format est réduit en conséquence et la ligne éditoriale adopte un ton franchement plus « progressiste ». La radicalisation initiée par Kampion, le direc-teur de la publication, transforme *Surfer* en un vecteur majeur de la contre-culture émergente, célébrant pêle-mêle la paix, la libération sexuelle, le *tube riding* et le droit imprescriptible de tout surfeur à se mettre en marge et à se « défoncer » par *tous* les moyens à sa disposition. Kampion, qui s'insurge publiquement contre la plupart des compétitions de surf organisées, publie des articles comme « Mauvais karma à Huntington Beach » et « À bas les compétitions ! », dans lesquels il cherche à promouvoir le surf comme une expérience métaphorique de l'harmonie cosmique et non comme un *ego trip* malsain vendu à une logique de mar-keting. Farouchement opposé à la guerre du Vietnam, qui vide les plages de leurs surfeurs à un rythme alarmant, il déclare la guerre au nouveau président Richard Nixon, qui a osé établir sa « Maison blanche de la Côte Ouest », outrage suprême, à San Clemente, et plus précisément à Trestles Beach, condamnant à chacune de ses visites l'accès à l'un des *surf breaks* les plus prisés de la côte.

Grannis, qui appartient à l'ancienne génération, est en décalage avec l'anticon-formisme ambiant de la nouvelle vague et se moque ouvertement des nouvelles « conventions » en vigueur dans le monde du surf. Ce vétéran de la Seconde Guerre mondiale, qui aide son fidèle ami Hop Swarts à organiser les compétitions de la United States Surfing Association que ce dernier vient de fonder, reste farou-chement attaché à l'idée que les compétitions de surf contribuent à la promotion du sport, notamment sur un plan social. En 1968, Grannis publie un éditorial dans lequel il vante les valeurs éthiques des compétitions et repousse d'un revers de manche les critiques des « ronchons qui n'ont nullement le droit de se plain-dre ». « Ces dernières années, on a eu droit à une série d'attaques en règle de la compétition dans des articles signés par des *has been* du surf, des éditorialistes hawaïens qui n'ont jamais posé le pied sur une planche, des V.R.P. véreux et des pseudo-directeurs de rédaction frustrés », écrit-il. « S'ils dénigrent autant la compé-tition, c'est tout simplement parce qu'ils ne sont pas à la hauteur. »

À la fin des années 1960, pourtant, la plupart des compétitions – y compris le prestigieux Prix des lecteurs du magazine *Surfer* – appartiennent au passé. Le seul événement pouvant ressembler, et seulement de loin, à une compétition professionnelle est un anti-concours déjanté baptisé « Expression Session », au cours duquel les as du surf démontrent leurs prouesses en l'absence de tout juge, de tout score et de tout trophée. « Cette année-là fut une saison foisonnante de créations et d'inventions : le *shortboard*, le *V-bottom*, la mini-planche, l'aileron souple, l'aileron court, bref de nouvelles planches au design radical », comme le constate Kampion en 1968, qui ajoute : « Le surfeur qui n'a pas changé de style ces douze derniers mois est un oiseau rare. » Pourtant, dans un éditorial éclairé, Grannis prédit avec précision le retour du *longboard* et du *noseriding*. Année après année, Grannis continue de diriger inlassablement son objectif sur une discipline à laquelle il a consacré son talent, immortalisant image après image les exploits des *longboarders* et des *shortboarders* sans se soucier des tendances et des mouvements qui faisaient et défaisaient la culture du surf.

Dans les premiers jours de décembre 1969, Hawaï et la Californie sont secoués par le terrible « *swell* du siècle ». Les gigantesques vagues de dix mètres qui balay-ent la côte nord d'Oahu détruisent soixante habitations et projettent des bateaux

Surf Photos by Grannis Sticker, 1963

"Granny's" famous stickers, designed by Stuart Lough, are now collectors' items. Grannis still gives one out to everyone he meets.

Die berühmten Aufkleber von „Granny's", entworfen von Stuart Lough, sind heute Sammlerstücke. Grannis verteilt sie noch immer an jeden, den er trifft.

Les fameux stickers de « Granny » réalisés par Stuart Lough sont devenus des col-lectors. Grannis continue de les distribuer généreusement autour de lui.

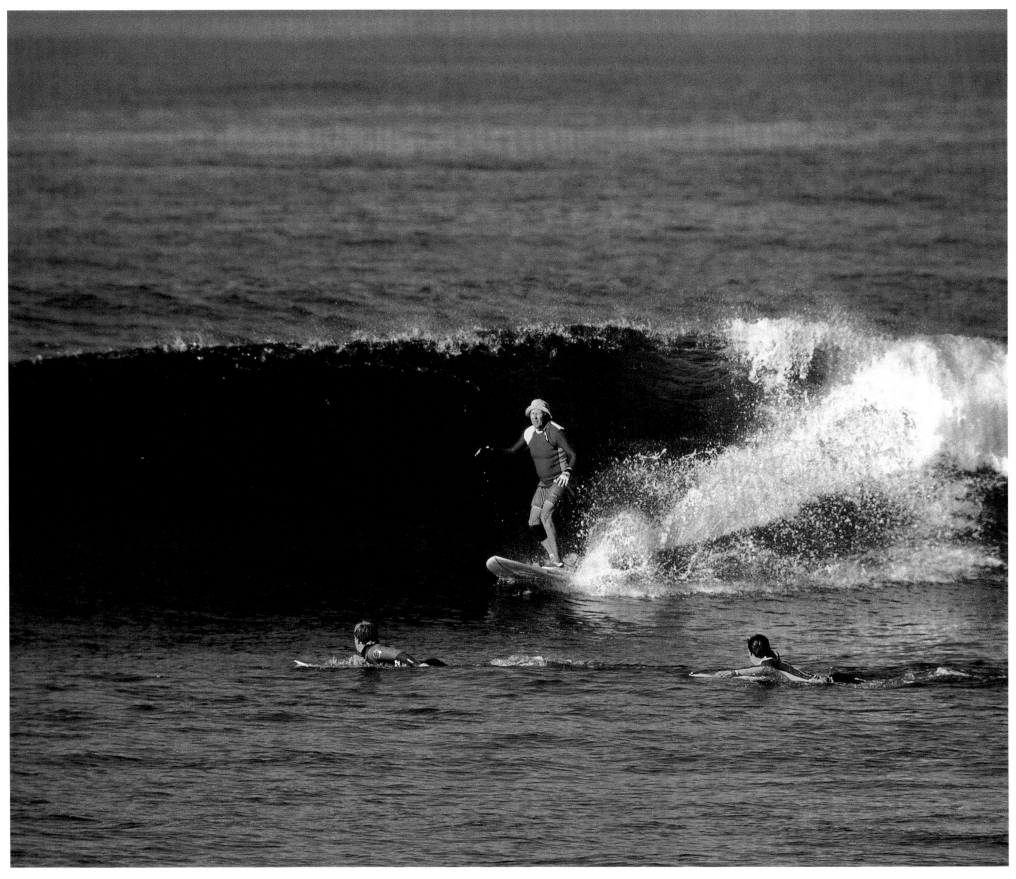

à cent mètres à l'intérieur des terres. Si les monstres de la côte nord se révélent impossibles à dompter, Greg Noll, accompagné d'une petite équipe de surfeurs, relève le défi de surfer les vagues de Makaha sur la côte ouest de l'île, légèrement moins furieuses que sur la côte nord. Ce jour-là, Noll affirme avoir chevauché la plus grande vague de toute l'histoire du surf. La seule chose dont on est sûr, c'est qu'il a survécu de justesse au *wipe-out*, l'inévitable chute finale. « Dans cette discipline malmenée par le tapage publicitaire et la révolution [du *shortboard*], un pur dinosaure des années 1950 a surfé la dernière grande vague de 1969 », commenta Drew Kampion.

Le « Swell de 1969 » fut perçu dans le monde du surf comme l'ultime secousse tellurique de la décennie la plus tumultueuse et la plus controversée de son histoire. « Ce que nous avons vécu ce fameux mois de décembre 69 a signé en quelque sorte le passage de l'ère du *longboard* – emblématique des années 1960 – au sacre du *shortboard* », rappellera bien des années plus tard Skip Frye, la légende du surf des années 1960. « On a assisté à un ménage en profondeur qui a complètement bouleversé les règles du jeu par la suite. » Pour Grannis, le débat sur la taille des planches n'était qu'une question de logistique, et sa prouesse a consisté à mettre son talent de photographe au service du dialogue et de la continuité entre deux générations. « Je photographiais des surfeurs, pas des planches », confia-t-il un jour. « Les effets de mode ne changeaient pas grand-chose pour moi. »

La dernière photo de surf prise par LeRoy Grannis pour *International Surfing* fut publiée en 1971. À la fin des années 1970, il quitta Pacific Bell Telephone et Hermosa Beach pour s'installer à Carlsbad, en Californie, et profiter de sa retraite. Là-bas, il continua à s'adonner au surf et à la photo. Pendant plus de vingt ans, il conserva chez lui des centaines de clichés et de négatifs, soigneusement archivés dans des classeurs à anneaux. Tandis qu'un cercle marginal de surfeurs passionnés transformait sa propre vision du surf en une industrie mondiale, c'est tout un pan de l'histoire des premières heures de ce sport qui sombrait dans un quasi-oubli.

Pionnier de la photographie sportive, Grannis a immortalisé l'histoire du surf en témoin inlassable de ses bouleversements et de son iconographie naissante. Cette rétrospective consacrée à son art – depuis les clichés classiques de son catalogue jusqu'aux témoignages inédits dénichés dans ses propres archives – invite le lecteur à découvrir un style de vie et une culture jadis réservés à une poignée d'adeptes et qui alimentent aujourd'hui une industrie rapportant chaque année quatre milliards de dollars de chiffre d'affaires. Aujourd'hui, dans l'océan de photographies professionnelles qui submerge le marché, la simplicité élégante des clichés de Grannis nous replonge avec délice dans les grands moments du surf dont il a été le témoin privilégié et nous ouvre une fenêtre sur la naissance d'une culture à part entière. « Je pratiquais le surf et j'aimais photographier ce qui plaisait à mon œil », se défend Grannis en toute modestie. « Je crois qu'on peut dire que j'ai eu beaucoup de chance. »

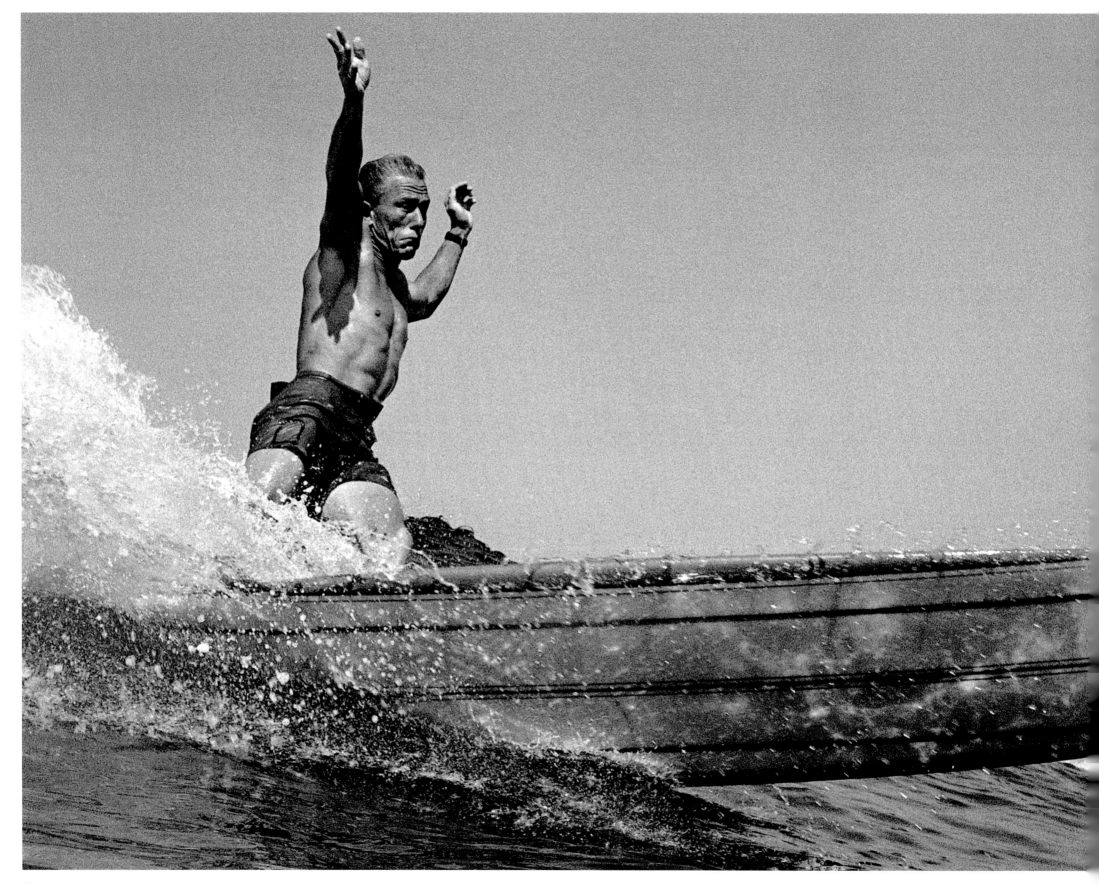

California

**Dewey Weber, 22nd Street,
Hermosa Beach, 1966**

Page 38: For this one frozen moment,
surfboard tycoon Weber was the embodi-
ment of the mythic California surfer.

Seite 38: Für diesen einen, für immer
verewigten Augenblick war der Surfboard-
Tycoon Weber die Verkörperung des my-
thischen kalifornischen Surfers.

Page 38: Immortalisé par ce fameux
cliché, le magnat de la planche de surf
Dewey Weber a incarné le mythe du
surfeur californien.

Chris Cattel, Huntington Beach, 1963

Below. Unten. Ci-dessous.

Miki Dora, Malibu, 1960

Opposite: One of Grannis's earliest shots
of "Da Cat." He trimmed with an elegant
bebop style that was copied by hundreds
of neophyte sixties surfers.

Gegenüber: Einer von Grannis' frühen
Schnappschüssen von „Da Cat". Sein ele-
ganter Bebop-Style wurde in den Sech-
zigern von hunderten von Neeophyten
nachgeahmt.

Page ci-contre: Un des premiers clichés
de « Da Cat » signés Grannis. Il maîtrisait
sa planche avec élégance et dans un style
be-bop qui fut copié par des centaines de
néophytes dans les années 1960.

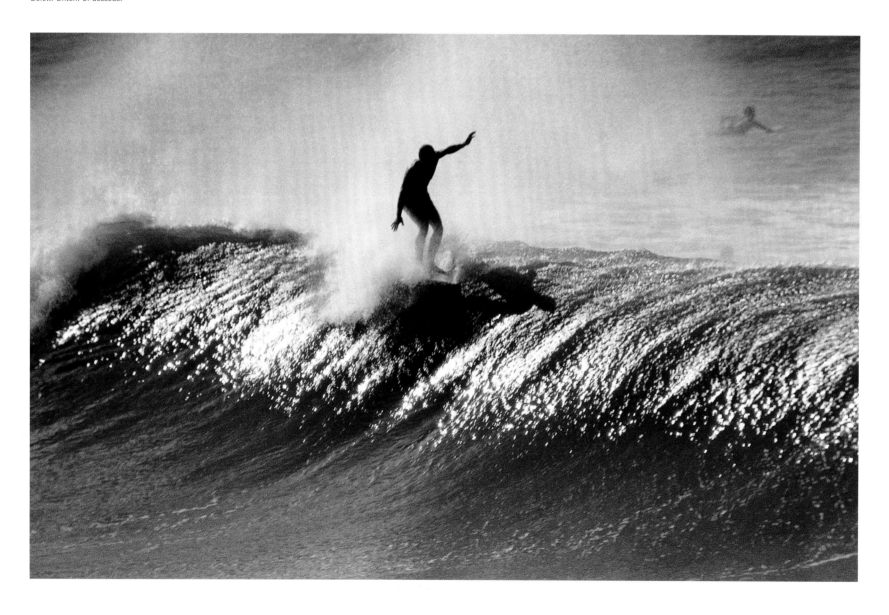

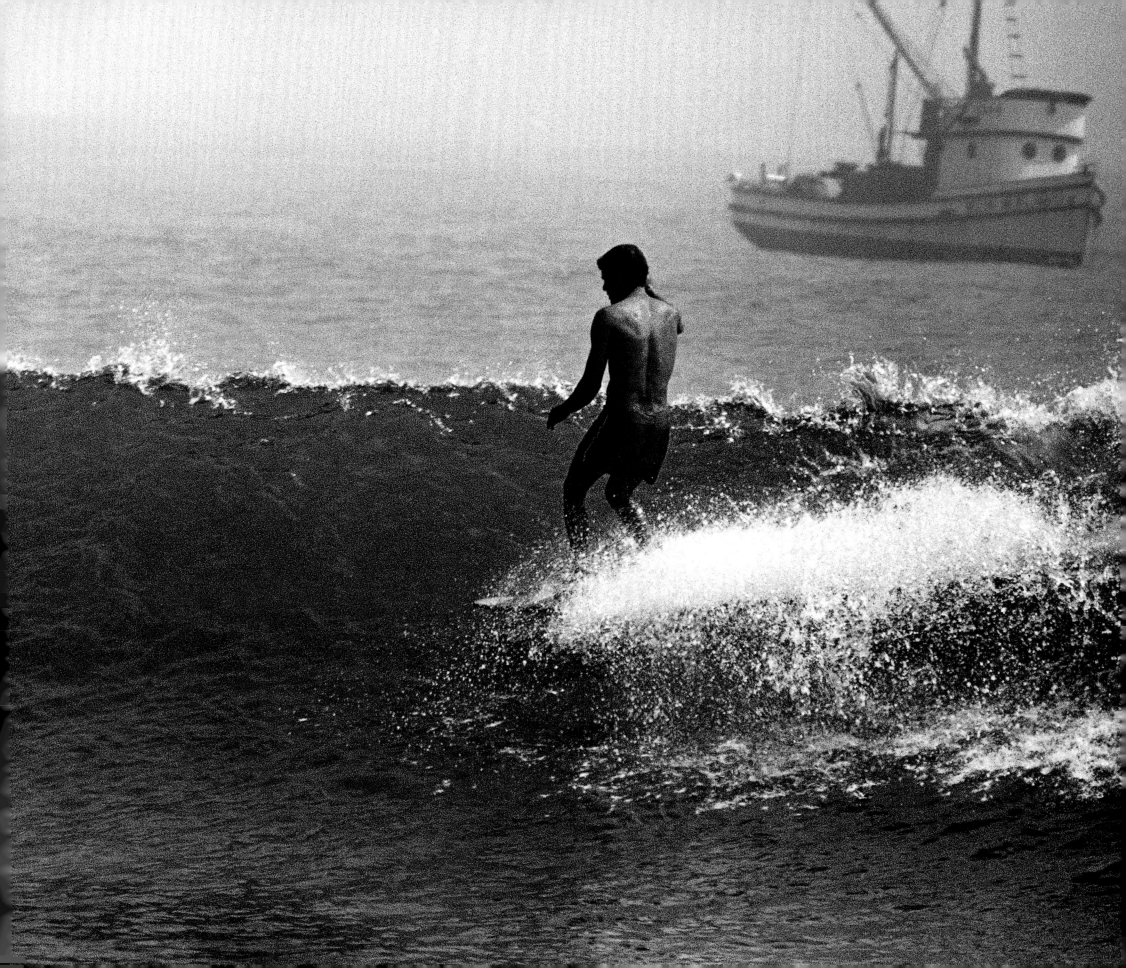

Henry Ford, Hermosa Beach, 1963

Below: Ford was a talented 22nd Street local who starred in many of Bruce Brown's early surf films, such as *Slippery When Wet*.

Unten: Ford war ein talentierter Surfer vom 22nd Street Beach, der in vielen frühen Surffilmen von Bruce Brown mitspielte, z. B. in *Slippery When Wet*.

Ci-dessous: Le talentueux Henry Ford, originaire de 22nd Street, fut la vedette de nombreux films de surf réalisés par Bruce Brown, dont *Slippery When Wet*.

Lance Carson, Malibu, 1962

Opposite: The premier Malibu stylist executing a "cheater five."

Gegenüber: Der beste Surfer von Malibu bei einem „Cheater Five".

Page ci-contre: Le roi de la figure de style de Malibu exécutant un «cheater five».

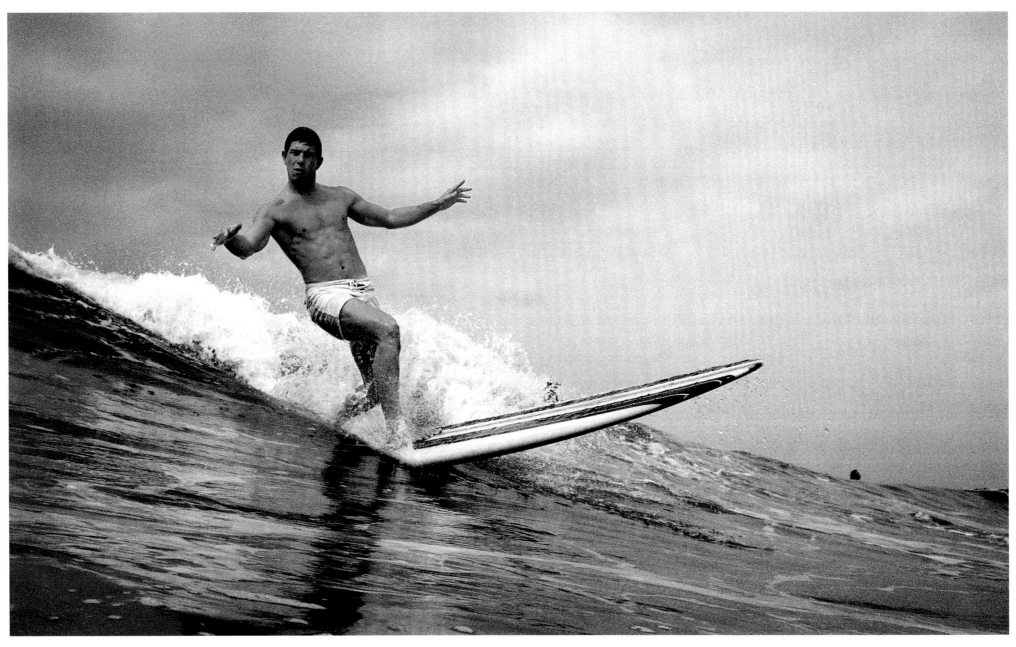

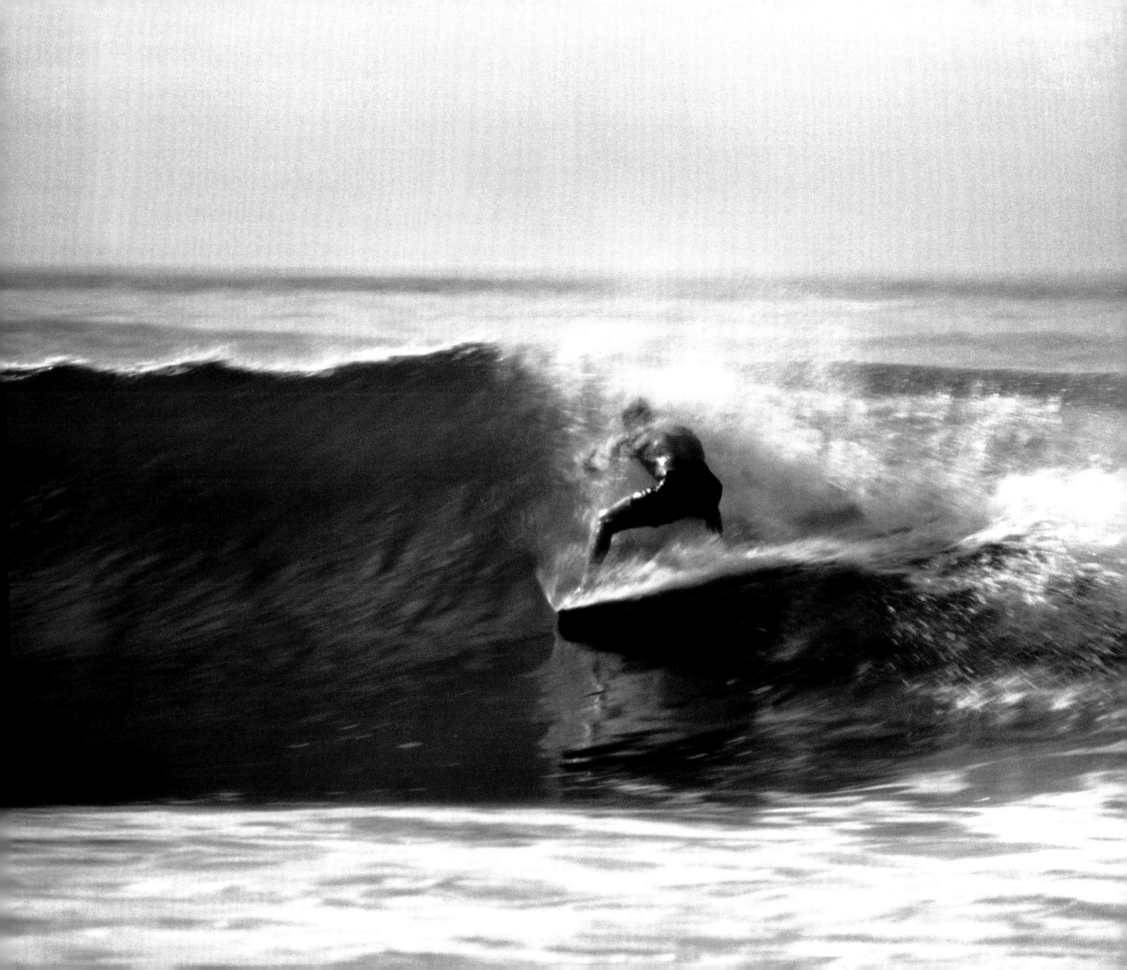

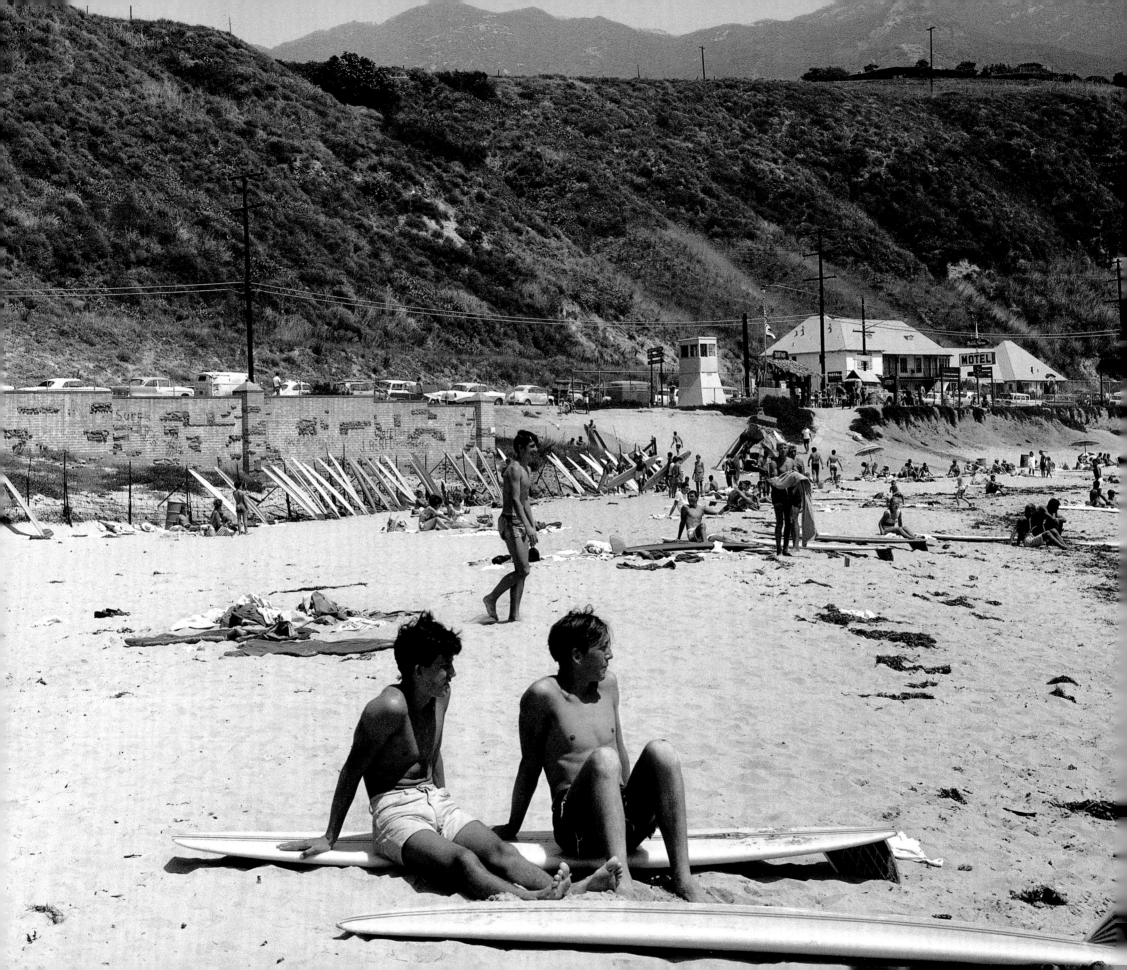

Malibu, 1963

Opposite: Two "gremmies," or young surfers, taking a break to watch the Malibu greats. The Chumash Indians called the area Humaliwo, which means "where the surf sounds loudly."

Gegenüber: Zwei „Gremmies", oder junge Surfer, die Pause machen und den Größen von Malibu zusehen. Die Chumash-Indianer nannten die Gegend „Humaliwo" – „wo die Brandung donnert".

Page ci-contre: Deux «gremmies» – surfeurs ados – font une pause pour suivre les exploits des pointures de Malibu. Les Indiens Chumash appelaient cette zone «Humaliwo», littéralement «le lieu où gronde le ressac».

Lance Carson, Hermosa Beach, 1963

Below: Carson, nicknamed "No-Pants Lance," was renowned for wild, drunken capers and long, elegant noserides. In later years he co-founded the Surfrider Foundation.

Unten: Carsons Spitzname war „No-Pants Lance", er war bekannt für wilde, trunkene Kapriolen und lange, elegante Nose-Rides. Später wurde er Mitbegründer der Surfrider Foundation.

Ci-dessous: Lance Carson, surnommé «No-Pants Lance» (Lance le sans-maillot) était réputé pour ses cabrioles extravagantes et ses longs *noserides* d'une rare élégance. Des années plus tard, il cofondera la Surfrider Foundation.

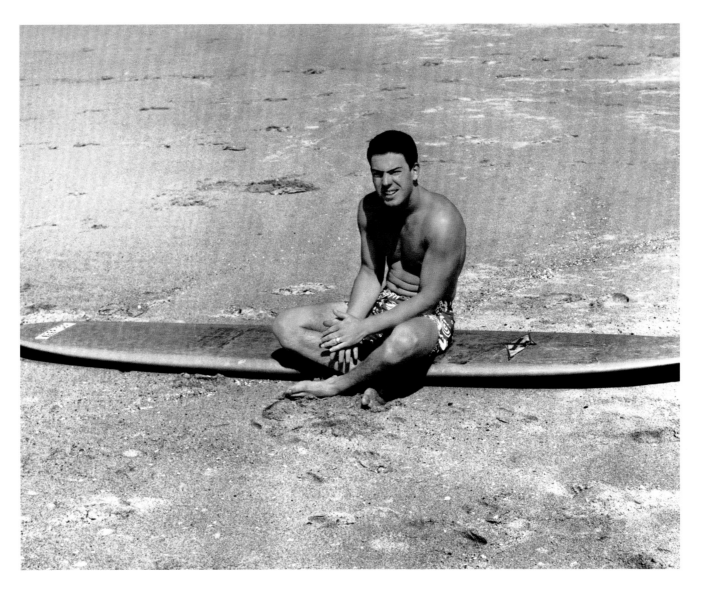

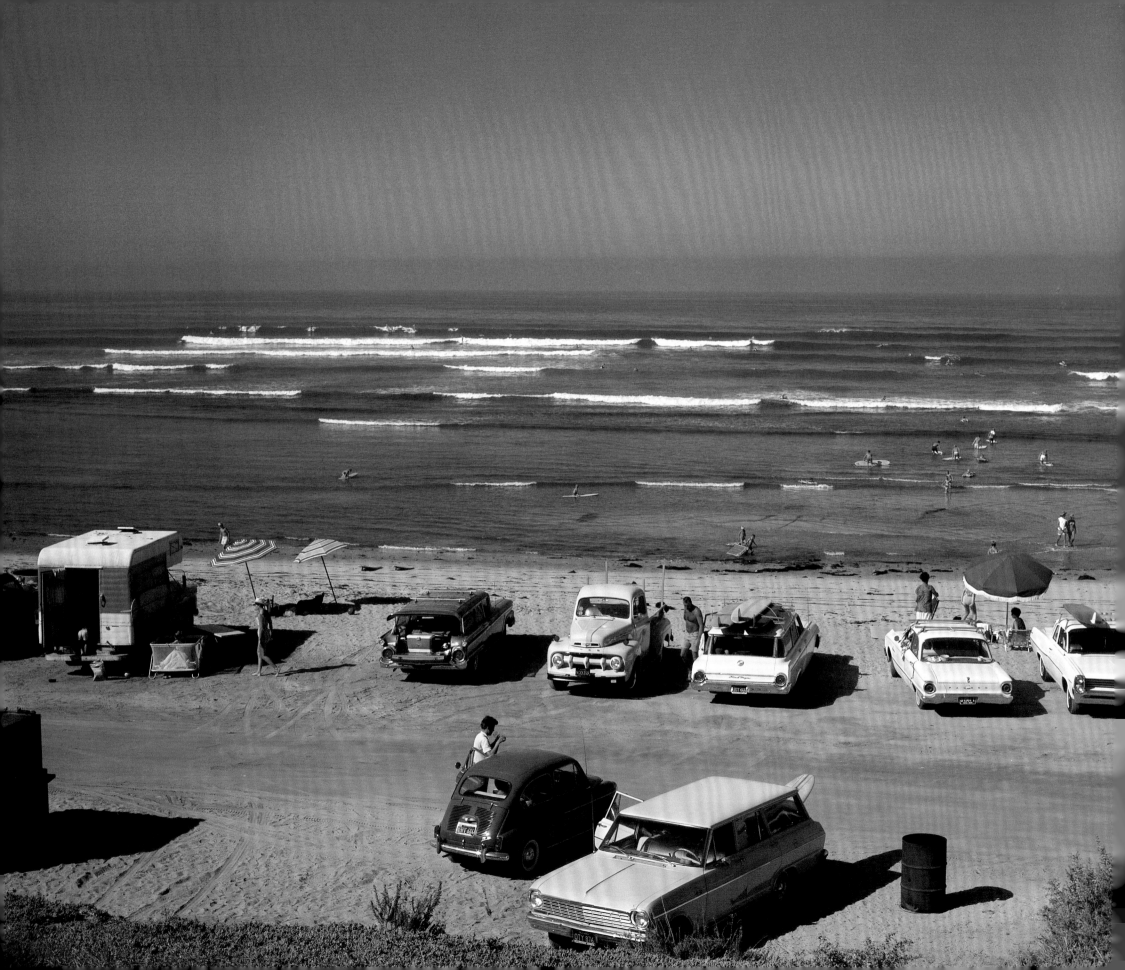

San Onofre, 1964

Opposite: Low tide over Sano's long, flat, cobblestone reef.

Gegenüber: Ebbe auf dem langen, flachen Kieselstein-Riff von San Onofre.

Ci-contre: Le vaste récif de galets émergeant sur les fonds plats de la plage de San Onofre à marée basse.

Malibu, circa 1965

Below: Malibu Point, inhabited by the Chumash Indians in ancient times, has been called "the cradle of modern surfing."

Unten: Malibu Point, einst von den Chumash-Indianern bewohnt, wurde als die „Wiege des modernen Surfens" bezeichnet.

Ci-dessous: Malibu Point, autrefois peuplé par les Indiens Chumash, a été baptisé le « Berceau du surf moderne ».

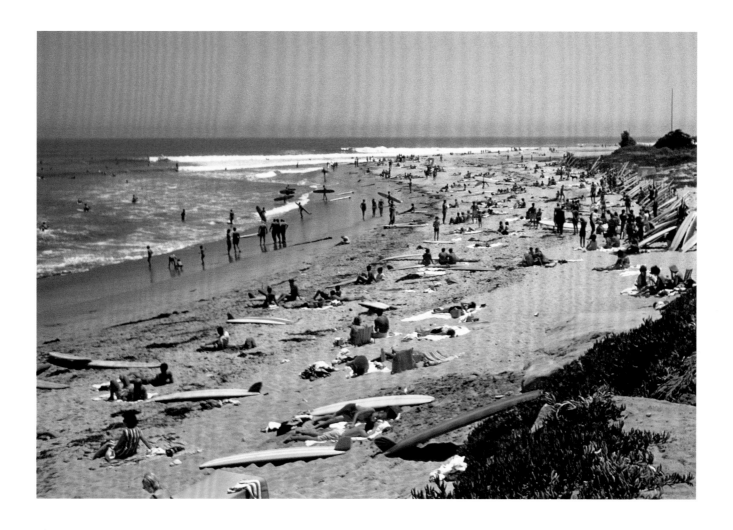

Jacobs Surfboards Advertising Shoot, Hermosa Beach, 1963

Below. Unten. Ci-dessous.

Ford Woody, Redondo Beach, 1963

Opposite: One of Grannis's favorite subjects was vintage "surf bombs." His surf photos were eventually used on the boxes of popular plastic model kits.

Gegenüber: Zu Grannis' Lieblingsmotiven gehörten die alten Autos der Surfer. Seine Fotos wurden später auch für die Verpakkungen von Modellbau-Autos verwendet.

Page ci-contre: LeRoy Grannis était passionné par les « surf-mobiles » d'époque. Ses photos de surf seront plus tard reproduites sur les emballages de modèles réduits.

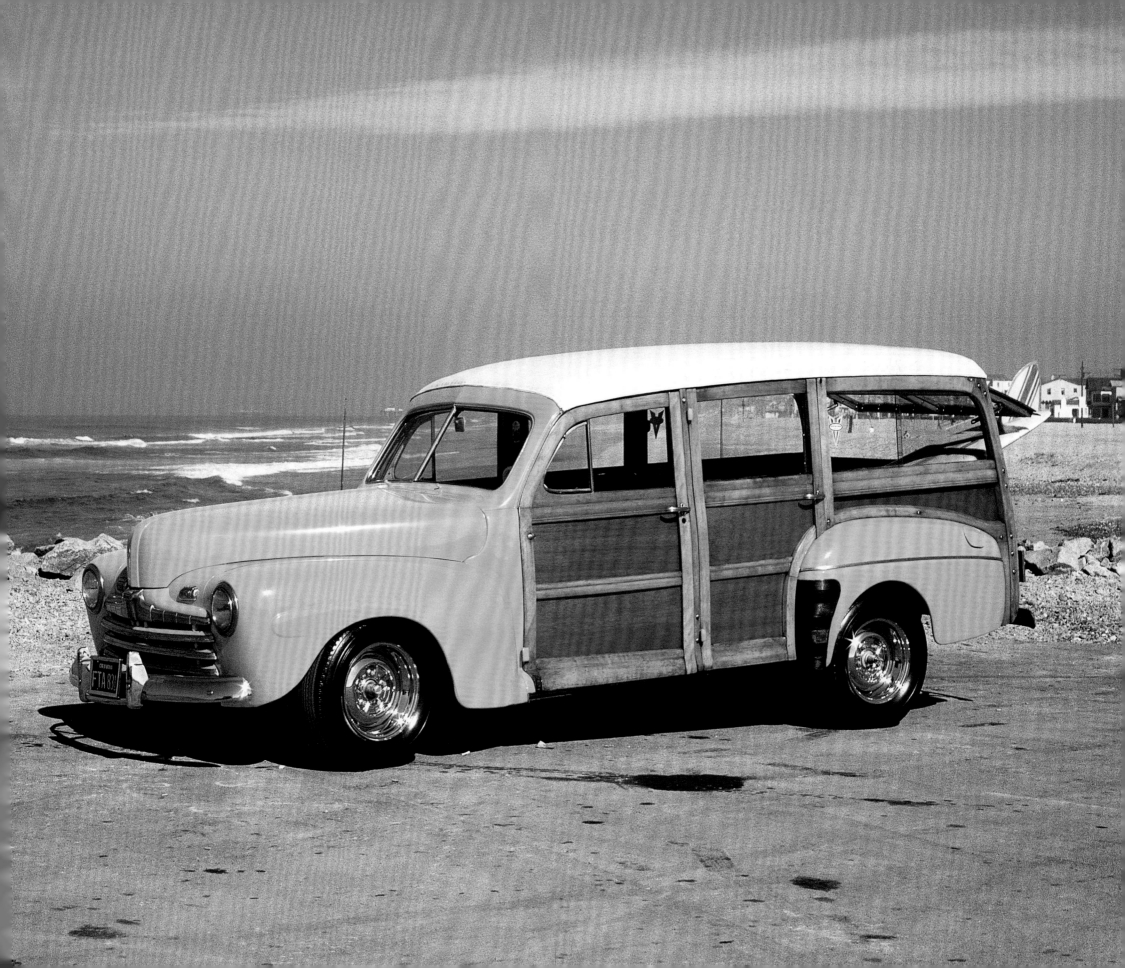

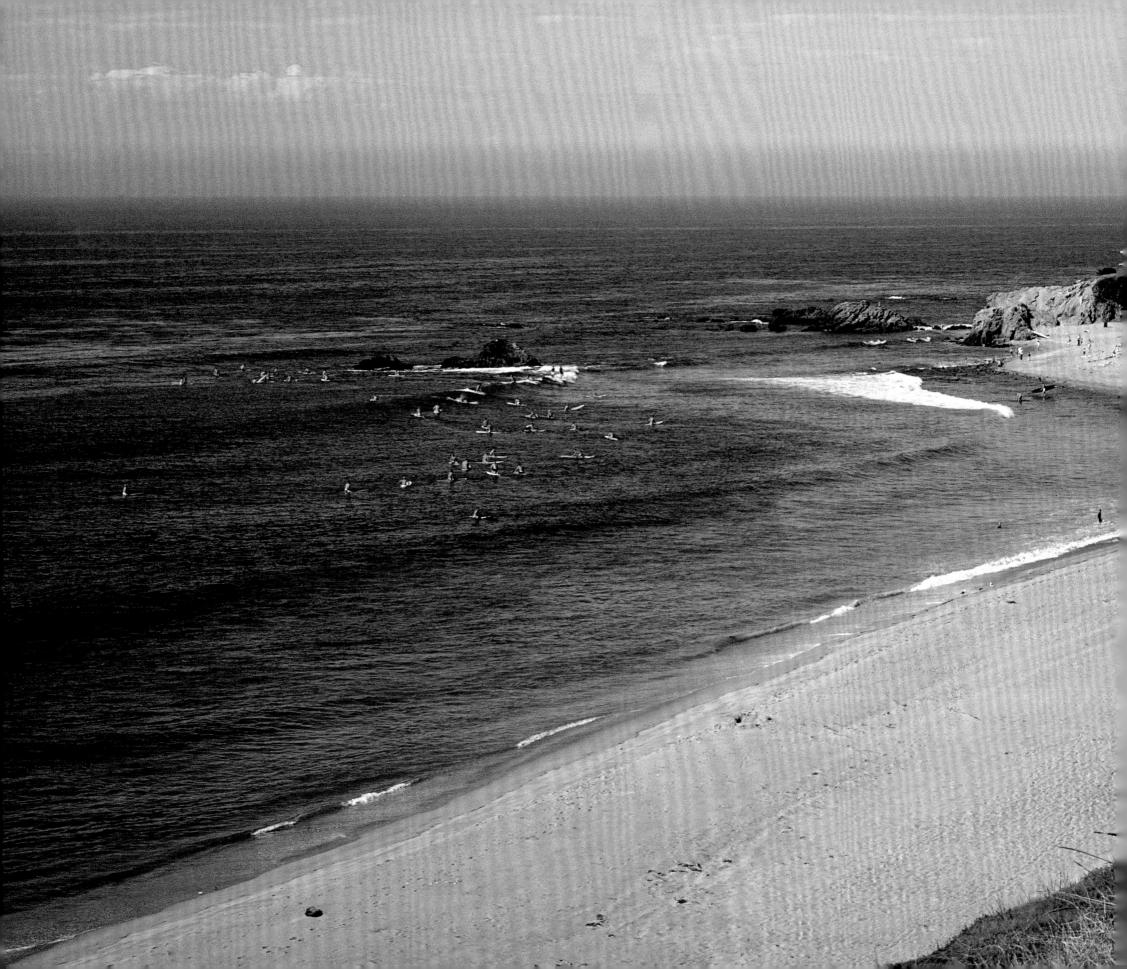

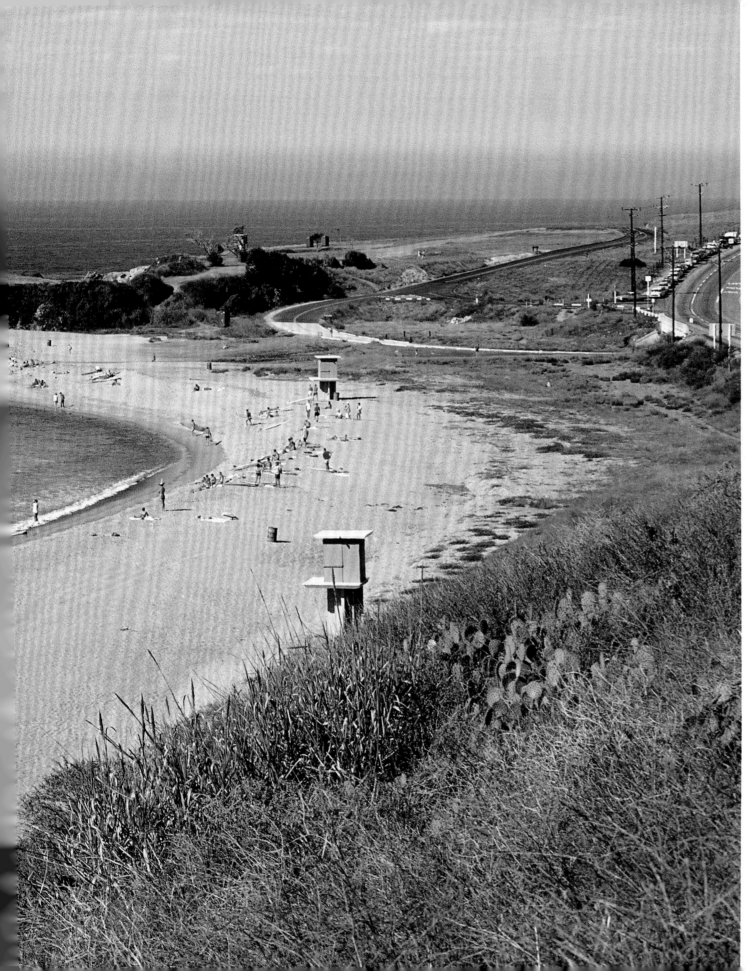

Secos, 1963

Arroyo Sequit, also known as "Secos," is an archetypal California beach that was used as a location for the original *Gidget* movie in 1959.

Arroyo Sequit, auch bekannt als „Secos", ist ein typischer kalifornischer Strand, an dem 1959 der Film *Gidget* gedreht wurde.

Archétype de la plage californienne, Arroyo Sequit ou «Secos» a servi de lieu de tournage pour la comédie originale *Un amour de vacances* en 1959.

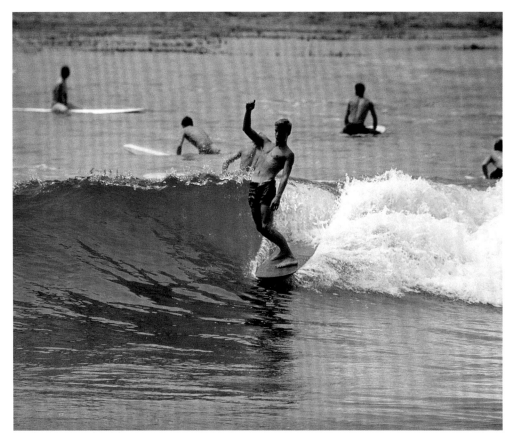

Dave Rochlen, Point Zero, 1961

Left, above: Rochlen, an early surf entre-
preneur, once built boards for movie star
Malibu residents Gary Cooper and Peter
Lawford.

Links oben: Rochlen, ein Unternehmer
aus den Anfangstagen der Surfbranche,
hat Bretter für die in Malibu ansässigen
Filmstars Gary Cooper und Peter Lawford
gebaut.

Ci-contre, en haut: Dave Rochlen,
alors jeune entrepreneur, a construit des
planches pour les stars de cinéma Gary
Cooper et Peter Lawford, résidents de
Malibu.

Joey Cabell, Laguna Beach, 1964

Left, below: Cabell "the Gazelle" was a
transplanted Hawaiian who was considered
one of the sixties' finest surfers. He later
founded the hugely successful Chart
House restaurants.

Links unten: Cabell „Die Gazelle" war ein
zugezogener Hawaiianer und galt als einer
der besten Surfer der Sechziger. Später
gründete er die erfolgreichen Chart-House-
Restaurants.

Ci-contre, en bas: Joy Cabell, dit « La
Gazelle », un natif de Hawaï, fut considéré
comme l'un des meilleurs surfeurs des
années 1960. Il fonda plus tard la chaîne
de restaurants à succès Chart House.

Secos, 1967

Opposite. Gegenüber. Page ci-contre.

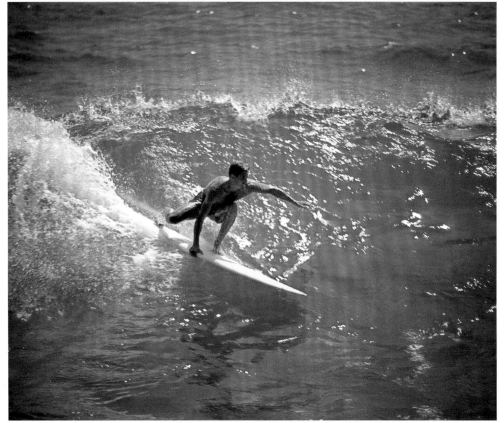

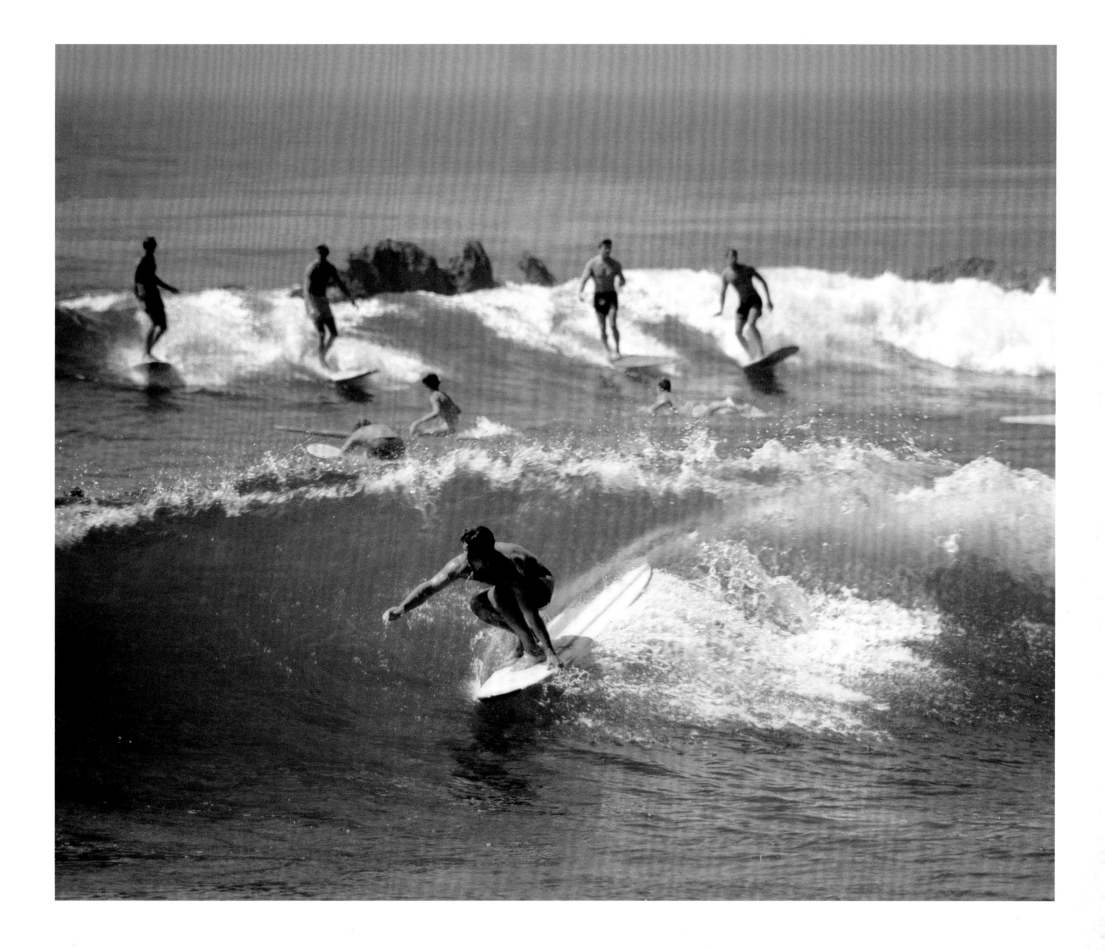

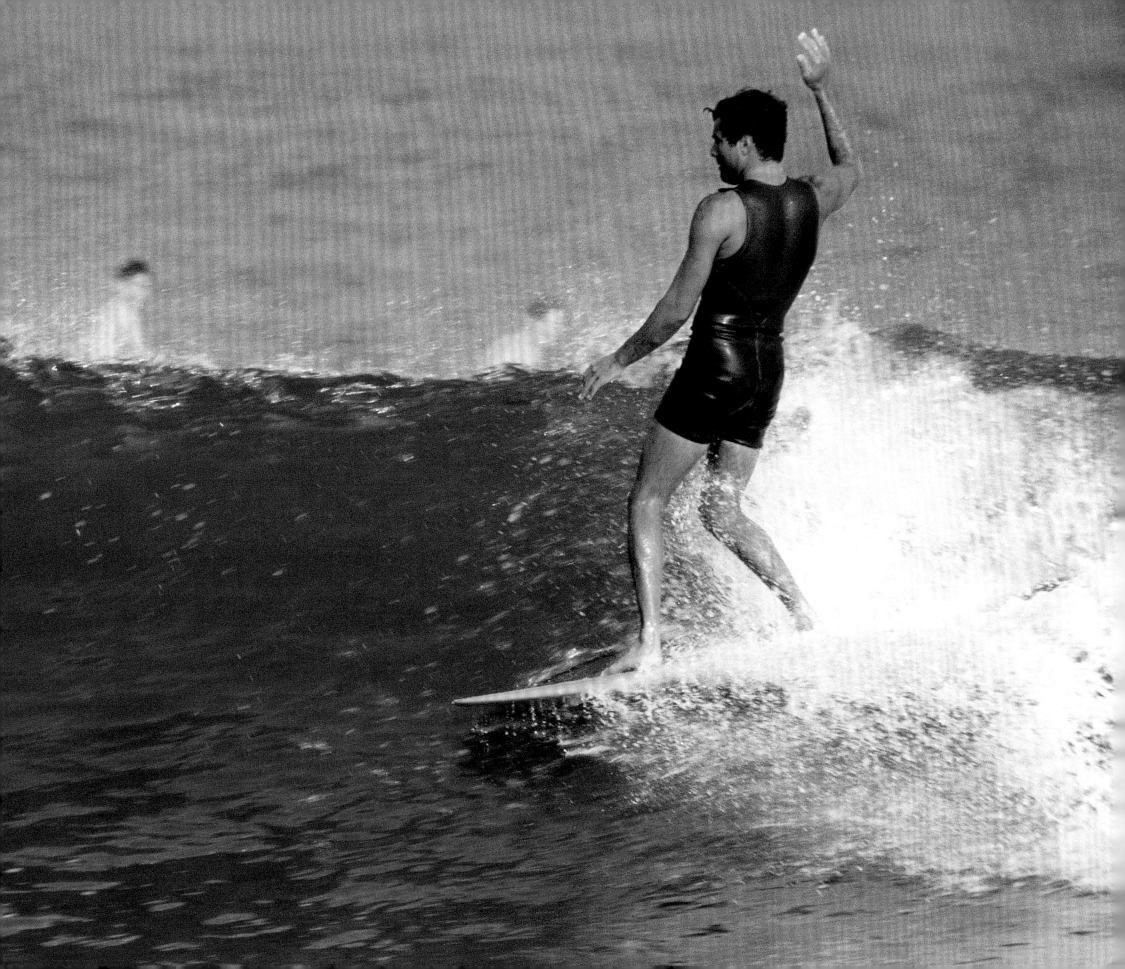

Miki Dora, Malibu, 1965

Opposite: Miki Dora, dubbed "the Black Knight," loved scams and pranks. His most famous caper was releasing a jar of live moths during a surf movie premiere.

Gegenüber: Miki Dora, genannt „Der schwarze Ritter", liebte verrückte Streiche. Bei seinem berühmtesten ließ er während der Premiere eines Surffilms lebende Motten aus einem Glas frei.

Page ci-contre: Surnommé « Le Chevalier noir », Miki Dora était un personnage facétieux. Il lâcha un jour un bocal entier de papillons de nuit vivants lors de la première d'un film consacré au surf.

Dewey Weber, Malibu, 1965

Below left: Weber, a one-time Duncan yo-yo champ and university wrestling all-star, was also a champion surf competitor. He's shown here in the finals of the 1965 Malibu Invitational.

Unten links: Weber, ein ehemaliger University- und Duncan Yo-Yo-Champion, nahm auch an Surfwettkämpfen teil. Hier sieht man ihn in der Endrunde des Malibu Invitational 1965.

Ci-dessous, à gauche: Dewey Weber, ancien champion de yo-yo Duncan et de lutte universitaire, fut également un as du surf. On le voit ici lors des épreuves finales de la Malibu Invitational de 1965.

Tom Morey, Malibu, 1961

Below right: The eccentric but brilliant Morey, inventor of the hugely popular Boogie Board, has become known as "the Thomas Edison of surfing."

Unten rechts: Der exzentrische, aber geniale Morey, Erfinder des extrem beliebten Boogie Boards, wurde auch als „ Thomas Edison des Surfens" bekannt.

Ci-dessous, à droite: L'excentrique et brillantissime Tom Morey, inventeur de la Boogie Board qui connut un succès populaire retentissant, fut baptisé le « Thomas Edision du surf ».

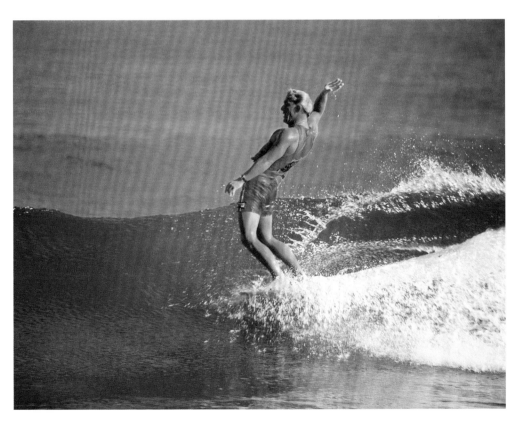

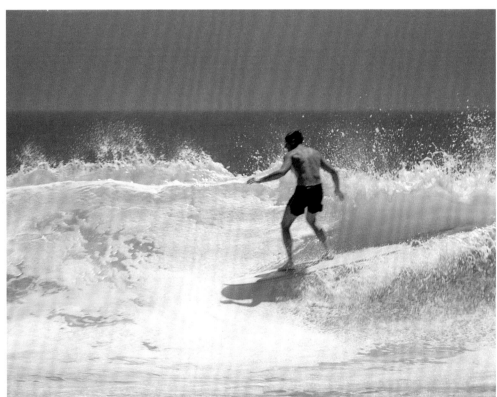

Miki Dora, Malibu, 1961

Below. Unten. Ci-dessous.

Stu Ford, Hermosa Beach, 1960

Opposite. Gegenüber. Page ci-contre.

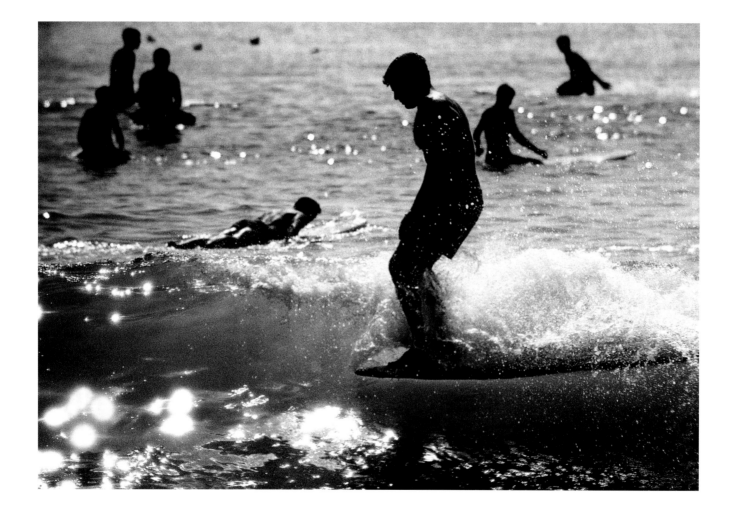

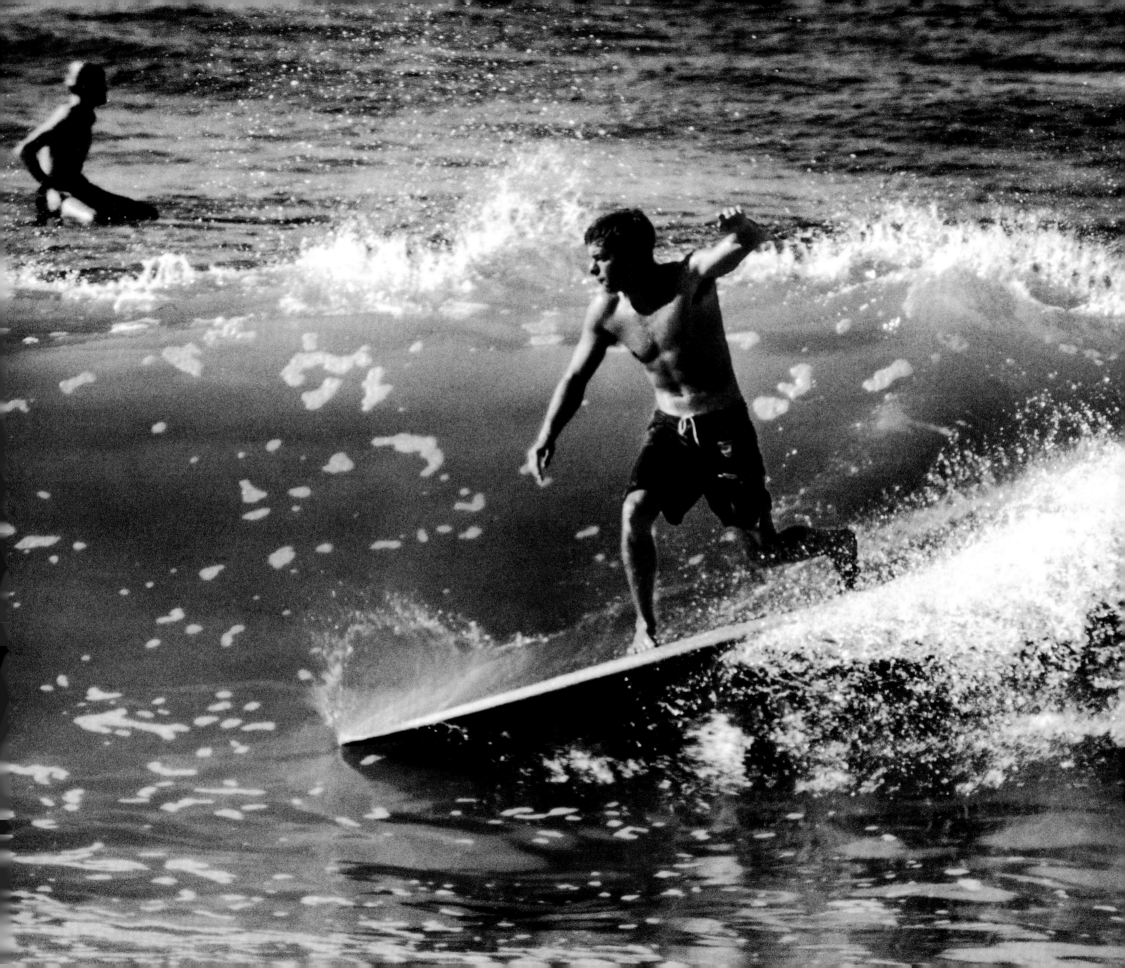

Mike Hynson, Hermosa Beach, 1964

Below: The brash and stylish San Diegan went on to costar in the 1966 documentary *The Endless Summer.*

Unten: Der elegante Draufgänger aus San Diego spielte später in dem Dokumentarfilm *The Endless Summer* von 1966 mit.

Ci-dessous: Le sémillant et élégant Myke Hynson, originaire de San Diego, fut l'une des vedettes du célèbre documentaire *The Endless Summer* de 1966.

Dave Rochlen, Malibu, 1962

Opposite. Gegenüber. Page ci-contre.

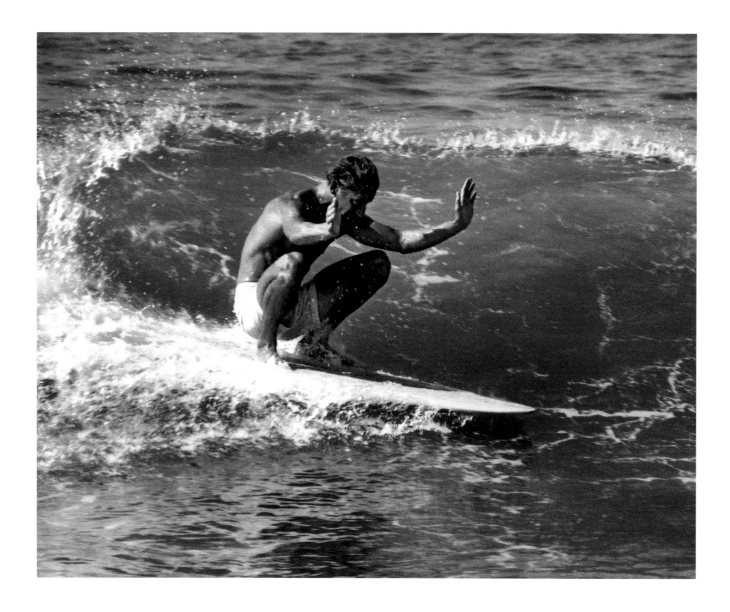

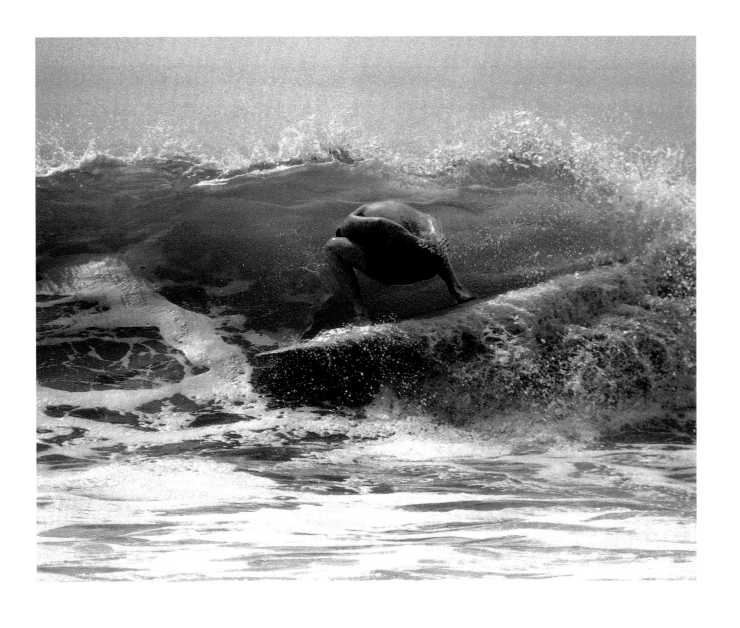

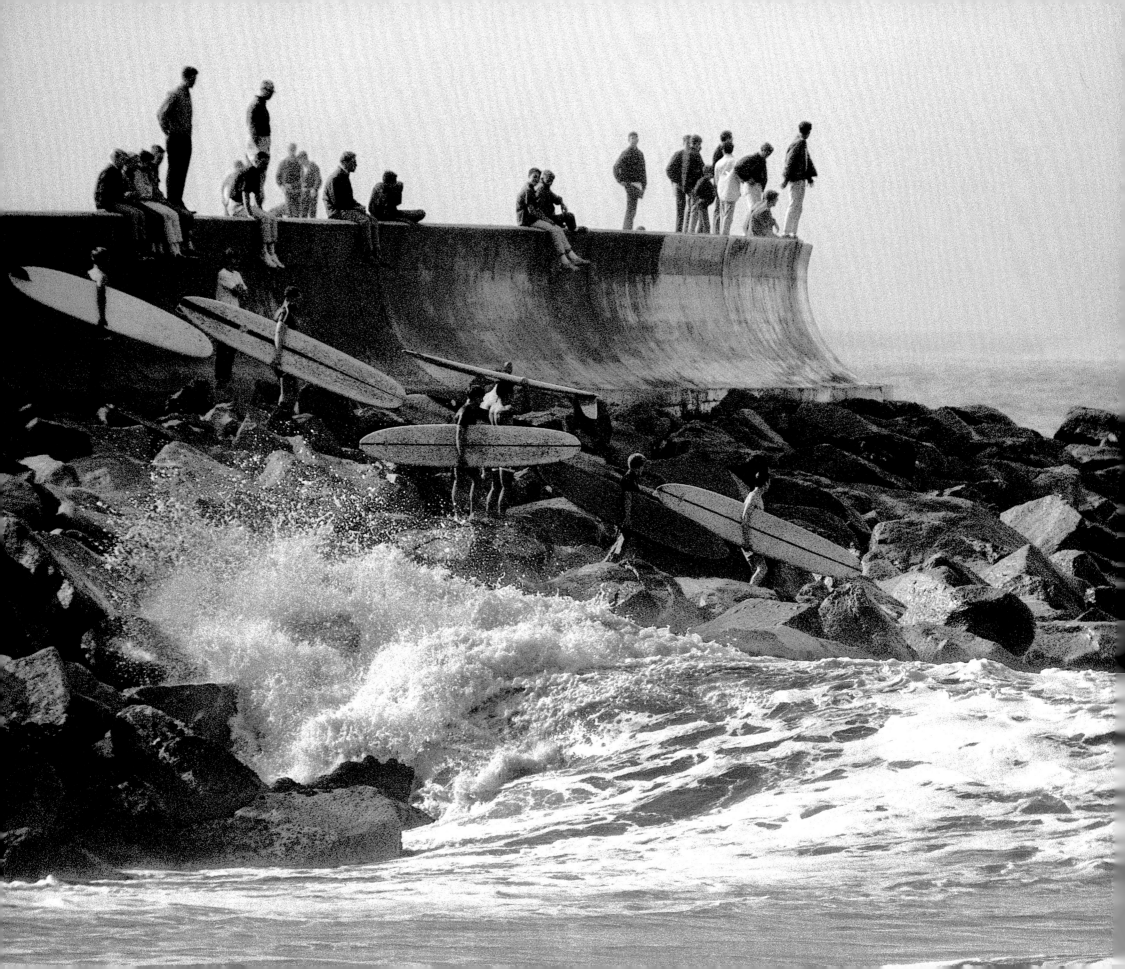

Redondo Beach Breakwater, 1963

Opposite: During a big winter swell, surfers saved themselves a brutal paddle by timing their entry between waves slamming the jetty's end.

Gegenüber: Während einer starken Winter-Dünung sparten sich die Surfer die gnadenlose Paddelei, indem sie zwischen den auf das Ende des Dammes aufschlagenden Wellen ins Wasser gingen.

Ci-contre: Par une forte houle hivernale, un groupe de surfeurs attend sur la jetée le moment opportun pour entrer dans l'eau entre deux déferlantes et s'épargner ainsi un pagayage épuisant.

Jim Fox, Redondo Beach Breakwater, 1963

Below: An exceptionally large day at the breakwater.

Unten: Ein Tag mit außergewöhnlich hohen Wellen an der Buhne.

Ci-dessous: Conditions exceptionnelles pour cette session de surf au pied d'un brise-lame.

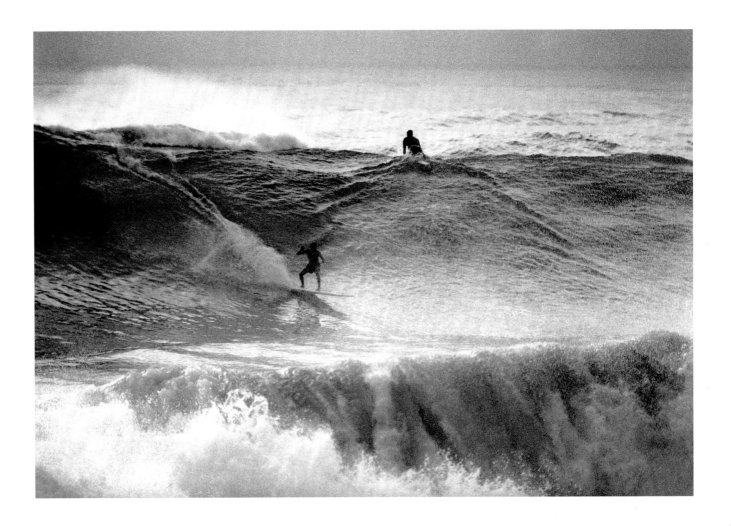

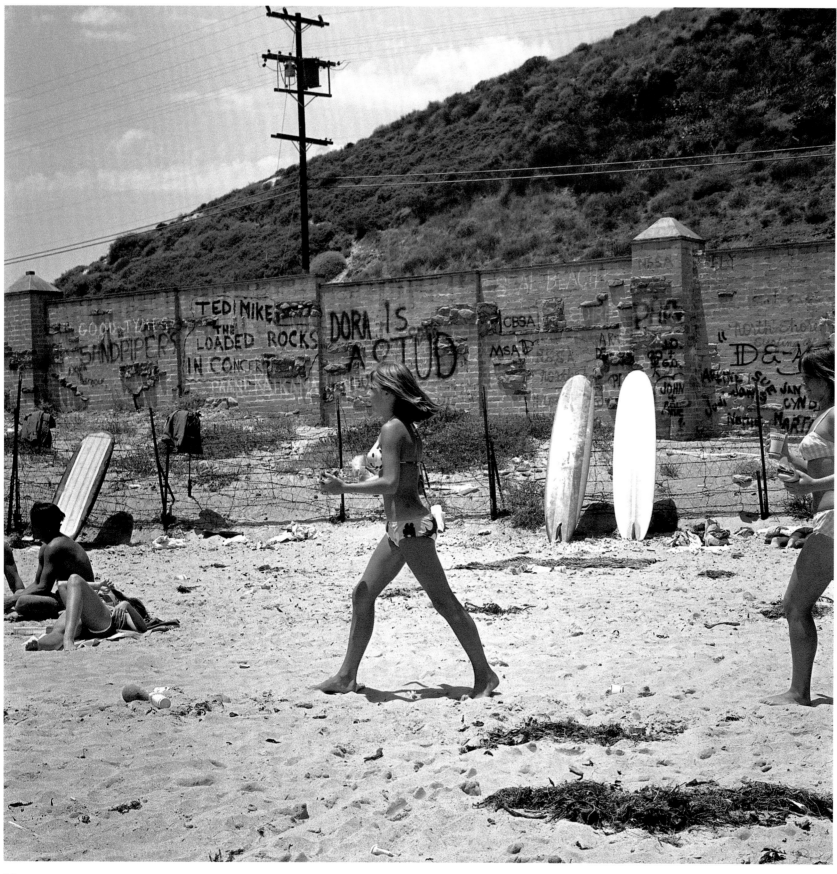

Malibu Wall, 1966

Opposite: The famous Malibu wall was rumored to be the remains of a ruined estate. Note the graffiti advertisement for Miki Dora.

Gegenüber: Die berühmte Malibu Wall gehörte angeblich zur Ruine eines Landsitzes. Ein Graffito rühmt Miki Dora.

Page ci-contre: Le fameux mur de Malibu était supposé être le vestige d'une ancienne propriété. On remarquera le graffiti vantant les mérites de Miki Dora.

Miki Dora, Oceanside, 1965

Below: Dora railed against contests as "cheap soggy carnivals" in surf magazines, but he craved the attention they drew.

Unten: Dora schimpfte in Surfzeitschriften zwar über Wettbewerbe als „billigen, nassen Karneval", genoss aber zugleich die Aufmerksamkeit, die sie ihm brachten.

Ci-dessous: Miki Dora dénigrait publiquement les compétitions de surf, mais lorsqu'il les qualifiait de « carnavals aquatiques à deux balles » dans les magazines spécialisés, c'était avant tout pour attirer l'attention.

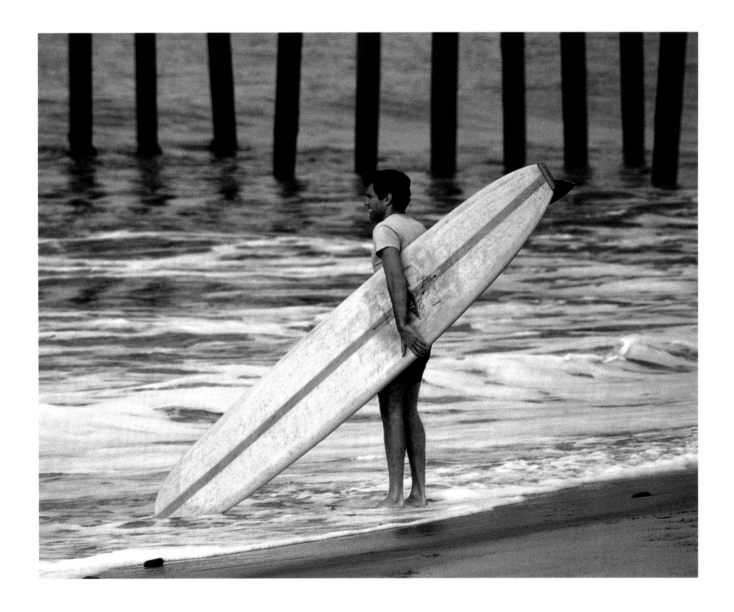

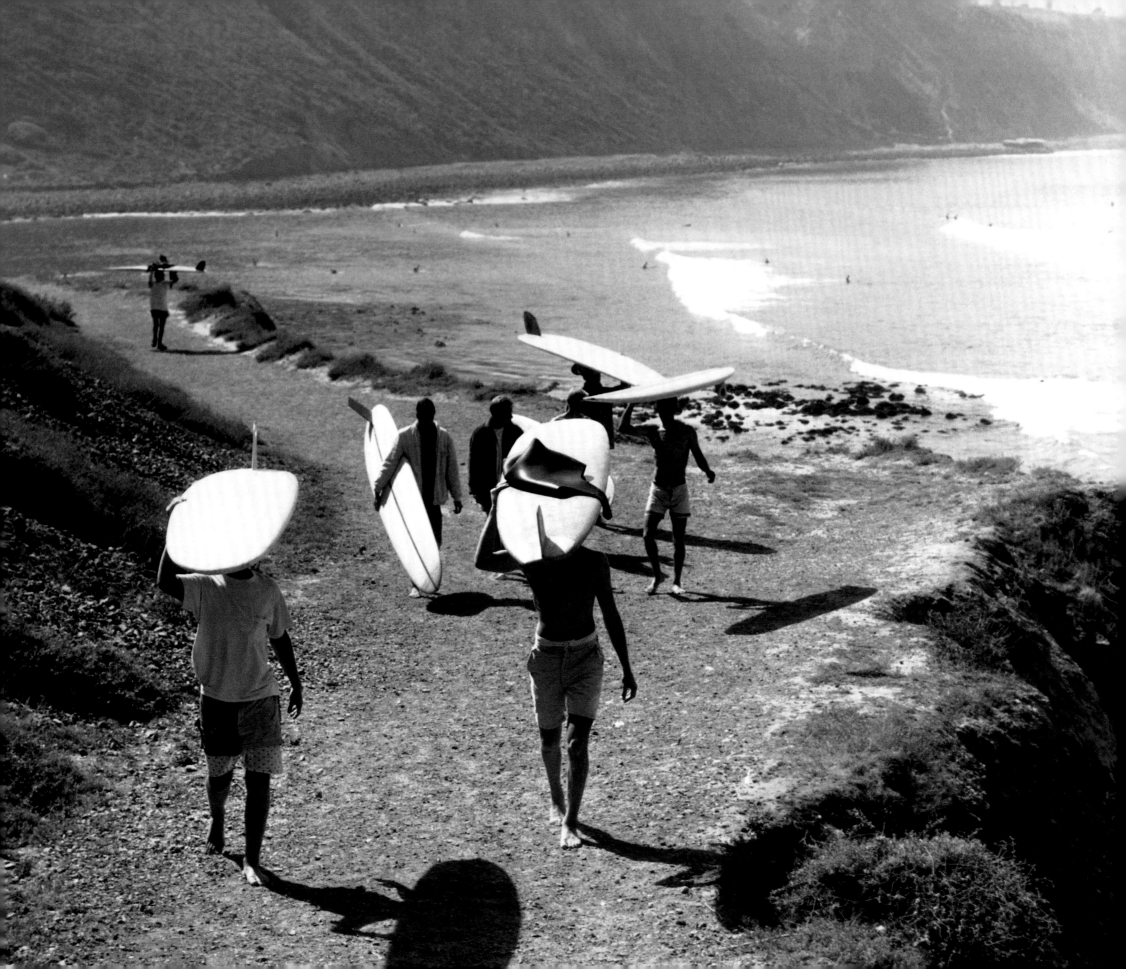

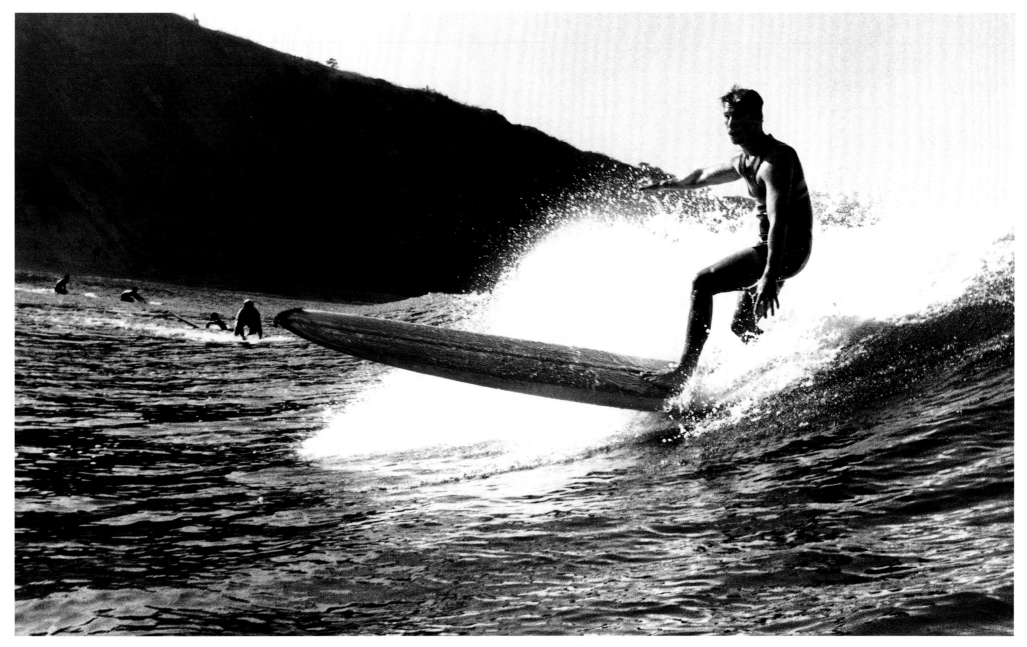

Torrance Beach, 1964

Right: "Rat's Beach," named after all the young "surf rats" who learned on its gentle waves before moving up to Hermosa or Redondo.

Rechts: „Rat's Beach" wurde nach den jungen Wasserratten benannt, die auf diesen sanften Wellen surfen lernten, bevor sie weiter hoch nach Hermosa oder Redondo zogen.

Ci-contre: « Rat's Beach » fut baptisée ainsi d'après les « petits rats du surf » qui venaient y taquiner la petite vague avant de se lancer sur les spots de Hermosa ou de Redondo.

Torrance Beach, 1964

Opposite: From this vantage you can see the span of the South Bay, the birthplace of the modern surf industry.

Gegenüber: Sicht auf die South Bay in voller Länge, den Geburtsort der modernen Surfindustrie.

Page ci-contre: Vue imprenable sur l'immense South Bay bande littorale de South Bay, berceau de l'industrie moderne du surf.

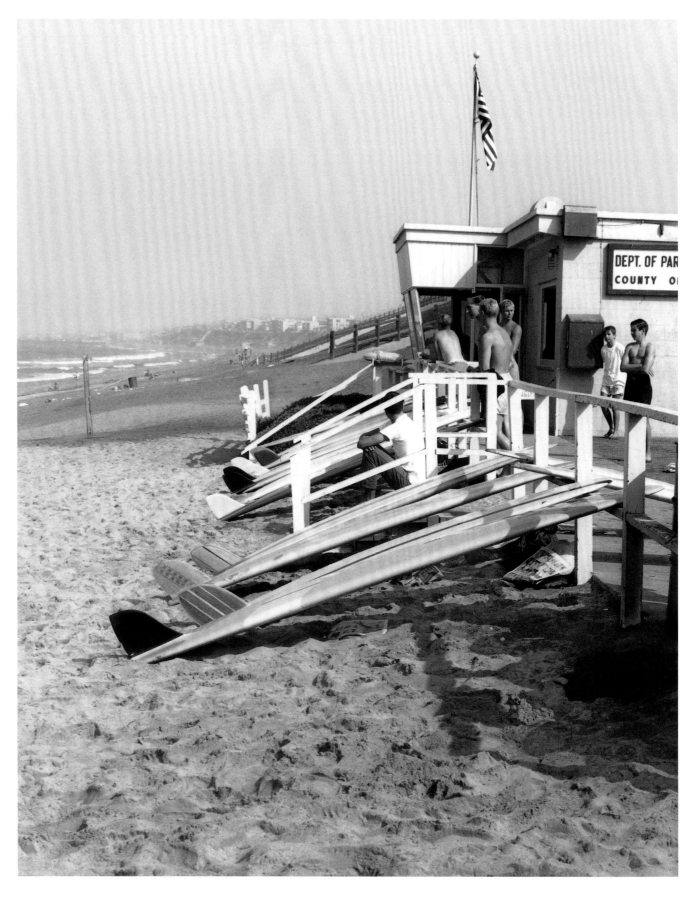

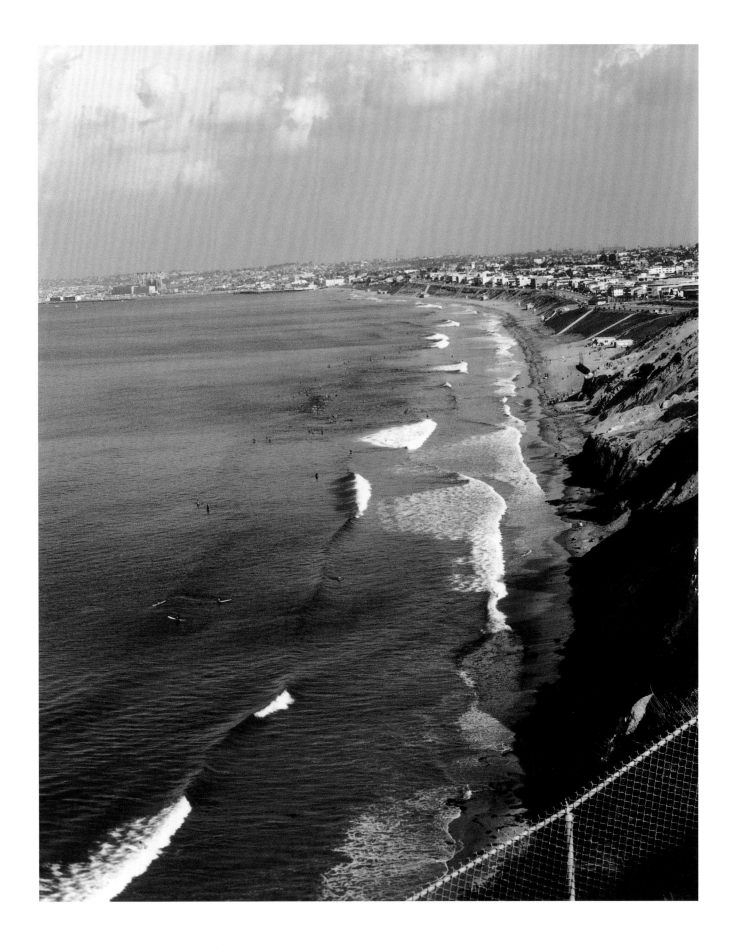

Hermosa Beach, 1963

Below: In 1963, the average Hermosa Beach bungalow sold for $22,000. Today, it would go for close to $1 million.

Unten: 1963 kostete ein durchschnittlicher Bungalow in Hermosa Beach 22.000 Dollar. Heute würde man dafür fast eine Million Dollar zahlen.

Ci-dessous: En 1963, un bungalow de Hermosa Beach se vendait en moyenne 22 000 dollars. Aujourd'hui, il faut compter près d'un million de dollars.

Frank Grannis, Redondo Beach Breakwater, 1963

Opposite. Gegenüber. Page ci-contre.

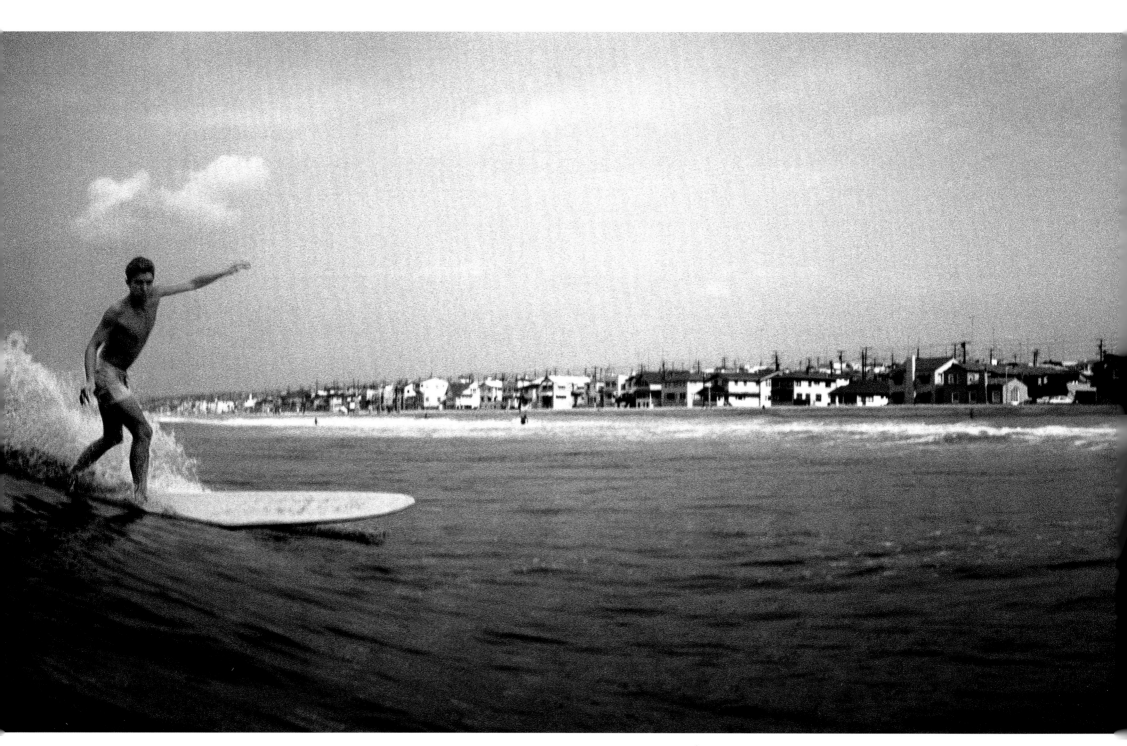

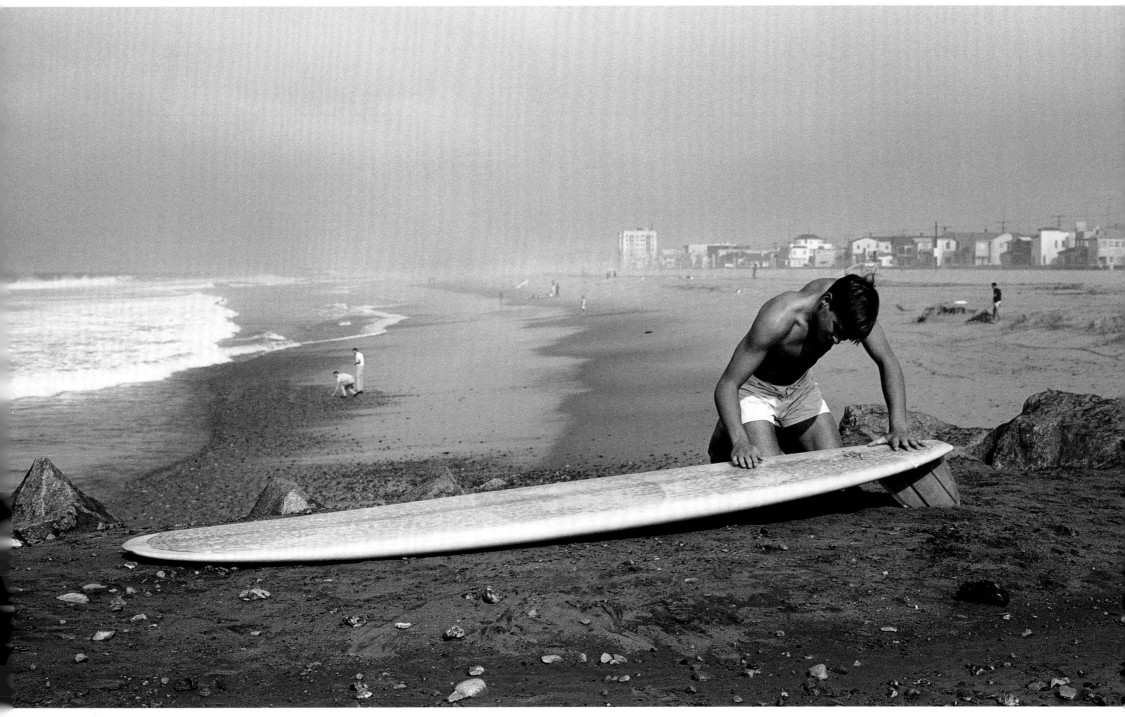

Bing Copeland, Hermosa Beach, 1966

Below: Herbert "Bing" Copeland, one of
the South Bay's master surfboard shapers,
also sold dune buggies on the side.

Unten: Herbert „Bing" Copeland, einer der
besten Surfbrettbauer an der South Bay,
verkaufte nebenbei auch Strand-Buggys.

Ci-dessous: Herbert « Bing » Copeland,
shaper de planches de compétition à
South Bay, vendait également des buggies
des sables.

Secos, 1963

Opposite: LeRoy Grannis's Chevy truck
filled with boards from his Explorer Scouts
troop. Note the Volkswagen Kombi in front,
another sixties surf icon.

Gegenüber: LeRoy Grannis' Chevy-Pick-up
voll mit Brettern seiner Pfadfinder-Gruppe.
Der VW-Bus davor war eine weitere Surf-
ikone der Sechziger.

Page ci-contre: Le pick-up Chevy de
LeRoy Grannis transportant les planches
de sa troupe de scouts. On aperçoit égale-
ment un combi Volkswagen, autre icône du
surf des années 1960.

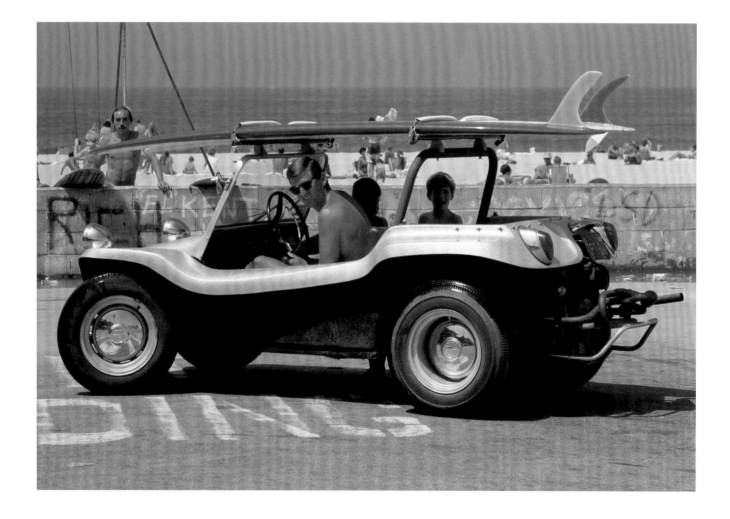

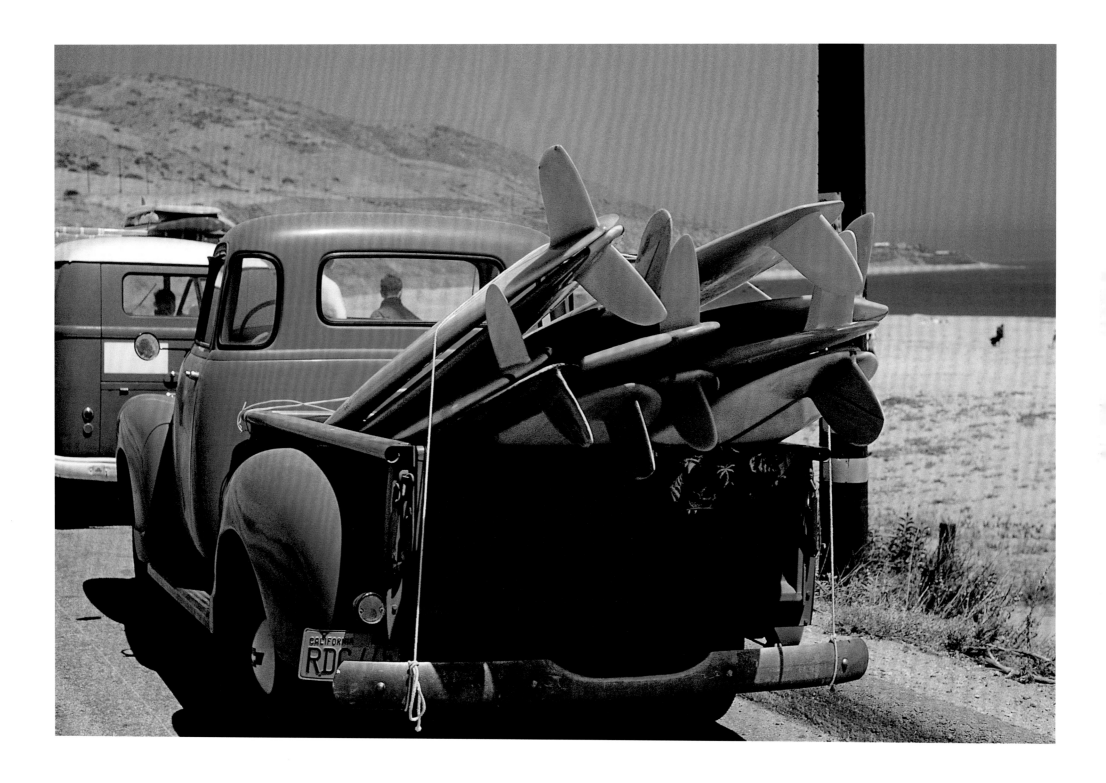

Mike Hynson, Malibu, 1968

Below: Although Hynson was in the vanguard of the shortboard revolution, he retained an elegant style from a bygone era. Here he performs the classic "Quasimodo."

Unten: Obwohl Hynson die Shortboard-Revolution anführte, behielt er den eleganten Stil einer vergangenen Ära bei. Hier zeigt er den klassischen „Quasimodo".

Ci-dessous: Bien que Mike Hynson ait été à l'avant-garde de la révolution du shortboard, il a conservé de cette époque révolue un style élégant. On le voit ici en train d'exécuter une figure classique, un « Quasimodo ».

Malibu, 1967

Opposite: Malibu on the verge of the shortboard revolution. Within a year, these big, beautiful boards would be dinosaurs headed for near-extinction.

Gegenüber: Malibu unmittelbar vor der Shortboard-Revolution. Innerhalb eines Jahres wurden aus diesen großen, schönen Brettern vom Aussterben bedrohte Dinosaurier.

Page ci-contre: Malibu à l'orée de la révolution du shortboard. En l'espace d'une année, ces magnifiques planches effilées seront vouées à une quasi-disparition.

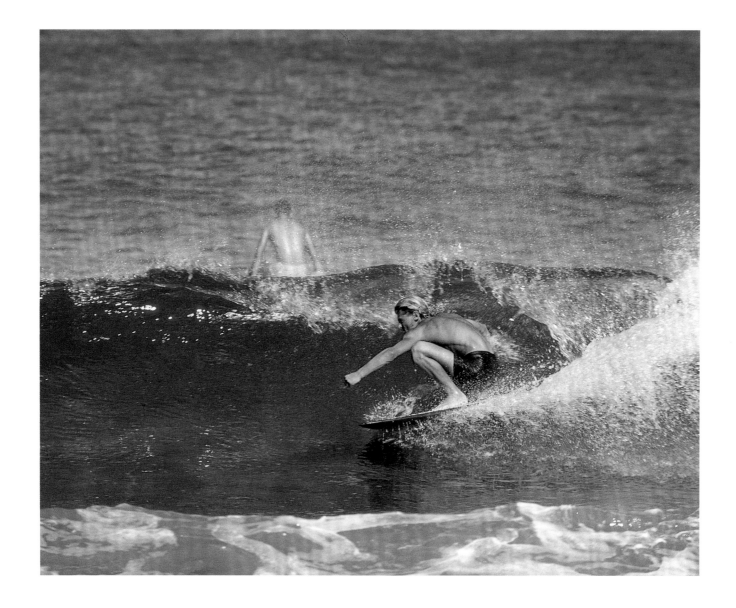

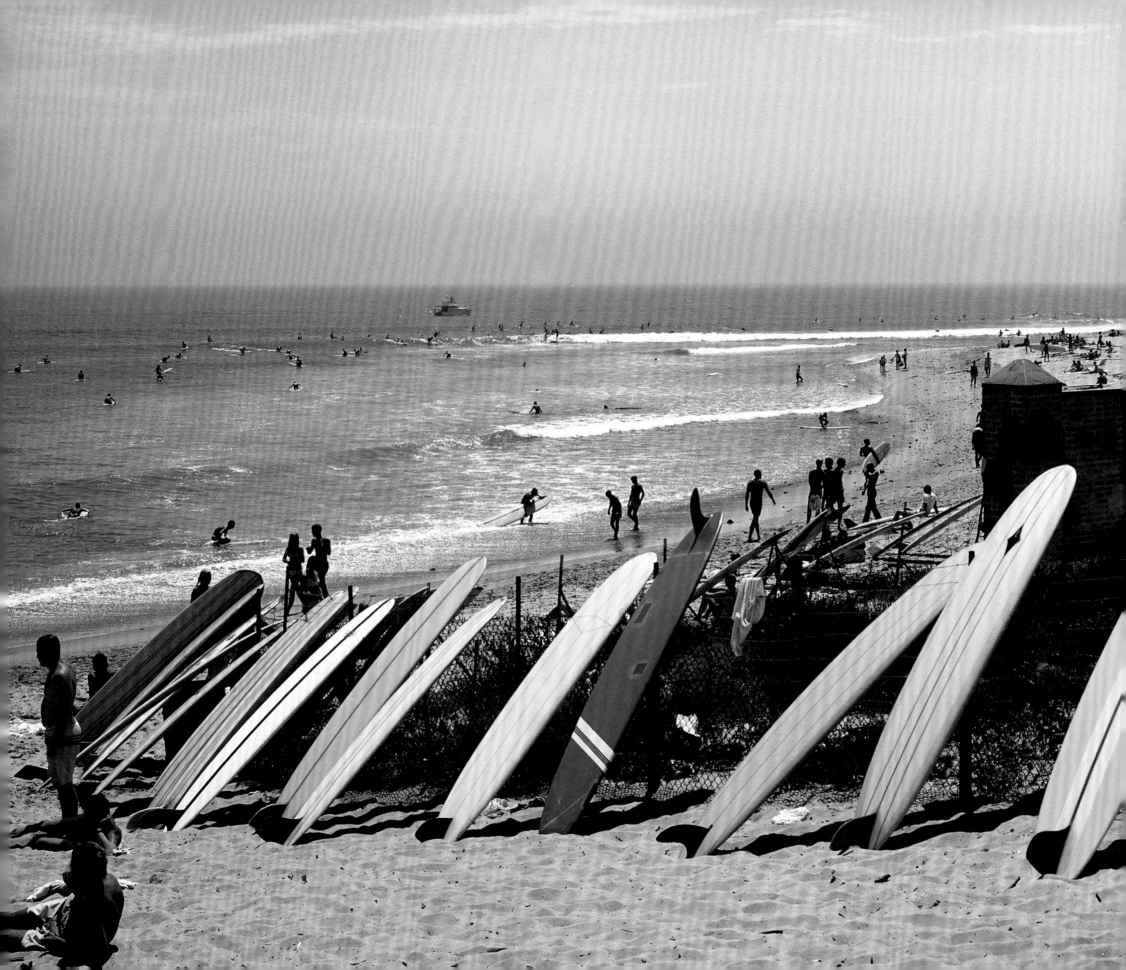

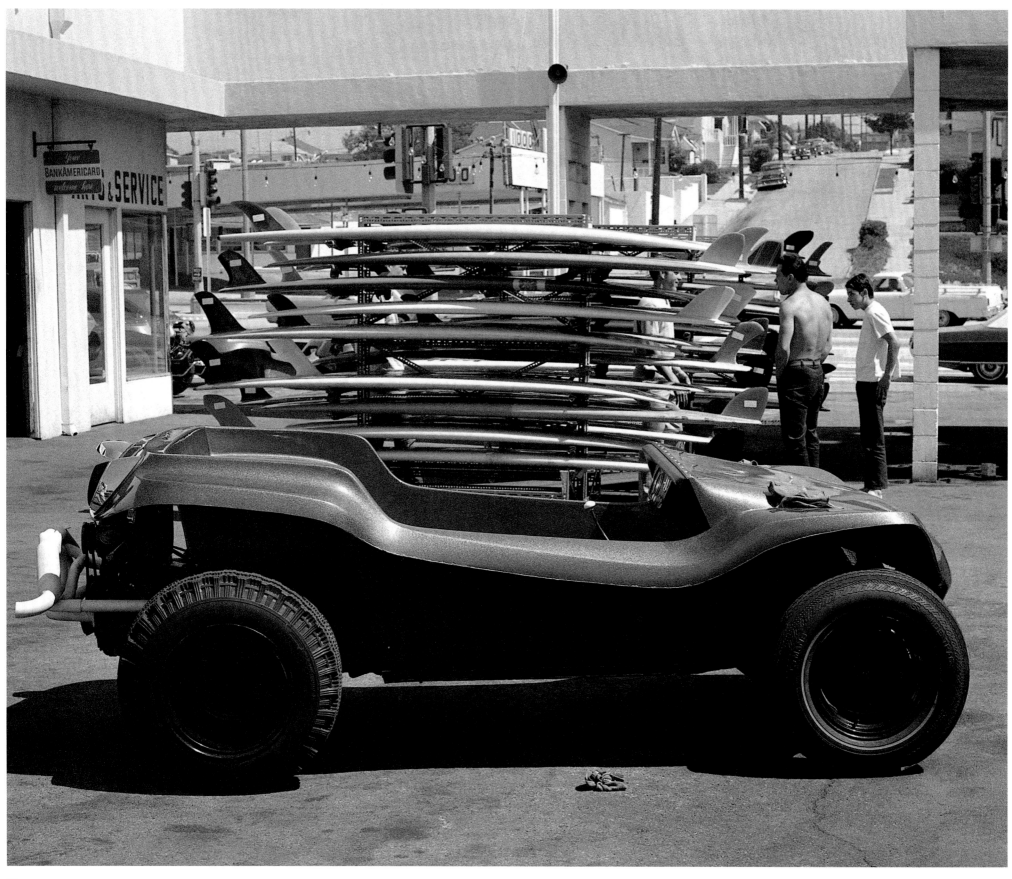

Bing Surfboards, Hermosa Beach, 1968

Opposite: In the early sixties, a short stretch of Pacific Coast Highway was home to the elite of early surfboard makers.

Gegenüber: In den frühen Sechzigern war ein kurzer Abschnitt des Pacific Coast Highway von der Elite der frühen Surf-bretthersteller besiedelt.

Page ci-contre: Au début des années 1960, l'élite des fabricants de planches de surf avait élu domicile le long d'une petite portion de la Pacific Coast Highway.

Dewey Weber, Hermosa Beach, 1962

Below. Unten. Ci-dessous.

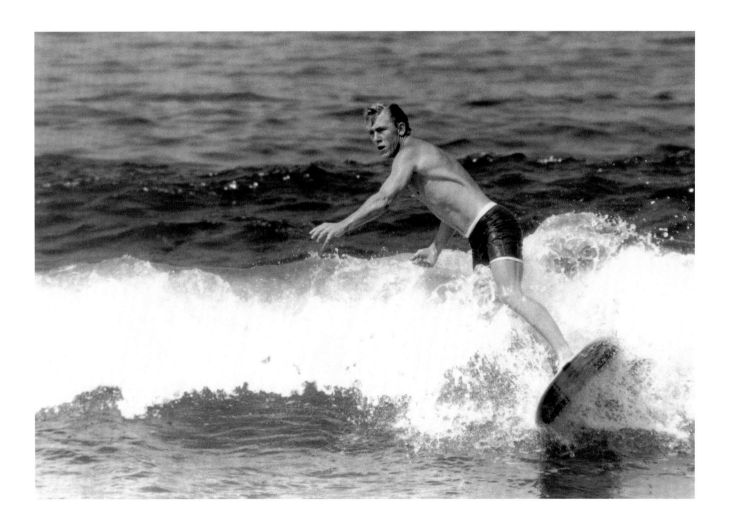

Huntington Beach Pier, 1965

Below. Unten. Ci-dessous.

Huntington Beach Pier, circa 1965

Opposite: "Shooting the pier" was a cutting-edge crowd pleaser in the sixties. If you fell, however, you risked shredding your skin on the razor-sharp mussels.

Gegenüber: Mit „Shooting the pier" konnte man in den Sechzigern bei den Zuschauern Furore machen. Bei einem Sturz riskierte man jedoch, sich die Haut an den rasiermesserscharfen Muscheln aufzuschneiden.

Page ci-contre: Un passe-temps qui fait fureur dans les années 1960: «Shooting the pier» ou comment foncer sous la jetée. Mais attention aux chutes: les moules agglutinées sur les piliers sont tranchantes comme des lames de rasoir!

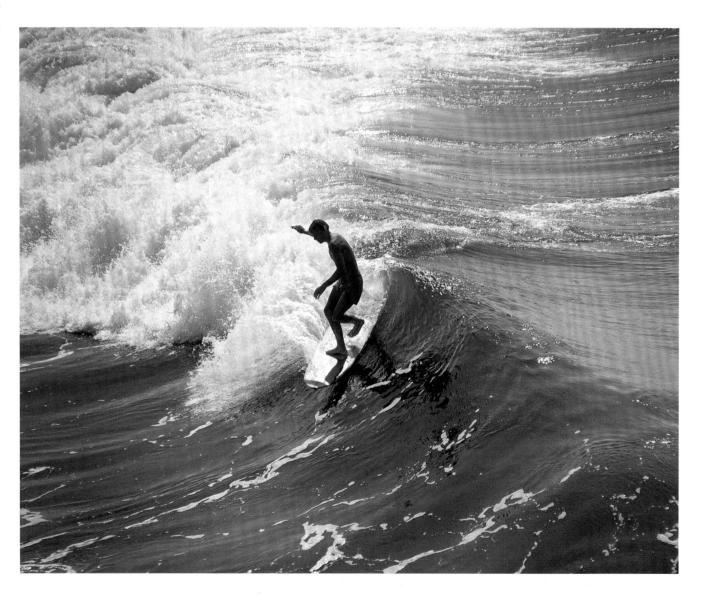

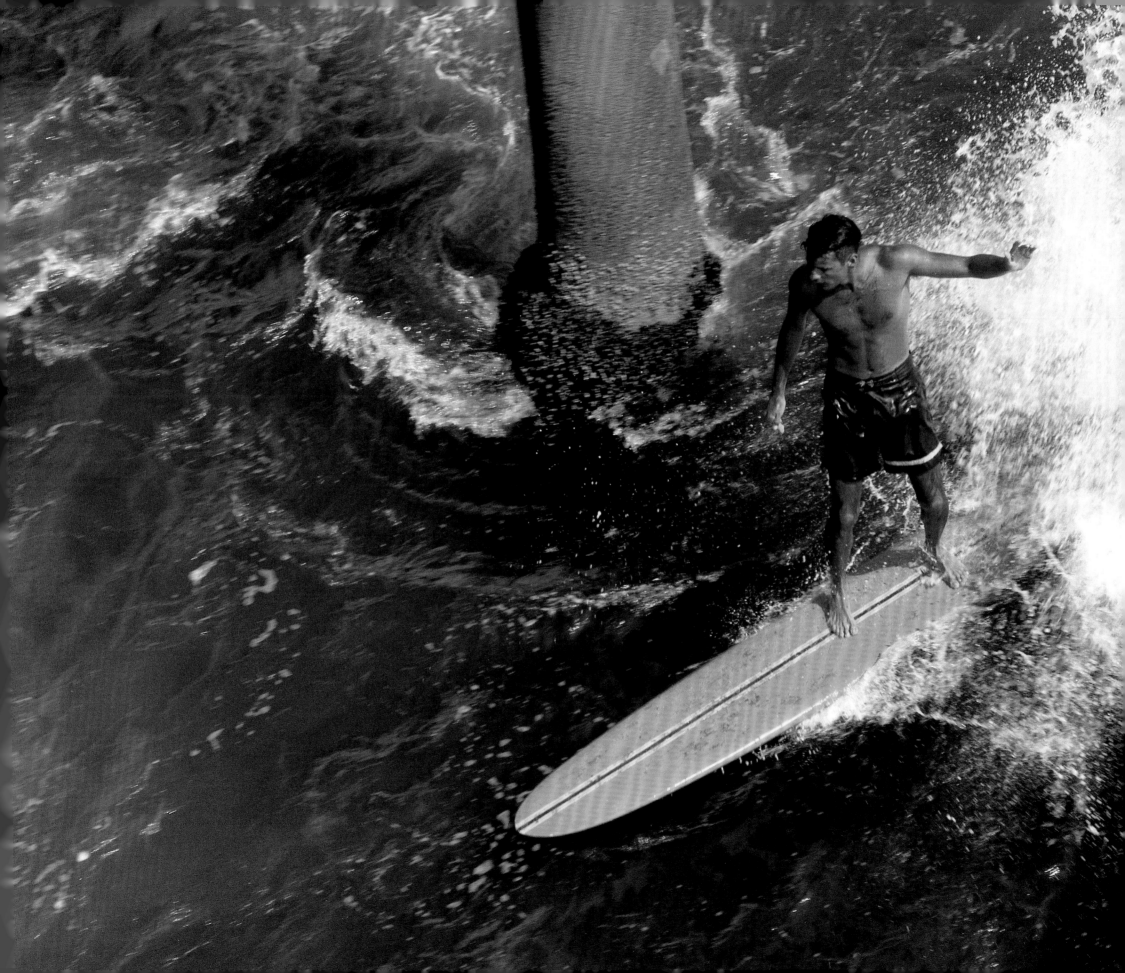

Sparky Hudson, Hermosa Beach, 1965

Below: Perfectly balanced, Hudson explores the Zen of hang ten.

Unten: In perfektem Gleichgewicht erkundet Hudson den Zen des Hang Ten.

Ci-dessous: En parfait équilibre, Sparky Hudson explore les bienfaits du zen en exécutant un *hang ten*.

Lance Carson, Malibu, 1967

Opposite: Filmmaker Bruce Brown once said of Carson's noseriding: "He's so relaxed up there, you get the feeling that he could have a ham sandwich while he's hanging around."

Gegenüber: Der Regisseur Bruce Brown sagte mal über Carsons Nose-Riding: „So entspannt, wie er dasteht, hat man das Gefühl, er könnte nebenbei noch ein Schinkenbrot essen."

Page ci-contre: Le réalisateur Bruce Brown a commenté en ces termes le *noseriding* de Lance Carson: « Il est tellement à l'aise sur sa planche qu'on pourrait l'imaginer un jambon-beurre à la main. »

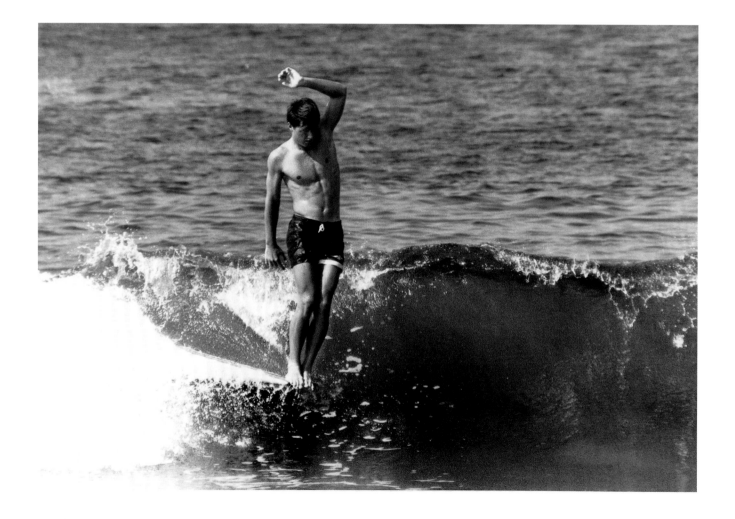

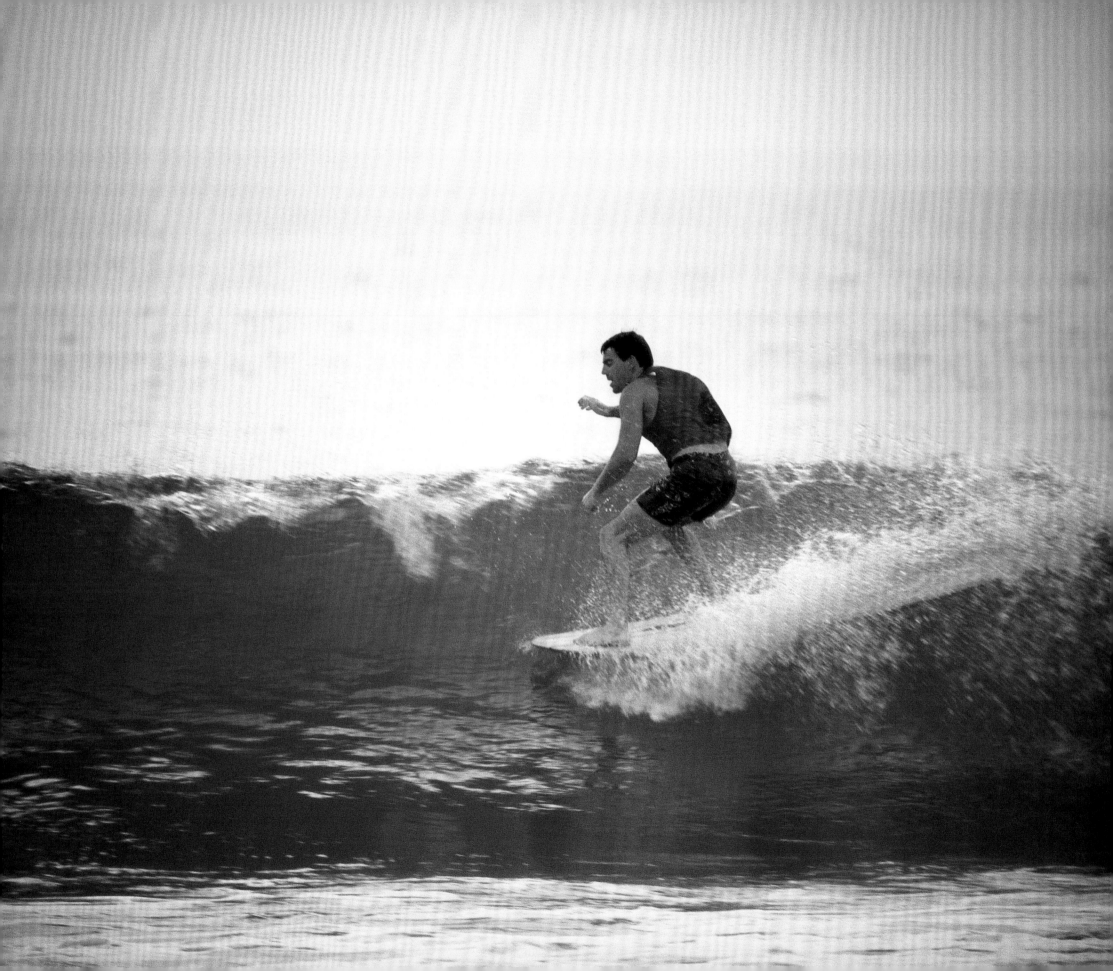

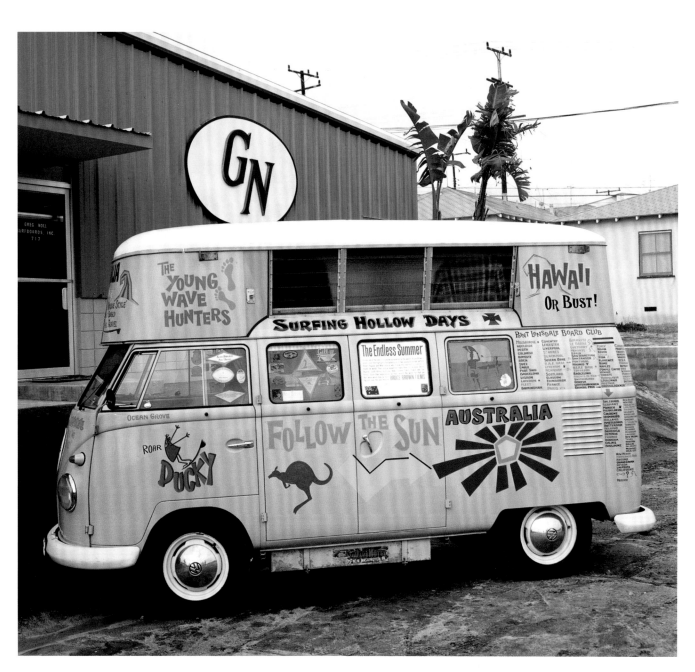

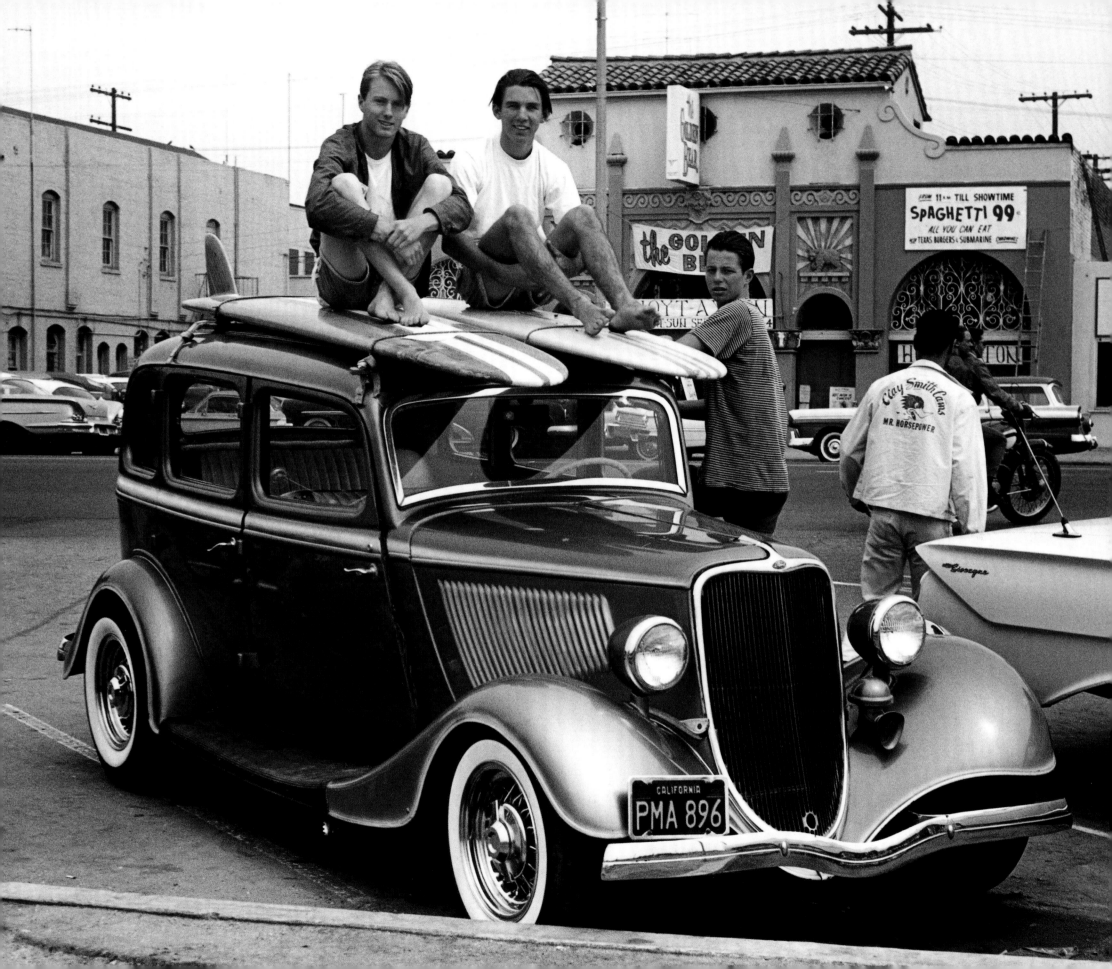

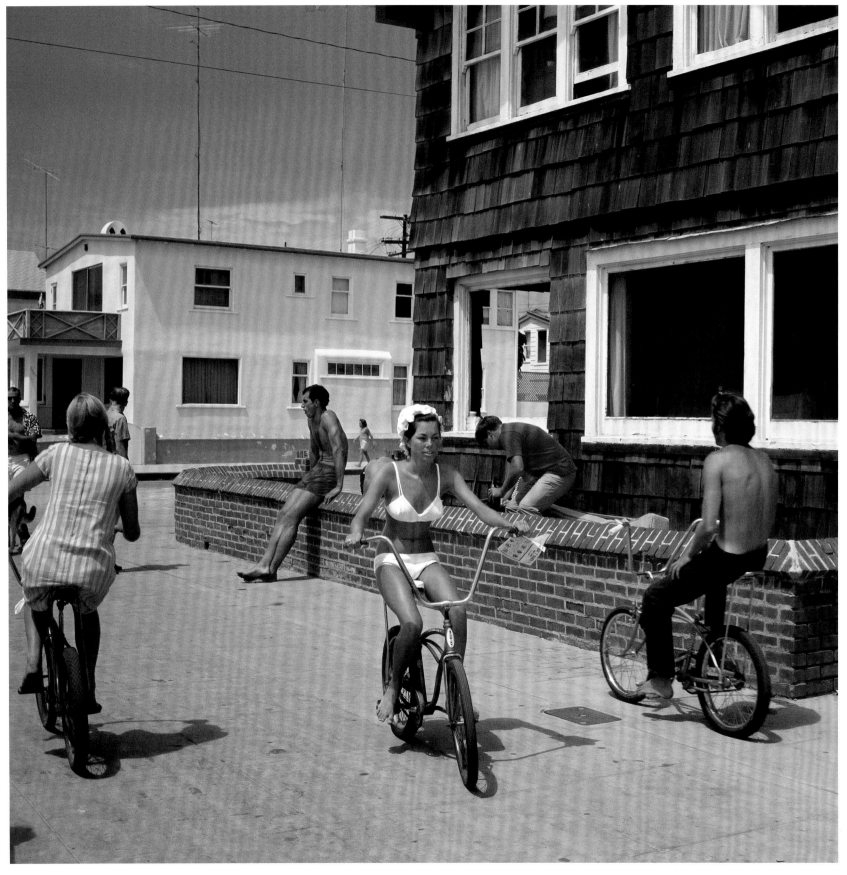

Hermosa Beach Strand, 1967

Opposite: Then, as now, Hermosa was one long summer vacation for the young and tanned. Check out the classic stingray bicycles with butterfly handlebars.

Gegenüber: Damals wie heute bedeutete Hermosa einen langen Sommerurlaub für die braun gebrannte Jugend. Die Stingray-Fahrräder mit Bananensattel und Gabellenker waren ein Teil davon.

Page ci-contre: Hier comme aujourd'hui, Hermosa est un lieu de rendez-vous estival de la jeunesse bronzée. On remarquera les bicyclettes Stingray à guidon « papillon ».

Hermosa Beach, 1963

Below: Ford Model B convertible coupe. Grannis loved shooting the various modes of transport surfers used to get to the beach.

Unten: Ford Model B Cabrio. Grannis liebte es, die unterschiedlichen Transportmittel zu fotografieren, mit denen die Surfer zum Strand kamen.

Ci-dessous: Coupé cabriolet Ford model B. Grannis aimait photographier les moyens de locomotion utilisés par les surfeurs pour se rendre sur les spots.

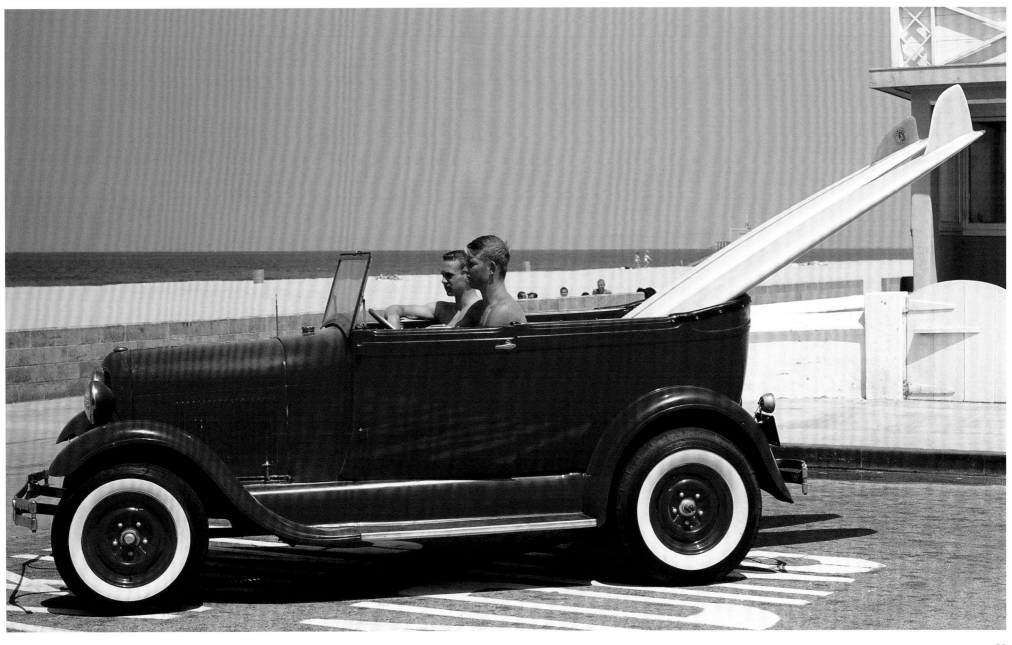

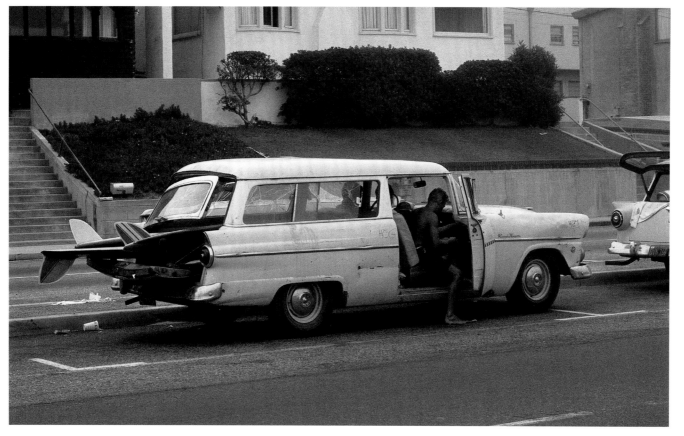

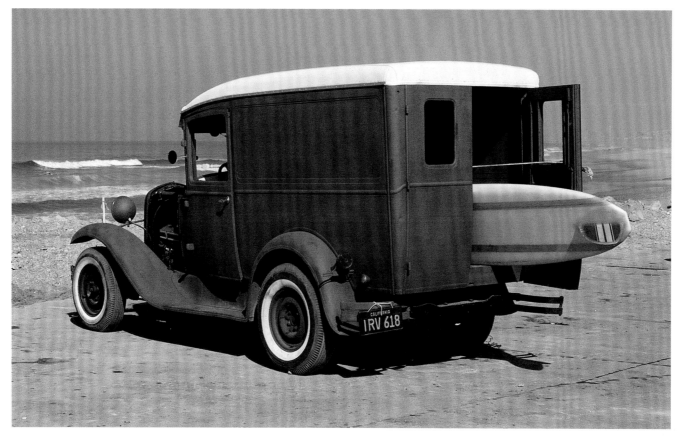

Hermosa Beach, 1964

Left, above: On any weekend, the streets around 22nd Street would be filled with board-stuffed cars. Surfers loved station wagons because they could sleep in them.

Links oben: Jedes Wochenende waren die Straßen rund um die 22nd Street mit Autos voller Surfbretter zugeparkt. Die Surfer mochten Kombis, weil sie in ihnen schlafen konnten.

Ci-contre, en haut: Chaque week-end, les rues adjacentes à 22nd Street étaient envahies de véhicules bondés de planches de surf. Les surfeurs avaient un faible pour les breaks du type Station Wagon car ils pouvaient dormir dedans.

Redondo Beach, 1963

Left, below: Depression-era delivery truck turned sixties surf habitat. Many of these old cars were bought in the fifties for under $100.

Links unten: Ein Lieferwagen aus der Zeit der großen Depression, umgewandelt in eine Surfherberge der Sechziger. Viele dieser alten Autos konnte man in den Fünfzigern für weniger als 100 Dollar kaufen.

Ci-contre, en bas: Camionnette de livraison des années de la Grande Dépression transformée en camping-car pour surfeurs dans les années 1960. De nombreux véhicules comme celui-ci se vendaient pour moins de 100 dollars dans les années 1950.

Dewey Weber Shop, Venice, 1963

Opposite: One-of-a-kind surf wagon.

Gegenüber: Ein einzigartiges Surfmobil.

Page ci-contre: Surf-mobile unique en son genre.

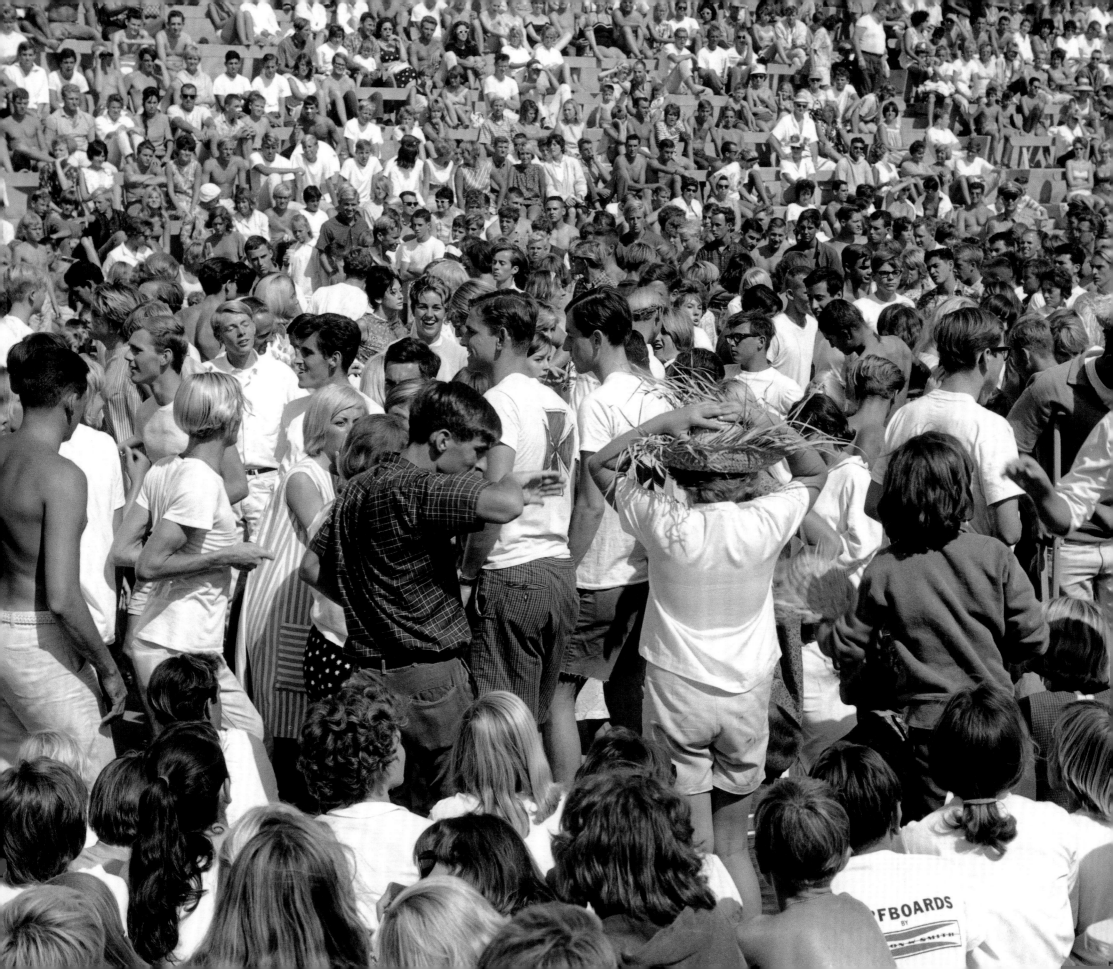

Huntington Beach, 1962

Opposite: Just before the awards ceremony for the West Coast Championships, the crowd went wild dancing the stomp to the surf sounds of The Challengers.

Gegenüber: Vor der Preisverleihung bei den West Coast Championships hotteten die Zuschauer zur Surfmusik der Challengers ab.

Page ci-contre: Juste avant la remise des prix du championnat de la Côte Ouest, une foule déchaînée danse le stomp au rythme du «Surf Sound» des Challengers.

Huntington Beach, 1964

Below: Skateboarding had its first big boom in the early sixties. The Jack's Surfboards skateboard team put on exhibitions featuring headstands and noserides.

Unten: Skateboarding erlebte seinen ersten großen Boom Anfang der Sechziger. Das Skateboardteam von Jack's Surfboards führte Kopfstände und Nose-Rides vor.

Ci-dessous: Le skateboard a connu ses premières heures de gloire au début des années 1960. Lors de ses exhibitions, l'équipe de skaters de Jack's Surfboards exécutait des figures telles que le poirier et le *noseride*.

Huntington Beach, 1962

The night before the West Coast Championships, a U.S. Navy ship rammed an offshore oil tanker. The oil slick drifted into the contest area during the tandem event. Left to right, Bob Moore, Shelly Amarine, Hobie Alter, Laurie Hoover, Pete Peterson.

Am Abend vor den West Coast Championships rammte ein Schiff der U.S. Navy einen vor der Küste liegenden Öltanker. Der Ölteppich trieb während des Tandem-Wettkampfs in den Wettbewerbsbereich. Von links nach rechts: Bob Moore, Shelly Amarine, Hobie Alter, Laurie Hoover, Pete Peterson.

Dans la nuit qui précéda le championnat de la Côte Ouest, un bâtiment de la U.S. Navy heurta un pétrolier stationnant au large. La nappe de pétrole a progressé jusque dans l'aire de compétition pendant les épreuves de tandem. De gauche à droite : Bob Moore, Shelly Amarine, Hobie Alter, Laurie Hoover et Pete Peterson.

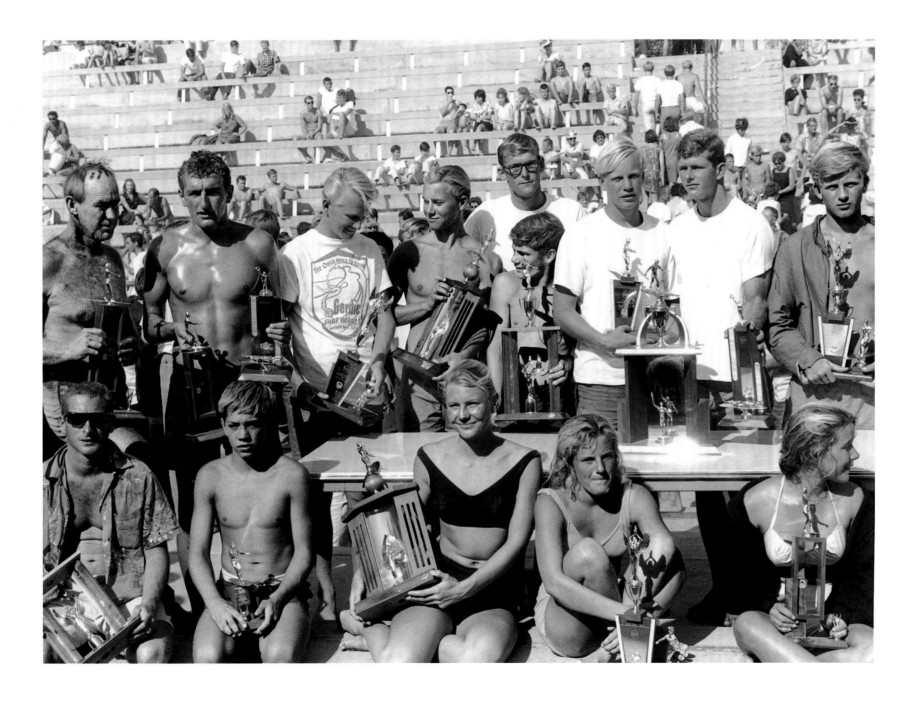

Huntington Beach Pier, 1964

Below: An unlucky competitor caught between the pilings after a wipeout during the annual U.S. Championships. He survived—his board didn't.

Unten: Ein Teilnehmer hatte das Pech, nach einem Sturz bei den alljährlichen U.S. Championships zwischen den Pfählen zu landen. Er überlebte es – sein Brett nicht.

Ci-dessous: Un concurrent malchanceux projeté par les vagues atterrit dans les piliers d'une jetée au cours du championnat américain. Il en sortira sain et sauf, mais sa planche, elle, n'a pas survécu.

Huntington Beach, 1963

Opposite: Beach stomp, midcontest, days before President John F. Kennedy's assassination. Dick Dale "King of the Surf Guitar" in the foreground.

Gegenüber: Beach-Disco zur Halbzeit des Wettbewerbs, wenige Tage vor dem Attentat auf Präsident John F. Kennedy. Im Vordergrund Dick Dale, der Meistergitarrist der Surferszene.

Page ci-contre: Session de stomp sur la plage en pleine compétition de surf, quelques jours avant l'assassinat de John F. Kennedy. Au premier plan on aperçoit le guitariste Dick Dale, considéré comme le « King » de la scène du surf.

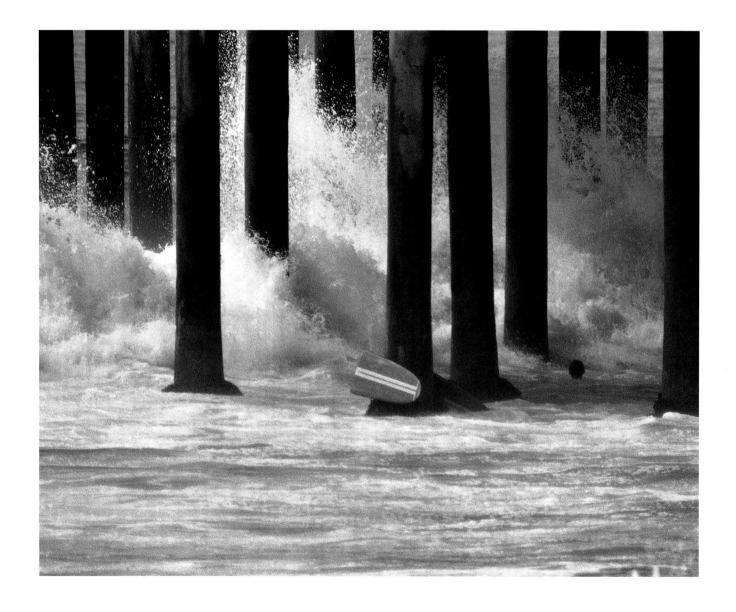

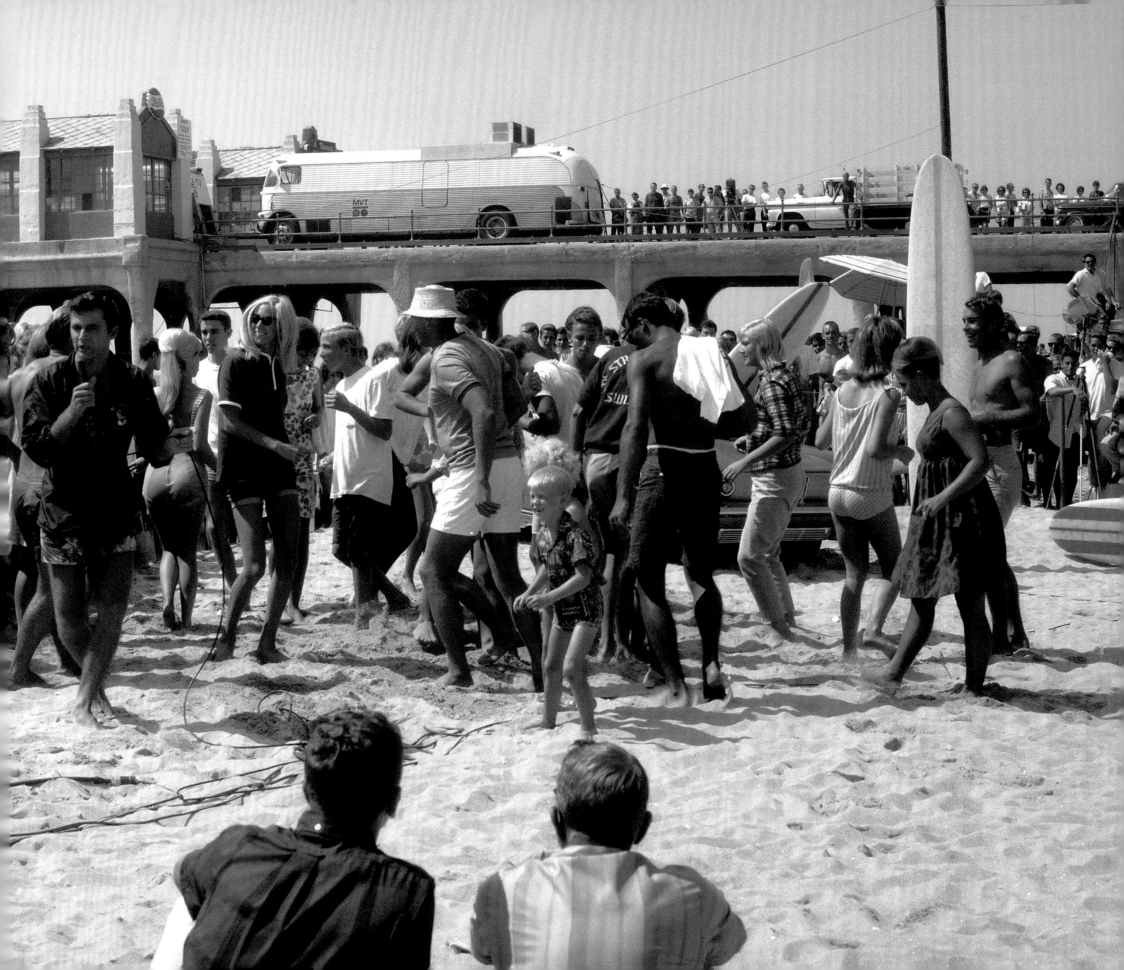

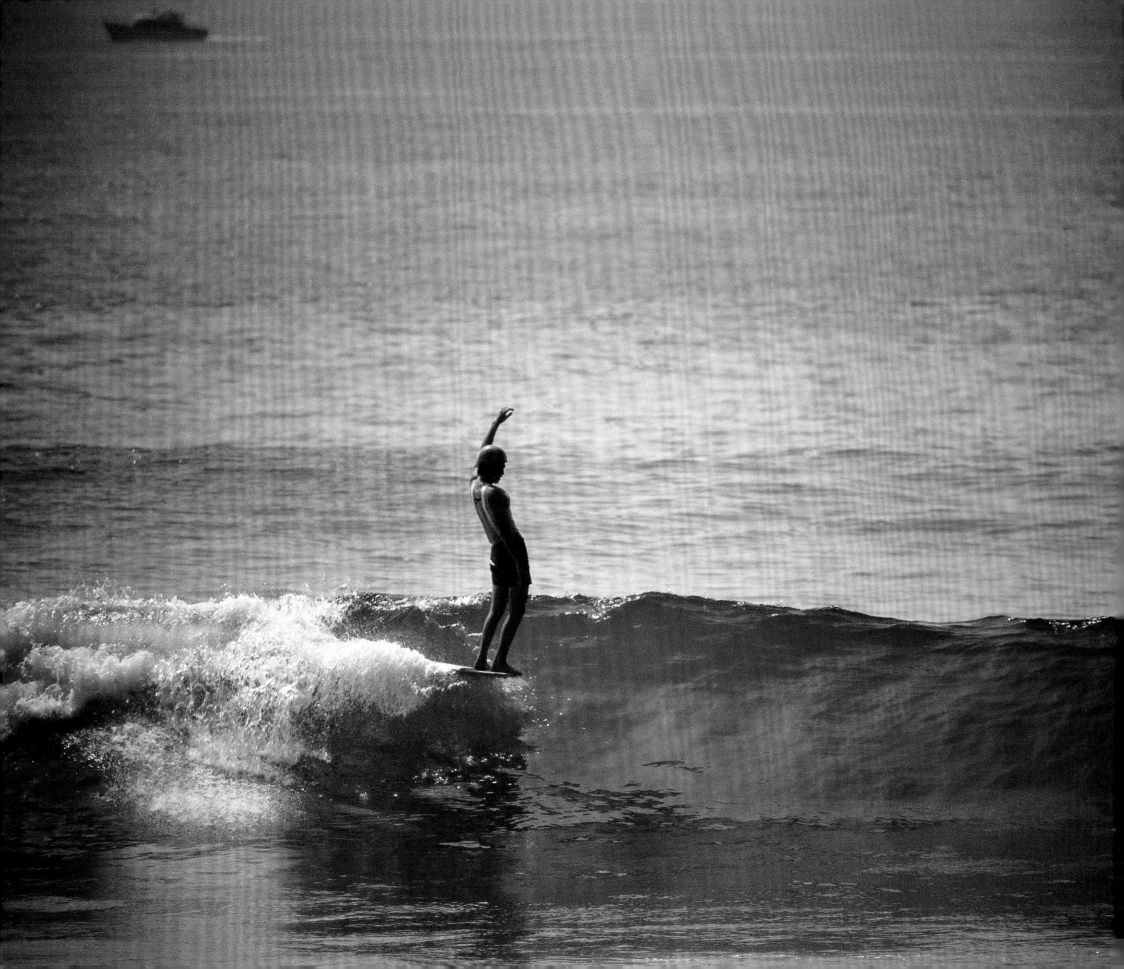

David Nuuhiwa, Huntington Beach, 1966

Opposite: In 1966, eighteen-year-old Hawaiian–born Nuuhiwa was surfing's hottest star. That year the flashy "goofyfoot" won both the U.S. Championships and *Surfer* magazine's prestigious Surfer Poll.

Gegenüber: 1966 war der achtzehnjährige Hawaiianer Nuuhiwa der heißeste Star der Surfszene. In diesem Jahr gewann der auffallende „Goofyfoot" sowohl die U.S. Championships als auch die angesehene Leserumfrage der Zeitschrift *Surfer*.

Page ci-contre : En 1966, alors âgé de 18 ans, le Hawaïen David Nuuhiwa devient la star incontestée du surf. Cette année-là, le sémillant *goofy* remporte à la fois le championnat américain et le prestigieux Prix des lecteurs du magazine *Surfer*.

Huntington Beach, 1964

Below: The annual U.S. Championships (now the U.S. Open) drew crowds of up to ten thousand on a weekend. More than fifty thousand spectators attend today.

Unten: Die alljährlich stattfindenden U.S. Championships (heute die U.S. Open) zogen an einem Wochenende bis zu 10.000 Zuschauer an. Heutzutage sind es mehr als 50.000.

Ci-dessous : Le championnat américain annuel (aujourd'hui U.S. Open) attire des dizaines de milliers spectateurs en un seul week-end. Aujourd'hui, il rassemble plus de 50 000 personnes.

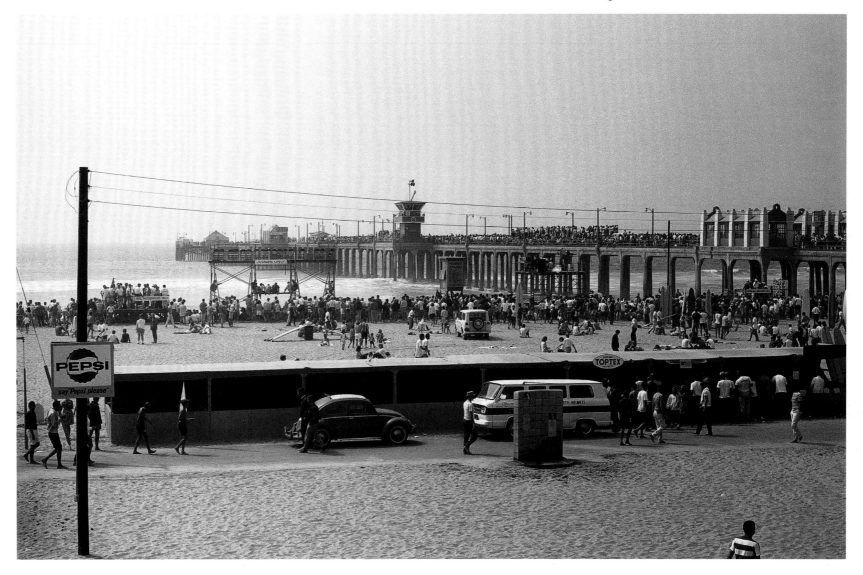

Ocean Beach, San Diego, 1964

Below: Competitors' boards at rest between heats at the Western Surfing Association contest.

Unten: Die Bretter der Teilnehmer machen Pause zwischen den Heats beim Wettbewerb der Western Surfing Association.

Ci-dessous: Répit mérité pour ces planches de compétition entre deux *heats* du championnat de la Western Surfing Association.

Johnny Fain, Miki Dora, Malibu, 1965

Opposite: On what became known as "the day war came to Malibu," superstars Fain (left) and Dora nearly came to blows over wave rights at the annual club contest.

Gegenüber: Dieser Tag ging als „der Tag, an dem der Krieg nach Malibu kam" in die Surfgeschichte ein: Die Superstars Fain (links) und Dora gerieten beim Club-Wettbewerb wegen der Vorfahrtregeln aneinander.

Page ci-contre: « Guerre à Malibu » : ce jour-là, la compétition annuelle du club donne lieu à une violente empoignade entre les deux stars du surf Johnny Fain (à gauche) et Miki Dora, qui se disputent la priorité sur les vagues.

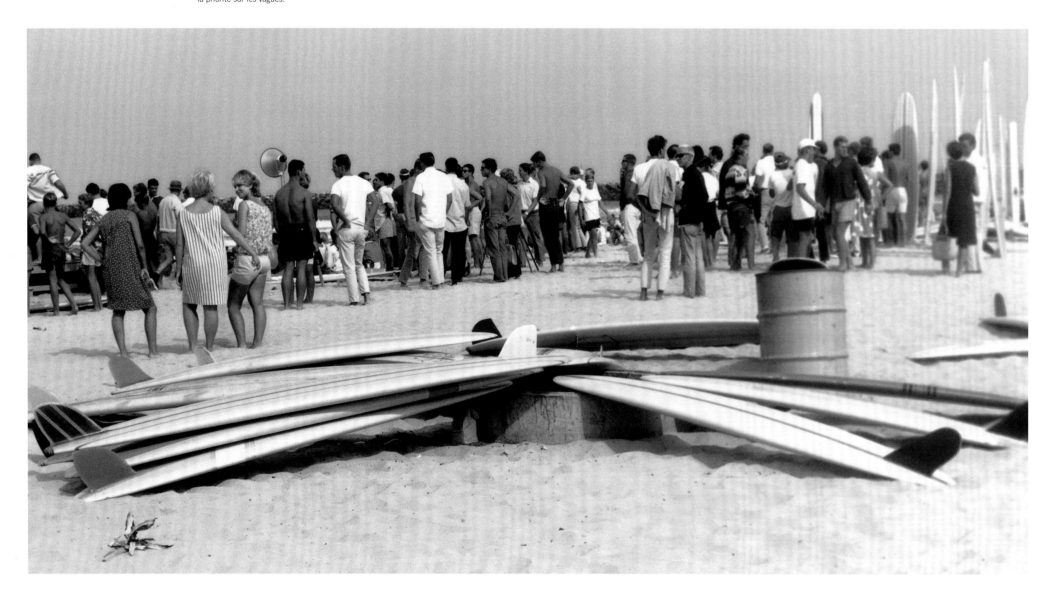

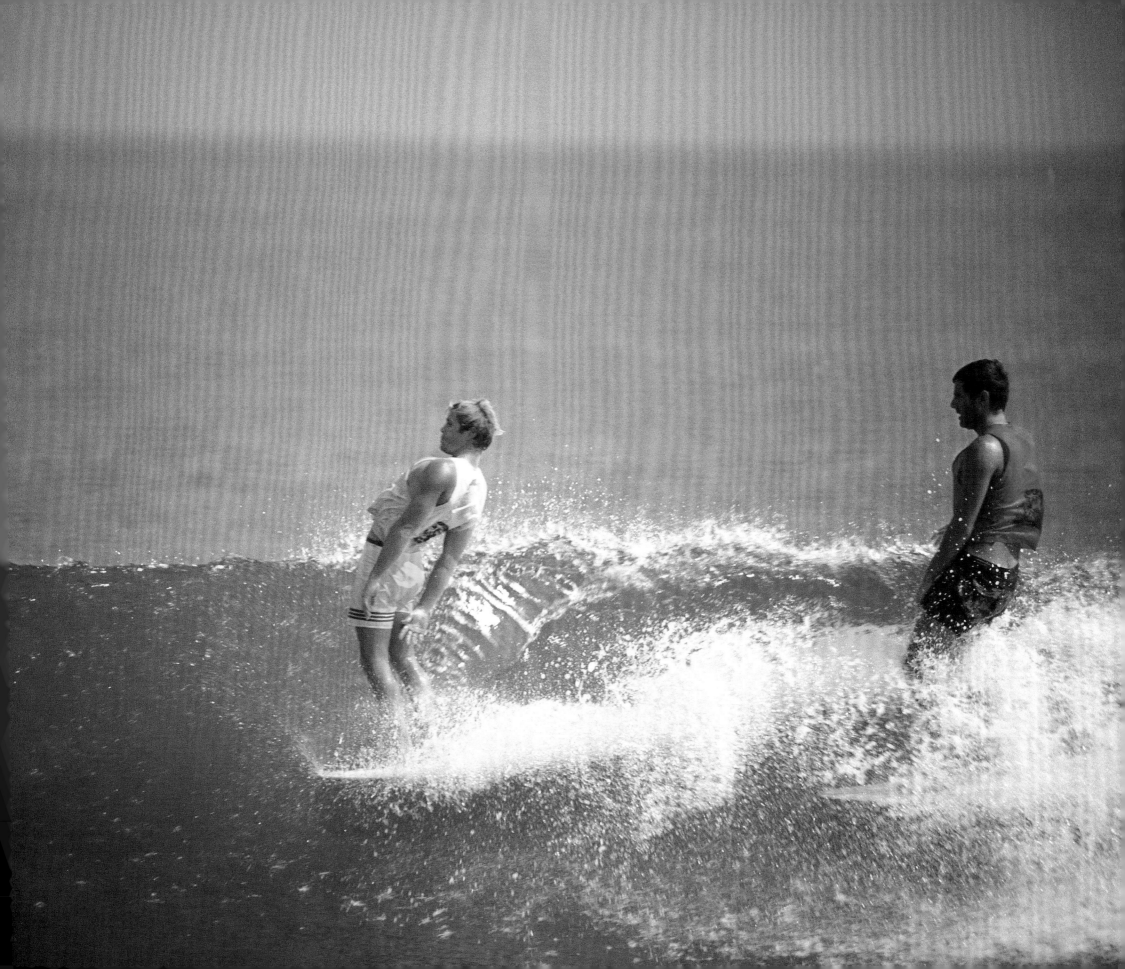

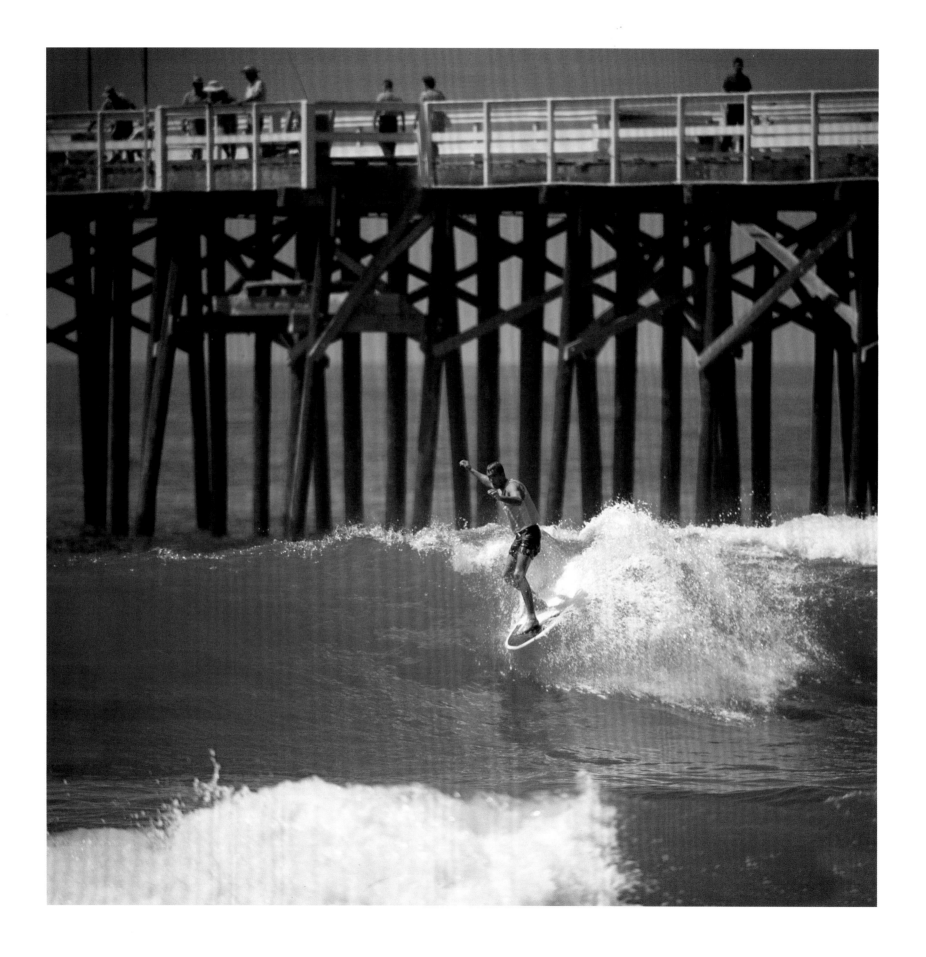

John Peck, Oceanside, 1966

Opposite: Riding his signature Tom Morey-designed "Penetrator" model, Peck draws a clean line at the Western Surfing Association contest.

Gegenüber: Auf seinem von Tom Morey entworfenen „Penetrator"-Brett zieht Peck eine klare Linie beim Wettbewerb der Western Surfing Association.

Page ci-contre: Debout sur son inséparable «Penetrator» conçue par Tom Morey, John Peck exécute un sans-faute lors du championnat de la Western Surfing Association.

Hevs McClelland, Oceanside, 1965

Below: Big Brennan "Hevs" McClelland was the leading surf-movie comedian throughout the sixties. Also an early surf organizer, he founded the U.S. Surfing Association in 1961.

Unten: Big Brennan „Hevs" McClelland war während der Sechziger der führende Komiker in Surffilmen. Er war auch bereits früh organisatorisch tätig und gründete 1961 die U.S. Surfing Association.

Ci-dessous: Big Brennan «Hevs» McClelland se distingue pendant les années 1960 comme l'acteur phare des comédies consacrées au surf. Il devient très tôt organisateur d'événements et fonde en 1961 la U.S. Surfing Association.

ANNOUNCER

Pacific Beach, San Diego, 1967

Below: Award presentations, Western Surfing Association contest. Left to right (with trophies), Corky Carroll, Mark Martinson, David Nuuhiwa, Skip Frye, Mike Purpus.

Unten: Preisverleihung beim Wettbewerb der Western Surfing Association. Von links nach rechts (mit Pokalen): Corky Carroll, Mark Martinson, David Nuuhiwa, Skip Frye, Mike Purpus.

Ci-dessous: Remise des prix lors du championnat de la Western Surfing Association. De gauche à droite (trophée en main): Corky Carroll, Mark Martinson, David Nuuhiwa, Skip Frye et Mike Purpus.

Ocean Beach, San Diego, 1966

Opposite: The annual World Championships were won by the brash, hard-turning Australian Robert "Nat" Young. His win signaled the beginning of the end of stately longboard era.

Gegenüber: Die alljährliche Weltmeisterschaft gewann der draufgängerische, harte Turns fahrende Australier Robert „Nat" Young. Sein Sieg markierte den Anfang vom Ende der Ära der stattlichen Longboards.

Page ci-contre: L'édition annuelle des championnats du monde est remportée par l'Australien Robert «Nat» Young, personnage fougueux et star du virage serré. Sa victoire marque le début de la fin des longboards, ces longues planches au profil élégant.

Nancy Katin, Ocean Beach, San Diego, 1972

Opposite: So much had changed in the six years between World Championships at Ocean Beach. Boards got shorter, hair got longer, and minds were blown. But surfers still wore Kanvas by Katin. The designer sits next to Katie Grannis (left) and renowned surfer Dru Harrison (behind).

Gegenüber: Es hatte sich viel verändert in den sechs Jahren seit der letzten Weltmeisterschaft in Ocean Beach. Die Boards waren kürzer, die Haare länger, das Bewusstsein erweitert. Aber die Surfer trugen immer noch Kanvas by Katin. Die Designerin sitzt neben Katie Grannis (links) und dem berühmten Surfer Dru Harrison (hinten).

Page ci-contre: Six ans après 1966, Ocean Beach accueille à nouveau les championnats du monde. Le changement est radical: les planches sont plus courtes, les cheveux plus longs et les esprits plus délurés. Mais les surfeurs arborent toujours les tenues Kanvas by Katin. La créatrice de la marque est assise à côté de Katie Grannis (à gauche) et de l'illustre surfeur Dru Harrison (derrière).

Huntington Beach, 1968

Below: Tandem surfing, considered an archaic fringe sport, all but died out before experiencing a limited revival in the mid-nineties.

Unten: Tandem-Surfen galt als archaische Randsportart und war fast ausgestorben, bevor es Mitte der Neunziger ein begrenztes Comeback erlebte.

Ci-dessous: Le surf en tandem, considéré comme une épreuve obsolète et marginale, tombe en désuétude avant de connaître un fragile come-back au milieu des années 1990.

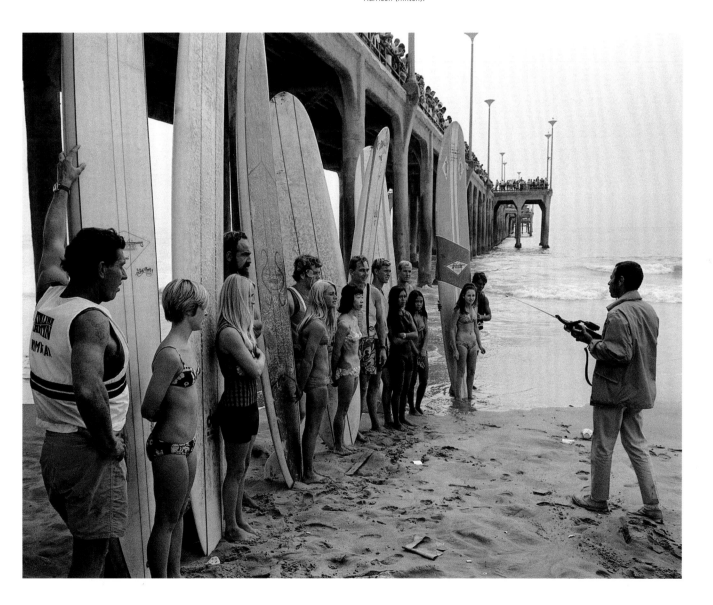

Santa Monica, 1966

Below: Induction into the International Surfing Hall of Fame. Back row, left to right, Dale Velzy (for Bob Simmons), Buzzy Trent, Duke Kahanamoku, Phil Edwards, Greg Noll, Miki Dora. Front row, Pete Peterson, George Downing, Hoppy Swarts, Dewey Weber, Don Hansen (for Mike Doyle).

Unten: Einführung in die International Surfing Hall of Fame. Hintere Reihe von links nach rechts: Dale Velzy (für Bob Simmons), Buzzy Trent, Duke Kahanamoku, Phil Edwards, Greg Noll, Miki Dora. Vordere Reihe: Pete Peterson, George Downing, Hoppy Swarts, Dewey Weber, Don Hansen (für Mike Doyle).

Ci-dessous: Visite guidée dans la galerie des célébrités du surf international. Debout, de gauche à droite: Dale Velzy (représentant Bob Simmons), Buzzy Trent, Duke Kahanamoku, Phil Edwards, Greg Noll et Miki Dora. Accroupis, de gauche à droite: Pete Peterson, George Downing, Hoppy Swarts, Dewey Weber et Don Hansen (représentant Mike Doyle).

Hermosa Beach, 1965

Opposite: At a "Dana Point Mafia" party thrown by Greg Noll at his Hermosa Beach factory. Left to right, Mickey Muñoz, Jeff Logan, Ronald Patterson.

Gegenüber: Auf einer von Greg Noll in seiner Hermosa Beach Factory veranstalteten „Dana Point Mafia"-Party. Von links nach rechts: Mickey Muñoz, Jeff Logan, Ronald Patterson.

Page ci-contre: Au cours d'une soirée du club « Dana Point Mafia » organisée par Greg Noll dans sa boutique sur la plage de Hermosa. De gauche à droite: Mickey Muñoz, Jeff Logan et Ronald Patterson.

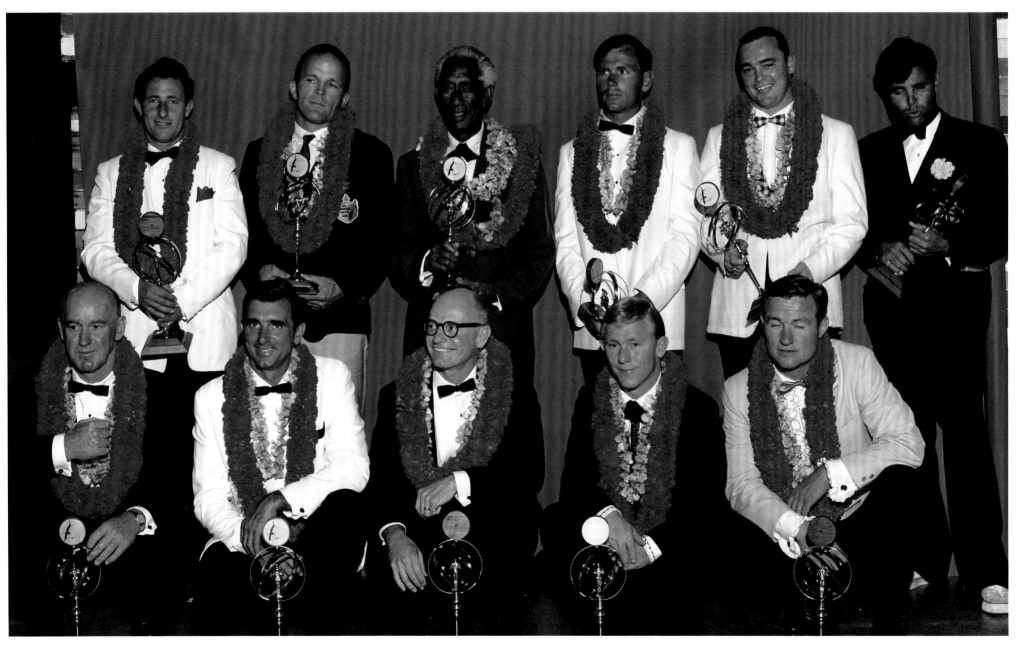

Santa Monica, 1963

Right: At the second annual Los Angeles Surf Fair (also known as "Surf-O-Rama"), the fledgling surf industry took baby steps toward respectability. At the *Surfing Illustrated* booth, left to right, Walt Phillips, Doni Nicastro, Frank Grannis, Katie Grannis.

Rechts: Auf der zweiten Los Angeles Surf- messe (auch „Surf-O-Rama" genannt) ver- sucht die noch junge Surfindustrie einen tapsigen Schritt in Richtung Respektabili- tät. Am Stand von *Surfing Illustrated*, von links nach rechts: Walt Phillips, Doni Nicastro, Frank Grannis, Katie Grannis.

Ci-contre: Lors de la deuxième édition du « Surf-O-Rama », le Salon annuel du surf de Los Angeles, l'industrie émergente du surf fait ses premiers pas laborieux vers la respectabilité. Sur le stand du magazine *Surfing Illustrated*, de gauche à droite: Walt Phillips, Doni Nicastro, Frank Grannis et Katie Grannis.

Santa Monica, 1963

Opposite: "Bergman of the Boards" Bruce Brown made five full-length surf films from 1957 to 1963 before embarking on his masterpiece, *The Endless Summer.*

Gegenüber: Der „Bergman der Boards" Bruce Brown drehte zwischen 1957 und 1963 fünf Surffilme, bevor er sein Meis- terwerk *The Endless Summer* vorlegte.

Page ci-contre: Bruce Brown, dit le « Berg- man de la planche de surf », a réalisé cinq longs métrages consacrés au surf entre 1957 et 1963 avant de se lancer dans son œuvre maîtresse, *The Endless Summer.*

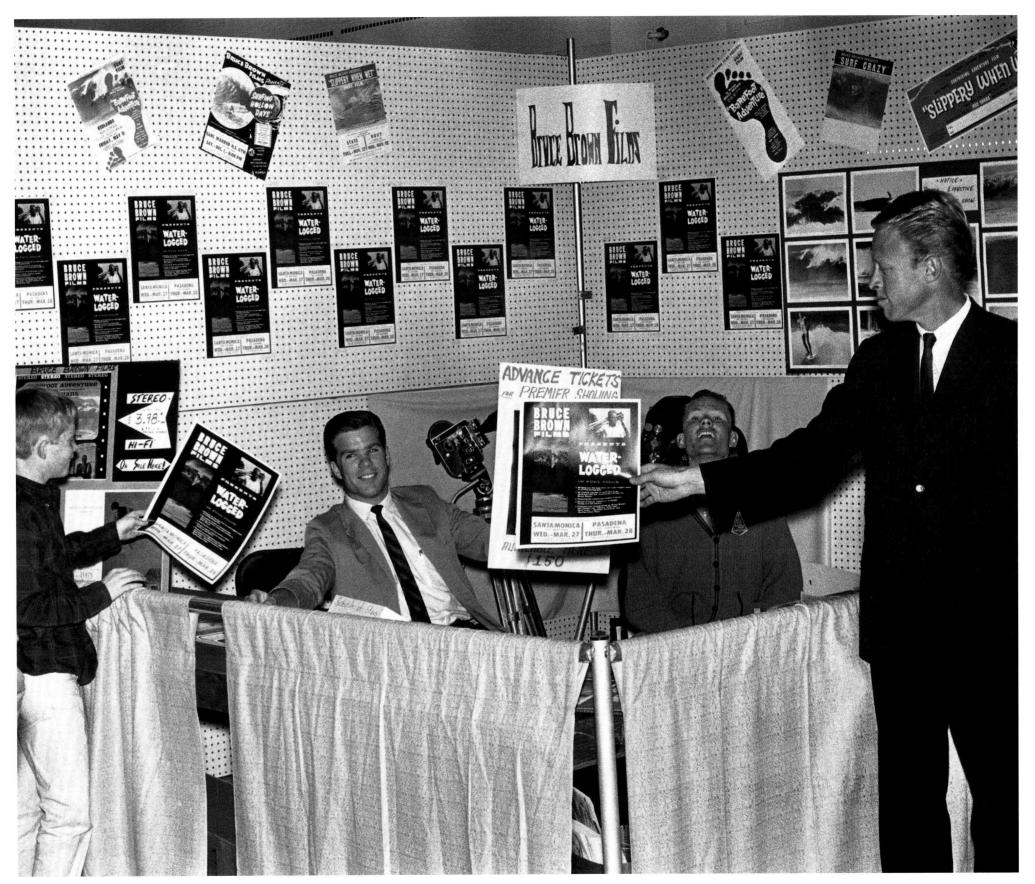

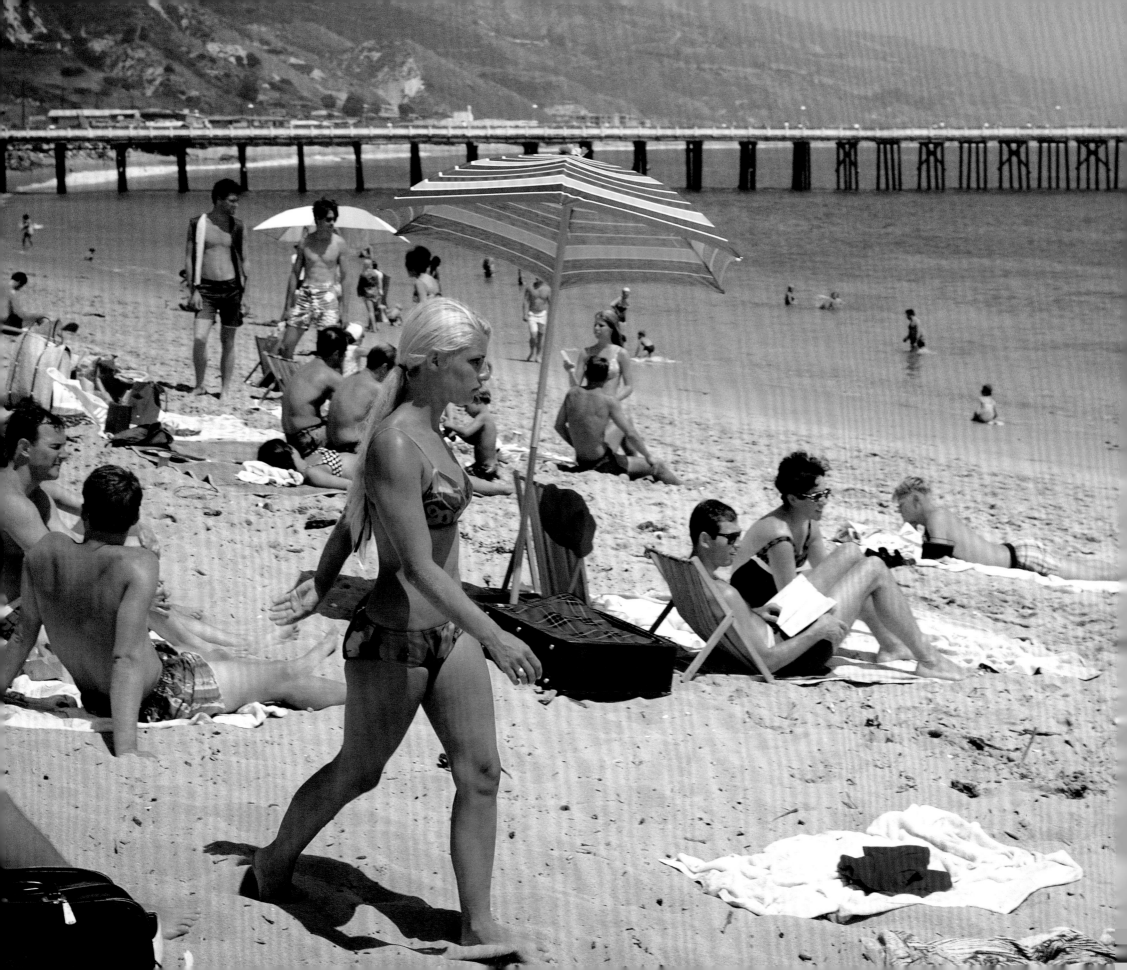

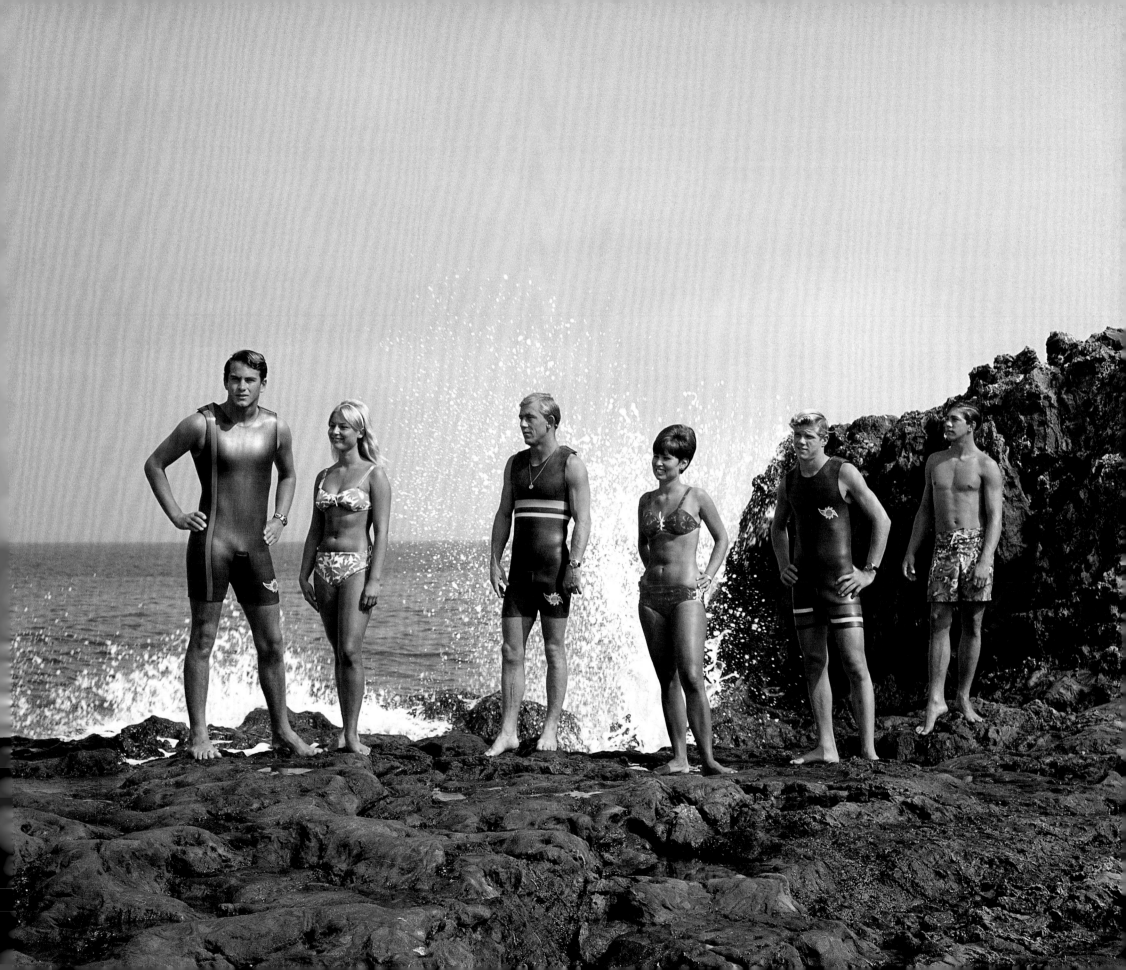

Diane Bolton, Malibu, 1967

Page 106: Bolton was the tandem surfing partner of Hobie Alter (of Hobie Surfboards fame).

Seite 106: Bolton war Tandem-Partnerin von Hobie Alter (bekannt durch Hobie Surfboards).

Page 106: Diane Bolton fut la partenaire de tandem de Hobie Alter (fondateur de la célèbre marque Hobie Surfboards).

Palos Verdes Cove, 1968

Page 107: Lunada Bay Wetsuits ad. Left to right, Bob Nall, unidentified, Dewey Weber, Caroline Weber, JoJo Perrin, Bobby Kookin.

Seite 107: Werbeanzeige für Neopren-Anzüge, Lunada Bay. Von links nach rechts: Bob Nall, unbekannt, Dewey Weber, Caroline Weber, JoJo Perrin, Bobby Kookin.

Page 107: Publicité pour des combinaisons en néoprène à Lunada Bay. De gauche à droite : Bob Nall, non identifié Dewey Weber, Caroline Weber, JoJo Perrin et Bobby Kookin.

Ocean Beach, San Diego, 1966

Right: Laguna swimwear ad. Grannis's photography helped the burgeoning surfwear industry take the lifestyle to the masses.

Rechts: Werbeanzeige für Laguna Bademode. Die Fotos von Grannis halfen der aufkeimenden Surfbekleidungsbranche, den Massen diesen Lifestyle nahezubringen.

Ci-contre: Publicité pour les vêtements de bain Laguna. Grâce à ses photos publicitaires pour l'industrie émergente du vêtement de surf, Grannis a largement contribué à populariser la mode du surf.

Palos Verdes Cove, 1965

Opposite: Lunada Bay Wetsuits ad. Center, Rick Stoner.

Gegenüber: Werbeanzeige für Surfanzüge, Lunada Bay. Mitte: Rick Stoner.

Page ci-contre: Publicité pour des combinaisons de surf à Lunada Bay. Au centre : Rick Stoner.

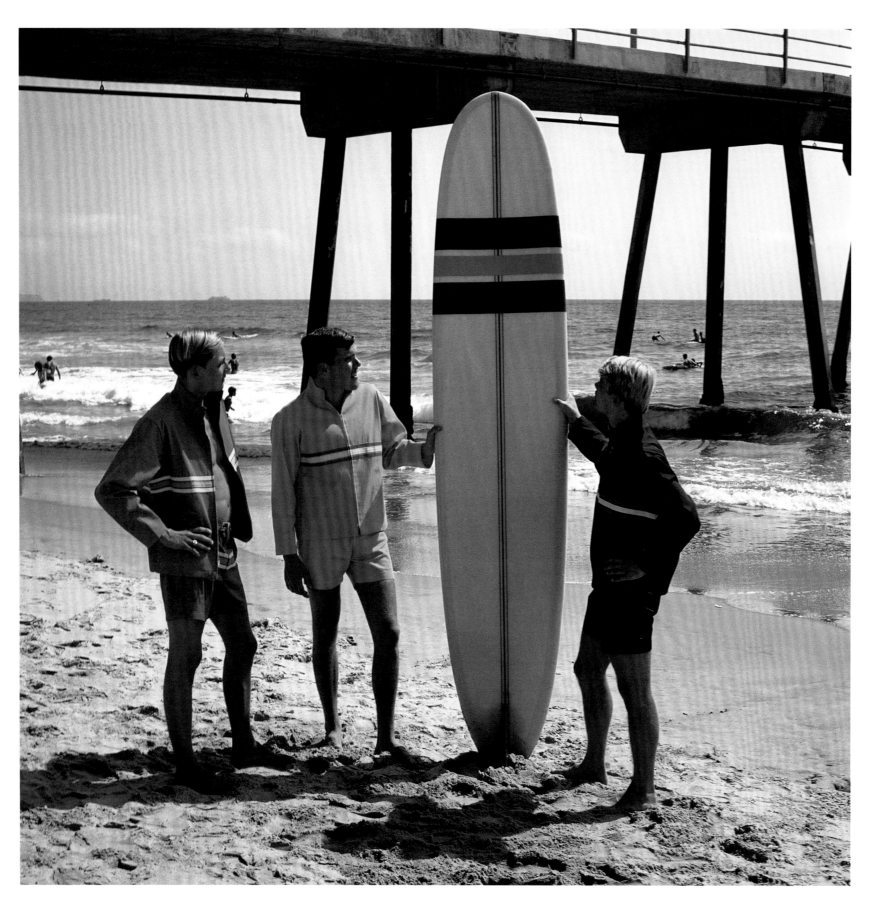

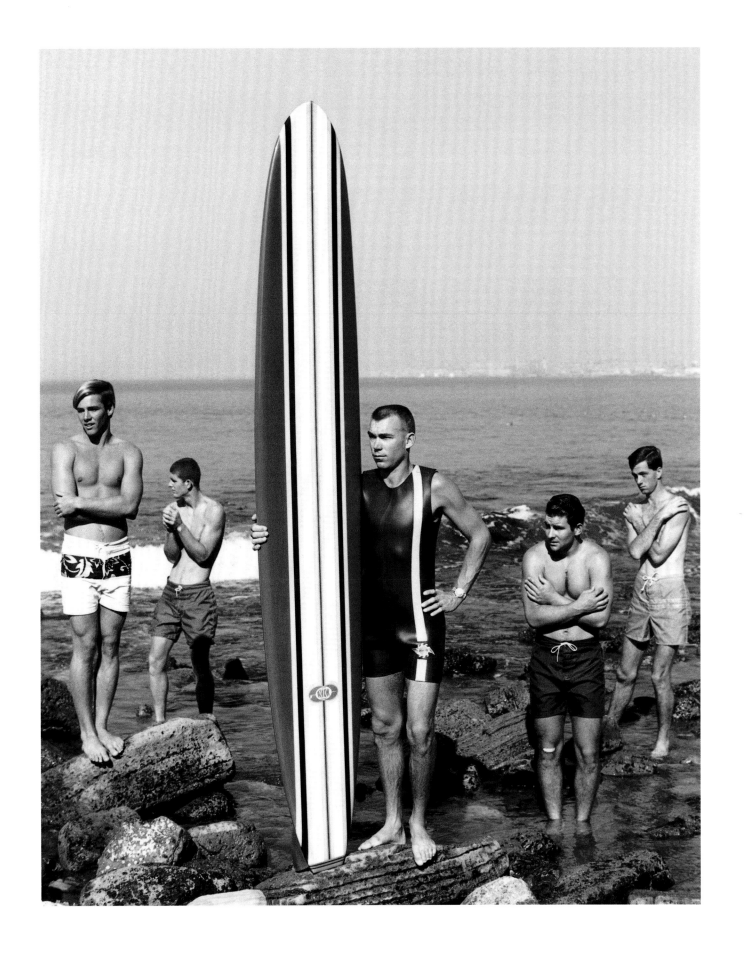

Ricky Hatch, Hermosa Beach, 1961

Below: The talented 22nd Street regular in a now-famous ad for Jacobs Surfboards.

Unten: Das Multitalent von der 22nd Street in einer inzwischen berühmten Werbeanzeige für Jacobs Surfboards.

Ci-dessous: Le talentueux Ricky Hatch, un habitué de 22nd Street, dans une publicité devenue célèbre pour la marque Jacobs Surfboards.

Gary Dalton, Hermosa Beach, 1964

Opposite: Ad captions for Greg Noll Surfboards: "He doesn't ride Greg Noll boards" (left); "He does ride Greg Noll boards" (right).

Gegenüber: Werbeslogans für Greg Noll Surfboards: „Er surft nicht auf Greg Noll Boards" (links); „Er surft auf Greg Noll Boards" (rechts).

Page ci-contre: Slogans publicitaires pour la marque Greg Noll Surfboards: «Sa planche n'est pas une Greg Noll» (à gauche); «Sa planche est une Greg Noll» (à droite).

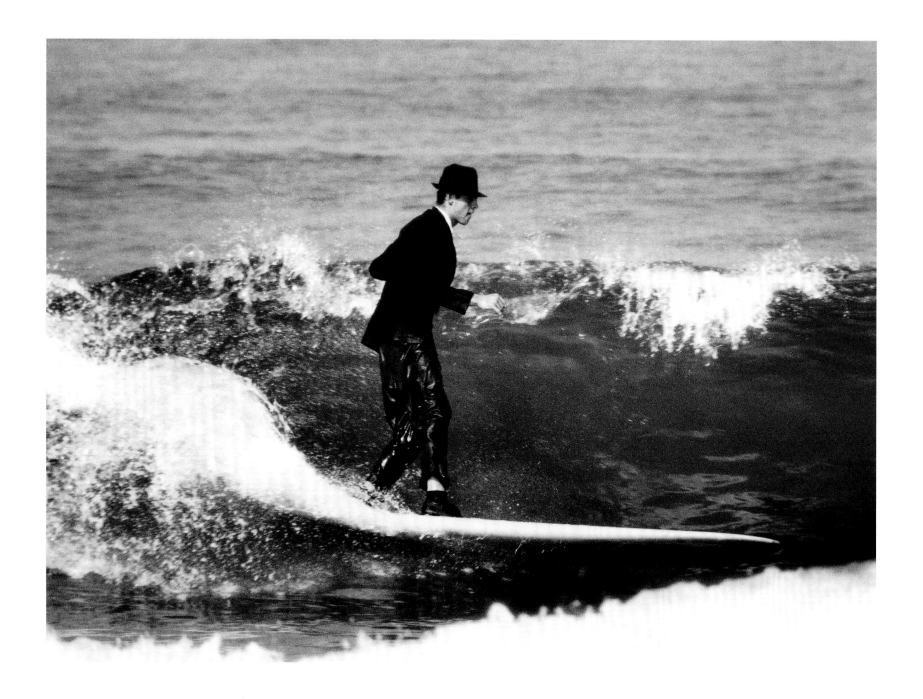

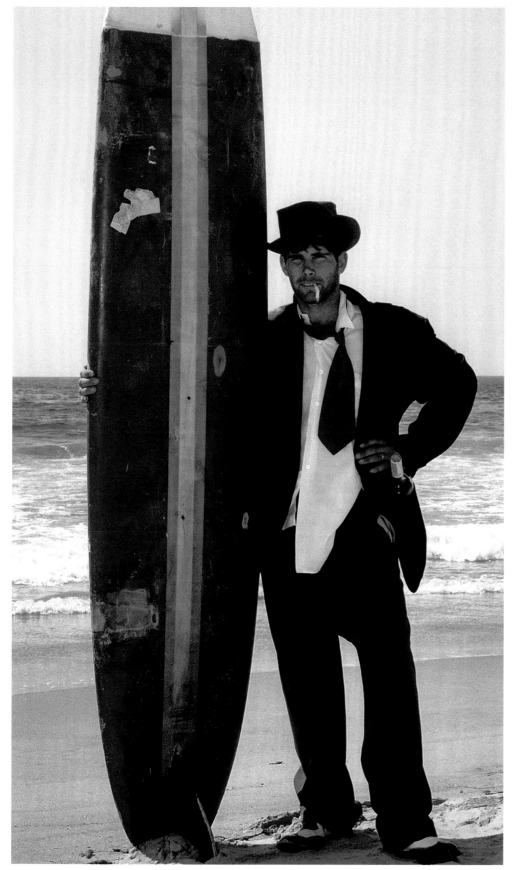
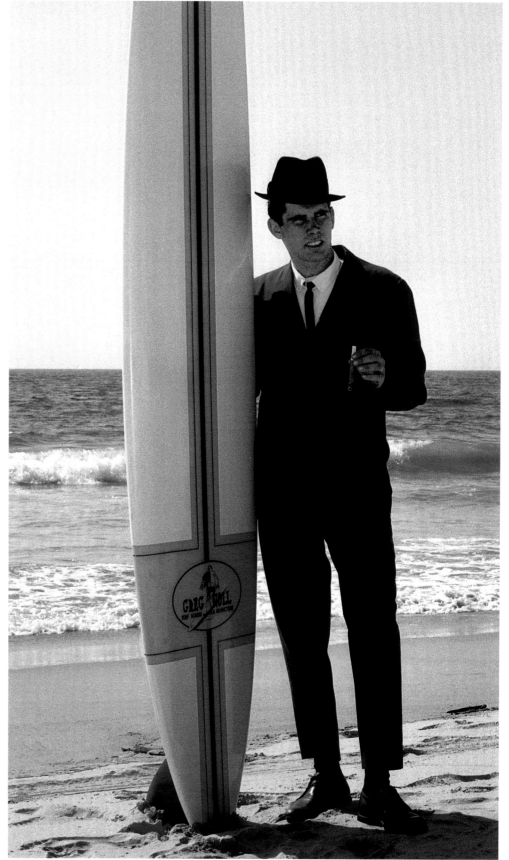

Opposite: Ad for Hang Ten, one of the first and most successful surfwear companies. If you didn't surf, you could at least buy the pose. Left to right, Chuck Linnen, Henry Ford, Mike Doyle, Rickie Wakeland.

Gegenüber: Anzeige für Hang Ten, einem der ersten und erfolgreichsten Hersteller von Surfbekleidung. Wer nicht surfte, konnte wenigstens so tun als ob. Von links nach rechts: Chuck Linnen, Henry Ford, Mike Doyle, Rickie Wakeland.

Page ci-contre: Publicité pour la marque Hang Ten, une des premières et des plus florissantes enseignes de vêtements de surf. Faute de savoir surfer, on pouvait au moins prendre la pose en Hang Ten. De gauche à droite: Chuck Linnen, Henry Ford, Mike Doyle et Rickie Wakeland.

Dana Point, 1965

Left: Greg Noll, Bettina Brenna, and Phil Edwards in a Hang Ten ad. Brenna would later have a brief career as a TV actress and Las Vegas showgirl.

Links: Greg Noll, Bettina Brenna und Phil Edwards in einer Anzeige für Hang Ten. Brenna machte später kurzzeitig als Fernsehschauspielerin und Showgirl in Las Vegas Karriere.

Ci-contre: Greg Noll, Bettina Brenna et Phil Edwards dans une publicité pour Hang Ten. Brenna connaîtra plus tard une brève carrière d'actrice de télé et de girl à Las Vegas.

Huntington Beach, 1964

Below: Ray-Ban battle, U.S. Championships. Joey Cabell (left) and unidentified.

Unten: Wer hat die coolere Ray Ban? U.S. Championships, Joey Cabell (links) und ein Unbekannter.

Ci-dessous: « Duel » de Ray-Ban au championnat américain entre Joey Cabell (à gauche) et son « concurrent » (non identifié).

Rick Griffin, Huntington Beach, 1964

Opposite: Rick Griffin, *Surfer* magazine's twenty-year-old staff cartoonist, went on to produce iconic posters for sixties psychedelic bands. The eye patch is from a near-fatal accident suffered the year before.

Gegenüber: Rick Griffin, der zwanzigjährige Cartoon-Zeichner der Zeitschrift *Surfer*, entwarf später Plakate für psychedelische Sechzigerjahre-Bands. Die Augenklappe rührt von einem beinah tödlichen Unfall im Vorjahr her.

Page ci-contre: Rick Griffin, le jeune dessinateur de l'équipe du magazine *Surfer* – il n'est alors âgé que de vingt ans – réalise des affiches pour des groupes psychédéliques des Sixties. Le bandeau à l'œil rappelle l'accident dont il a réchappé de justesse un an plus tôt.

Miki Dora, Malibu, 1963

Below: Beat at the beach—Dora strikes at the heart of gray-flannel conformity.

Unten: Beat at the Beach – Dora protestiert gegen angepasste Flanellträger.

Ci-dessous: Sur la plage de Malibu, Miki Dora s'attaque au conformisme vestimentaire avec sa tenue beatnik.

Huntington Beach, 1964

Opposite: Mike Doyle (left) and Mickey Muñoz represented the pinnacle of early sixties competitive surfing. Both would distinguish themselves as big-wave riders at Waimea Bay.

Gegenüber: Mike Doyle (links) und Mickey Muñoz repräsentierten die Spitze des Wettkampfsurfens der frühen Sechziger. Beide glänzten später als Big-Wave-Surfer in Waimea Bay.

Page ci-contre: Mike Doyle (à gauche) et Mickey Muñoz incarnaient le summum de la compétition de surf au début des années 1960. Les deux as du *big-wave riding* se distinguaient par leur domptage des monstres de Waimea.

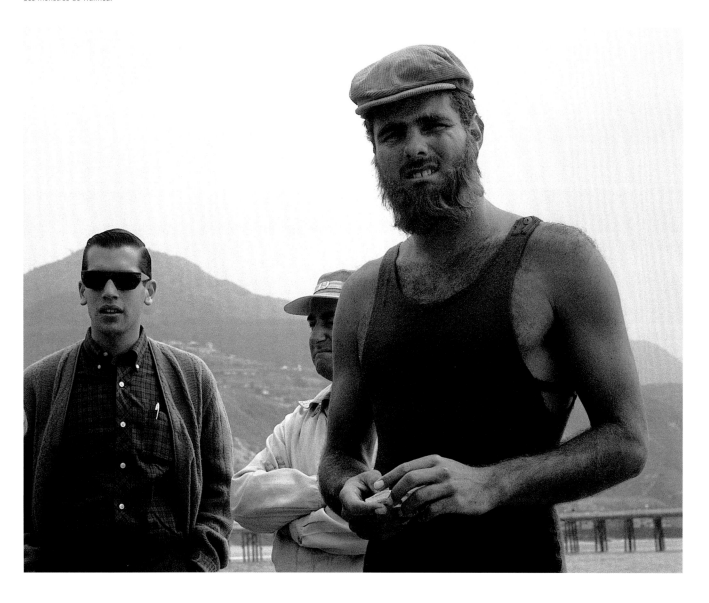

Linda Benson, Hermosa Beach, 1968

Below: Powerful and scrappy, Linda Benson broke the gender barrier in 1959 when she became the first woman to ride Waimea Bay's monster waves.

Unten: Die kräftige, streitlustige Linda Benson durchbrach die Geschlechterrollen, als sie 1959 als erste Frau die gigantischen Wellen in Waimea Bay ritt.

Ci-dessous: Battante acharnée, la puissante Linda Benson s'est imposée dans le petit monde des hommes en 1959 en devenant la première femme à surfer les gigantesques vagues de Waimea Bay.

Gail Yarbrough, Hermosa Beach, 1964

Opposite: In ancient Hawaii, women rode alongside men and even had surf spots named in their honor.

Gegenüber: In Hawaii surften die Frauen seit Urzeiten genau wie die Männer, es wurden sogar Surfspots nach ihnen benannt.

Page ci-contre: Jadis, à Hawaï, les femmes surfaient aux côtés des hommes. En leur honneur, certains spots portaient même leurs noms.

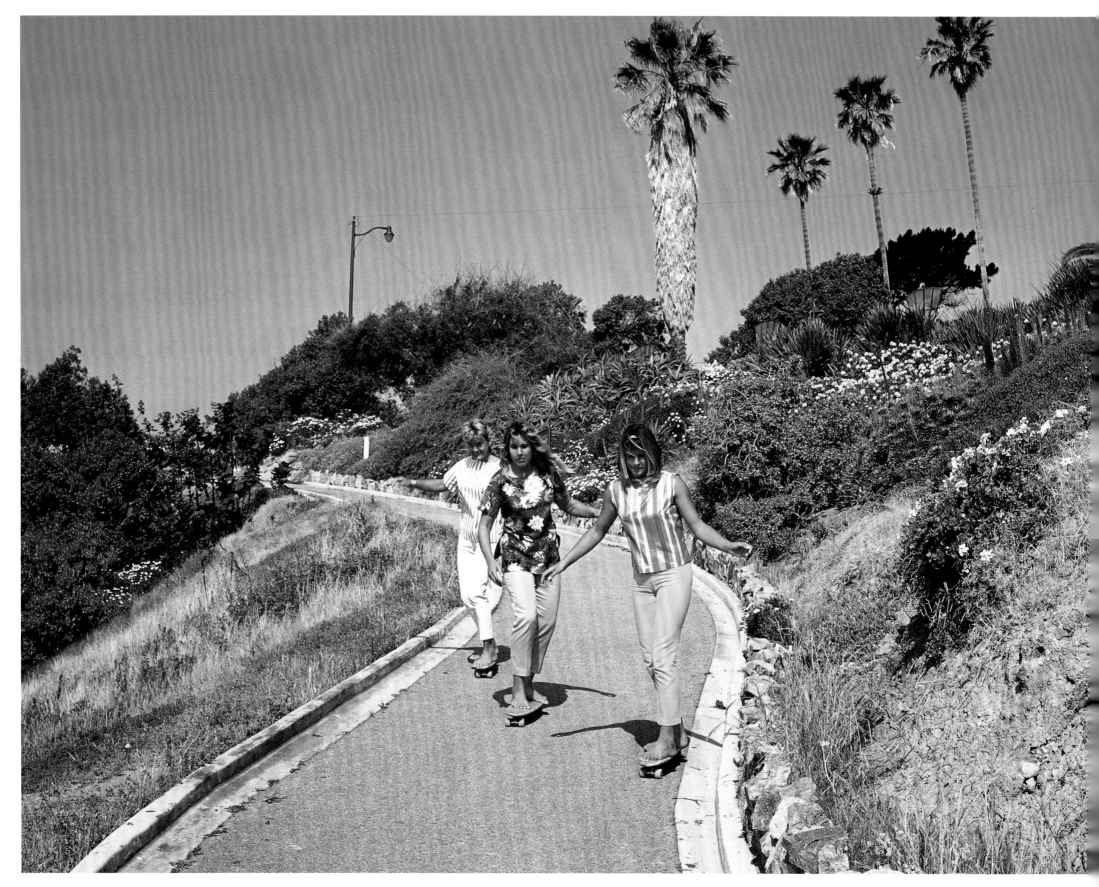

Calhoun "Sisters," Laguna Beach, 1964

Opposite: The trio of surf "sisters" was actually Marge (left) and her daughters Candy (center) and Robin (right). Mike Doyle wrote, "They were like ocean goddesses to me."

Gegenüber: Die drei „Surfschwestern" waren eigentlich Marge (links) und ihre Töchter Candy (Mitte) und Robin (rechts). Mike Doyle schrieb: „Sie waren wie Meeresgöttinnen für mich."

Page ci-contre: Le trio des « sœurs Calhoun »: Marge (à gauche) et ses deux filles, Candy (au centre) et Robin. Mike Doyle a écrit à leur sujet : « Elles étaient pour moi des déesses de l'océan. »

Robin Calhoun, Laguna Beach, 1964

Below left: Robin was the youngest of the Calhouns, and an award-winning surfer.

Unten links: Robin war die Jüngste der Calhouns und eine preisgekrönte Surferin.

Ci-dessous, à gauche: Robin, la benjamine des sœurs Calhoun, remporta de nombreuses compétitions.

Marge Calhoun, Laguna Beach, 1964

Below right: Marge, the matriarch, was an all-around waterwoman who learned to surf at Malibu in the late forties and later won the women's Makaha Championships.

Unten rechts: Marge, die Matriarchin, war eine absolute Wasserfrau, die in den späten Vierzigern in Malibu surfen lernte und später die Makaha Championships für Frauen gewann.

Ci-dessous, à droite: Marge, la mère, était une athlète complète. Elle apprit le surf à Malibu à la fin des années 1940 et remporta plus tard les épreuves féminines du championnat de Makaha.

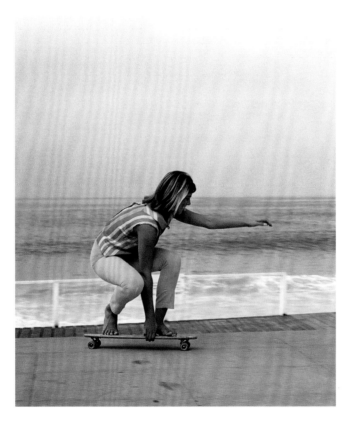

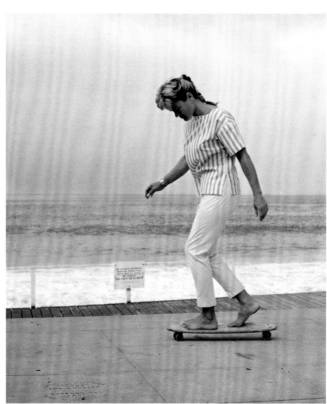

Rickie Wakeland, Hermosa Beach, 1963

Right: Rickie Wakeland was one of the statuesque blondes strategically placed in ads to help sell surfboards and bikinis to a fast-growing mainstream market.

Rechts: Rickie Wakeland gehörte zu den stattlichen Blondinen, die in Anzeigen platziert wurden, um den Verkauf von Surfbrettern und Bikinis auf dem schnell wachsenden Massenmarkt anzukurbeln.

Ci-contre: Rickie Wakeland était une de ces belles blondes qui prêtaient leurs silhouettes pour des publicités destinées à booster le marché en plein essor des planches de surf et des bikinis.

Donald Takayama, Bettina Brenna, Hermosa Beach, 1965

Opposite: Renowned surfer and board shaper Takayama, shown here clowning with Brenna, learned to surf at age seven from the legendary Waikiki Beach Boys.

Gegenüber: Der berühmte Surfer und Board-Shaper Takayama, der hier mit Brenna herumalbert, lernte mit sieben Jahren das Surfen von den legendären Waikiki Beach Boys.

Page ci-contre: Surfeur et shaper de renom, Donald Takayama, que l'on voit ici en train de faire le pitre avec Bettina Brenna, apprit à surfer dès l'âge de sept ans auprès des légendaires Waikiki Beach Boys.

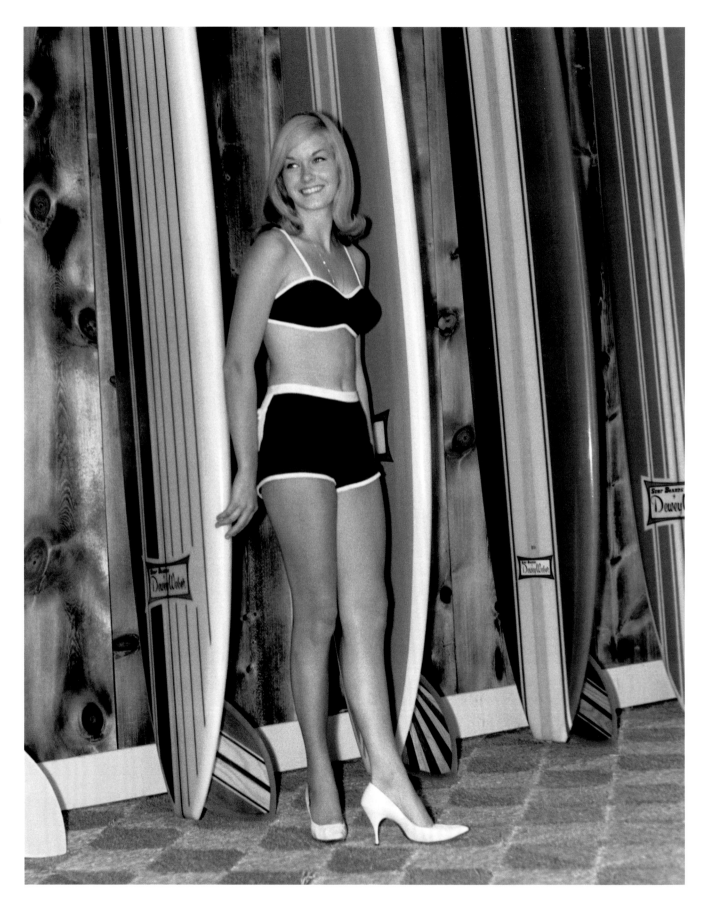

Manhattan Beach, 1962

Using techniques borrowed from hot rod customizers, surfers personalized their boards with vibrant colors and imagery.

Mit Techniken, die von den aufgemotzten Hot Rods abgeschaut waren, gestalteten Surfer ihre Bretter individuell mit leuchtenden Farben und Bildern.

À l'aide de techniques empruntées au tuning des *hot rods*, les surfeurs personnalisaient leurs planches avec des motifs expressifs et des couleurs vibrantes.

Mike Doyle, Hermosa Beach, 1963

Doyle was known as "Tiki Mike" for his skill at carving wooden tikis as a teenager. These days he's an accomplished artist.

Doyle wurde auch „Tiki Mike" genannt, da er als Teenager besonders gut im Schnitzen von hölzernen Tikis war. Heute ist er ein anerkannter Künstler.

Mike Doyle avait reçu le sobriquet « Tiki Mike » en raison de son talent précoce de sculpteur de tikis. Aujourd'hui, il est reconnu comme un artiste accompli.

Marsha Bainer, Torrance Beach, 1964

Bainer was a highly popular surf model who appeared in ads for various manufacturers throughout the early to mid-sixties.

Bainer war ein sehr beliebtes Surfmodel und war Anfang bis Mitte der Sechziger in Anzeigen unterschiedlicher Hersteller zu sehen.

Mannequin de surf très populaire à l'époque, Marsha Bainer a posé pour différents fabricants de planches dans la première moitié des années 1960.

Doc Ball, Palos Verdes Cove, 1966

John "Doc" Ball, a pioneering surfer and surf photographer, was a lifelong friend and mentor to Grannis. He passed away in 2001 at age ninety-four.

John „Doc" Ball, ein bahnbrechender Surfer und Surffotograf, war ein lebenslanger Freund und Mentor von Grannis. Er verstarb 2001 im Alter von vierundneunzig Jahren.

John « Doc » Ball, photographe de surf et un des pionniers de la discipline, était l'ami fidèle et le mentor de Grannis. Il est décédé en 2001 à l'âge de 94 ans.

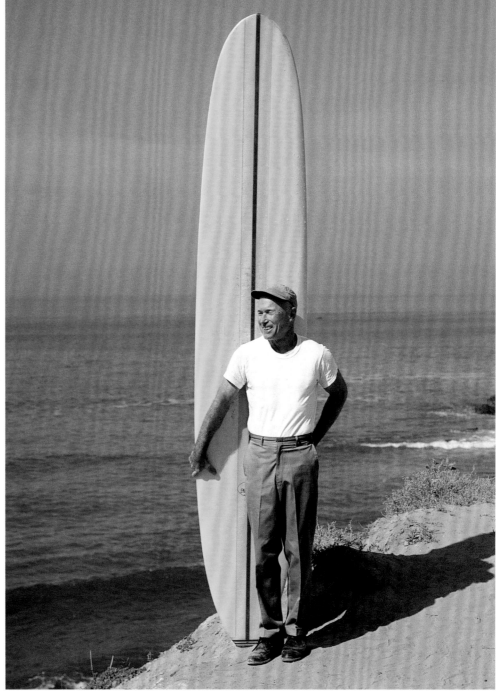

Palos Verdes Cove, circa 1965

Below: Hang Ten ad shoot. Left to right, Mike Doyle, Chuck Linnen, Rickie Wakeland, Henry Ford, Robert August.

Unten: Werbefoto für Hang Ten. Von links nach rechts: Mike Doyle, Chuck Linnen, Rickie Wakeland, Henry Ford, Robert August.

Ci-dessous: Photo publicitaire pour la ligne de vêtements Hang Ten. De gauche à droite : Mike Doyle, Chuck Linnen, Rickie Wakeland, Henry Ford et Robert August.

Ocean Beach, San Diego, 1966

Opposite: Laguna swimwear ad. "… [P]retty soon every kid in Utica, N.Y., is buying a pair of them," wrote Tom Wolfe in his 1968 essay "The Pump House Gang."

Gegenüber: Werbeanzeige für Laguna Badebekleidung. „… bald kaufen sich alle Jugendlichen in Utica, N.Y. ein Paar davon", schrieb Tom Wolfe 1968 in seinem Essay „The Pump House Gang".

Page ci-contre: Publicité pour les combinaisons Laguna. «[…] très rapidement, elles devinrent incontournables auprès des ados d'Utica, dans l'État de New York», écrit Tom Wolfe en 1968 dans son essai *The Pump House Gang.*

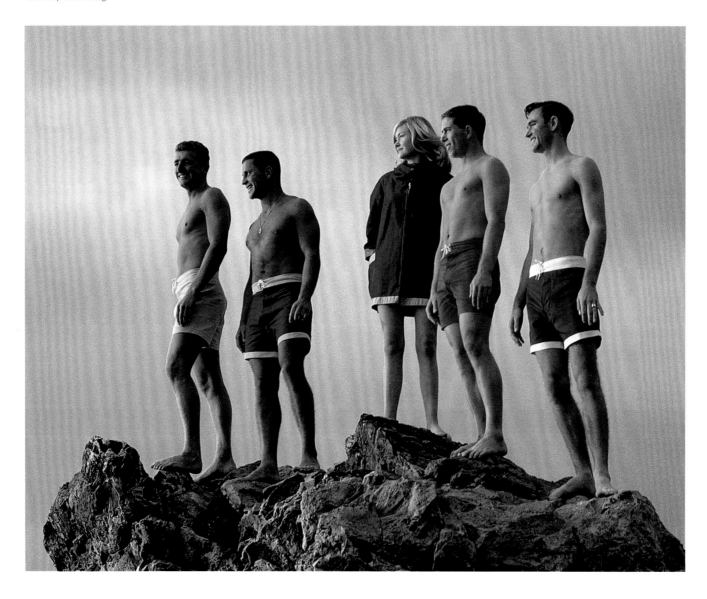

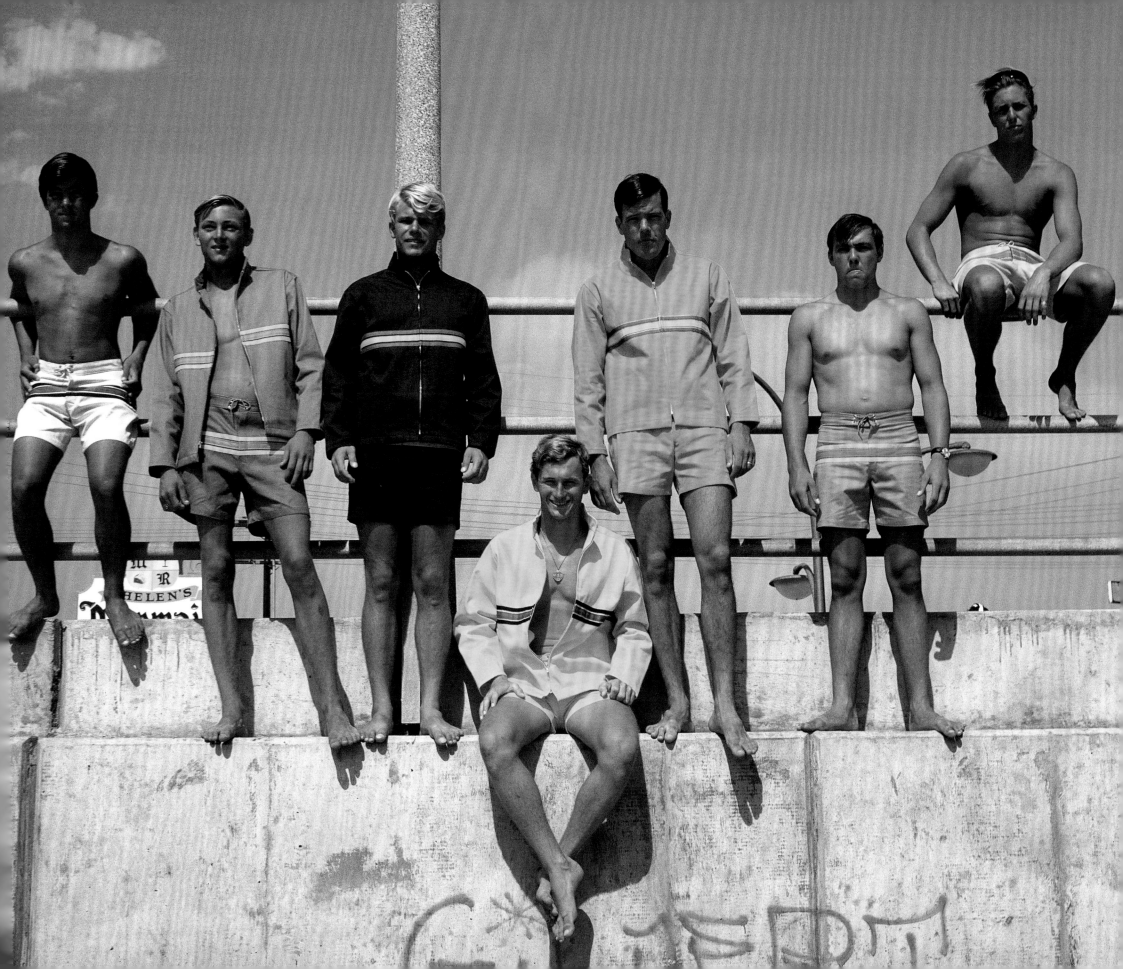

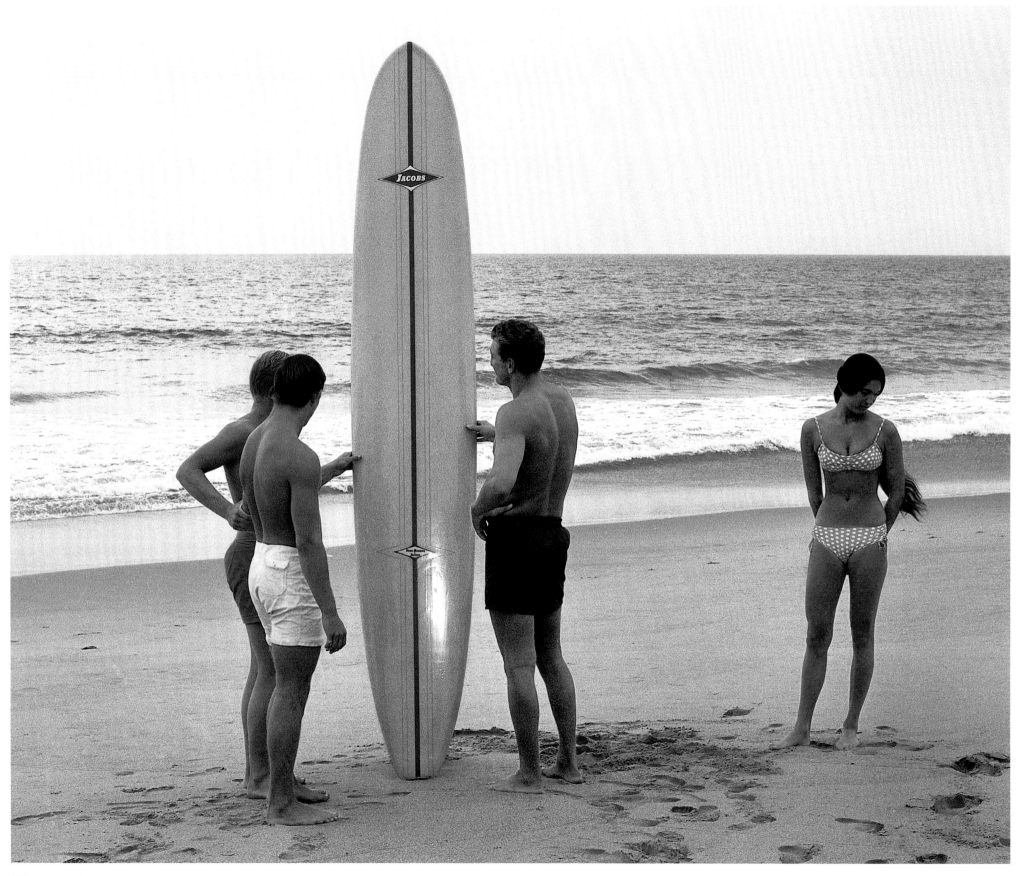

Hermosa Beach, 1963

Opposite: This Jacobs Surfboards ad ran with the caption: "We have new shapes." Left to right, Tim Kelly, Henry Ford, Mike Doyle, Marsha Bainer.

Gegenüber: Diese Anzeige von Jacobs Surfboards hatte den Slogan: „Wir haben neue Shapes." Von links nach rechts: Tim Kelly, Henry Ford, Mike Doyle, Marsha Bainer.

Page ci-contre: Cette publicité pour les planches Jacobs Surfboards était accompagnée du slogan: « Nous avons changé de profil ! » De gauche à droite: Tim Kelly, Henry Ford, Mike Doyle et Marsha Bainer.

Hermosa Beach, 1963

Below: Outtakes from the shoot. For a few years in the early sixties, Doyle and Bainer were a couple.

Unten: Outtakes von den Aufnahmen. In den frühen Sechzigern waren Doyle and Bainer für einige Jahre ein Paar.

Ci-dessous: Clichés non publiés. Mike Doyle et Marsha Bainer ont vécu en couple au début des années 1960.

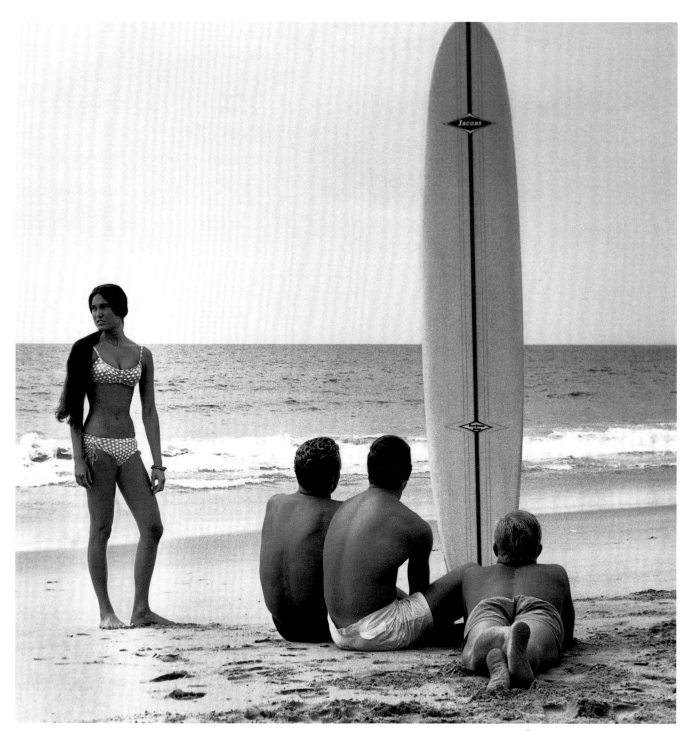

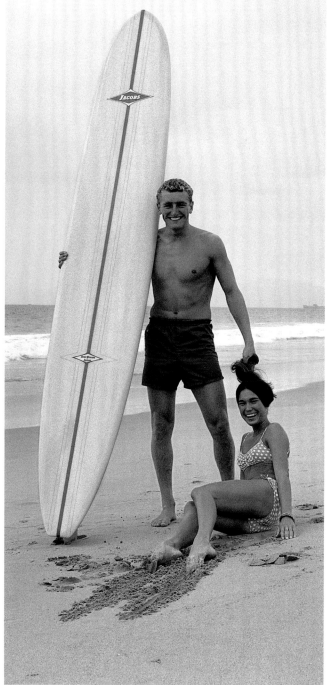

Jacobs Shop, Hermosa Beach, 1963

Opposite and below: Dudley "Hap" Jacobs split from Dale Velzy in 1959 to start his own label. His impeccable store was called "the Notre Dame of surf shops." Over the next few years, Grannis would document most of the sixties' prominent surfboard manufacturers.

Gegenüber und unten: Dudley „Hap" Jacobs stieg 1959 bei Dale Velzy aus, um seine eigene Firma zu gründen. Sein makelloser Laden wurde die „Notre Dame unter den Surfläden" genannt. Im Laufe der folgenden Jahre porträtierte Grannis die meisten bekannten Surfbrett-Hersteller der Sechziger.

Ci-dessous et page ci-contre : Dudley « Hap » Jacobs s'est séparé de Dale Velzy en 1959 pour lancer sa propre marque. Sa boutique impeccablement tenue est surnommée la « Notre-Dame des boutiques de surf ». Au cours des années suivantes, Grannis travaillera comme photographe pour la plupart des prestigieuses marques de planches des années 1960.

Hap Jacobs, Hermosa Beach, 1963

Below: Jacobs handcrafts one of his prized boards. Today, a mint-condition Jacobs from this era can fetch thousands of dollars at auction.

Unten: Jacobs fertigt eines seiner begehrten Boards von Hand. Heute kann ein neuwertiges Jacobs aus dieser Zeit bei Auktionen mehrere Tausend Dollar erzielen.

Ci-dessous: Jacobs en train de travailler à la main sur un de ses modèles les plus prisés. Aujourd'hui, une planche d'époque en parfait état peut atteindre des milliers d'euros aux enchères.

Hap Jacobs, Hermosa Beach, 1960

Opposite. Gegenüber. Page ci-contre.

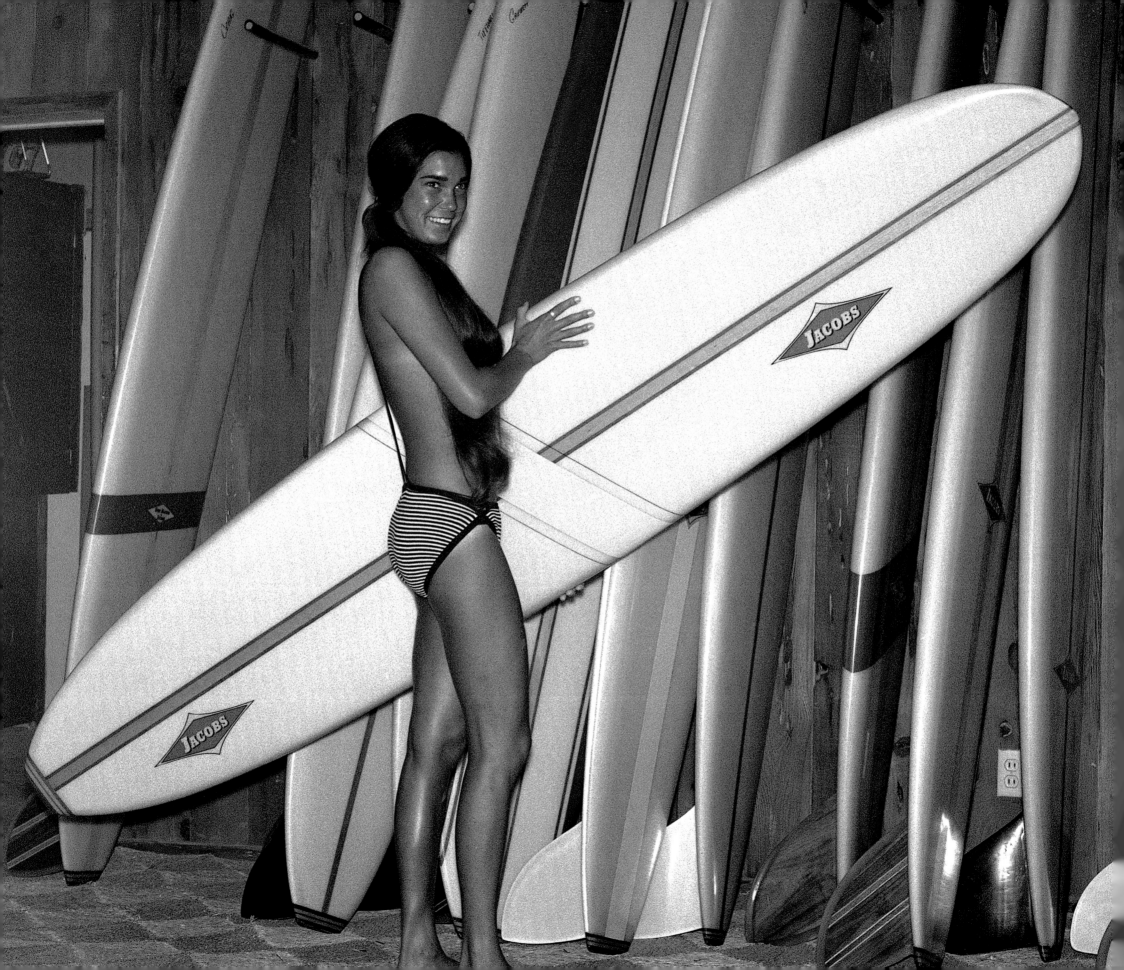

Marsha Bainer, Hermosa Beach, 1964

Opposite: Seventeen-year-old Bainer posed "topless" for this Jacobs Surfboards ad.

Gegenüber: Die siebzehnjährige Bainer posierte für die Anzeige von Jacobs Surfboards „oben ohne".

Page ci-contre: Marsha Bainer à dix-sept ans, posant sans le haut pour une publicité de Jacobs Surfboards.

Ken Tilton, Hermosa Beach, 1962

Right: Tilton was Jacobs's lead shaper.

Rechts: Tilton war leitender Shaper bei Jacobs.

À droite: Ken Tilton était shaper en chef chez Jacobs.

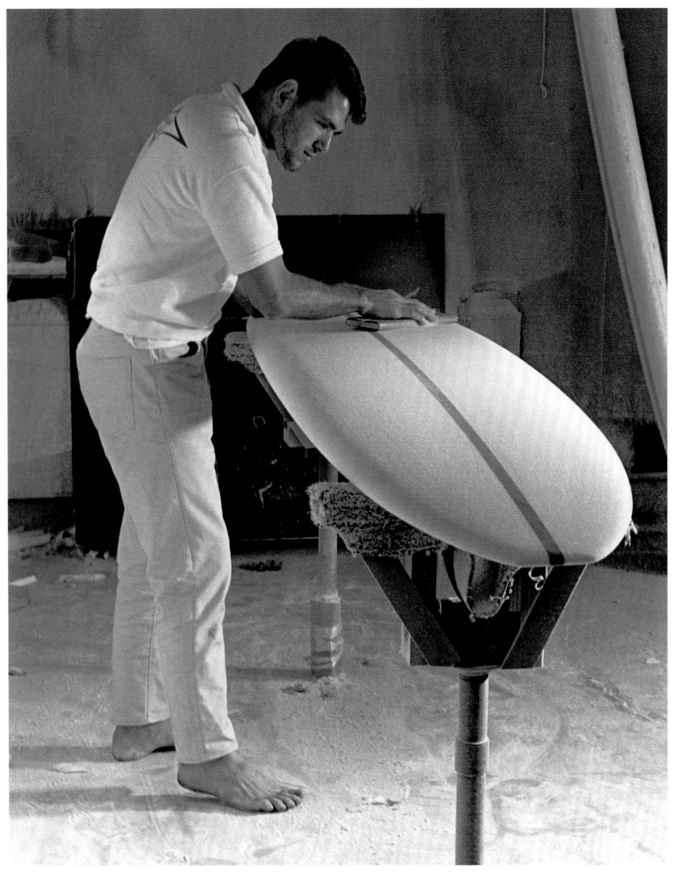

Rich Harbour, Seal Beach, 1963

Opposite: Forty-three years later, Harbour still produces quality boards at the same Seal Beach location.

Gegenüber: Auch nach dreiundvierzig Jahren stellt Harbour immer noch hochwertige Boards am selben Ort in Seal Beach her.

Page ci-contre: 43 ans plus tard, Rich Harbour continue de fabriquer des planches de qualité dans les mêmes ateliers de Seal Beach.

Joe Quigg, Orange County, 1963

Below: Quigg, a visionary surfboard designer, is credited with making the first shortboard prototype, the "Darrylin" board.

Unten: Quigg, ein Visionär der Surfbrettentwicklung, stellte den ersten Prototyp eines Shortboards her, das „Darrylin"-Board.

Ci-dessous: C'est au créateur visionnaire Joe Quigg que l'on doit la « Darrylin Board », le tout premier prototype de shortboard.

Larry Gordon, Floyd Smith, Pacific Beach, San Diego, 1963

Below: Gordon and Smith, or "G&S," have employed the elite of surfboard shapers over their forty-six-year history.

Unten: Bei Gordon und Smith, oder „G&S", arbeiteten im Verlauf der sechsundvierzigjährigen Firmengeschichte alle führenden Surfbrett-Shaper.

Ci-dessous: Gordon and Smith (G&S) peut compter sur le talent de l'élite des shapers depuis plus de 46 ans.

Greg Noll Factory, Hermosa Beach, 1965

Opposite: Left to right, Rick James, Greg Noll, Gary Propper. Propper was an East Coast small-wave genius renowned for his volatile style.

Gegenüber: Von links nach rechts: Rick James, Greg Noll, Gary Propper. Propper war ein auf kleine Wellen spezialisiertes Surfgenie von der Ostküste, bekannt für seinen lebhaften Stil.

Page ci-contre: De gauche à droite: Rick James, Greg Noll et Gary Propper. Ce dernier, véritable virtuose de la petite vague de la Côte Est, était réputé pour son style turbulent.

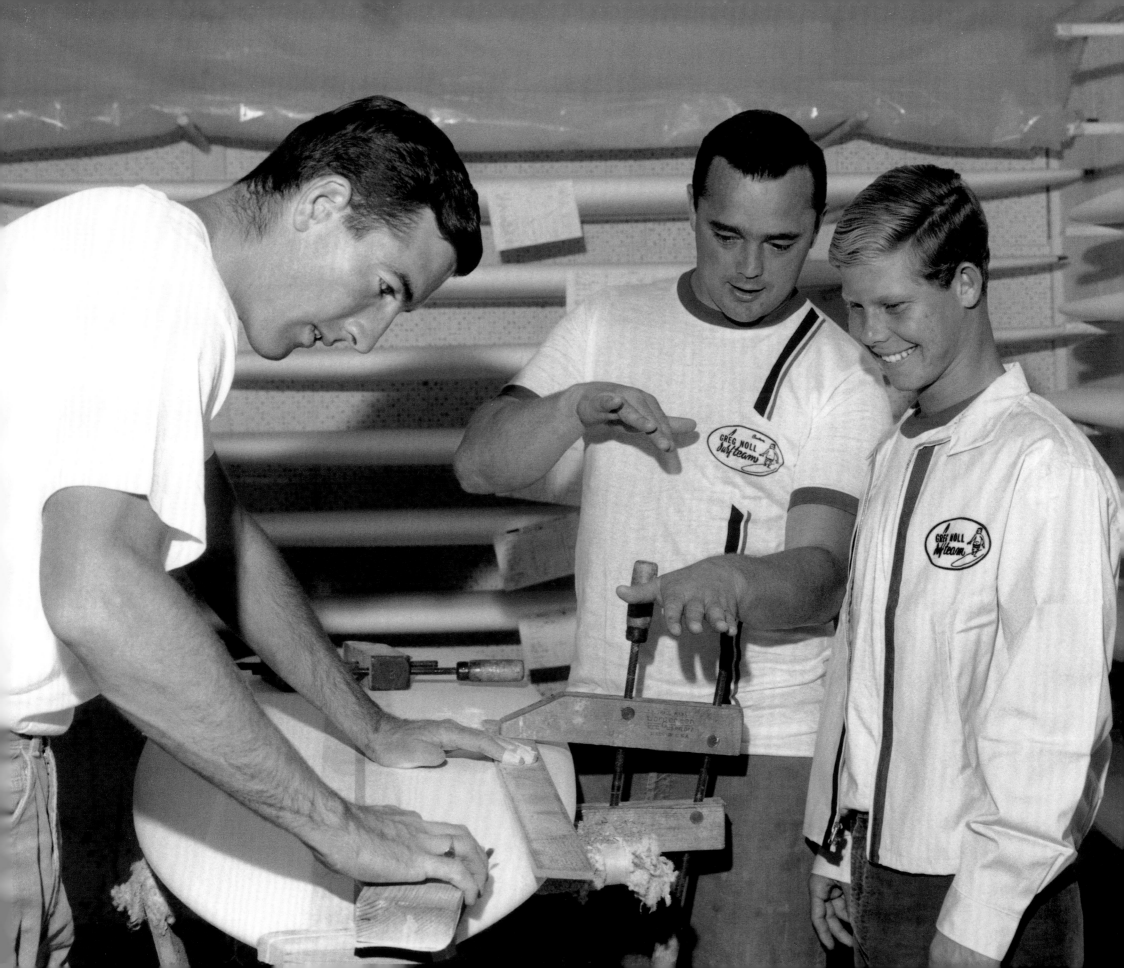

Greg Noll Shop, Hermosa Beach, 1963

Below: If you look carefully, you can see Noll hiding in the doorway's shadows.

Unten: Wenn man genau hinschaut, sieht man Noll im Schatten der Eingangstür stehen.

Ci-dessous: L'œil attentif reconnaîtra Greg Noll tapi dans l'ombre à l'entrée de sa boutique.

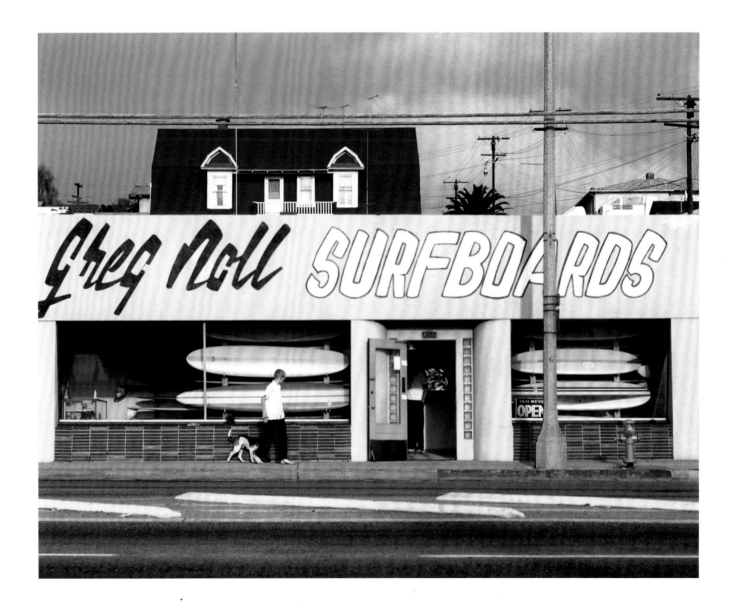

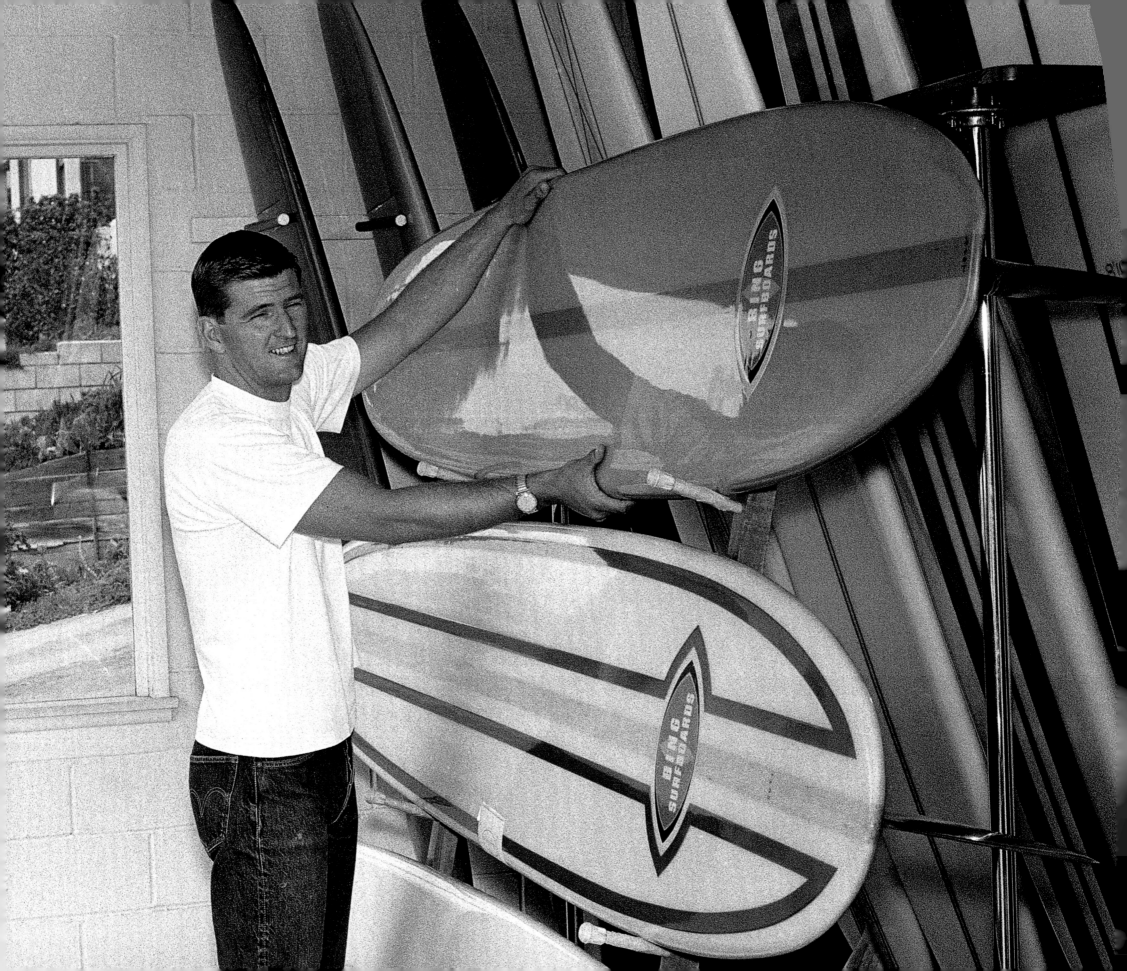

Opposite and below: Copeland's boards were some of the most prized on the West Coast. By 1974, however, he had sold the business and moved to the mountains of Idaho.

Gegenüber und unten: Die Bretter von Copeland gehörten zu den begehrtesten an der Westküste. 1974 hat er jedoch das Geschäft verkauft und sich in die Berge von Idaho zurückgezogen.

Ci-dessous et page ci-contre: Les planches de Bing Copeland comptaient parmi les plus prisées de la Côte Ouest. En 1974, après avoir cédé sa boutique, il s'est retiré dans les montagnes de l'Idaho.

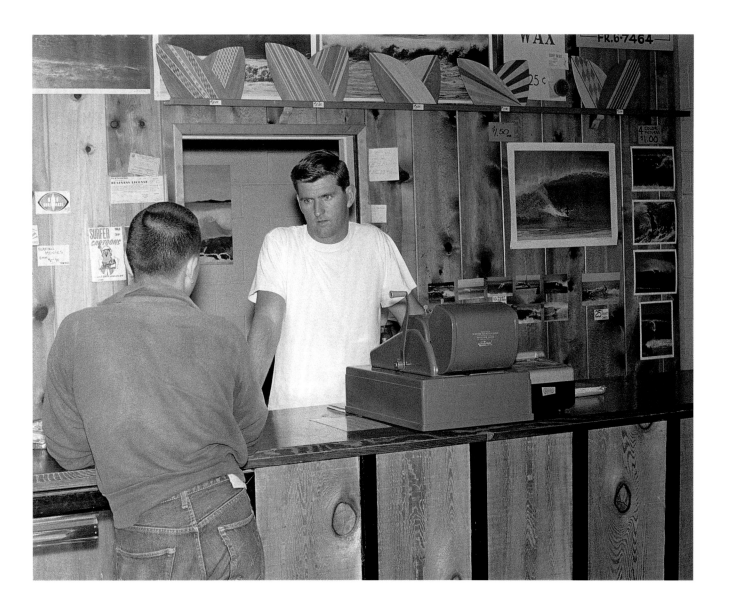

Jack Haley Shop, Seal Beach, 1963

Below left: Nicknamed "Mr. Excitement" for his charismatic style, Haley later opened a popular restaurant called Captain Jack's in nearby Sunset Beach.

Unten links: Für seinen charismatischen Stil erhielt Haley den Spitznamen „Mr. Excitement". Später eröffnete er ein beliebtes Restaurant mit dem Namen Captain Jack's am nahegelegenen Sunset Beach.

Ci-dessous, à gauche: Surnommé « Mister Excitement » en raison de son style charismatique, Jack Haley ouvrira plus tard non loin de sa boutique, à Sunset Beach, un restaurant très en vogue auquel il donnera le nom de Captain Jack's.

Don Hansen, Cardiff, 1963

Below right: Hansen, a savvy surf marketer, built his one-room shop in North San Diego County into a small empire worth millions of dollars today.

Unten rechts: Hansen, ein cleverer Surfvermarkter, baute seinen kleinen Laden in North San Diego County zu einem Millionen-Dollar-Imperium aus.

Ci-dessous, à droite: Don Hansen, en homme d'affaires averti, a fait de sa minuscule boutique du comté de San Diego Nord un véritable empire de plusieurs millions de dollars.

Dewey Weber Shop, Venice, 1968

Opposite: Weber's most popular models were the "Performer" and the "Weber Feather." Caroline Weber in front.

Gegenüber: Die beliebtesten Modelle von Weber nannten sich „Performer" und „Weber Feather". Caroline Weber vor dem Laden.

Page ci-contre: Les modèles Performer et Weber Feather étaient les plus prisés des ateliers de Dewey Weber. Caroline Weber pose devant la boutique.

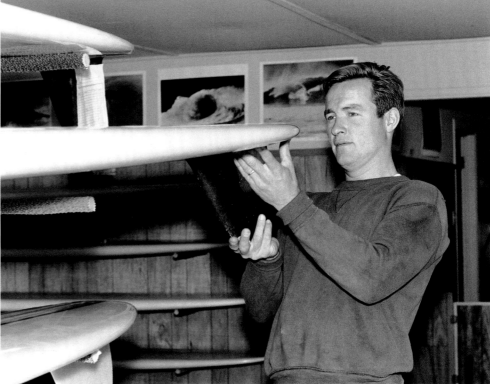

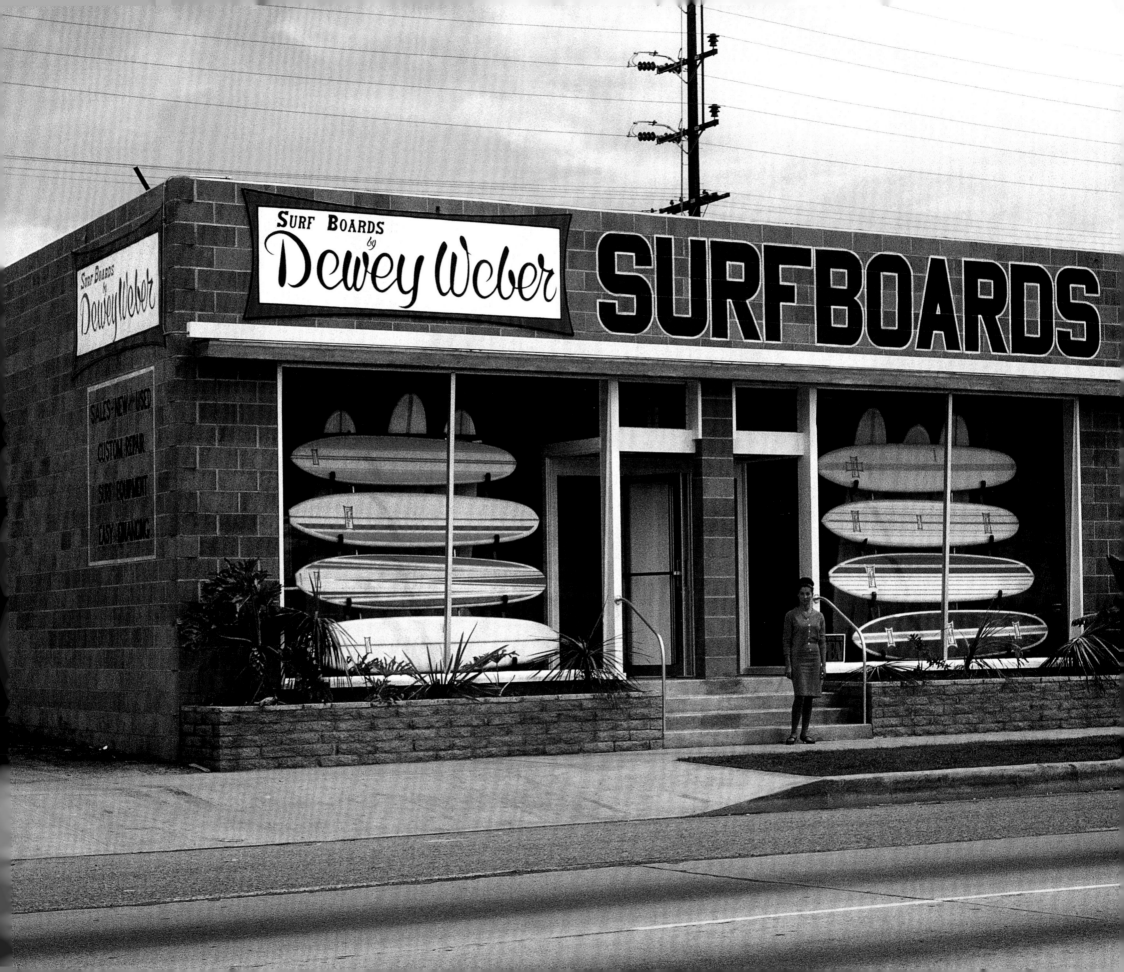

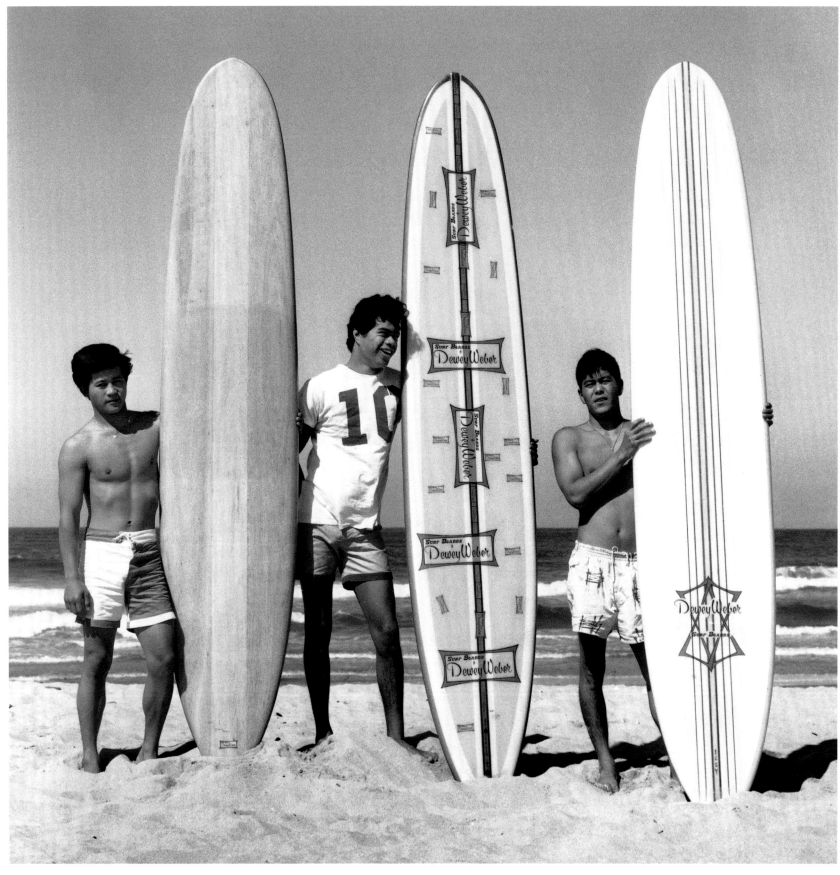

Donald Takayama, Peter Kahapea, Harold Ige, Hermosa Beach, 1963

Three transplanted Hawaiians at 22nd Street.

Drei Exil-Hawaiianer an der 22nd Street.

Trois natifs de Hawaï sur la plage de 22nd Street.

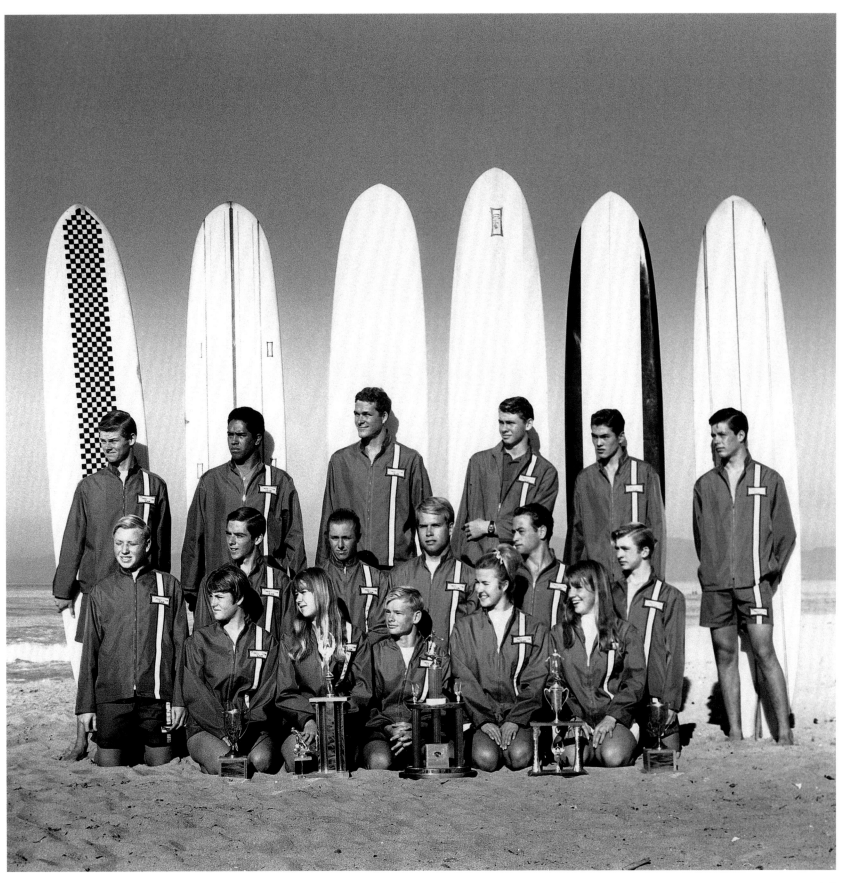

Rick Surfboards, Hermosa Beach, 1963

Below: Young John Grannis shoots it
out with the son of renowned South Bay
shaper Rick Stoner at the Pacific Coast
Highway shop.

Unten: Der kleine John Grannis beim
Duell mit dem Sohn des berühmten South
Bay Shaper Rick Stoner im Pacific Coast
Highway Shop.

Ci-dessous: Caché derrière de « gros cali-
bres », le petit John Grannis joue au cow-
boy avec le fils de Rick Stoner, le célèbre
shaper de South Bay, dans la boutique de
ce dernier sur la Pacific Coast Highway.

Dale Velzy, Santa Monica, 1963

Opposite: Velzy, a charismatic entre-
preneur who split his passions equally
between surfing, hot rods, and horses,
was always on the lookout for the next big
thing. This beach buggy wasn't it.

Gegenüber: Velzy, ein charismatischer
Geschäftsmann, dessen Leidenschaften
Surfen, Hot Rods und Pferde waren, war
immer auf der Suche nach dem nächsten
großen Ding. Dieser Beach Buggy war es
nicht.

Page ci-contre: L'homme d'affaires cha-
rismatique Dale Velzy avait trois passions:
le surf, les *hot rods* et les chevaux. Il était
constamment à l'affût d'un bon coup. Ce
buggy de plage ne fera pas son affaire.

Hermosa Beach, 1967

Opposite: It seemed that every other girl on Hermosa Beach, located just five miles from Los Angeles International Airport, was an off-duty stewardess.

Gegenüber: Man hatte den Eindruck, dass jedes zweite Mädchen in Hermosa Beach, nur acht km vom Los Angeles International Airport entfernt, eine Stewardess außer Dienst war.

Page ci-contre: Les filles de Hermosa Beach étaient si belles qu'on pouvait penser que la moitié d'entre elles étaient des hôtesses de l'air en escale (la plage n'est qu'à huit kilomètres de l'aéroport international de Los Angeles).

Malibu, 1965

Below: Sixties surfing, while not misogynistic, was definitely sexist. A perfect "surfer girl" was expected to wait hours for her surf hero to come in.

Unten: Die Surfszene in den Sechzigern war zwar nicht frauenfeindlich, aber definitiv sexistisch. Von einem perfekten „Surfer Girl" wurde erwartet, dass es stundenlang wartete, bis ihr Held vom Surfen zurückkam.

Ci-dessous: Sans être misogynes, les surfeurs des années 1960 cultivaient néanmoins un sexisme à toute épreuve. Même les «surfeuses de rêve» devaient attendre des heures entières le retour de leurs héros, trop occupés qu'ils étaient à danser avec les vagues.

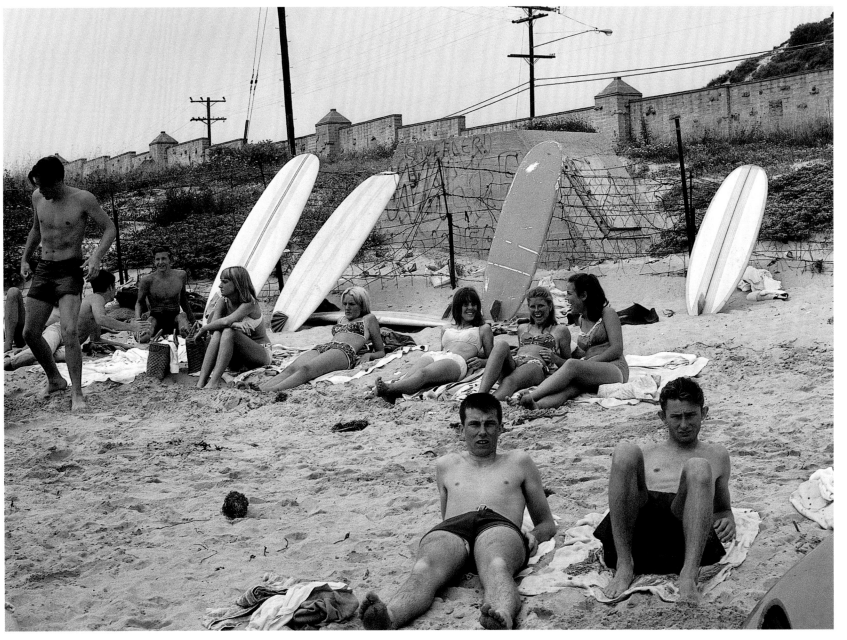

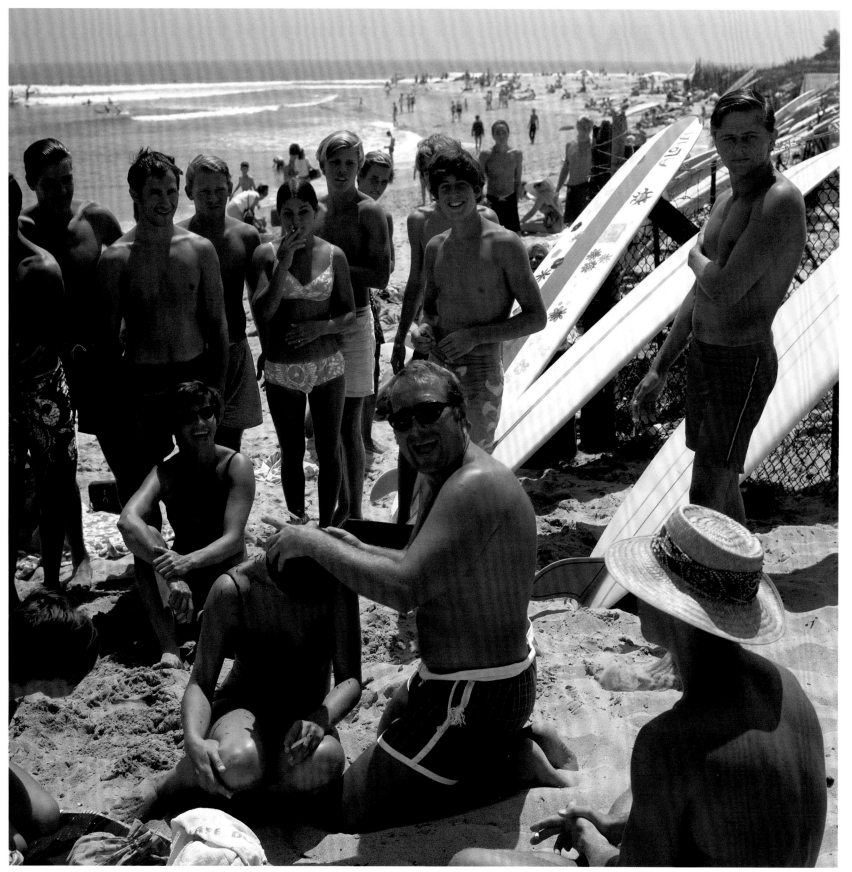

Malibu, 1967

Left: Beach haircut.

Links: Haareschneiden am Strand.

Ci-contre: Séance de coiffure sur la plage.

Hermosa Beach, 1967

Opposite: It took eons of westward global migration to create this iconic California beach scene.

Gegenüber: Generationen mussten westwärts ziehen, bis diese typisch kalifornische Strandszene entstehen konnte.

Page ci-contre: Cette scène de plage idyllique de Californie est l'aboutissement d'un long processus de migration humaine et de conquête de l'Ouest.

Torrance Beach, 1964

Page 154: A weekend logjam at Rat's Beach. The Palos Verdes peninsula is in the background.

Seite 154: Ein Wochenendstau am Rat's Beach. Im Hintergrund sieht man die Halbinsel von Palos Verdes.

Page 154: Affluence de week-end à Rat's Beach. À l'arrière-plan, la péninsule de Palos Verdes.

Malibu, 1967

Page 155: When Grannis returned with a friend to Malibu shortly after World War II, they found a crowd of twelve people surfing. "That's it," he said. "This place is ruined."

Seite 155: Als Grannis kurz nach dem Zweiten Weltkrieg mit einem Freund zurück nach Malibu kam, sahen sie zwölf Leute surfen. Er sagte: „Das war's. Der Ort ist ruiniert."

Page 155: Quand Grannis retourne à Malibu avec un ami peu après la Seconde Guerre mondiale, il y croise en tout et pour tout une douzaine de surfeurs. « Et voilà, soupire-t-il, il n'y a plus rien à chercher par ici ! »

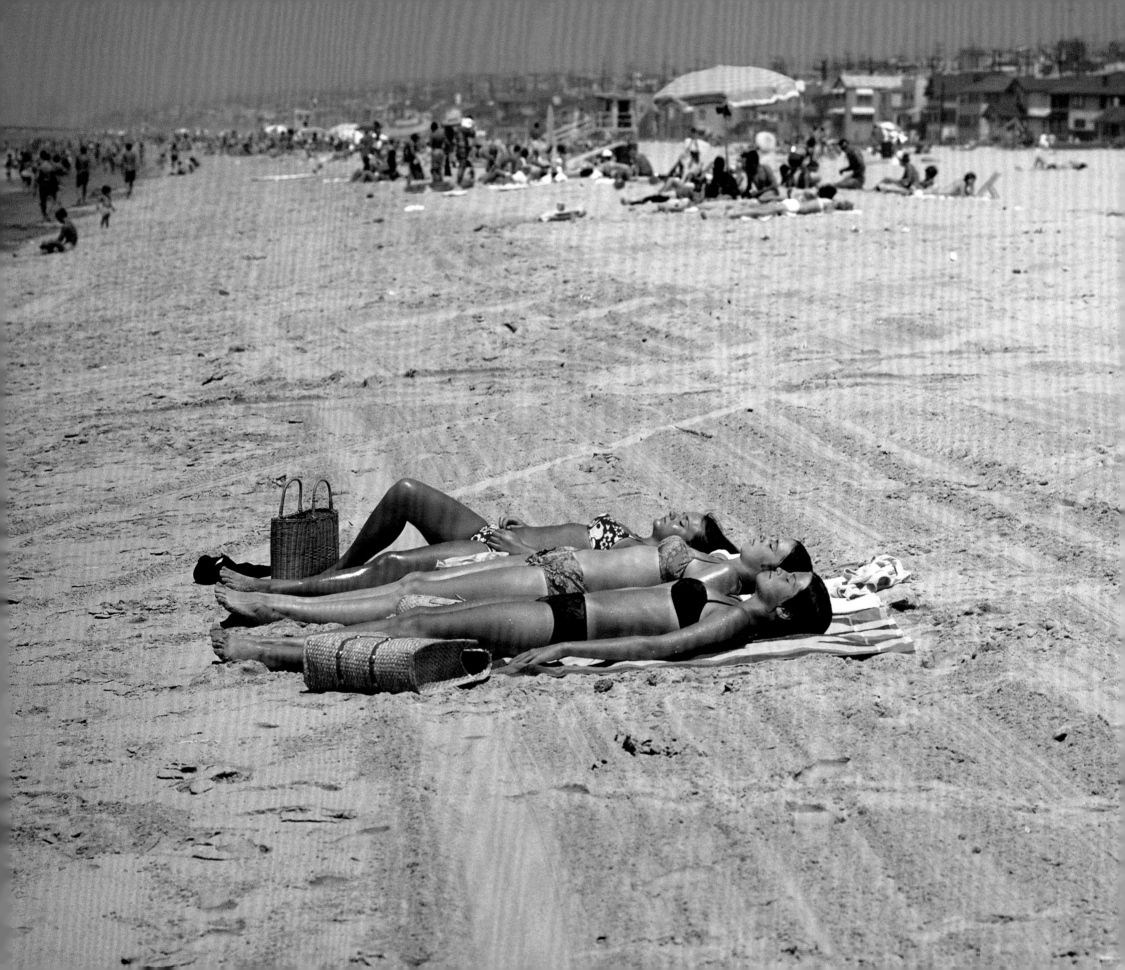

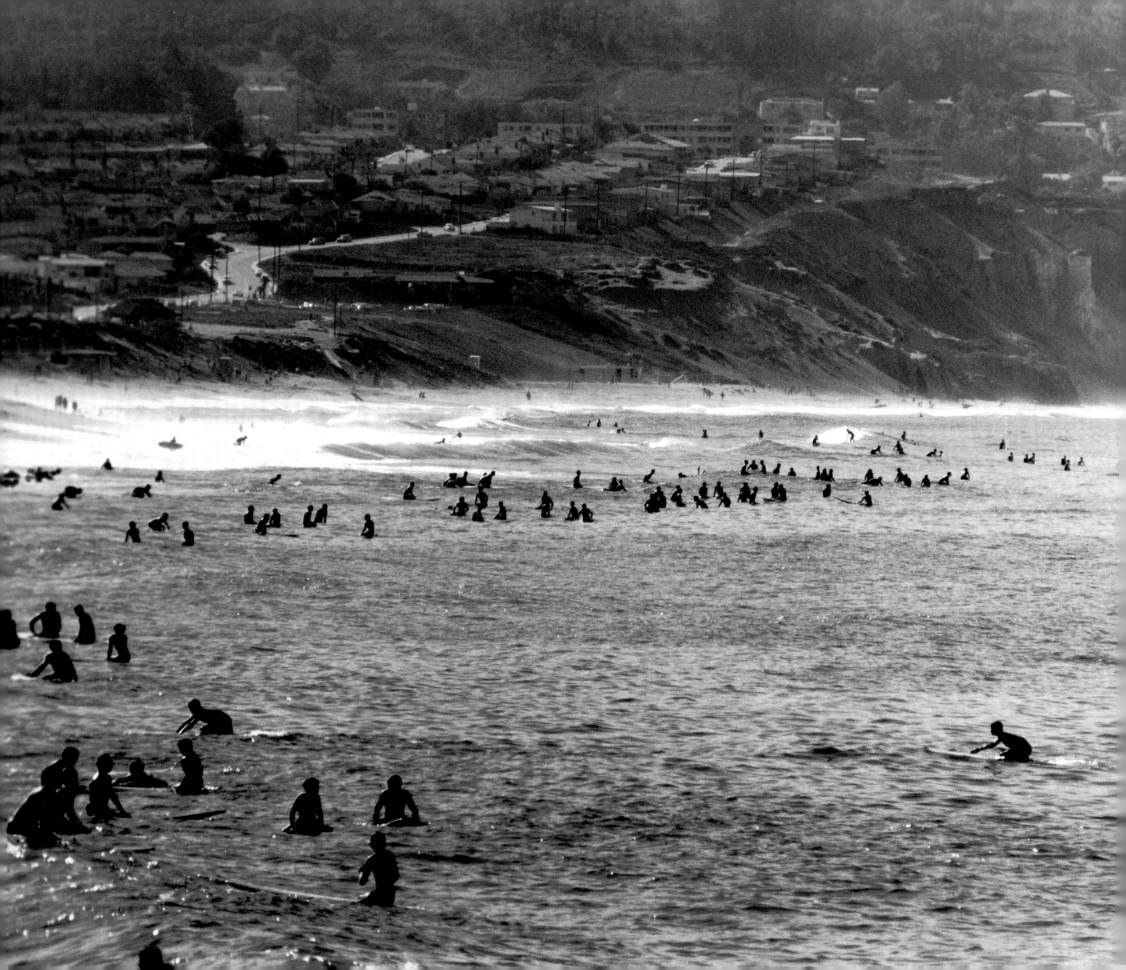

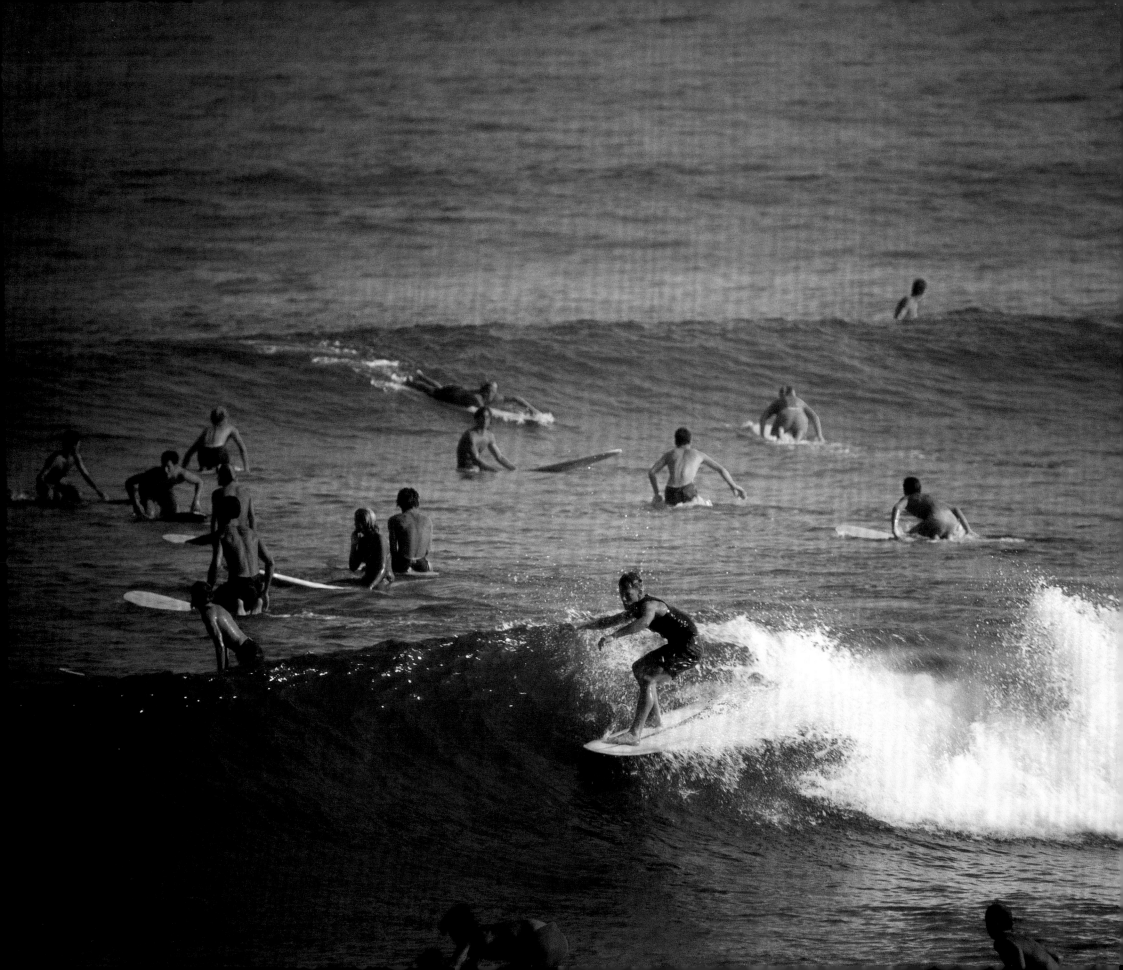

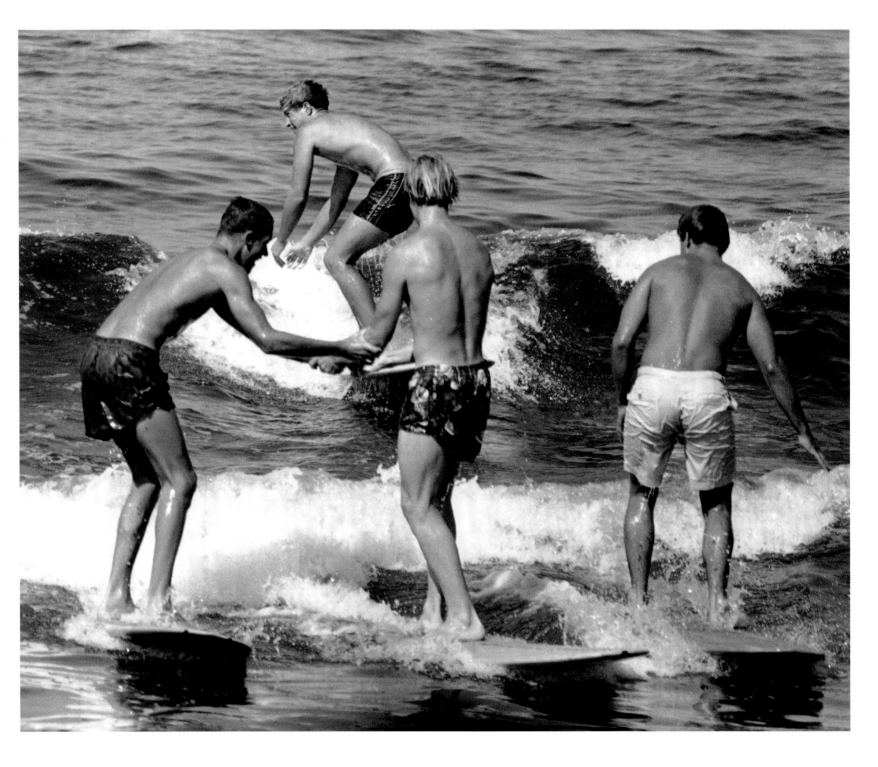

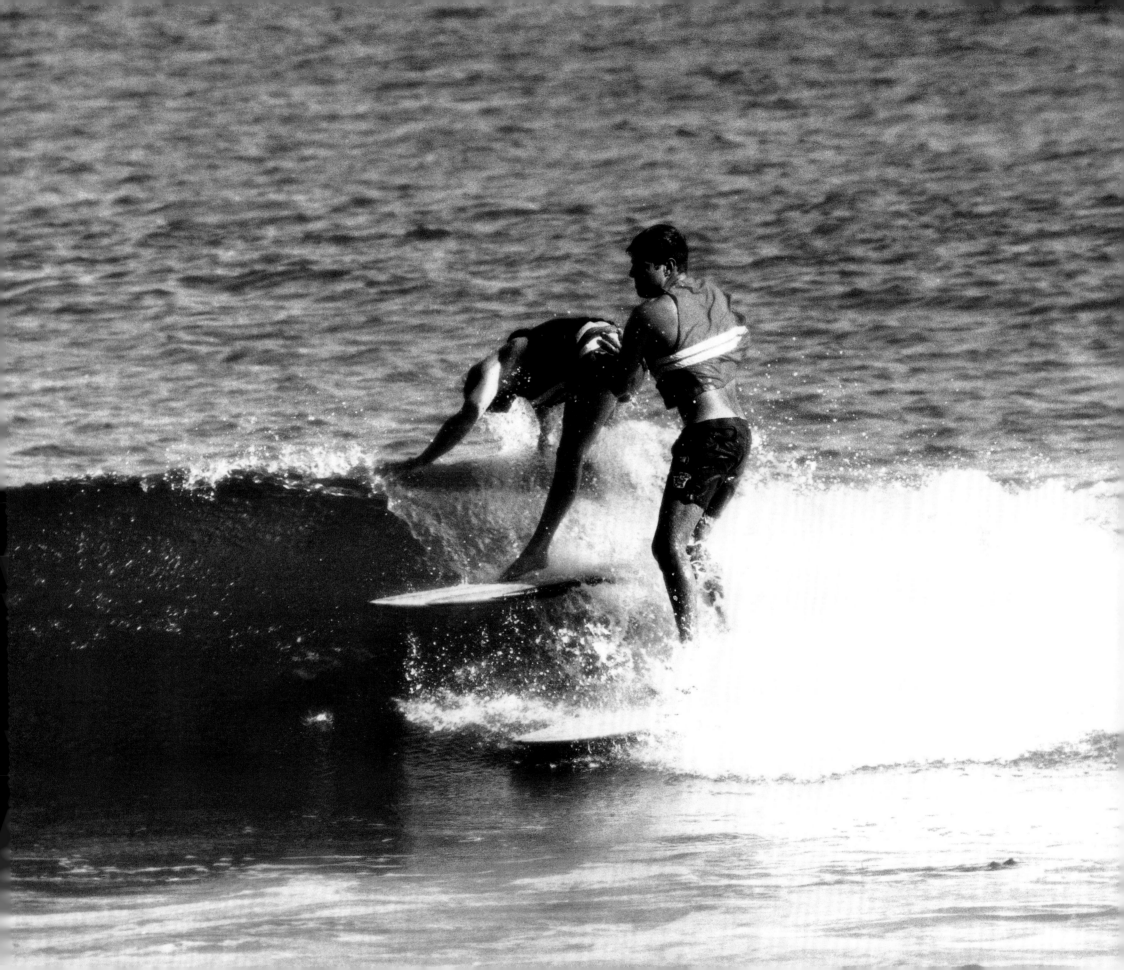

Palos Verdes Cove, 1967

Right: On a big winter swell, waves of twenty feet or larger march into the cove.

Rechts: Bei einer starken Winter-Flut stürzen über sechs Meter hohe Wellen in die kleine Bucht.

Ci-contre: Pendant les swells d'hiver, des vagues de plus de six mètres de haut se brisent dans la baie.

Lunada Bay, 1970

Opposite: Los Angeles's premier big-wave spot, notorious for sharks, nasty currents, and even nastier locals. In 1961, Greg Noll rode twenty-foot waves there.

Gegenüber: Der beste Big-Wave-Spot in Los Angeles, berüchtigt für Haie, schlimme Strömungen und noch schlimmere ortsansässige Surfer. 1961 ritt Greg Noll hier zwanzig Fuß hohe Wellen.

Page ci-contre: Le meilleur spot de grosses vagues de Los Angeles, réputé pour ses requins, ses courants dangereux et le caractère exécrable de ses habitants. En 1961, Greg Noll y a surfé des vagues de sept mètres.

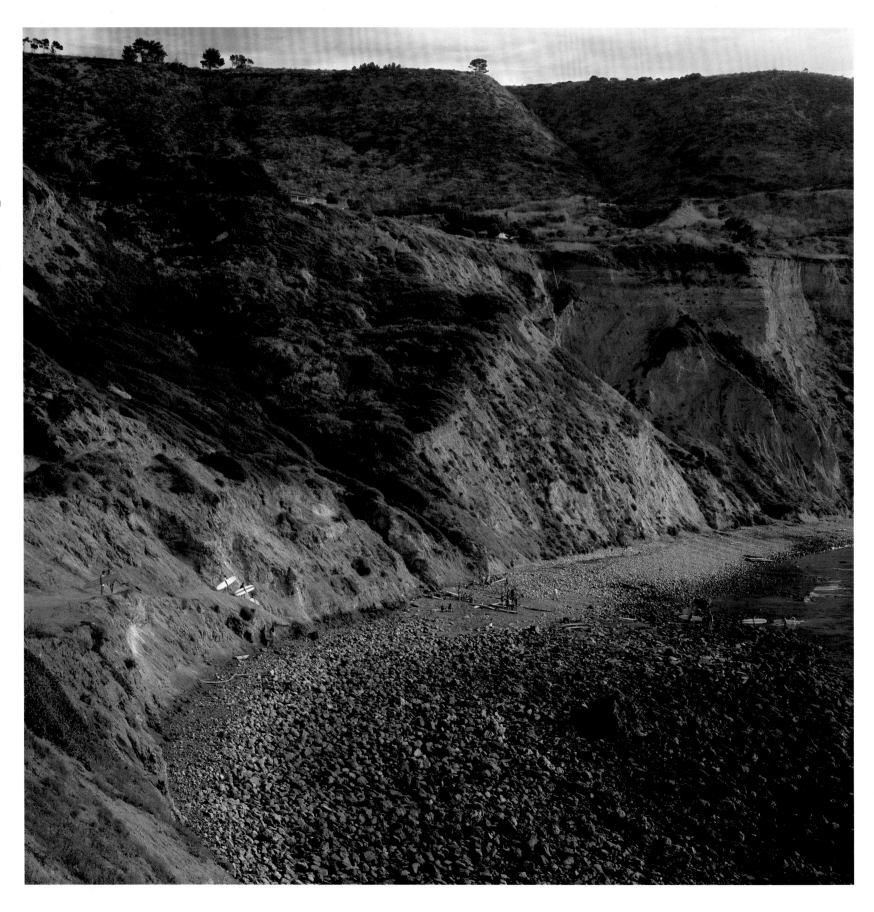

Palos Verdes Cove, 1970

Opposite: The lineup at "Ski Jump," a big-wave spot at the north end of Palos Verdes Cove.

Gegenüber: Unterwegs zum „Ski Jump", einem Big-Wave-Spot am nördlichen Ende von Palos Verdes Cove.

Page ci-contre: Descente vers «Ski Jump», un spot de grosses vagues à l'extrémité nord de Palos Verdes Cove.

Arroyo Sequit Beach, 1963

Below: Only twenty miles from Hollywood, Arroyo Sequit beach is often used as a location for films and TV. Look for it in *Point Break*, *The Karate Kid*, and *Baywatch*.

Unten: Der nur dreißig Kilometer von Hollywood entfernte Strand von Arroyo Sequit wird häufig als Drehort für Film und Fernsehen benutzt, so z. B. in *Point Break*, *Karate Kid* und *Baywatch*.

Ci-dessous: À seulement 30 kilomètres de Hollywood, la plage d'Arroyo Sequit a servi de lieu de tournage pour bon nombre de films et de séries. On la reconnaît dans des longs métrages comme *Point Break*, *Karaté Kid* et dans la série *Alerte à Malibu*.

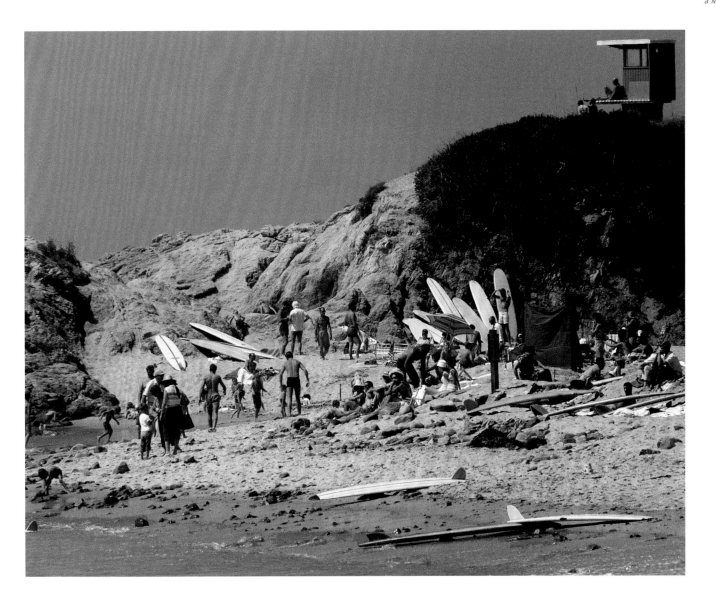

Dale Dobson, Santa Cruz, 1967

Below: The "Rivermouth" is a sandbar break popular with Santa Cruz locals. Average year-round water temperature: 12°C.

Unten: „Rivermouth" ist eine bei den Surfern aus Santa Cruz beliebte Sandbank-Welle. Die Wassertemperatur beträgt das ganze Jahr über um die 12° C.

Ci-dessous: «Rivermouth» est un *break* à bancs de sable très apprécié par la population locale de Santa Cruz. L'eau y affiche une température moyenne de 12 °C été comme hiver.

Jack O'Neill, Corky Carroll, Steamer Lane, Santa Cruz, 1969

Opposite: O'Neill, a pioneer Santa Cruz surfer, developed the first surfing wetsuits to brave Monterey Bay's excellent but chilly waves.

Gegenüber: O'Neill, ein Wegbereiter der Surfszene von Santa Cruz, entwickelte die ersten Neopren-Anzüge für Surfer, die den fantastischen, aber eisigen Wellen der Monterey Bay trotzten.

Page ci-contre: Jack O'Neill, un des pionniers du surf de Santa Cruz, a mis au point les premières combinaisons en néoprène permettant d'affronter les vagues exceptionnelles – mais glaciales – de Monterey Bay.

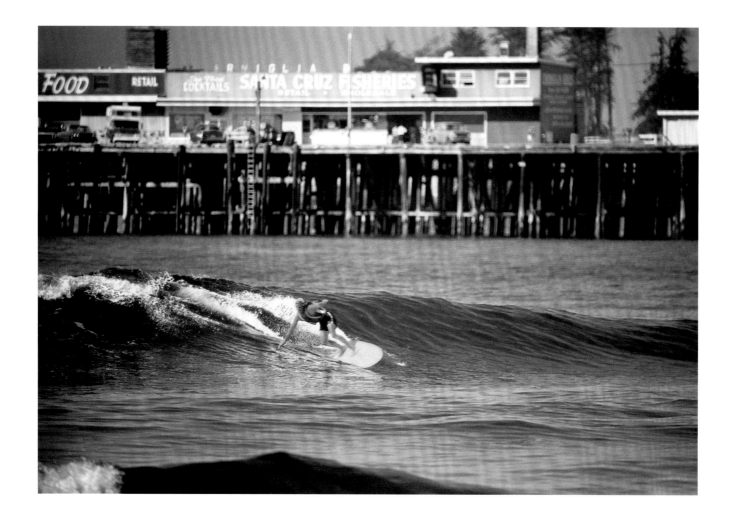

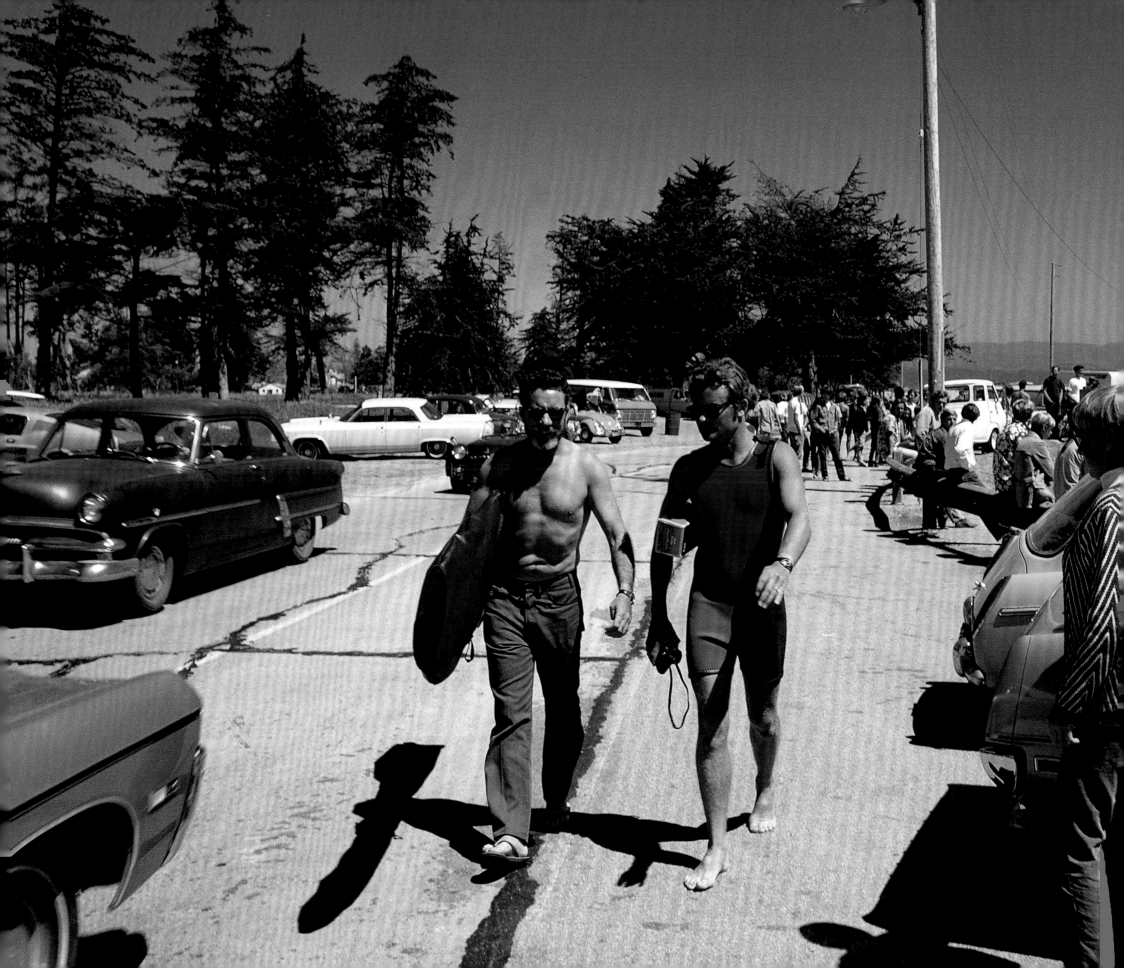

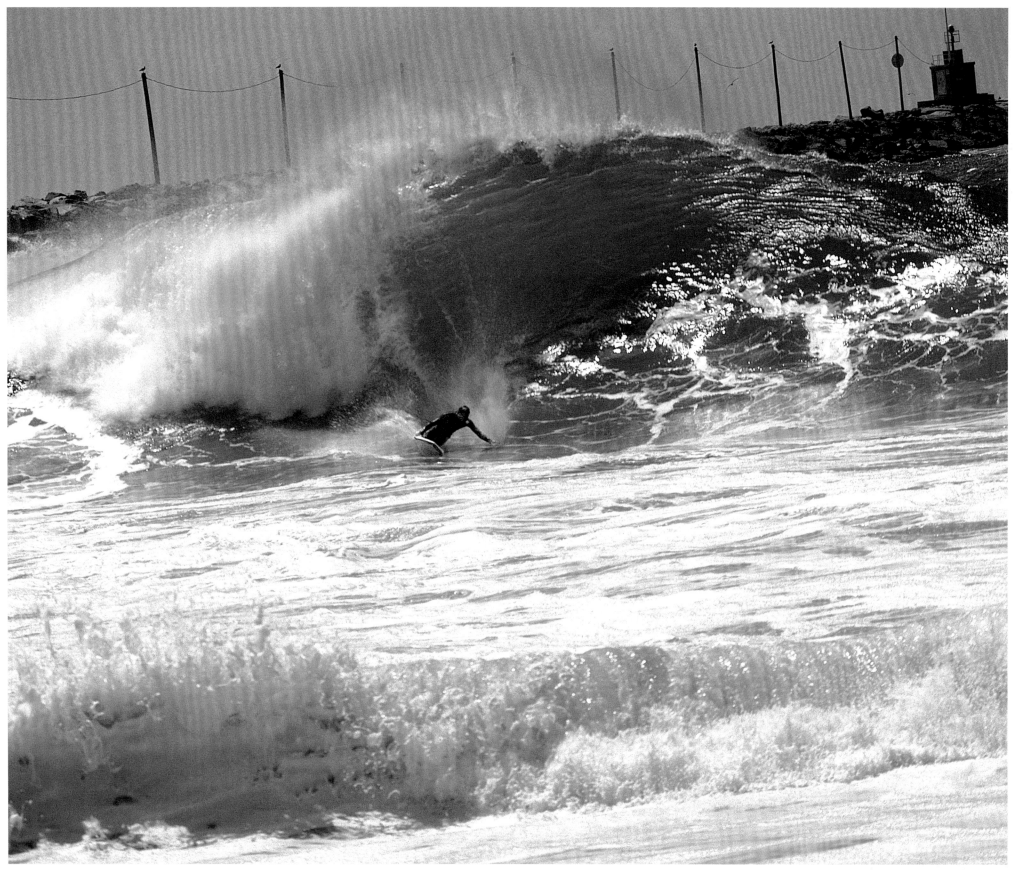

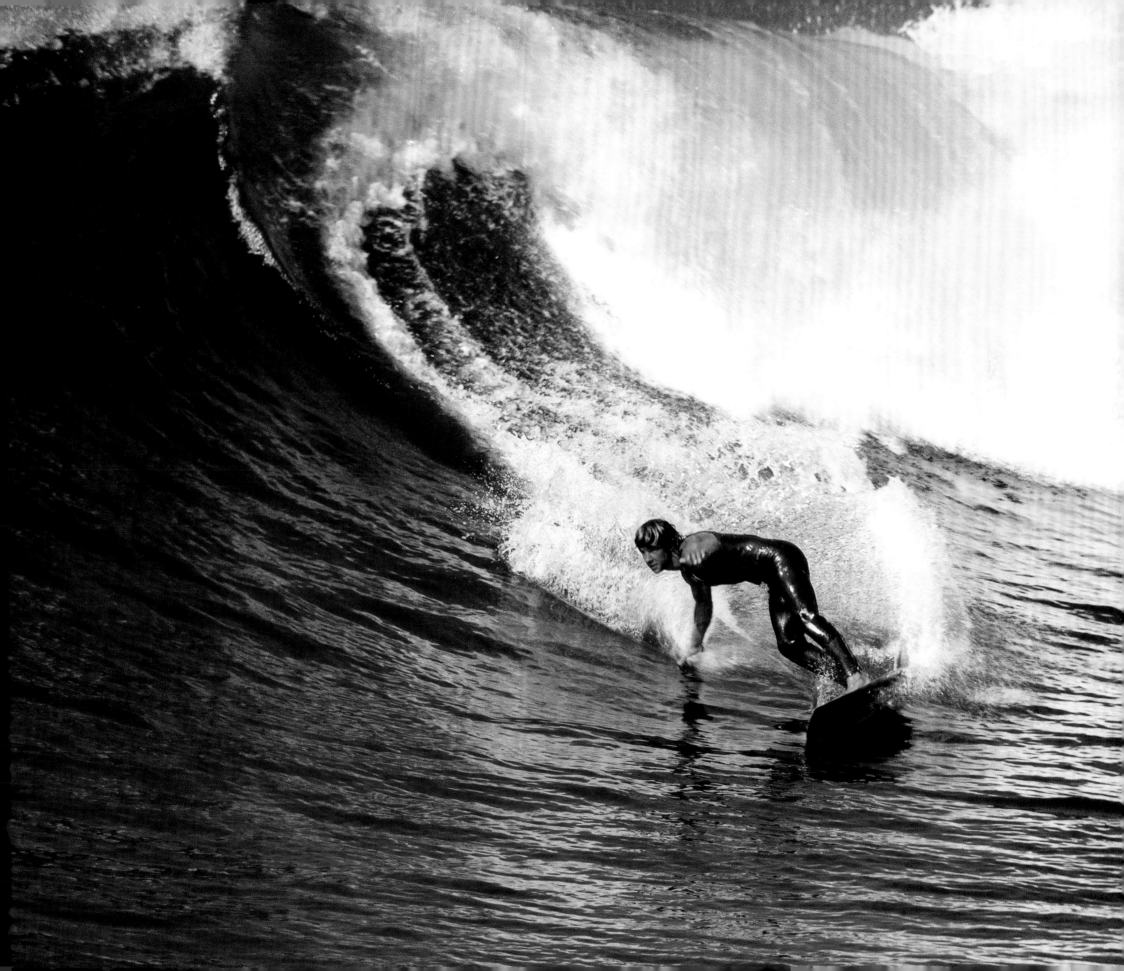

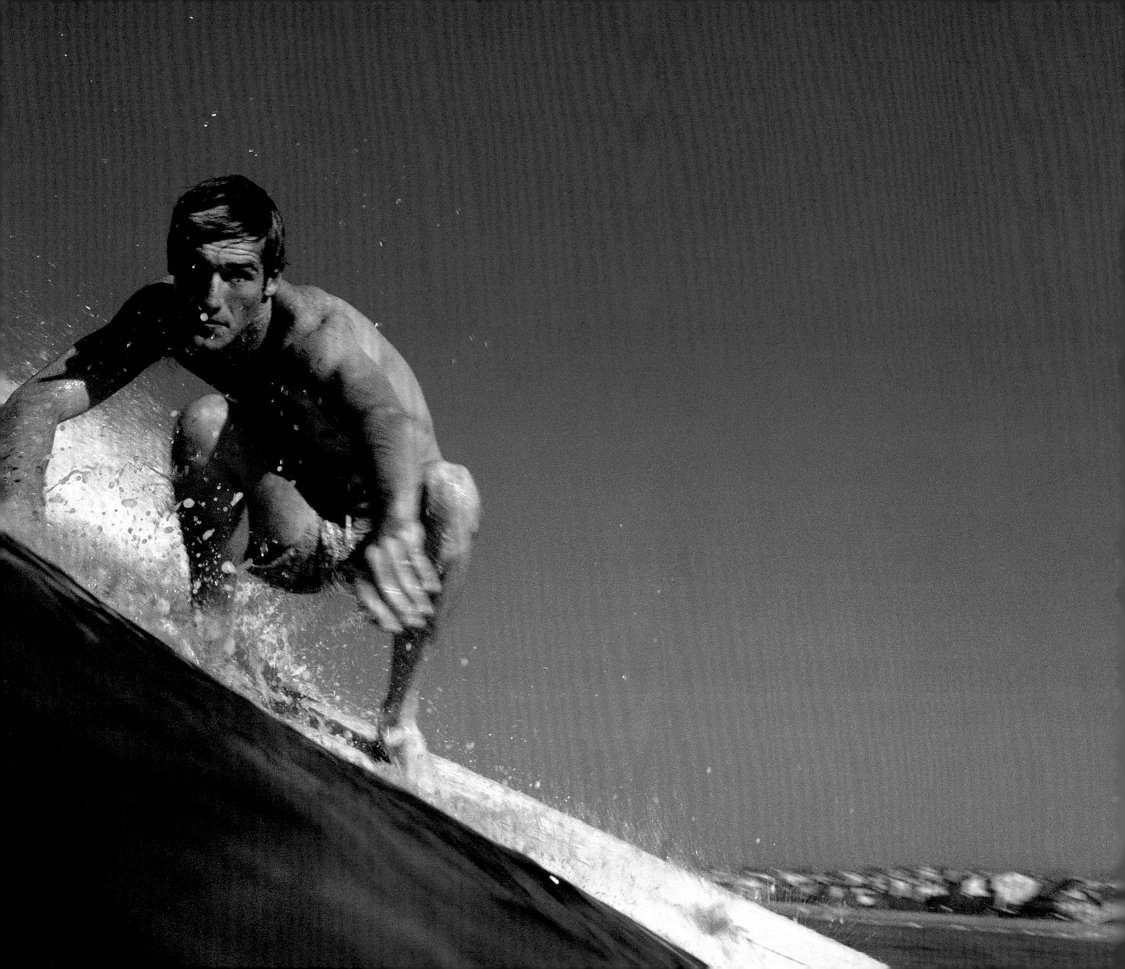

Newport Beach, 1978

Page 164: The "Dirty Old Wedge" is a fickle, dangerous summer wave spot mostly favored by a crazy crew of devoted bodysurfers and kneeboarders.

Seite 164: „Dirty Old Wedge" ist ein heikler, gefährlicher Sommer-Wave-Spot, der hauptsächlich bei einer verrückten Truppe von Bodysurfern und Kneeboardern beliebt ist.

Page 164: Le « Dirty Old Wedge » est un spot estival imprévisible et dangereux fréquenté principalement par de petits groupes d'irréductibles fanatiques, adeptes du bodysurf et du kneeboard.

Dru Harrison, Huntington Beach, 1969

Page 165: Harrison, raised in Hermosa Beach as a classic longboard stylist, made the radical transition to shortboards in the late sixties.

Seite 165: Der in Hermosa Beach aufgewachsene Harrison war ein klassischer Longboard-Surfer, bevor er Ende der Sechziger den radikalen Wechsel zum Shortboard vollzog.

Page 165: Dru Harrison, qui a grandi sur les plages de Hermosa, fut d'abord un virtuose du longboard avant de passer au shortboard à la fin des années 1960.

Kent Layton, Hermosa Beach, 1969

Opposite. Gegenüber. Page ci-contre.

George Ferguson, Hermosa Beach, 1969

Below. Unten. Ci-dessous.

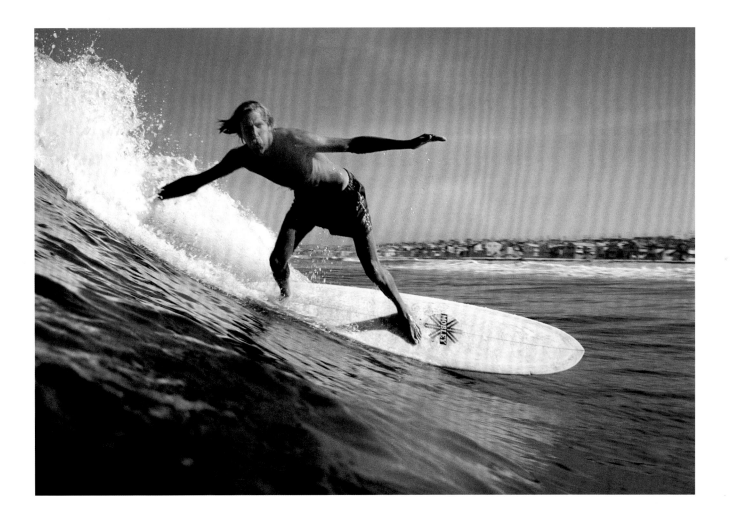

Angie Reno, Rincón, Puerto Rico, 1968

Below: The evidence left from an all-night beach party held during the trouble-plagued and controversial 1968 World Championships.

Unten: Überbleibsel einer nächtlichen Strandparty während der problem-beladenen und kontroversen Weltmeister-schaft von 1968.

Ci-dessous: Traces d'une interminable beach-party nocturne pendant les cham-pionnats du monde controversés et agités de 1968.

Skip Frye, Rincón, Puerto Rico, 1968

Opposite: Californian Frye, who gracefully bridged the longboard and shortboard eras, performs a flawless "stretch five" during the World Championships.

Gegenüber: Der Kalifornier Frye, der elegant den Übergang von der Longboard-zur Shortboard-Ära meisterte, zeigt bei der Weltmeisterschaft einen fehlerlosen „Stretch Five".

Page ci-contre: Le Californien Skip Frye, qui a su gérer avec brio la rupture entre le longboard et le shortboard, exécute un im-peccable « stretch five » lors d'une épreuve des championnats du monde.

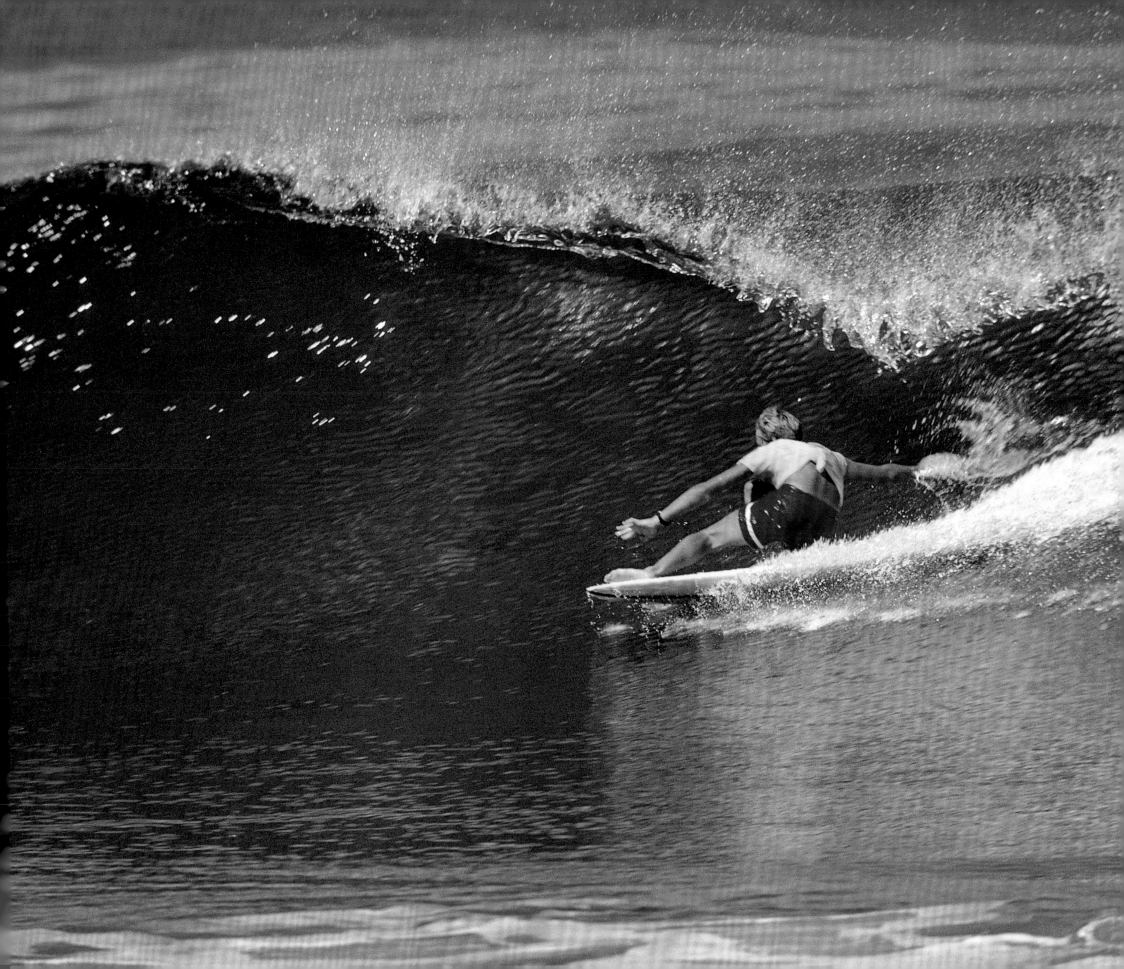

Big Surf Wave Pool, Tempe, Arizona, 1969

Below: Located 380 miles inland in the middle of the Arizona desert, Big Surf water park offered endless chlorinated "mushburgers" for the masses. It produced waves by dropping millions of gallons down a forty-foot vertical chute and channeling the surge to a gently upward-sloping beach.

Unten: Der 612 km von der Küste entfernt inmitten der Wüste von Arizona gelegene Big Surf Wasserpark bot den Massen nie enden wollende, gechlorte, einförmige Wellen. Die Wellen entstanden, indem Millionen Liter Wasser eine zwölf Meter hohe Wand hinunterstürzten und diese Brandung auf einen leicht ansteigenden Strand geleitet wurde.

Ci-dessous: Dans le parc aquatique de Big Surf, situé à 612 kilomètres de la côte au beau milieu du désert de l'Arizona, les conditions étaient loin d'être idéales pour la pratique du surf: en guise de vagues, les surfeurs devaient se contenter d'un clapotis monotone généré par un mur d'eau de donze mètres déversant en continu des millions de litres d'eau chlorée dans un bassin plat à pente douce.

Big Surf Wave Pool, Tempe, Arizona, 1969

Pages 171–173: Opened in 1969, Big
Surf was highlighted in the classic 1970
surf film *Pacific Vibrations*, which featured
flamboyant U.S. Champion Corky Carroll in
paid exhibitions.

Seiten 171–173: Der 1969 eröffnete
Big Surf Park wurde in dem klassischen
Surffilm *Pacific Vibrations* von 1970
vorgestellt, für den der extravagante U.S.
Champion Corky Carroll engagiert wurde.

Pages 171–173: Ouvert en 1969, Big
Surf servit de lieu de tournage pour *Pacific
Vibrations*, le célèbre film de surf de
1970, dans lequel le flamboyant champion
américain Corky Carroll fut engagé pour
des démonstrations de surf.

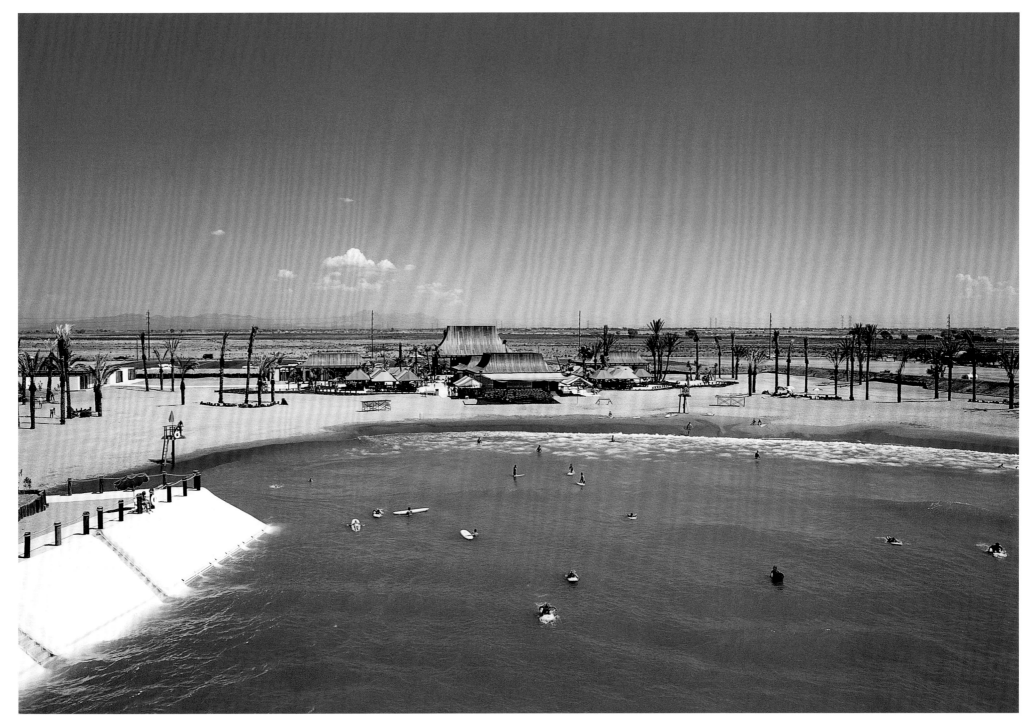

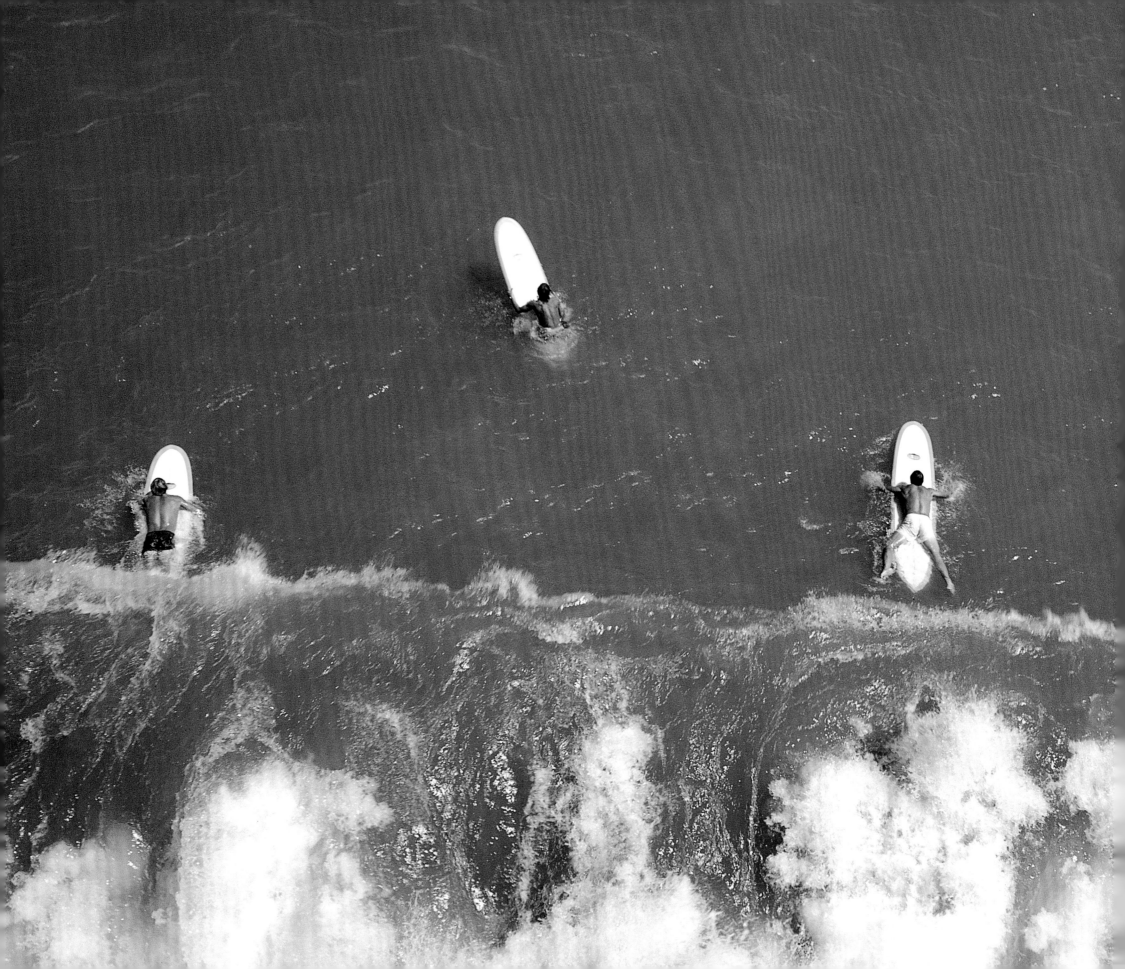

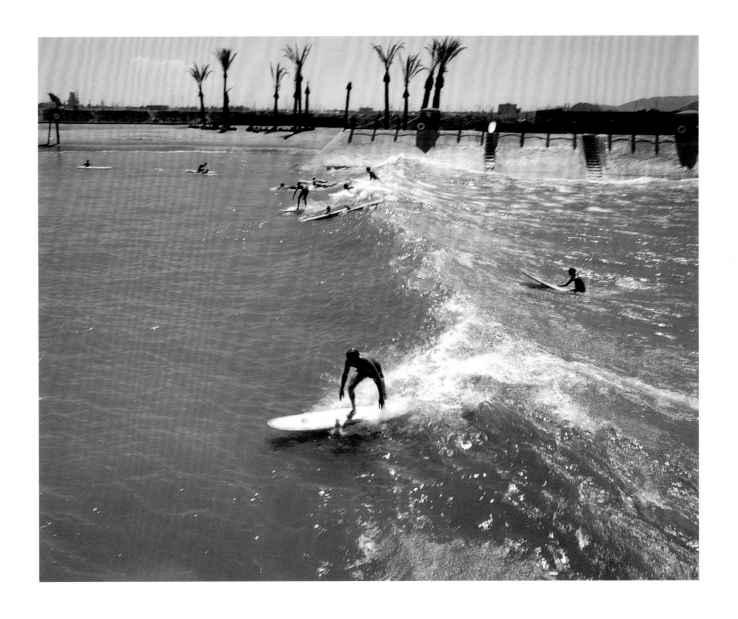

Mickey Muñoz, Rincon, California, 1968

Below: Rincon is a colder, more powerful version of Malibu, which breaks best in the winter.

Unten: Rincon ist eine kältere, stärkere Version von Malibu, hier brechen sich die Wellen im Winter am besten.

Ci-dessous: Rincon est un spot plus froid et plus violent que Malibu et offre d'excellents *breaks* surtout pendant la saison hivernale.

South Side, Hermosa Beach Pier, 1977

Opposite. Gegenüber. Page ci-contre.

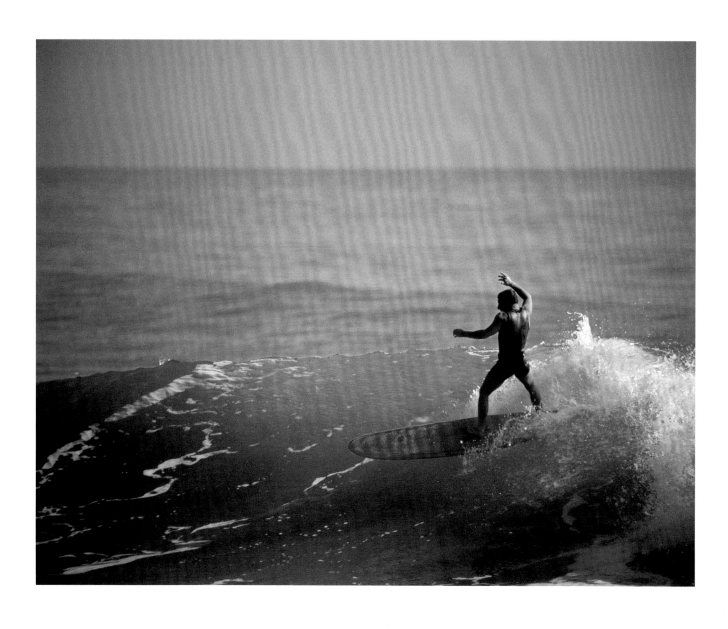

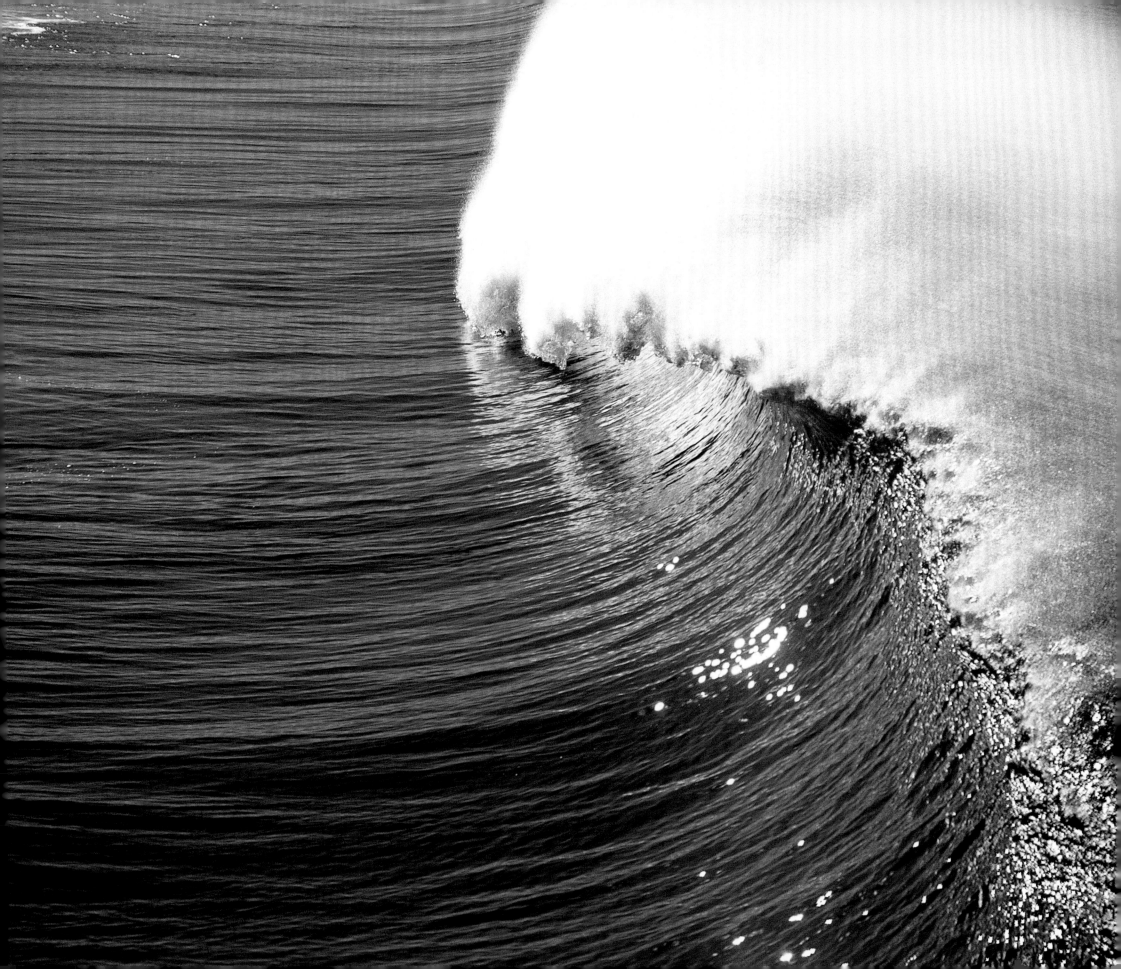

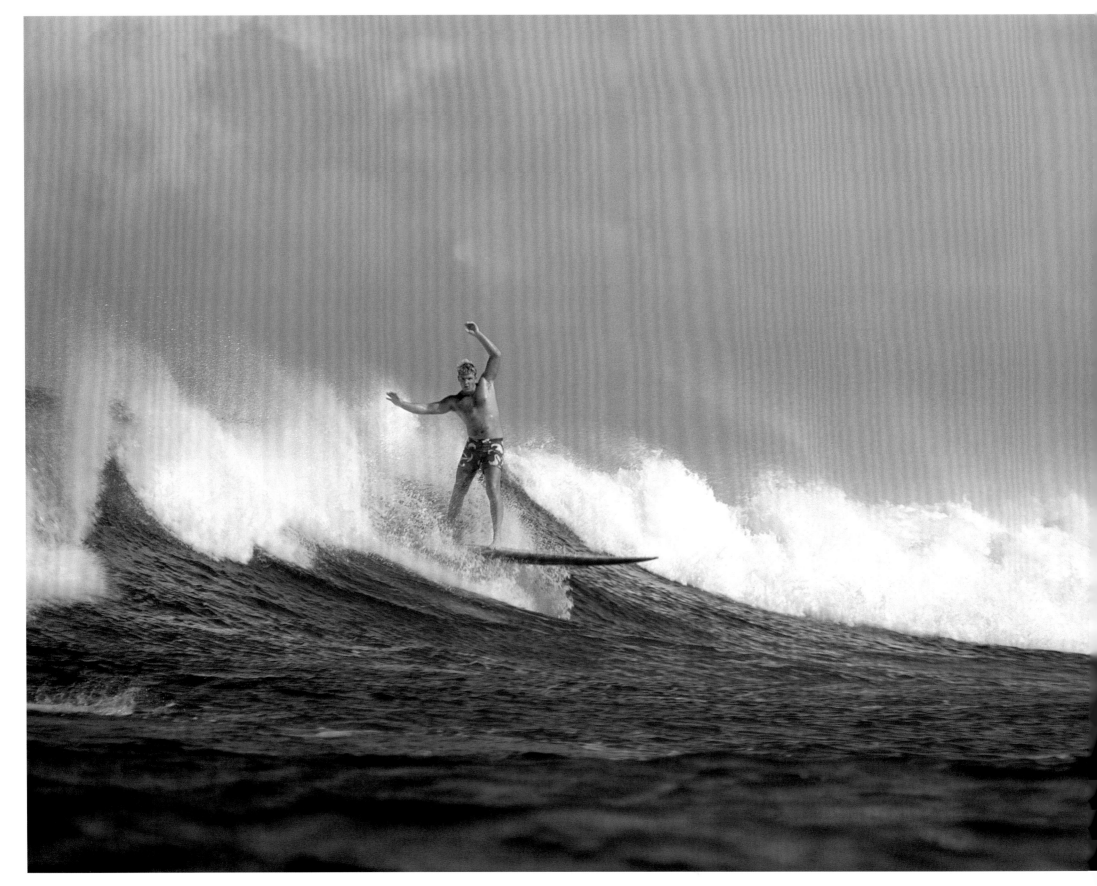

Hawaii

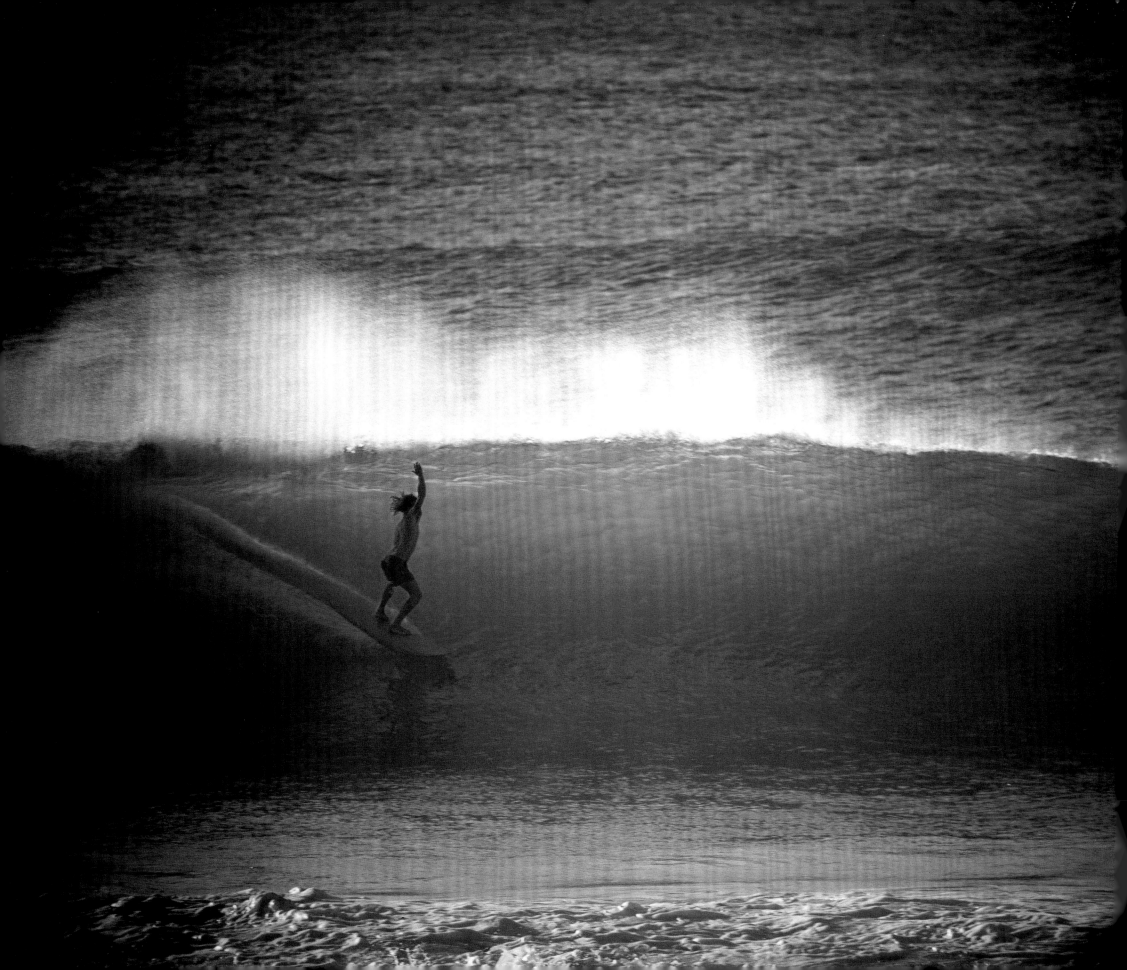

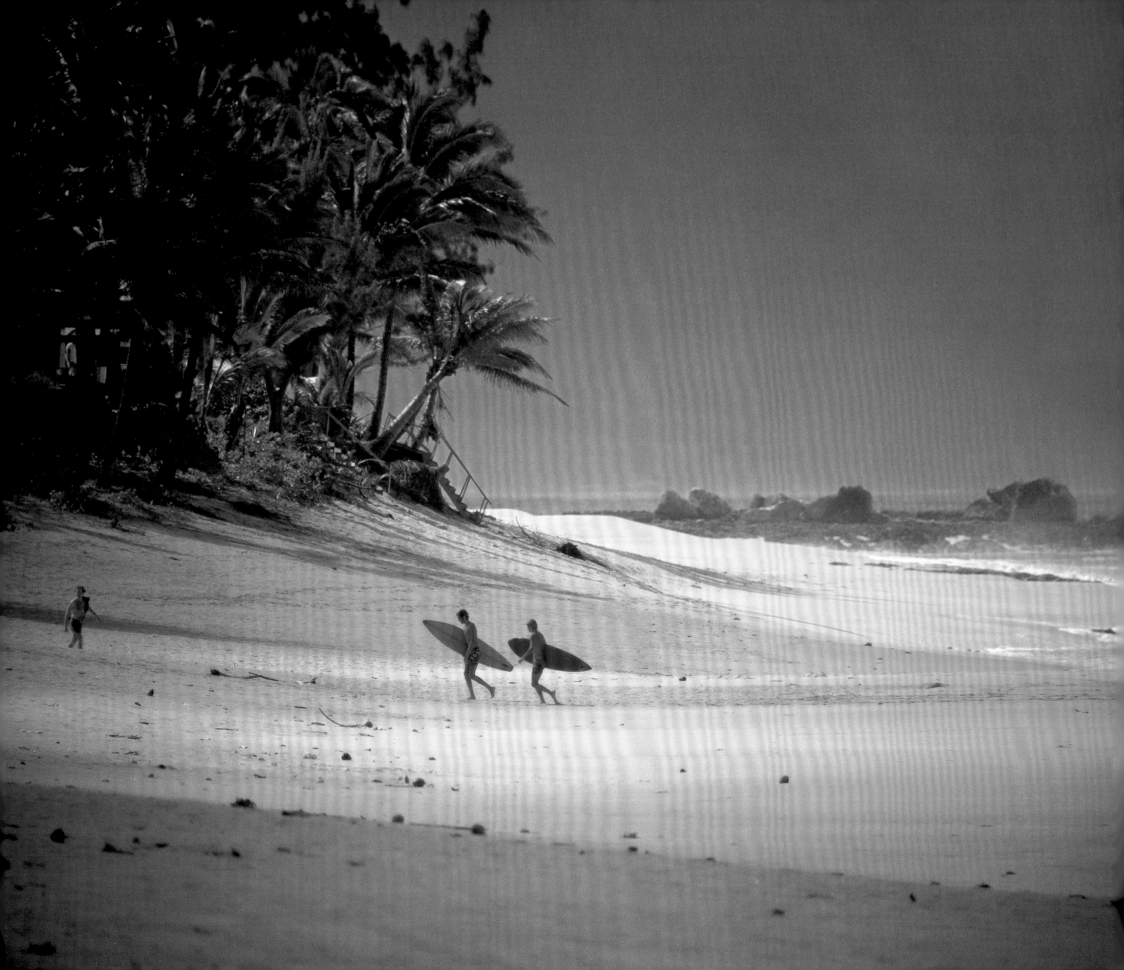

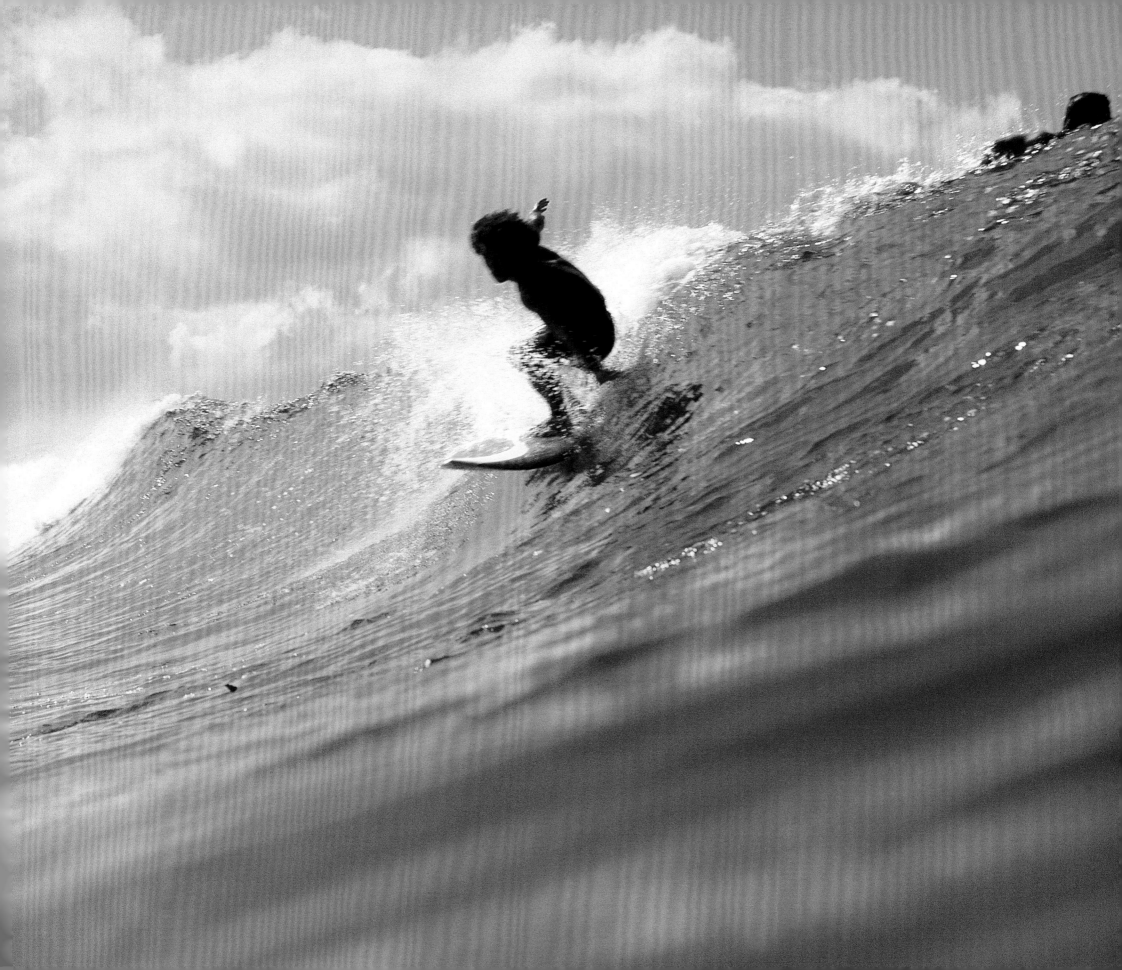

Chun's Reef, 1965

Page 176–177: One of the North Shore's gentler breaks, Chun's is favored by longboarders, kids, and older surfers.

Seite 176–177: Als einer der sanfteren Breaks am North Shore wird Chun's von Longboardern, Kindern und älteren Surfern bevorzugt.

Page 176–177: Relativement peu exigeant, le *break* de Chun, sur le North Shore, est particulièrement prisé par les longboarders, les enfants et les vétérans.

John Boozer, Pipeline, 1966

Page 178. Seite 178. Page 178.

Nuuanu Pali, Oahu, 1973

Page 179: Looking out over Kaneohe Bay, on Oahu's east side.

Seite 179: Ausblick über Kaneohe Bay an der Ostseite von Oahu.

Page 179: Vue sur Kaneohe Bay, sur la côte est d'Oahu.

Shark's Cove, North Shore, 1974

Page 180: The view from Ehukai Beach toward the razor-sharp lava rocks of Ke Iki Beach.

Seite 180: Aussicht von Ehukai Beach auf die rasiermesserscharfen Lavafelsen von Ke Iki Beach.

Page 180: Vue sur les rochers de lave acérées de Ke Iki Beach depuis Ehukai Beach.

Larry Bertleman, Pipeline, 1975

Page 181: Nicknamed "the Rubberman" for his radical low turns, the Hawaiian Bertleman influenced a generation of surfers and skateboarders.

Seite 181: Für seine extrem niedrigen Turns bekam der Hawaiianer Bertleman den Spitznamen „The Rubberman" und beeinflusste damit Generationen von Surfern und Skateboardern.

Page 181: Surnommé « The Rubberman » (l'homme élastique) pour ses virages extrêmement bas, le Hawaïen Larry Bertleman a influencé toute une génération de surfeurs et de skateboarders.

Nat Young, Sunset Beach, 1966

Right: With his enormous feet and aggressive style, the Australian Young was called "the Animal." He's shown here shortly after becoming world champion in San Diego.

Rechts: Wegen seiner riesigen Füße und seines agressiven Stils wurde der Australier Young „The Animal" genannt. Hier sieht man ihn kurz nachdem er den Weltmeistertitel in San Diego gewann.

Ci-contre: En raison de ses pieds énormes et de son style agressif, l'Australien Nat Young fut baptisé « The Animal ». On le voit ici peu après son titre de champion du monde obtenu à San Diego.

Rusty Miller, Waimea Bay, 1966

Opposite: Miller, a Californian, had gotten off the jet only an hour before tackling this twenty-foot Waimea wall.

Gegenüber: Der Kalifornier Miller bezwang diese Sechs-Meter-Welle in Waimea, nachdem er nur eine Stunde zuvor dem Flugzeug entstiegen war.

Page ci-contre: Le Californien Rusty Miller affronte un mur d'eau de six mètres de haut à Waimea une heure seulement après sa descente d'avion.

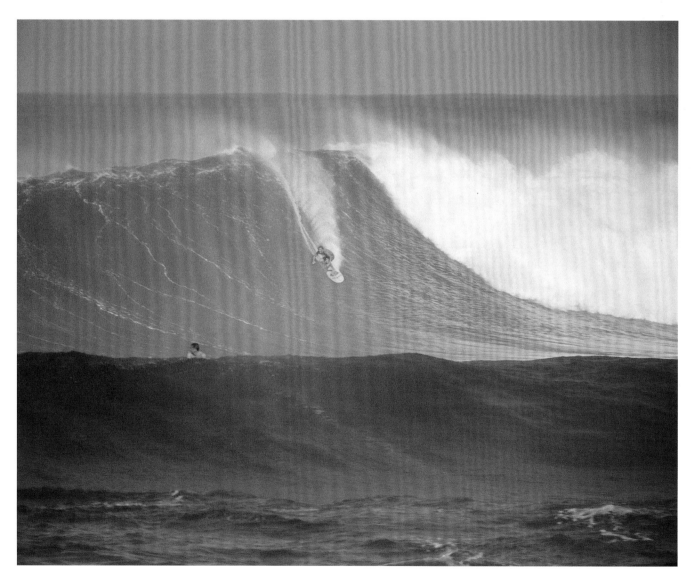

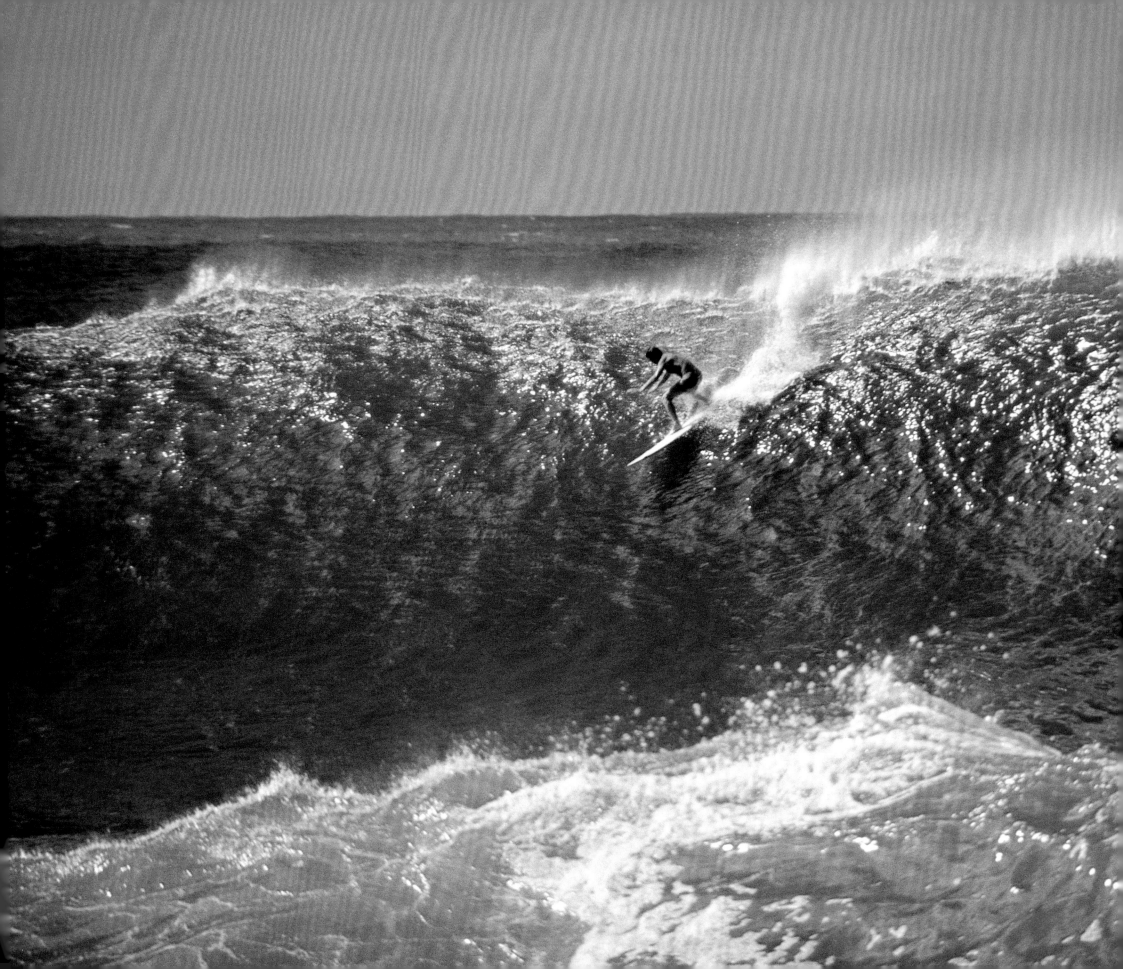

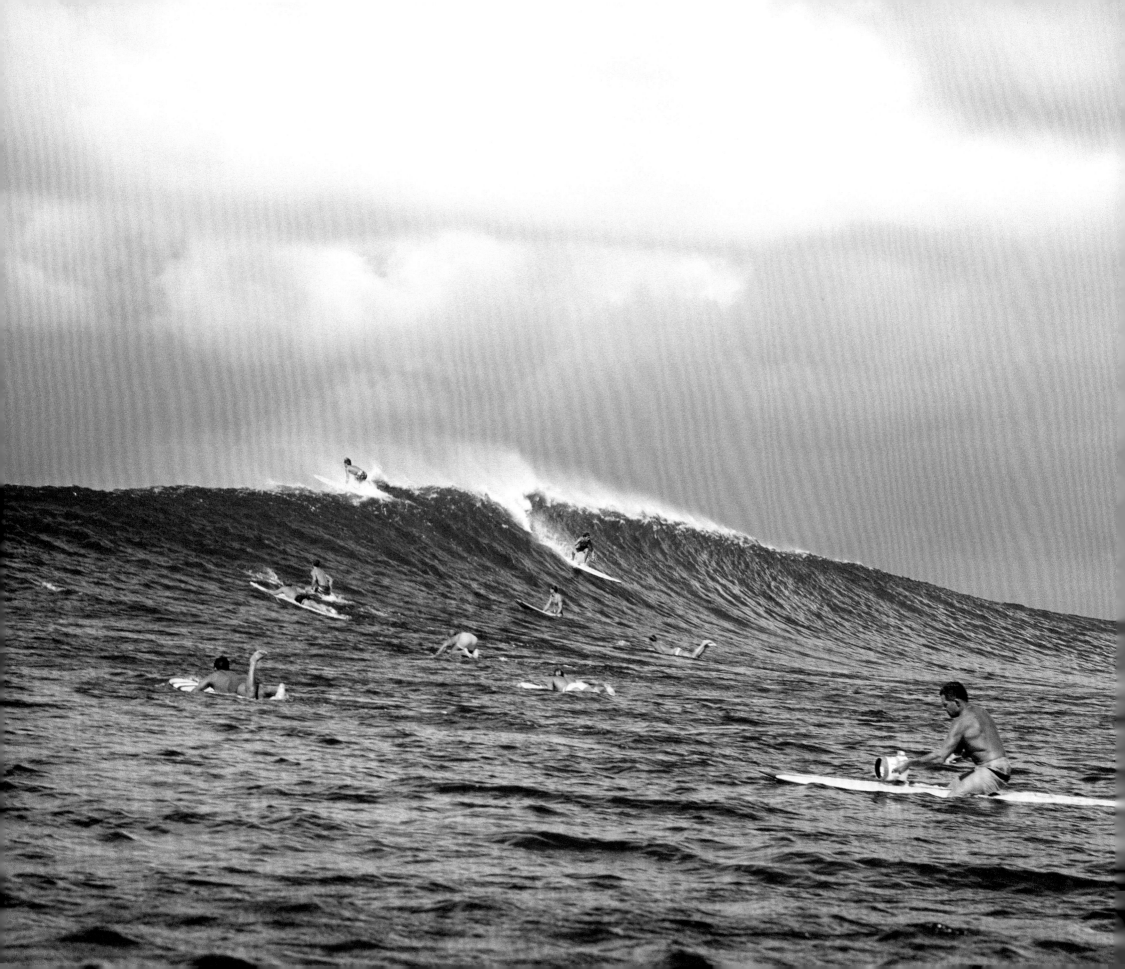

Jeff Hakman, Sunset Beach, 1966

Opposite: Fickle, incredibly powerful, and often crowded, Sunset is still the ultimate litmus test of a complete surfer. Foreground, Don James with his "waterbox" camera.

Gegenüber: Launisch, unglaublich gewaltig und häufig überfüllt: Sunset ist noch immer die ultimative Bewährungsprobe für jeden richtigen Surfer. Im Vordergrund: Don James mit seiner „Waterbox"-Kamera.

Page ci-contre: Imprévisible, d'une puissance inouïe et souvent bondé, le spot de Sunset est un laboratoire idéal pour révéler les nouveaux talents. Au premier plan: Don James avec son appareil photo à «boîtier étanche».

Buzzy Trent, Sunset Beach, 1968

Below: Trent, a holdover from the fifties, was an ace waterman well into the eighties. Shown catching a ride in between lifeguarding duties for the Duke Classic.

Unten: Trent, ein Überbleibsel aus den Fünfzigern, war bis in die Achzigerjahre ein großartiger Wassersportler. Hier surft er zwischen seinen Schichten als Rettungsschwimmer beim Duke Classic.

Ci-dessous: «Rescapé» des années 1950, Buzzy Trent resta un virtuose de la planche jusque dans les années 1980. Sauveteur pendant les épreuves de la Duke Classic, on le voit ici en train de dévaler une vague juste avant de reprendre son service.

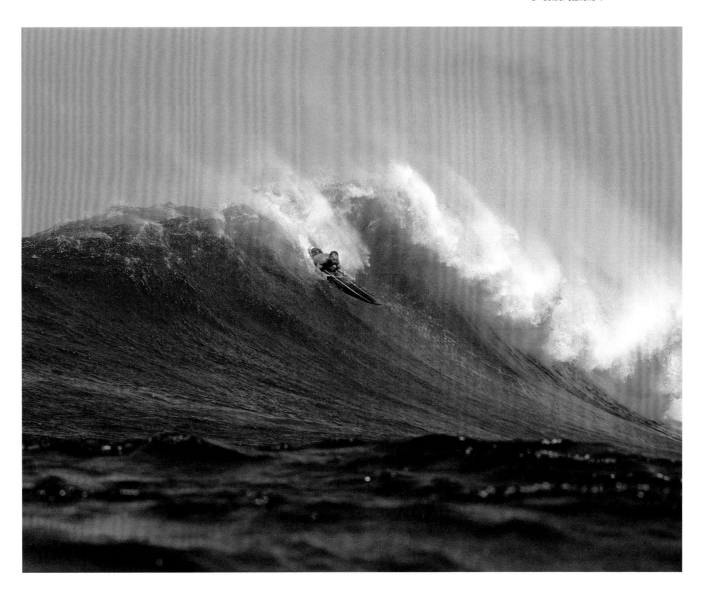

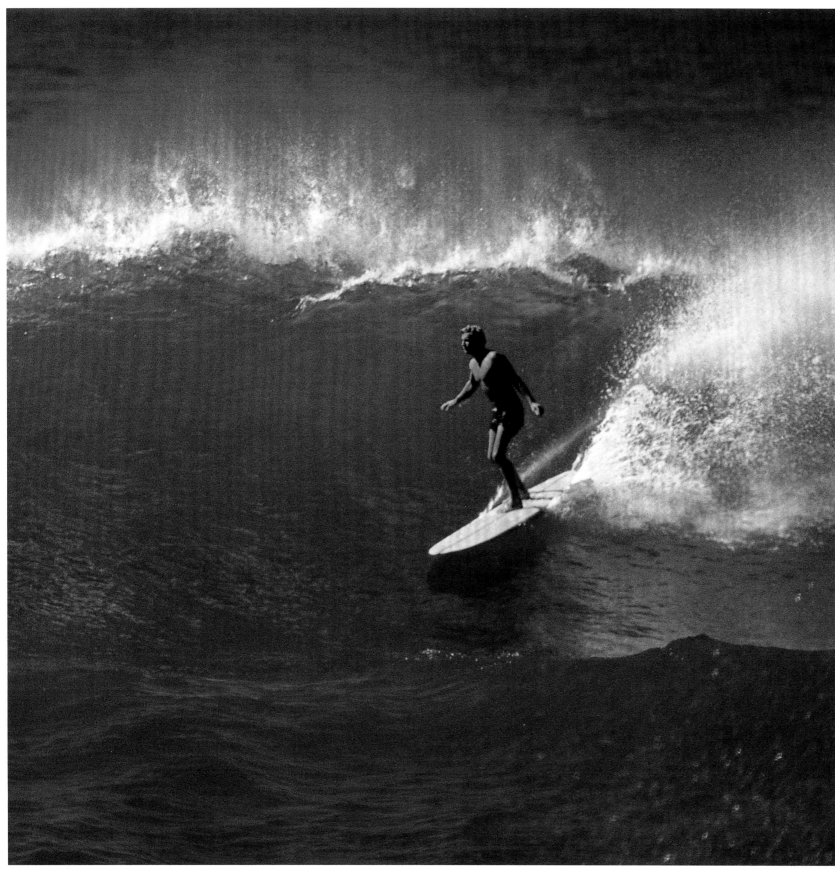

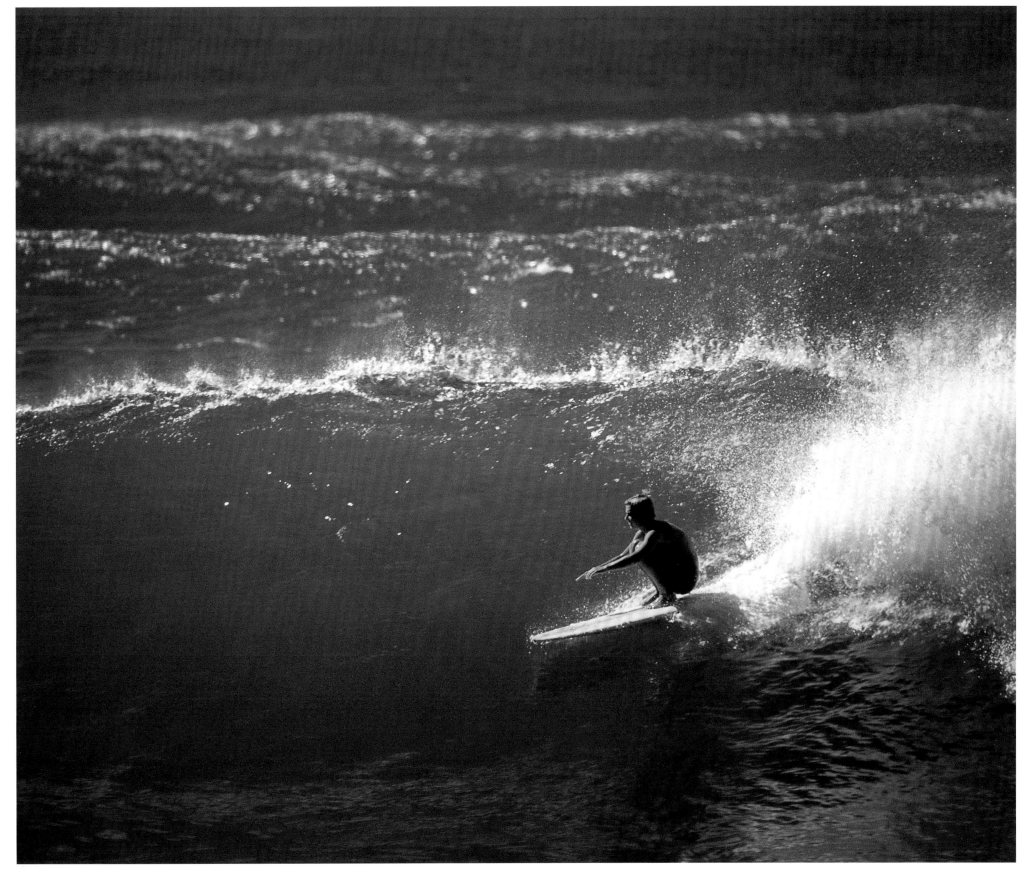

Sunset Beach, 1967

Below: Sunset Point on the North Shore is a powerful magnet for waves as well as surfers.

Unten: Der Sunset Point am North Shore ist ein besonderer Anziehungspunkt für Wellen und Surfer.

Ci-dessous: Sunset Point, sur le North Shore, exerce une attraction littéralement magnétique tant sur les vagues que sur les surfeurs.

Waimea Bay, 1966

Opposite: Left to right, Ron Newman, unidentified, and Ponce Rosa (wiping out). On days this big, surfers have reported seeing huge boulders rolling beneath the waves.

Gegenüber: Von links nach rechts: Ron Newman, ein Unbekannter und Ponce Rosa (beim Hechtsprung). Bei solchem Wellengang haben Surfer schon riesige Felsblöcke unter den Wellen herumrollen sehen.

Page ci-contre: De gauche à droite: Ron Newman, non identifié et Ponce Rosa (en train de plonger). Certains jours de swell comme celui-ci, des surfeurs ont affirmé avoir vu d'énormes galets rochers sous les vagues.

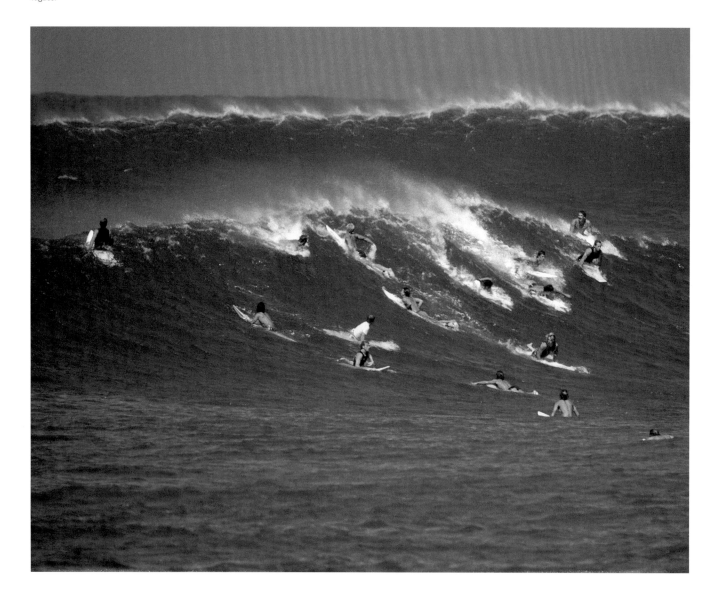

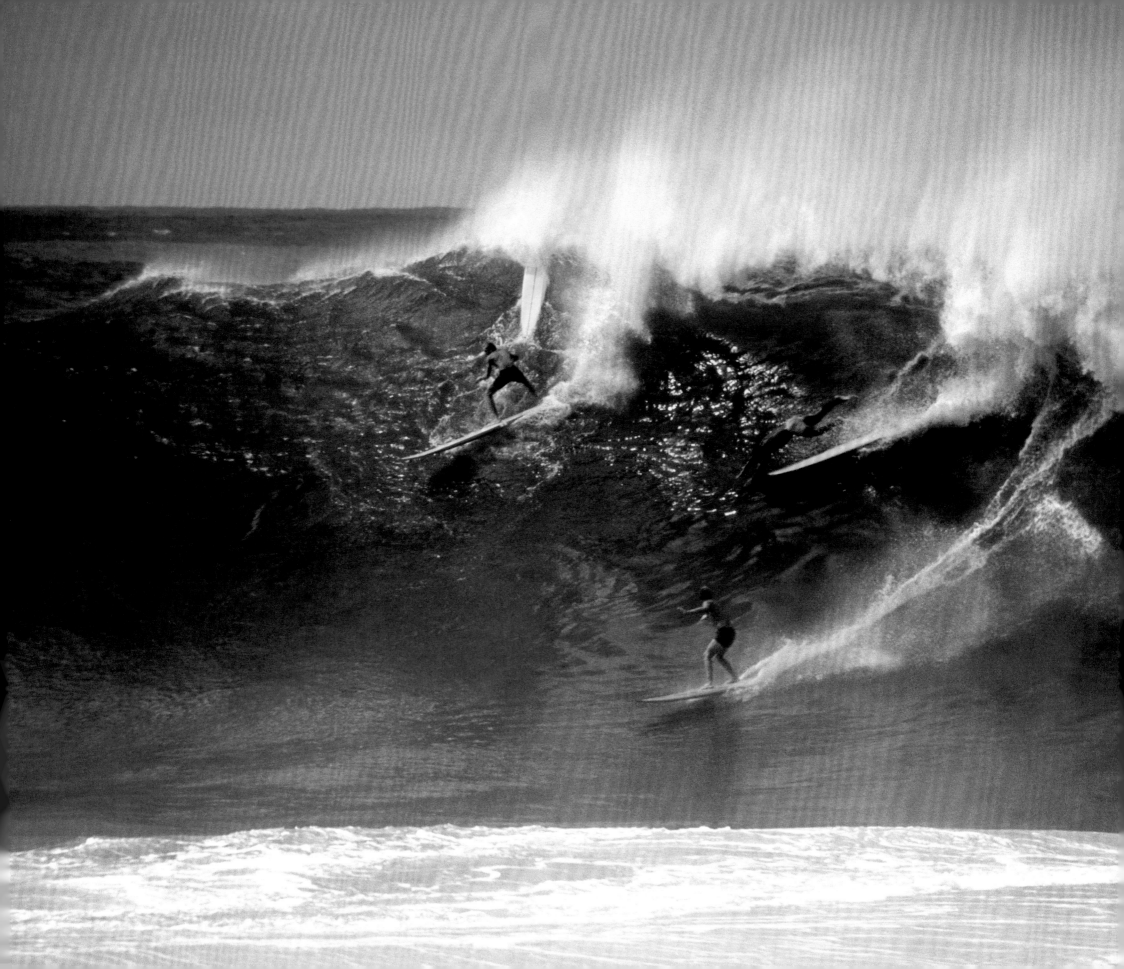

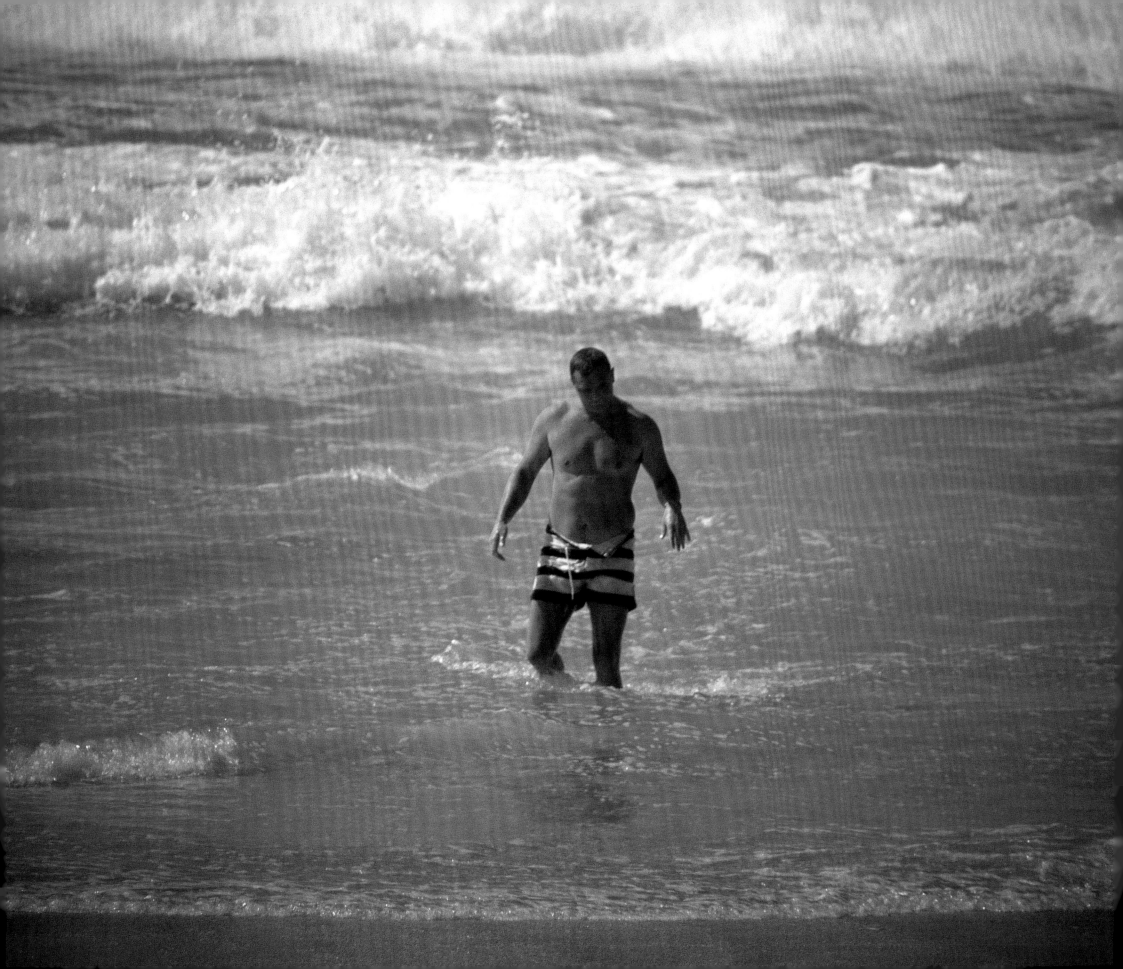

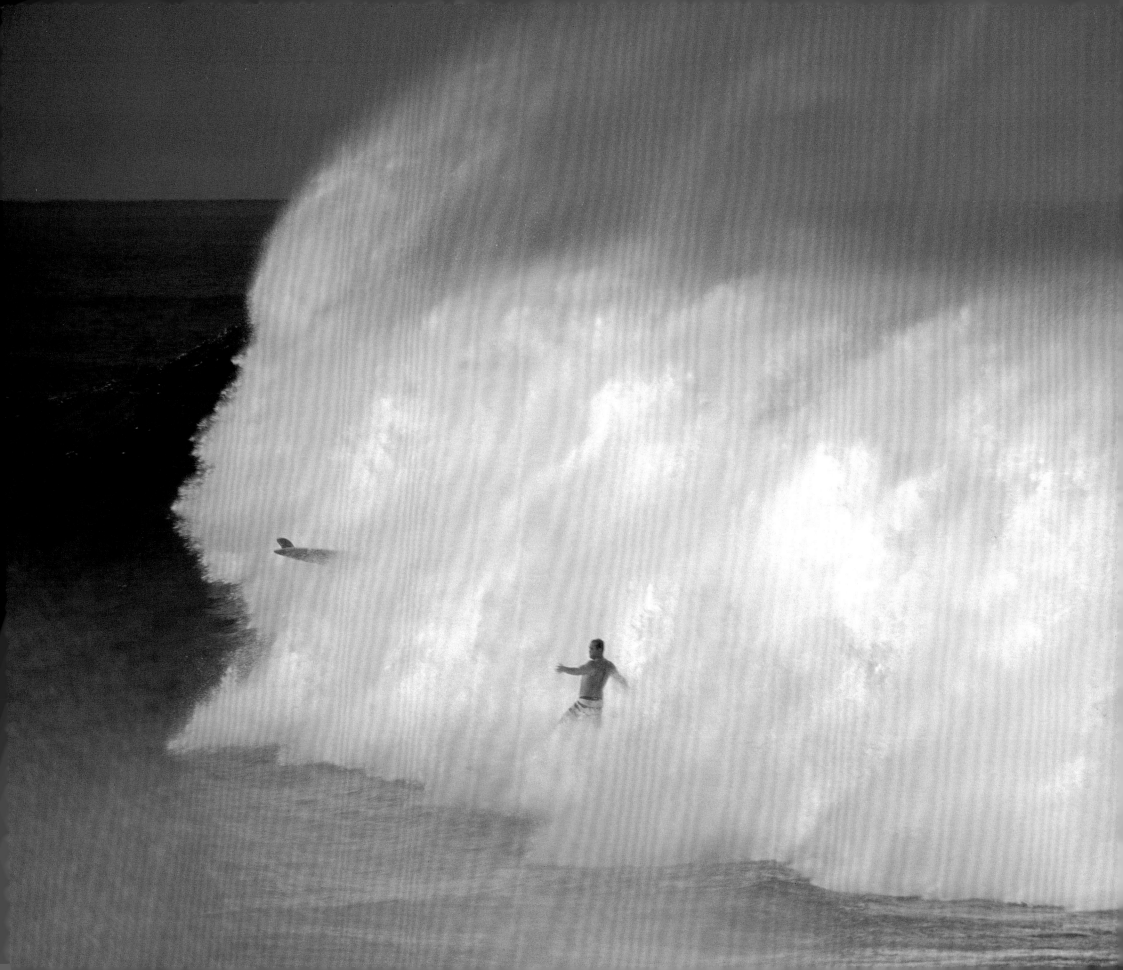

Greg Noll, Pipeline, 1964

Page 190: With his wrestler's build and fearless, bowlegged style of riding big waves, Noll was called "the Bull."

Seite 190: Dank seiner Ringerstatur und seinem furchtlosen, o-beinigen Stil beim Surfen großer Wellen wurde Noll „The Bull" genannt.

Page 190: Sa stature de catcheur, son intrépidité et sa posture arquée à la manière d'un cow-boy lorsqu'il chevauchait les grosses vagues, ont valu à Greg Noll le surnom de « The Bull » (le taureau).

Greg Noll, Waimea Bay, 1966

Page 191: "The Bull" about to be buried by a Waimea avalanche.

Seite 191: „The Bull", kurz bevor er von einer Waimea-Lawine begraben wird.

Page 191 : « The Bull » sur le point de se faire avaler par un monstre à Waimea.

The Calhouns, Makaha, 1962

Below: Real women have curves and surfboards. A famous shot of the Calhoun women. Left to right, Robin, Marge, and Candy.

Unten: Wahre Frauen haben Kurven und Surfbretter. Eine berühmte Aufnahme der Calhoun-Frauen. Von links nach rechts: Robin, Marge und Candy.

Ci-dessous : Les « vraies femmes » ont des courbes … et une planche de surf. Un fameux cliché des « sœurs Calhoun ». De gauche à droite : Robin, Marge et Candy.

Don James, Makaha, 1962

Right: Dr. Don James was Grannis's good friend and surf photography associate for decades.

Rechts: Dr. Don James war für Grannis jahrzehntelang ein guter Freund und Partner bei der Surffotografie.

Ci-contre: Le photographe de surf Don James fut l'associé et le fidèle ami de Grannis pendant de longues années.

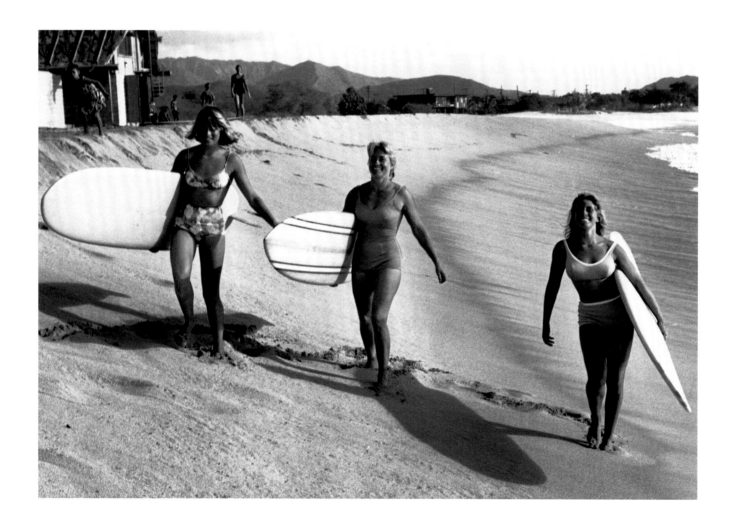

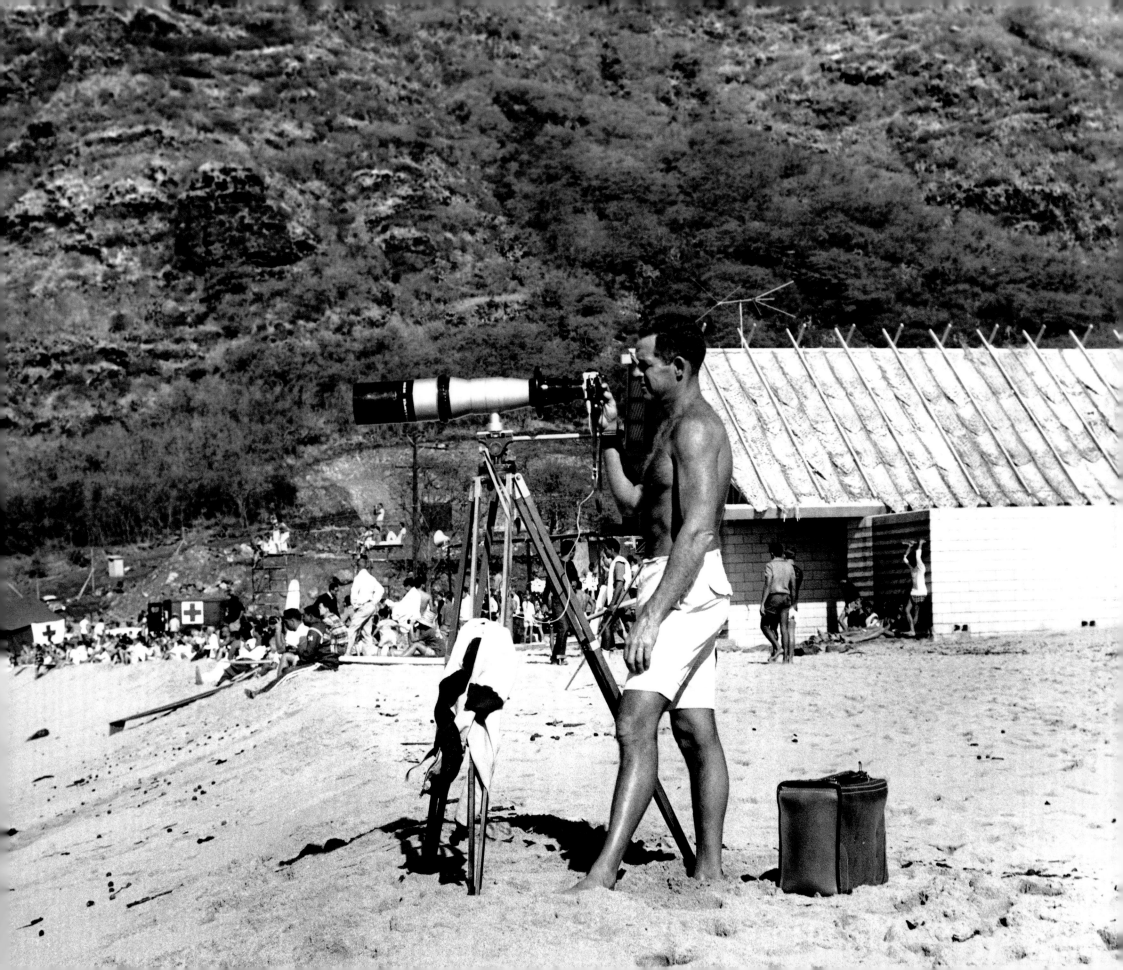

Makaha, 1968

Below. Unten. Ci-dessous.

Makaha, 1964

Opposite: La Jolla's Windansea Surf Club bought this old junker for $65 in Honolulu and made it their official team car for the Makaha Championships. Left to right, Eric Hauser, George Rotgans, Dickie Moon, John Sandera, Rodney Sumpter.

Gegenüber: Der La Jolla Windansea Surf Club kaufte die alte Klapperkiste für 65 Dollar in Honolulu und benutzte sie als offiziellen Team-Wagen für die Makaha Championships. Von links nach rechts: Eric Hauser, George Rotgans, Dickie Moon, John Sandera, Rodney Sumpter.

Page ci-contre: Le Windansea Surf Club de La Jolla acheta cette épave à Honolulu pour 65 dollars et en fit sa voiture d'équipe pour le championnat de Makaha. De gauche à droite: Eric Hauser, George Rotgans, Dickie Moon, John Sandera et Rodney Sumpter.

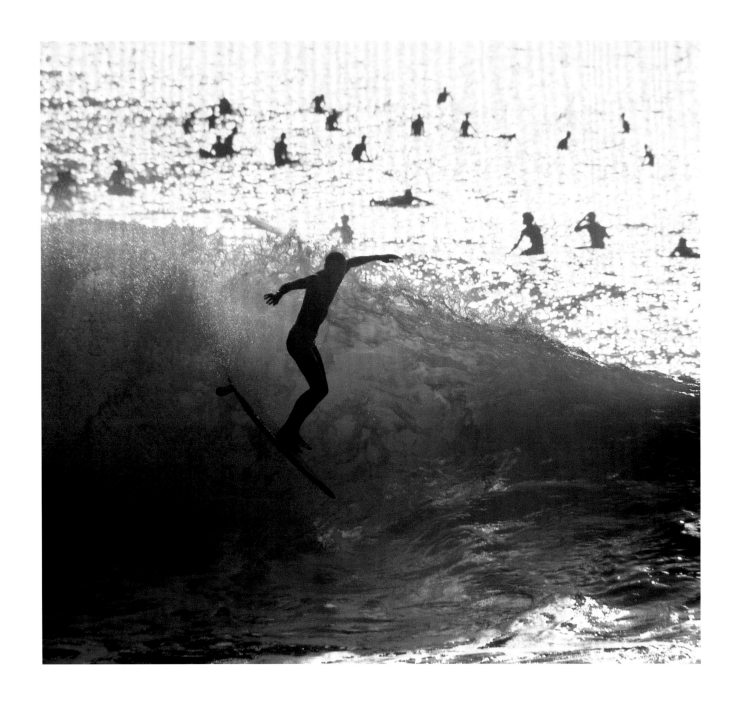

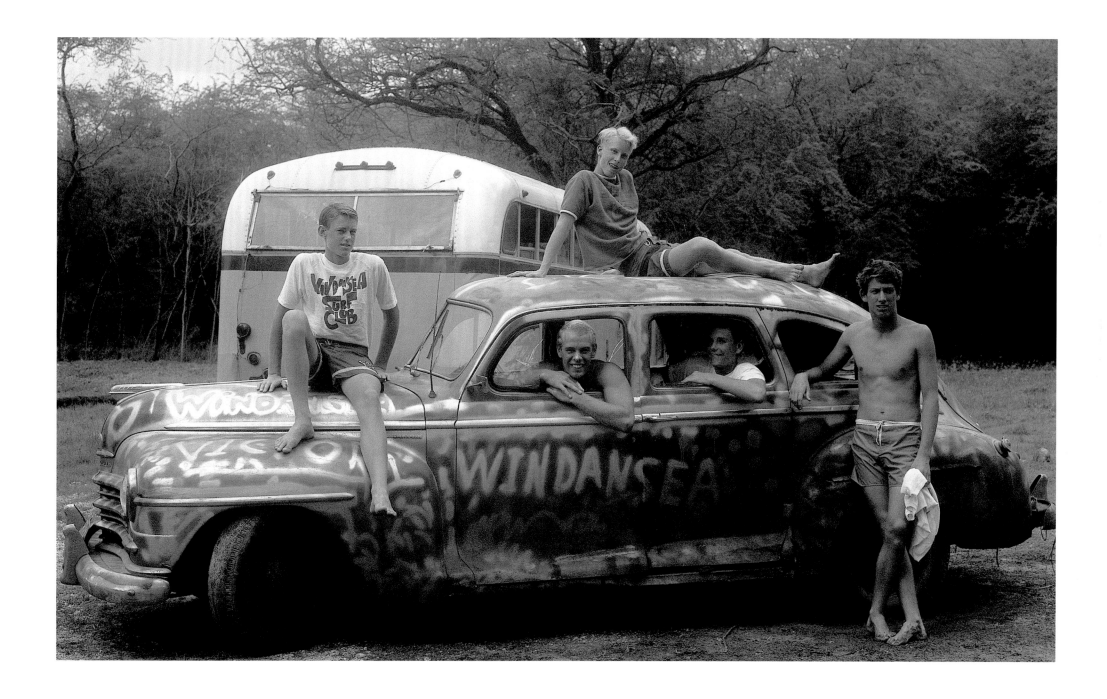

Makaha, 1965

Below: Semifinalists, men's division, Makaha Championships. Left to right, Fred Hemmings Jr., Buffalo Keaulana, Steve Bigler, Dewey Weber, George Downing, Paul Strauch Jr., Joey Cabell, Rick Steere, Kiki Spangler, Ken Rocky, Ben Aipa, Aka Hemmings, Mike Doyle. Downing won the contest.

Unten: Teilnehmer am Halbfinale der Männer, Makaha Championships. Von links nach rechts: Fred Hemmings Jr., Buffalo Keaulana, Steve Bigler, Dewey Weber, George Downing, Paul Strauch Jr., Joey Cabell, Rick Steere, Kiki Spangler, Ken Rocky, Ben Aipa, Aka Hemmings, Mike Doyle. Downing gewann den Wettbewerb.

Ci-dessous : Semi-finalistes des épreuves masculines du championnat de Makaha. De gauche à droite : Fred Hemmings Jr., Buffalo Keaulana, Steve Bigler, Dewey Weber, George Downing (vainqueur), Paul Strauch Jr., Joey Cabell, Rick Steere, Kiki Spangler, Ken Rocky, Ben Aipa, Aka Hemmings et Mike Doyle.

Windansea Surf Club, Makaha, 1964

Opposite: The star-studded Windansea Club at the height of the amateur contest era. Top row, left to right, Lee Kiefer, Diane Bolton, Mike Hynson, Mickey Muñoz, J. J. Moon, Hobie Alter, Donald Takayama, Ken Adler, Robert Keneally, Rodney Sumpter, Lee Lewis, Thor Svenson, Chuck Hasley, Joey Cabell. Middle row, left to right, Eric Hauser, Chris Prowse, Don Schmidt, Dickie Moon, Dede Arevalos, Joyce Hoffman, Howard Chapleau, Billy Hamilton, Barry Kanaiaupuni, Skip Frye, Joey Hamasaki, Judy Dibble. Bottom row, left to right, David Adams, Steve Jenner, Steve Broda, Petey Johnson, George Rotgans, Bob Moore, Mike Purpus, John Sandera, Dru Harrison.

Gegenüber: Der vor Stars wimmelnde Windansea Club auf dem Höhepunkt der Ära der Amateur-Wettbewerbe. Obere Reihe, von links nach rechts: Lee Kiefer, Diane Bolton, Mike Hynson, Mickey Muñoz, J. J. Moon, Hobie Alter, Donald Takayama, Ken Adler, Robert Keneally, Rodney Sumpter, Lee Lewis, Thor Svenson, Chuck Hasley, Joey Cabell. Mittlere Reihe, von links nach rechts: Eric Hauser, Chris Prowse, Don Schmidt, Dickie Moon, Dede Arevalos, Joyce Hoffman, Howard Chapleau, Billy Hamilton, Barry Kanaiaupuni, Skip Frye, Joey Hamasaki, Judy Dibble. Untere Reihe, von links nach rechts: David Adams, Steve Jenner, Steve Broda, Petey Johnson, George Rotgans, Bob Moore, Mike Purpus, John Sandera, Dru Harrison.

Page ci-contre : La piste aux étoiles du Windansea Club à l'époque glorieuse des compétitions d'amateurs. Rangée du haut, de gauche à droite : Lee Kiefer, Diane Bolton, Mike Hynson, Mickey Muñoz, J. J. Moon, Hobie Alter, Donald Takayama, Ken Adler, Robert Keneally, Rodney Sumpter, Lee Lewis, Thor Svenson, Chuck Hasley et Joey Cabell ; rangée du milieu, de gauche à droite : Eric Hauser, Chris Prowse, Don Schmidt, Dickie Moon, Dede Arevalos, Joyce Hoffman, Howard Chapleau, Billy Hamilton, Barry Kanaiaupuni, Skip Frye, Joey Hamasaki et Judy Dibble ; rangée du bas, de gauche à droite : David Adams, Steve Jenner, Steve Broda, Petey Johnson, George Rotgans, Bob Moore, Mike Purpus, John Sandera et Dru Harrison.

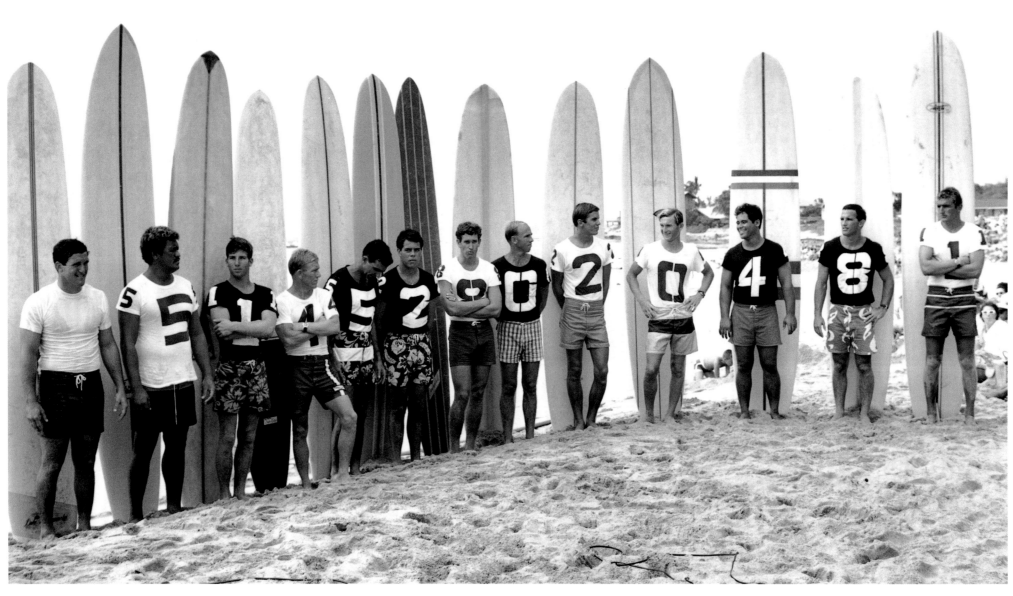

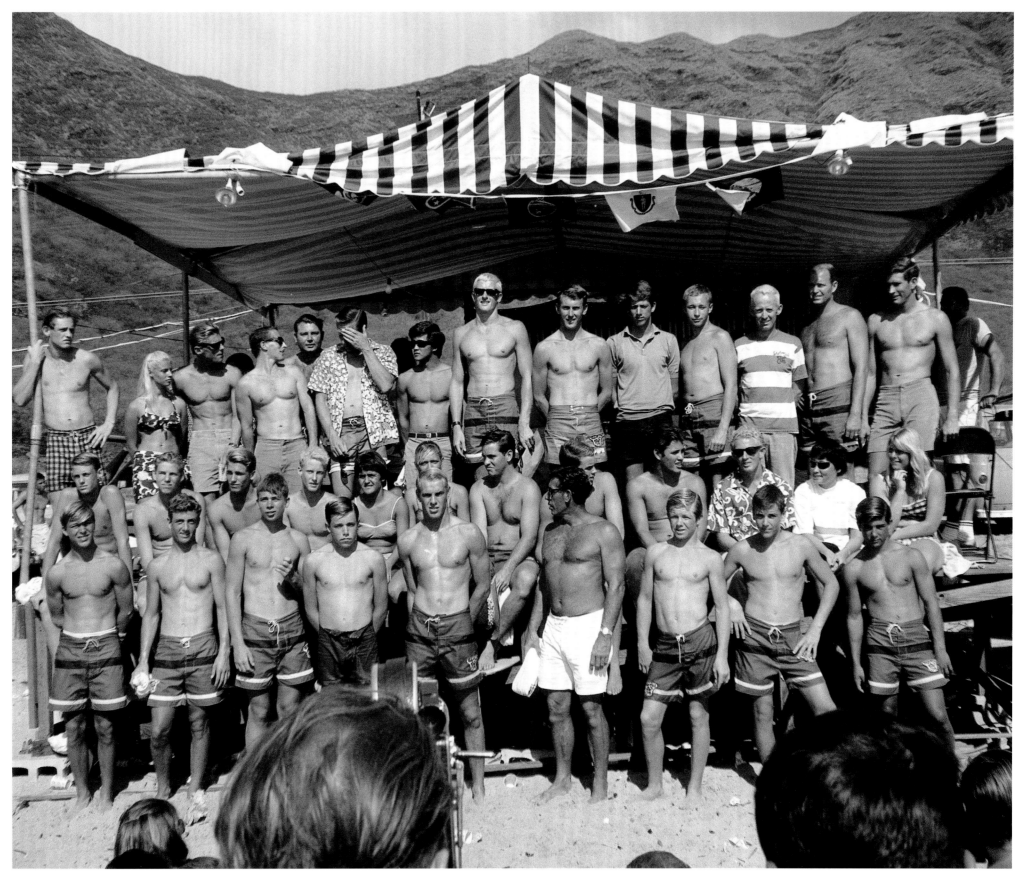

Joyce Hoffman, Margo Godfrey, Makaha, 1968

Below: Just prior to the Makaha contest's women's finals. La Jolla's Godfrey (later Oberg) would eventually win the championship.

Unten: Unmittelbar vor dem Finale der Frauen beim Wettbewerb von Makaha. Godfrey (später Oberg) aus La Jolla gewann den Wettbewerb.

Ci-dessous: Quelques minutes avant la finale féminine du championnat de Makaha. L'épreuve fut remportée par Margo Godfrey (plus tard Oberg) du club de La Jolla.

Duke Classic Finalists, Sunset Beach, 1968

Opposite: Left to right, Rusty Miller, Mike Doyle, Rick Grigg. Using a lightweight board he'd shaped in California only two days before, Doyle won the contest in eighteen-foot surf.

Gegenüber: Von links nach rechts: Rusty Miller, Mike Doyle, Rick Grigg. Mit einem leichten Board, das er nur zwei Tage zuvor in Kalifornien geshapt hatte, gewann Doyle den Wettbewerb in achtzehn Fuß, d.h. über sechs Meter hohen Wellen.

Page ci-contre: De gauche à droite: Rusty Miller, Mike Doyle et Rick Grigg. Sur une planche légère qu'il a shapée en Californie deux jours plus tôt, Doyle remporte l'épreuve de la « dix-huit pieds » (vague de plus de six mètres).

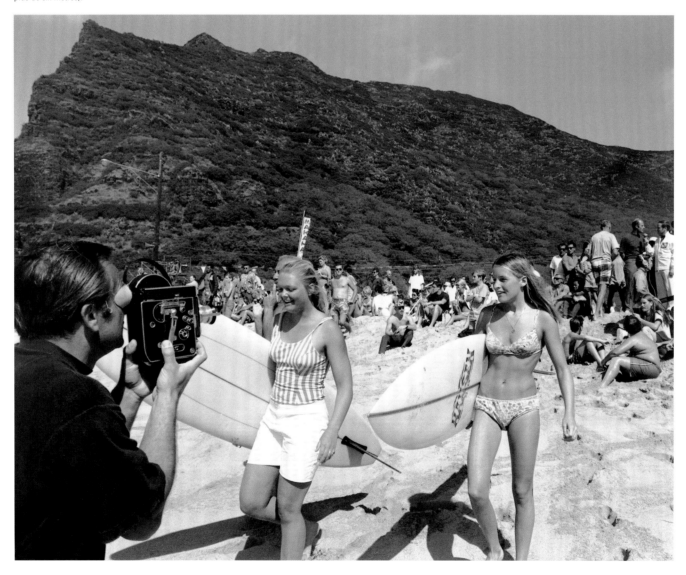

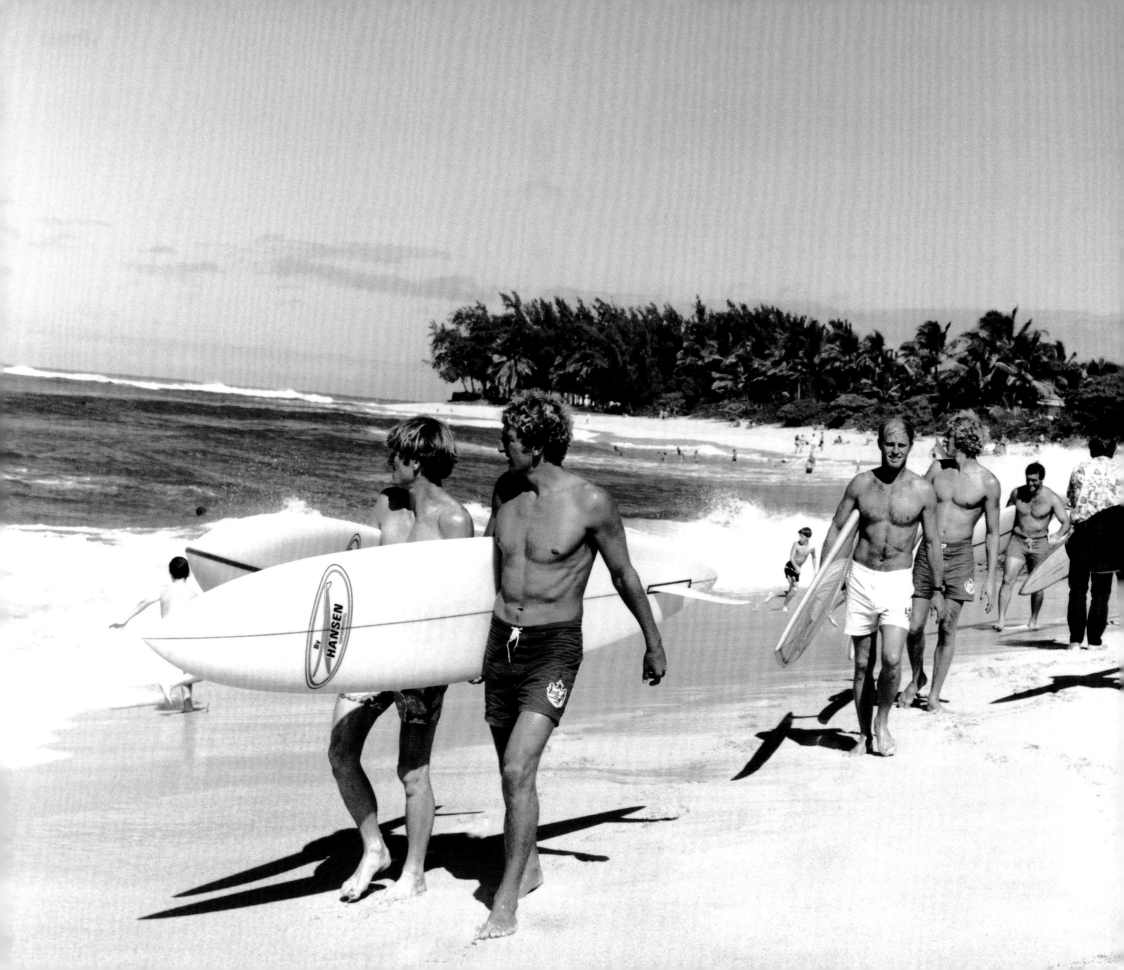

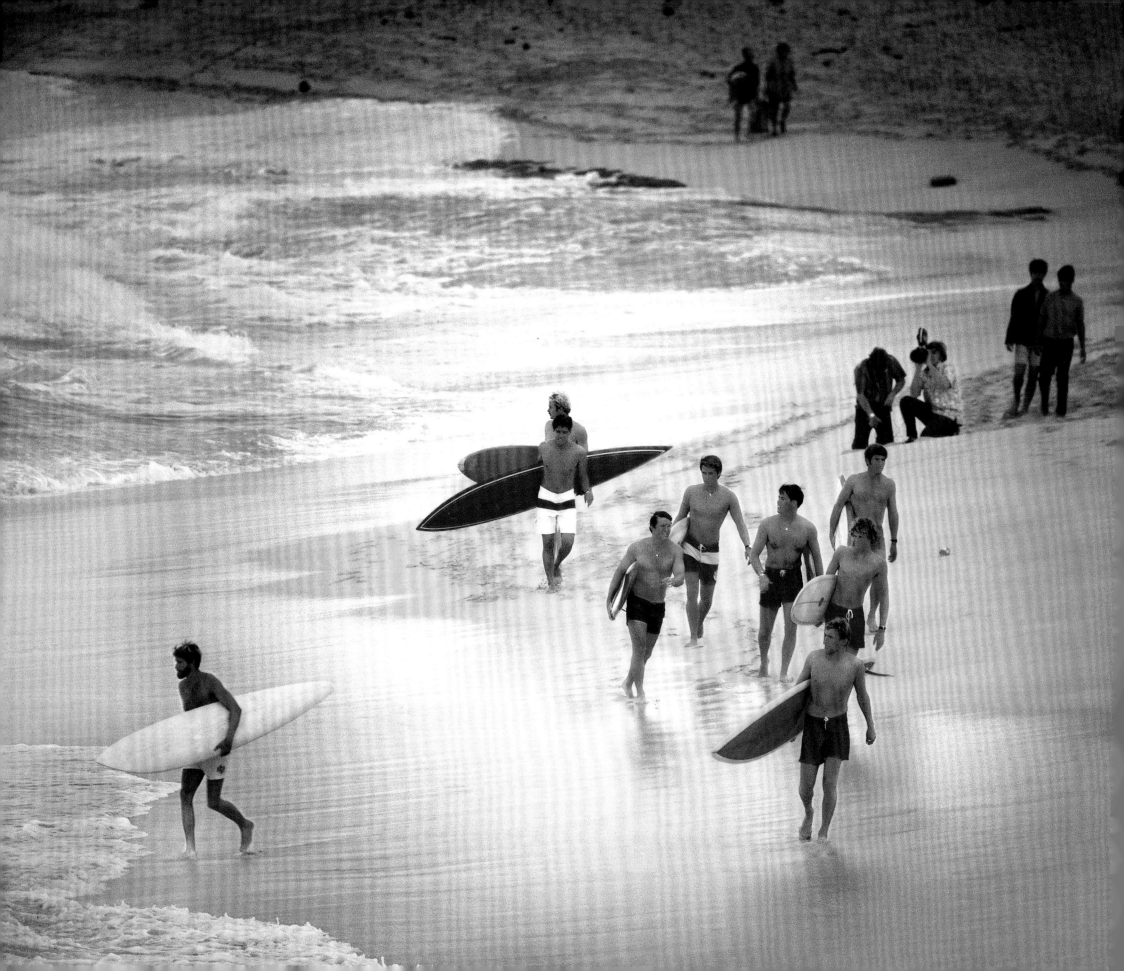

Duke Classic Finalists, Sunset Beach, 1969

Opposite: Left to right, Joey Cabell, Eddie Aikau, Billy Hamilton, Fred Hemmings, Gordo Barreda, Paul Strauch Jr., Mike Doyle, Rolf Aurness, Felipe Pomar.

Gegenüber: Von links nach rechts: Joey Cabell, Eddie Aikau, Billy Hamilton, Fred Hemmings, Gordo Barreda, Paul Strauch Jr., Mike Doyle, Rolf Aurness, Felipe Pomar.

Page ci-contre: De gauche à droite: Joey Cabell, Eddie Aikau, Billy Hamilton, Fred Hemmings, Gordo Barreda, Paul Strauch Jr., Mike Doyle, Rolf Aurness et Felipe Pomar.

Makaha Championships, 1963

Below. Unten. Ci-dessous.

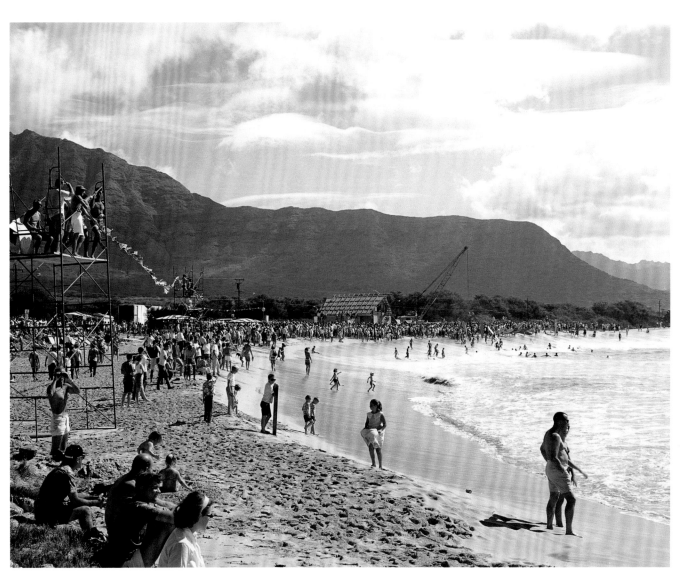

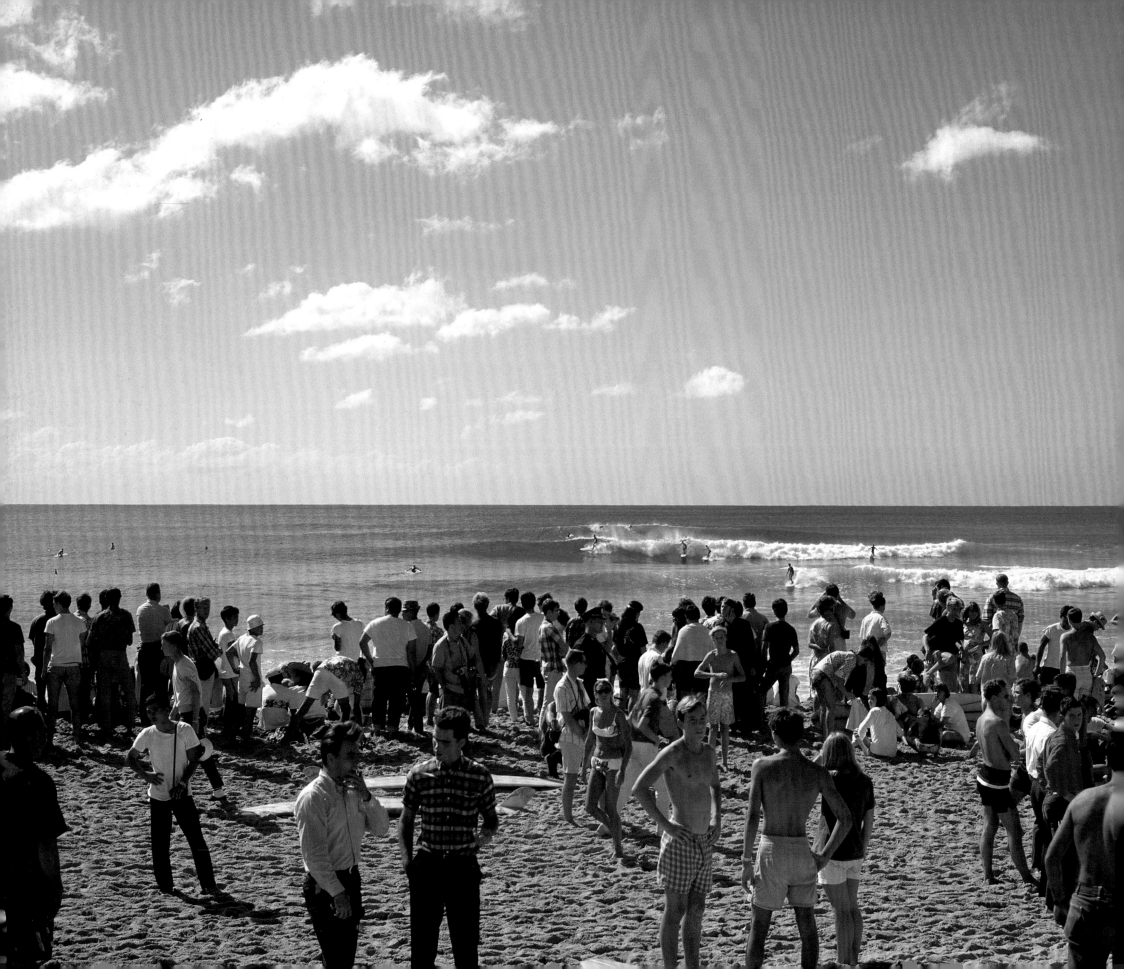

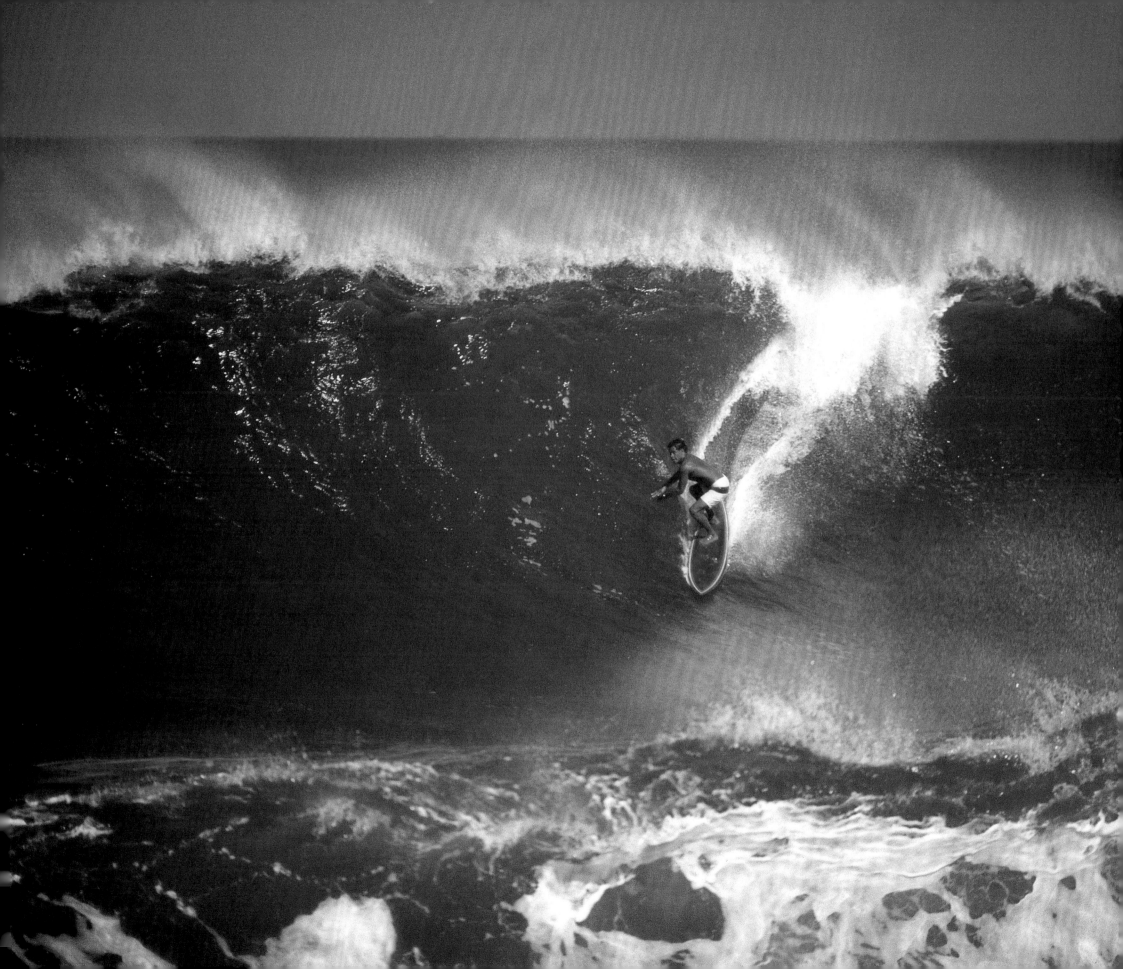

Makaha Championships, 1963

Page 202. Seite 202. Page 202.

Eddie Aikau, Haleiwa, circa 1972

Page 203: A kingly big-wave surfer and the North Shore's first professional lifeguard, Aikau later lost his life in 1978 while attempting to paddle twelve miles at night for help after the sailing canoe *Hokule'a* overturned in the Molokai Channel.

Seite 203: Aikau, der großartige Big-Wave-Surfer und erste professionelle Rettungsschwimmer am North Shore, kam 1978 ums Leben, als er versuchte, bei Nacht zwanzig Kilometer zu paddeln, um Hilfe für das Segelkanu *Hokule'a* zu holen, das im Molokai-Kanal gekentert war.

Page 203: Le roi du *big-wave riding* Eddie Aikau, qui fut aussi le premier sauveteur professionnel du North Shore, est mort en 1978 alors qu'il tentait de parcourir, en pleine nuit et à la seule force des ses bras, les vingt kilomètres qui le séparaient de la côte pour chercher du secours après le dessalage du catamaran *Hokule'a* dans le canal de Molokai.

Pupukea, North Shore, 1971

Below: Waiting for a lull between big waves.

Unten: Warten auf eine Lücke zwischen den großen Wellen.

Ci-dessous: En attendant un creux entre deux grosses vagues.

Duke Classic Contestants, Sunset Beach, 1972

Opposite: Terry "Speed Sultan" Fitzgerald and Leroy Dennis just prior to their contest heat. Fitzgerald was famed for his beautiful boards, decorated by Martin Worthington.

Gegenüber: Terry „Speed Sultan" Fitzgerald und Leroy Dennis direkt vor ihrem Wettbewerbs-Heat. Fitzgerald war für seine schönen, von Martin Worthington gestalteten Bretter bekannt.

Page ci-contre: Terry « Speed Sultan » Fitzgerald et Leroy Dennis juste avant leur *heat*. Fitzgerald était réputé pour ses planches magnifiquement décorées par Martin Worthington.

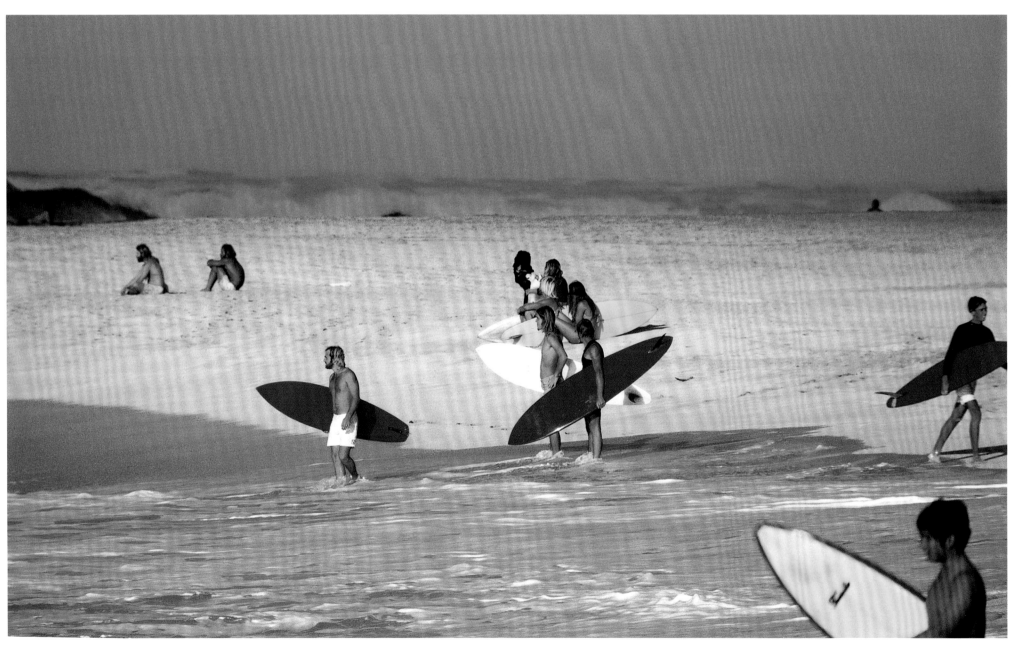

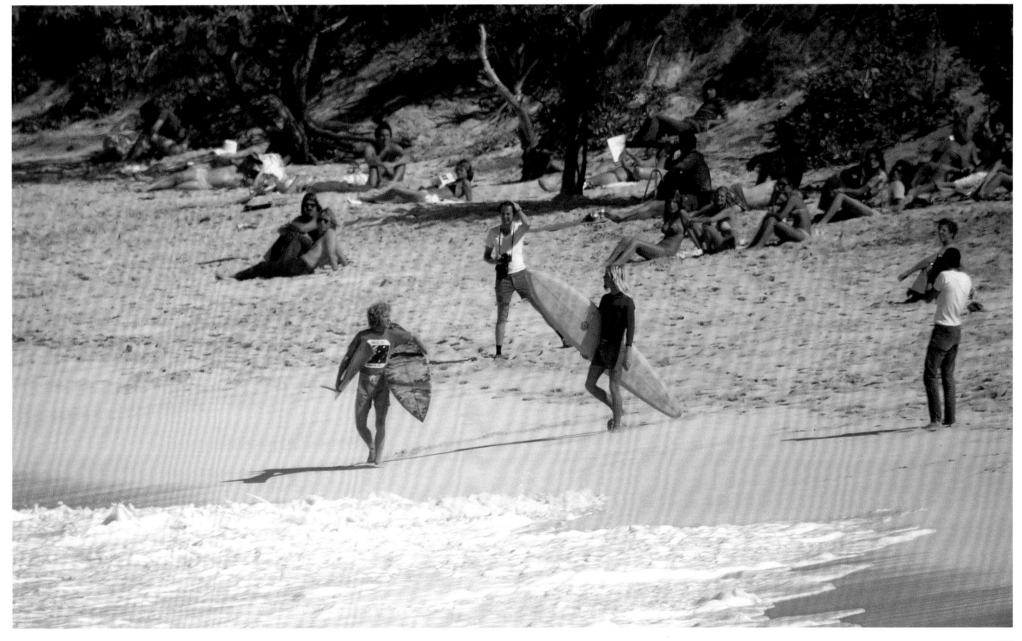

Mike Doyle, Sunset Beach, 1968

Opposite: Doyle shortly before the Duke Classic at surf filmmaker Val Valentine's Sunset Point house, the unofficial contest headquarters. "Val's Reef" is named after Valentine.

Gegenüber: Doyle kurz vor dem Duke Classic beim Haus des Surfregisseurs Val Valentine in Sunset Point, dem inoffiziellen Wettkampfzentrum. Das „Val's Reef" ist nach Valentine benannt.

Page ci-contre: Mike Doyle peu avant les épreuves de la Duke Classic devant la maison du réalisateur de films de surf Val Valentine à Sunset Point, Q. G. officieux de la compétition. Valentine a donné son nom au spot de « Val's Reef ».

Charlie Galento, North Shore, 1966

Right: Galento was one of the unsung surfers who kept riding Waimea when big-wave popularity dipped in the seventies. He's shown with his "speed paddleboard."

Rechts: Galento war einer der vielen Surfer, die weiter in Waimea surften, als die Popularität des Big-Wave-Surfing in den Siebzigern zurückging. Hier sieht man ihn mit seinem „Speed Paddleboard".

Ci-contre: Charlie Galento faisait partie de ces surfeurs de l'ombre qui ont continué à surfer les grosses vagues de Waimea jusque dans les années 1970 malgré la baisse de popularité du *big-wave riding*. On le voit ici avec son « speed paddleboard ».

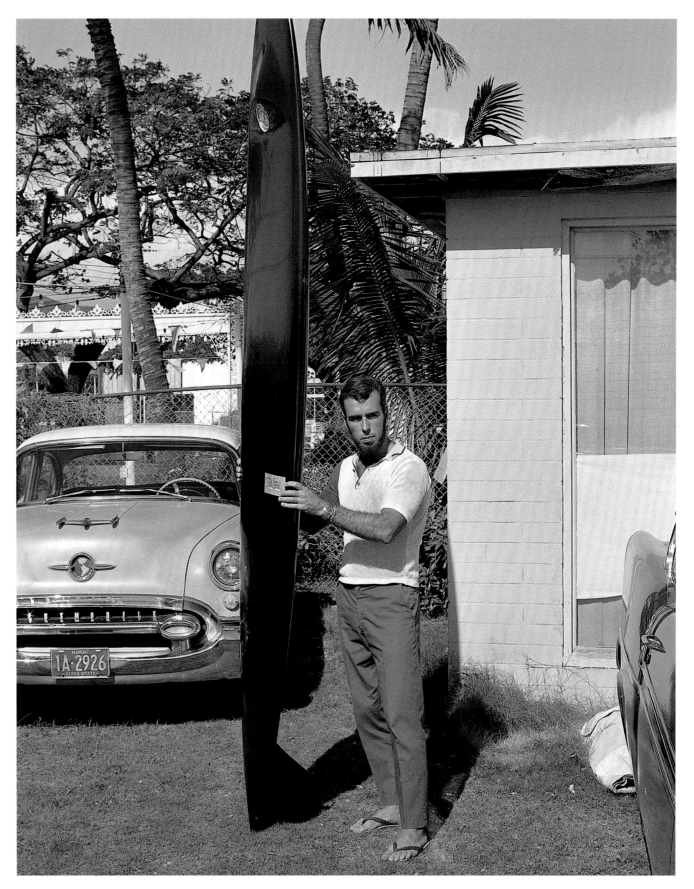

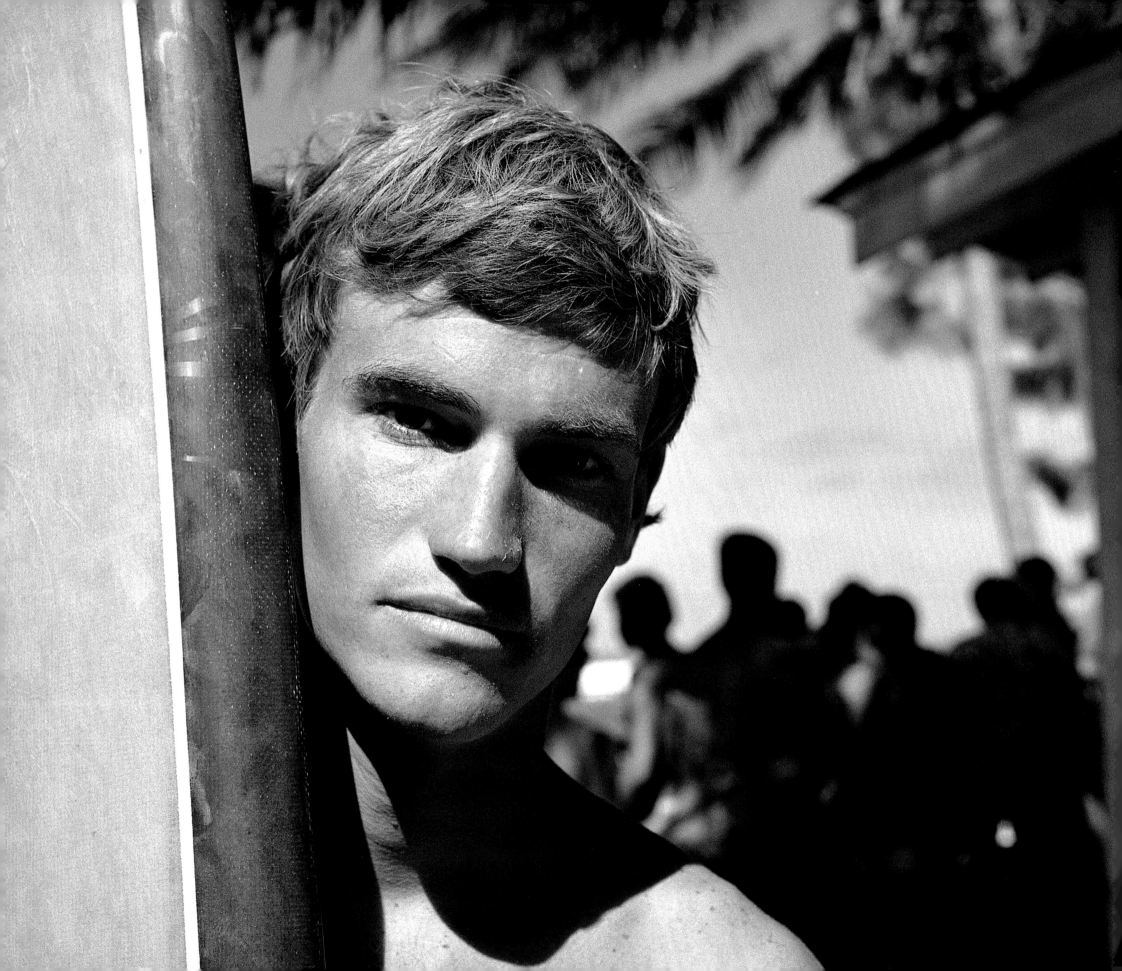

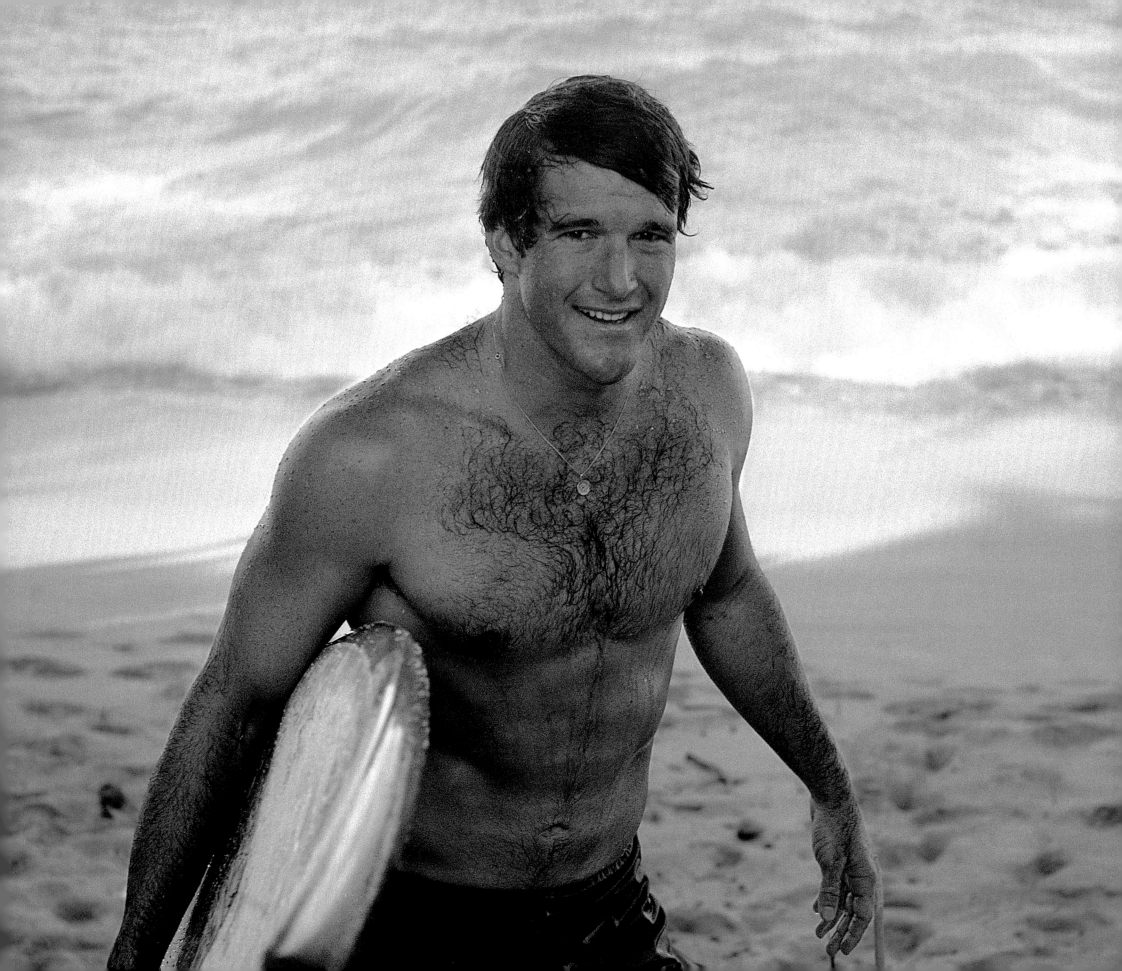

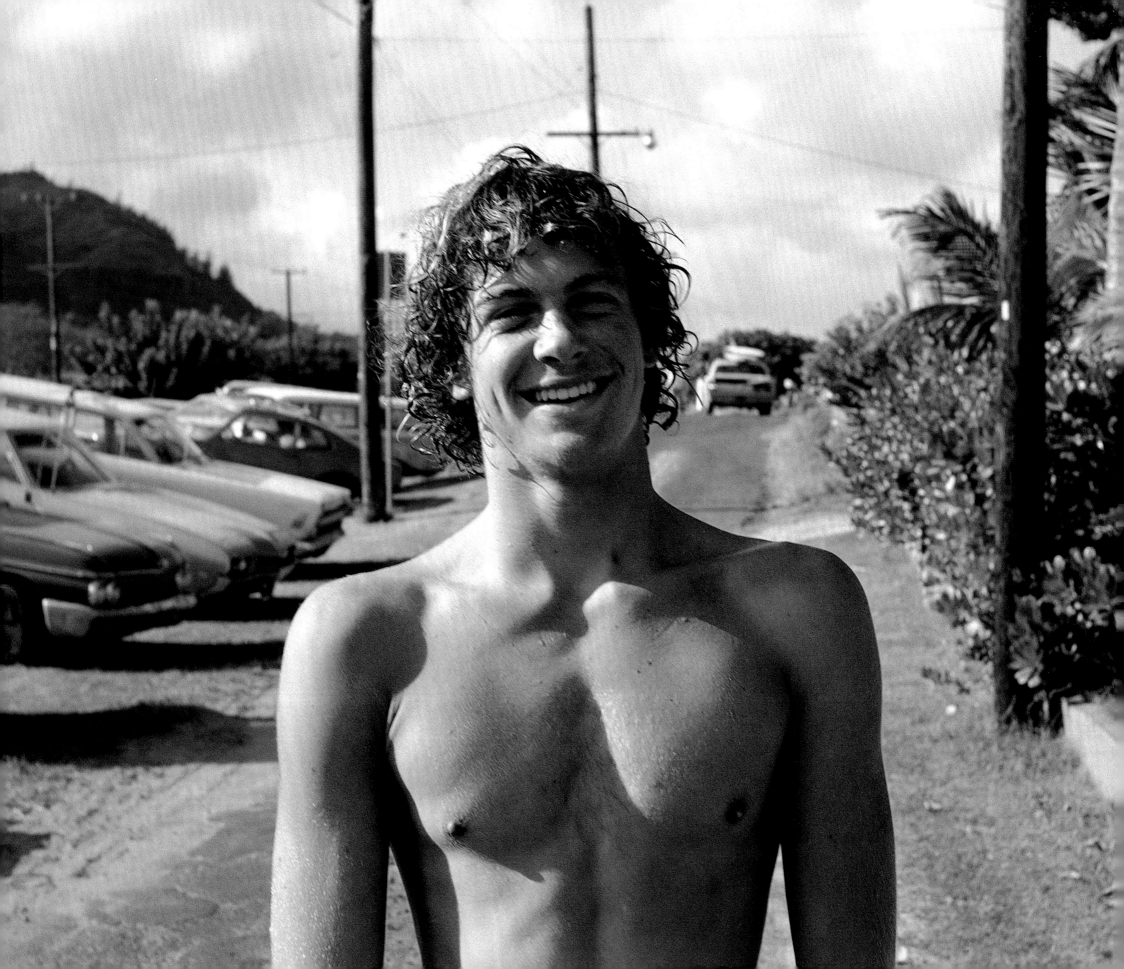

Jock Sutherland, North Shore, 1968

Page 208: Nicknamed "the Extraterrestrial" for his brilliant LSD-fueled style, Sutherland surfed Waimea alone, at night, in 1969. He called Pipeline "the Pope's living room."

Seite 208: Für seinen genialen, LSD-inspirierten Stil wurde Sutherland „The Extraterrestrial" genannt. 1969 surfte er Waimea allein bei Nacht. Er nannte die Pipeline „das Wohnzimmer des Papstes".

Page 208: Surnommé « L'Extraterrestre » en raison de son style génial et psychédélique – inspiré par le LSD –, Jock Sutherland a surfé Waimea seul et de nuit en 1969. Il a surnommé le spot de Pipeline « Le Salon du pape ».

Fred Hemmings, North Shore, 1969

Page 209: Hemmings, a sixties North Shore regular, would go on to found the first professional surfing circuit and become a Hawaii state representative.

Seite 209: Hemmings war in den Sechzigern regelmäßig am North Shore. Er gründete später den ersten professionellen weltweiten Surfwettbewerb und wurde Politiker in Hawaii.

Page 209: Fred Hemmings, un habitué du North Shore dans les années 1960, lança par la suite le premier rendez-vous mondial du circuit professionnel et fut élu à la Chambre des représentants de l'État de Hawaï.

Rolf Aurness, Sunset Beach, 1969

Opposite: The soft-spoken Californian won a world championship in 1970 and then quickly dropped out of the public eye. "I don't know how to be famous," he said.

Gegenüber: Der zurückhaltende Kalifornier wurde 1970 Weltmeister und verschwand dann schnell aus dem Blickfeld der Öffentlichkeit. „Ich kann mit dem Berühmtsein nichts anfangen", sagte er.

Page ci-contre: De nature discrète et débonnaire, le Californien Rolf Aurness fut sacré champion du monde en 1970 avant de se retirer provisoirement de la scène publique. « Je n'ai pas d'aptitude à la célébrité », confia-t-il un jour.

Margo Godfrey, Makaha, 1968

Below: Shown here at fifteen, shortly before she won the first of four world championships.

Unten: Im Alter von fünfzehn Jahren, kurz bevor sie den ersten ihrer vier Weltmeistertitel gewann.

Ci-dessous: Margo Godfrey à l'âge de quinze ans, peu avant le premier de ses quatre titres de championne du monde.

Eddie Aikau, Waimea, 1972

Below: The motto for the prestigious "Eddie" invitational big-wave contest now held at Waimea is "Eddie Would Go."

Unten: Das Motto des renommierten „Eddie"-Invitational Big-Wave-Wettbewerbs, der in Waimea stattfindet, lautet: „Eddie Would Go".

Ci-dessous: « Eddie Would Go » (Eddie n'hésiterait pas) est devenu la célèbre devise de la compétition de grosses vagues Eddie invitational qui se dispute aujourd'hui à Waimea.

Rick Grigg, Waimea, 1972

Opposite: Grigg, who holds a doctorate in oceanography, spent fifteen days underwater in SEALAB II in 1965 as part of a NASA project.

Gegenüber: Grigg, ein Doktor der Ozeanografie, verbrachte 1965 fünfzehn Tage unter Wasser im SEALAB II als Teil eines Projekts der NASA.

Page ci-contre: Rick Grigg, titulaire d'un doctorat en océanographie, a passé quinze jours à bord du bathyscaphe SEALAB II en 1965 dans le cadre d'une mission pour la NASA.

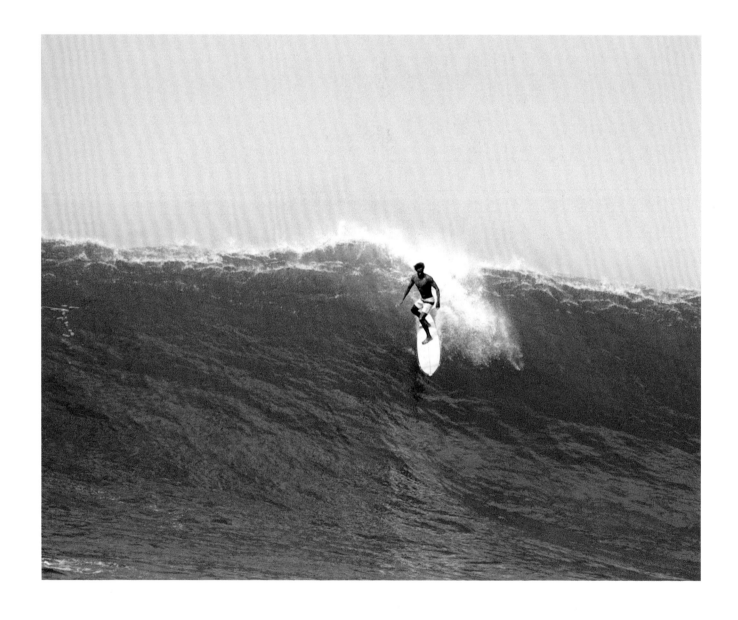

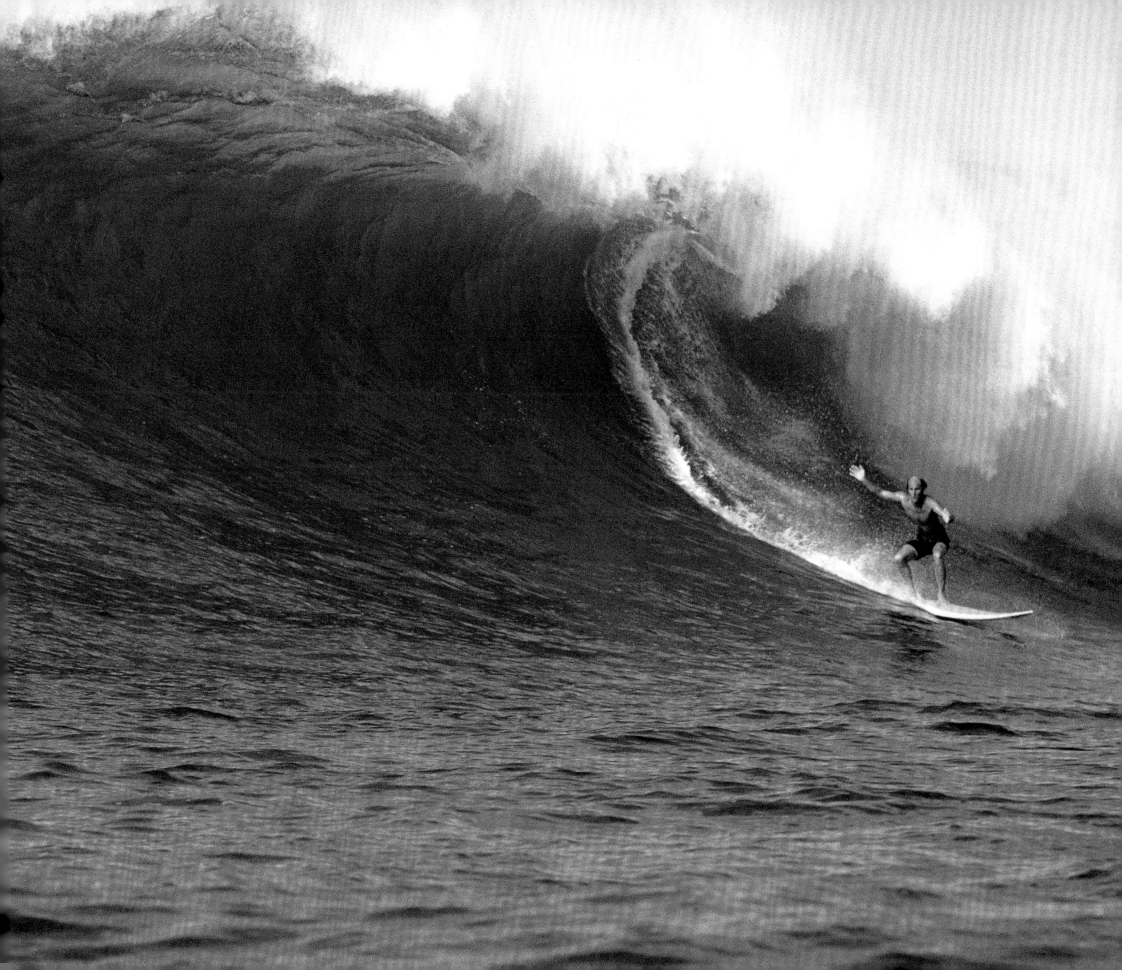

Jeff Hakman, Rick Grigg, Waimea Bay, 1974

Below. Unten. Ci-dessous.

Sunset Beach, 1971

Opposite: Very risky "elevator-drop" free-fall. It's likely this surfer got pitched and beaten up badly over Sunset's "Boneyard" reef.

Gegenüber: Ein sehr riskanter „Elevator-Drop" mit freiem Fall. Wahrscheinlich stürzte dieser Surfer und verletzte sich am „Boneyard Reef".

Page ci-contre: Un périlleux « elevator-drop » (chute d'ascenseur). Le surfeur a toutes les chances d'être précipité dans le creux de la vague et de heuter violemment le récif de « Boneyard » (littéralement, « l'ossuaire »).

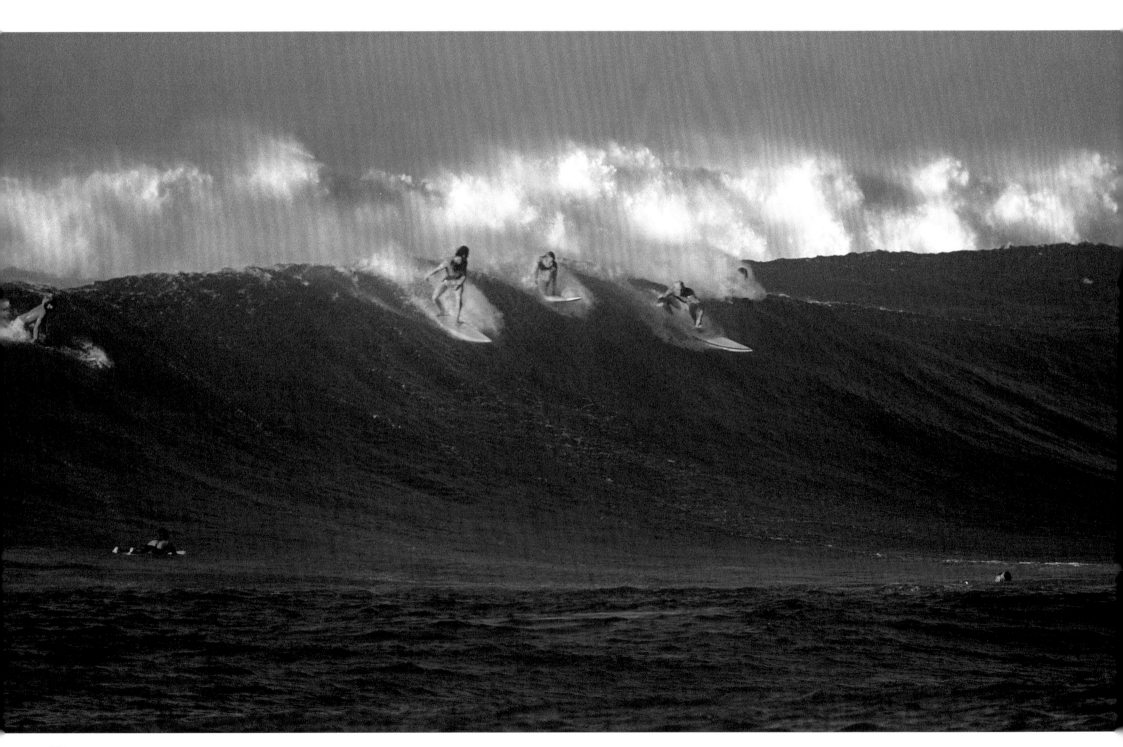

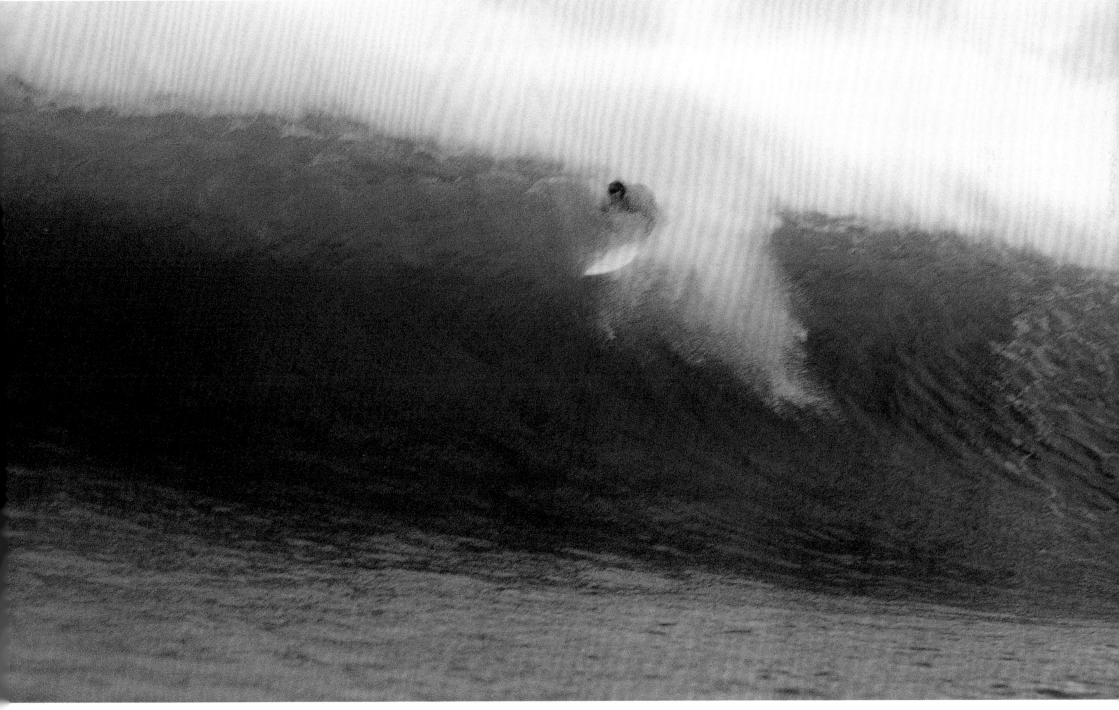

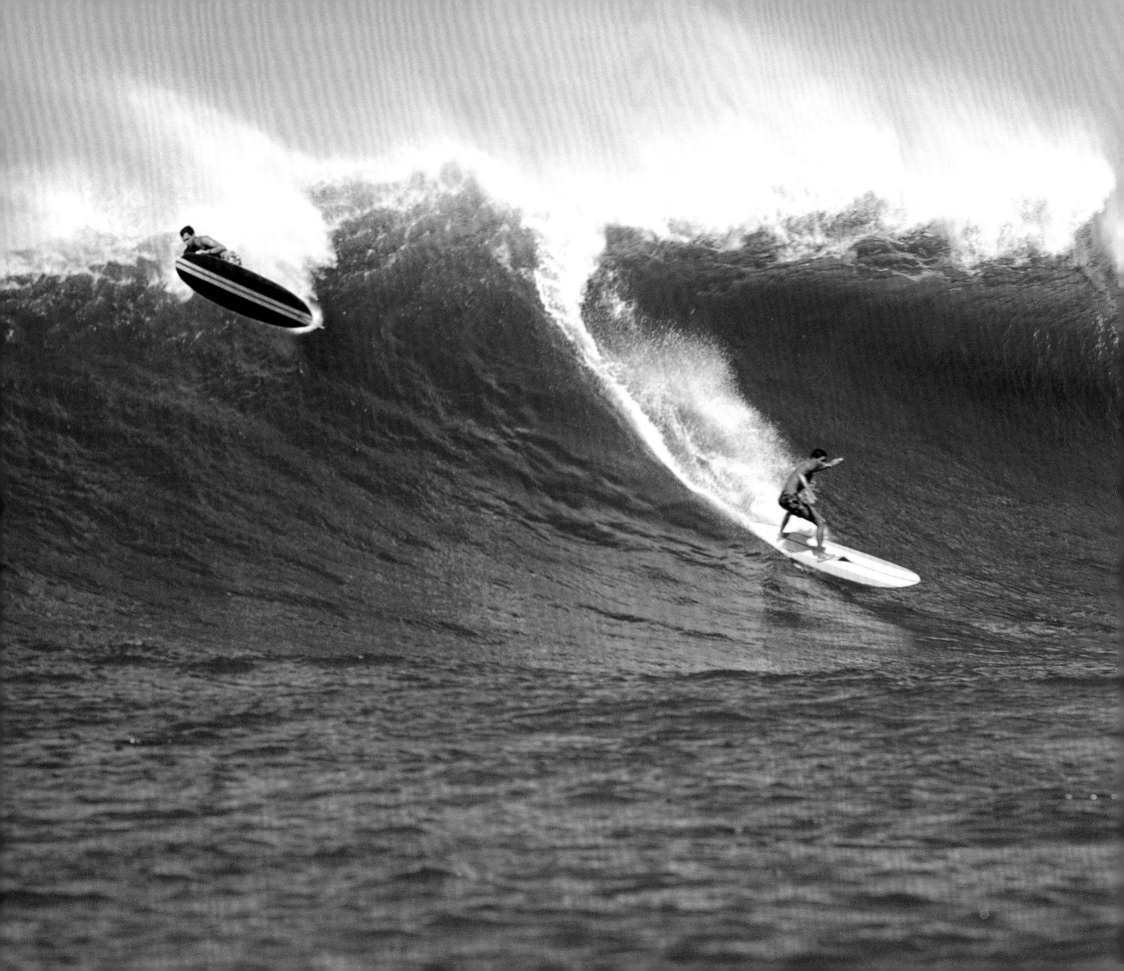

Jackie Eberle, Waimea Bay, 1964

Opposite: Two-time Duke Classic winner Eberle talked softly but surfed big. He was one of the best of the first generation of surfers to tackle Pipeline.

Gegenüber: Der zweimalige Duke Classic-Sieger Eberle sprach leise, surfte aber aufsehenerregend. Er gehörte zu den besten der ersten Surfergeneration, die sich an die Pipeline wagten.

Page ci-contre: La nature débonnaire du double vainqueur de la Duke Classic Jackie Eberle tranchait avec sa témérité à toute épreuve. Il fut l'un des plus brillants surfeurs de la première génération à dompter les swells de Pipeline.

Sammy Lee, Sunset Beach, 1971

Below: Lee was an early Waimea star. He's shown here trying to outrace a fast, treacherous Sunset tube.

Unten: Lee war in den frühen Tagen ein Star in Waimea. Hier sieht man ihn beim Wettrennen mit einer schnellen, tückischen Sunset-Tube.

Ci-dessous: Sammy Lee compte parmi les stars de la première heure de Waimea. On le voit ici en train de se mesurer à un *tube* redoutablement puissant de Sunset Beach.

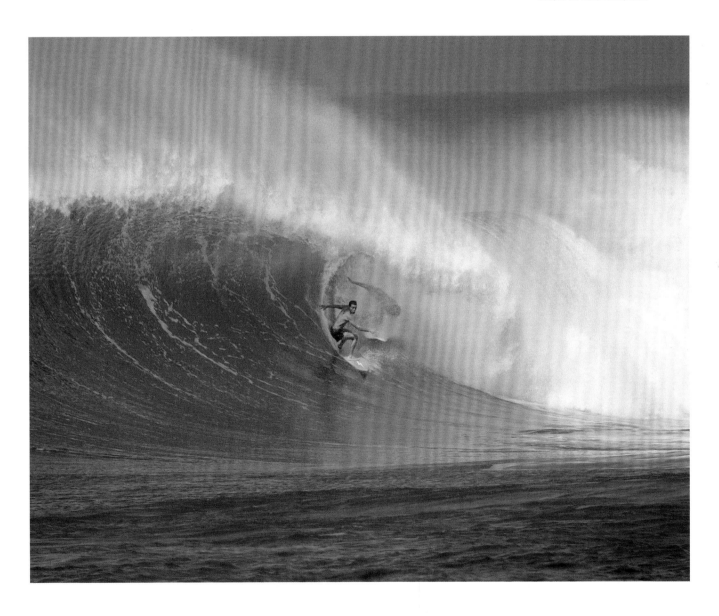

Makaha, 1966

Below: The infamous Makaha shore break launches another victim. This classic shot has been used in many advertisements.

Unten: Der berüchtigte Shorebreak von Makaha findet ein weiteres Opfer. Diese klassische Aufnahme wurde in vielen Werbeanzeigen verwendet.

Ci-dessous: Le surfeur malchanceux est terrassé par l'impitoyable *shore break* de Makaha. Ce cliché devenu célèbre fut utilisé dans de nombreuses publicités.

Pipeline, 1971

Opposite: Pipeline is notorious for breaking bodies and boards. The jagged coral reef lies only two meters under this unlucky surfer.

Gegenüber: Pipeline ist berüchtigt für das Brechen von Knochen und Brettern. Das zerklüftete Korallenriff liegt nur zwei Meter unter diesem unglücklichen Surfer.

Page ci-contre: Le spot de Pipeline est connu pour briser les reins… et les planches. Les rochers déchiquetés de son récif de corail affleurent à deux mètres seulement au-dessous de ce surfeur infortuné.

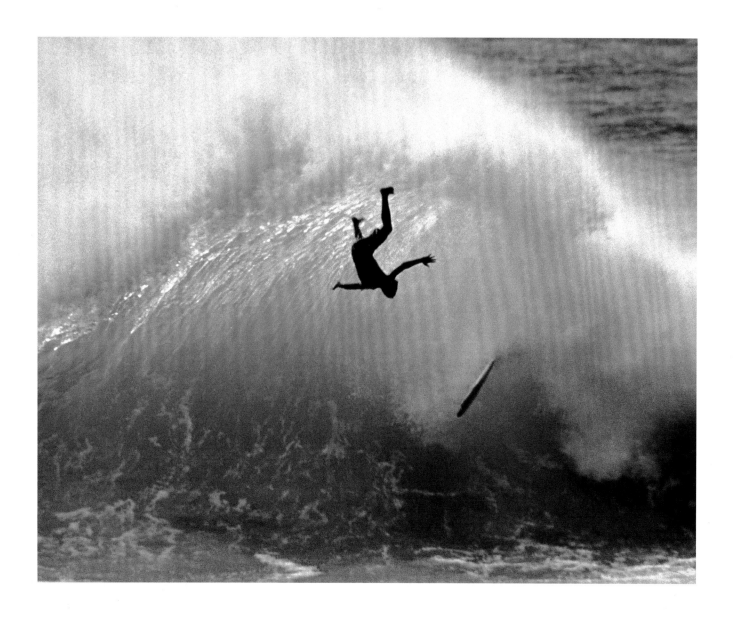

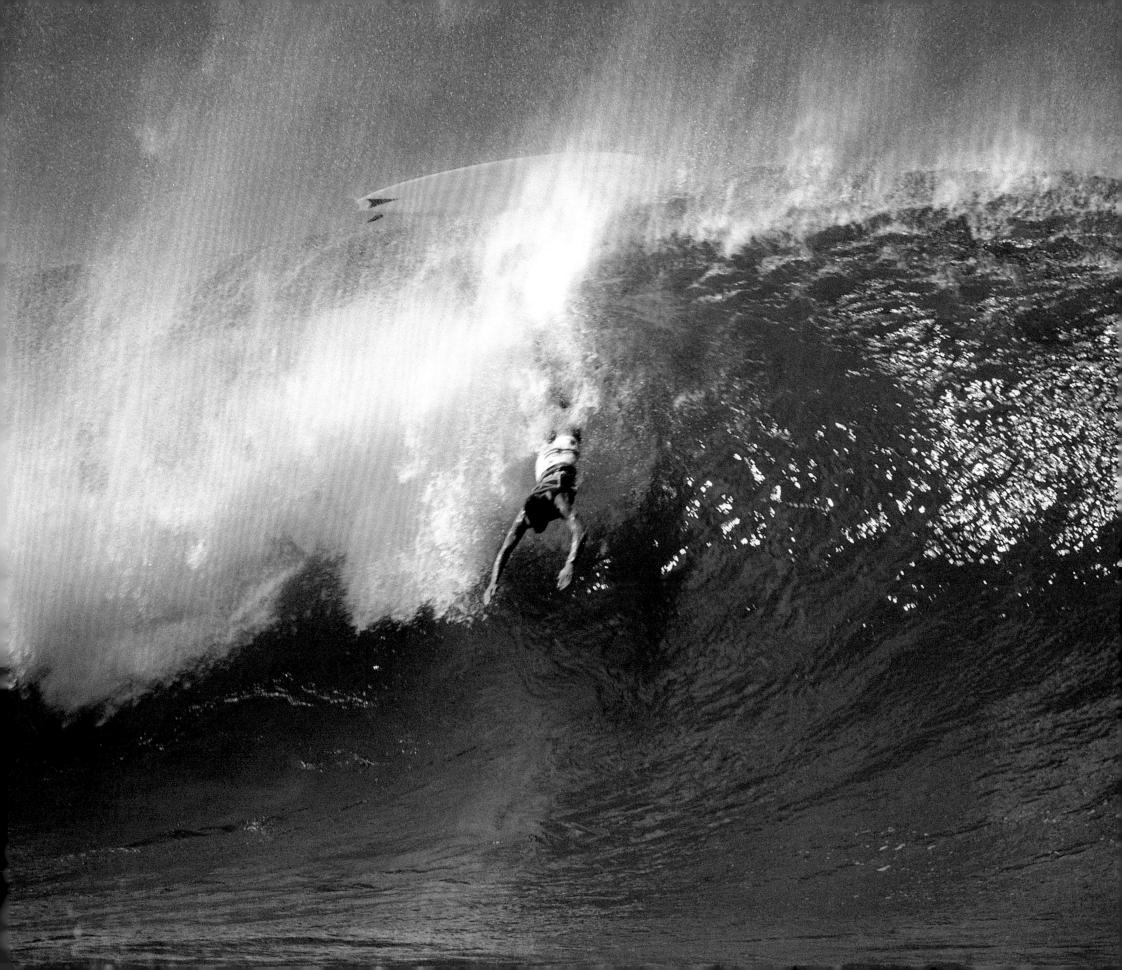

Pipeline, 1967

Below. Unten. Ci-dessous.

Sunset Beach, 1972

Opposite: A quick exit out the back of a nonnegotiable Sunset wave.

Gegenüber: Eine schnelle Flucht nach hinten aus einer nicht zu bewältigenden Sunset-Welle.

Page ci-contre: Face à ce monstre indomptable de Sunset Beach, une seule échappatoire: passer par derrière.

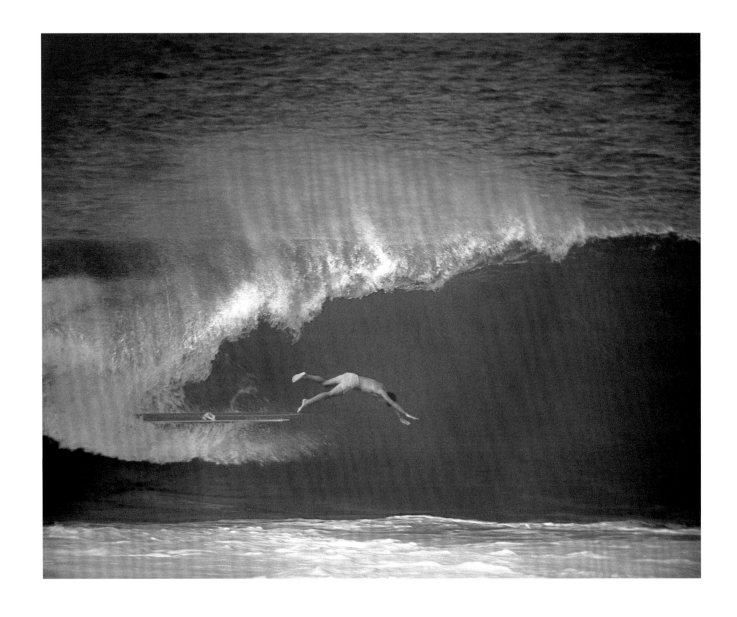

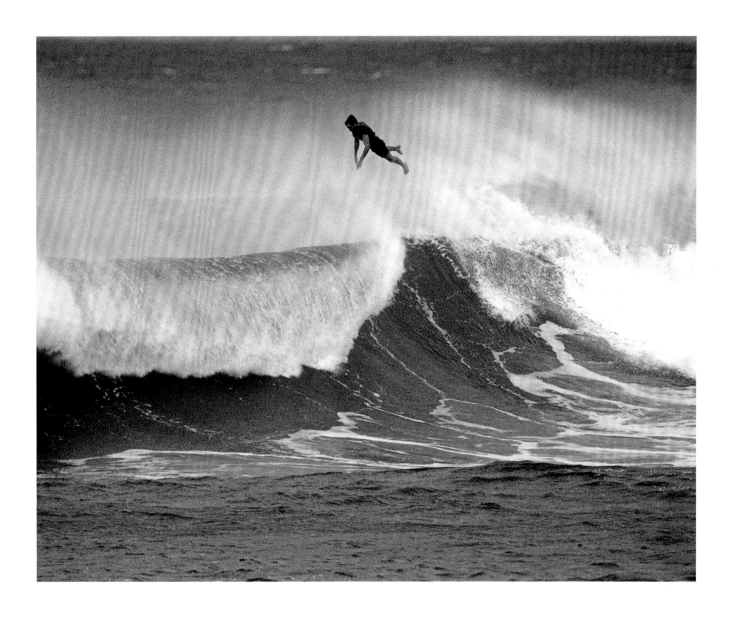

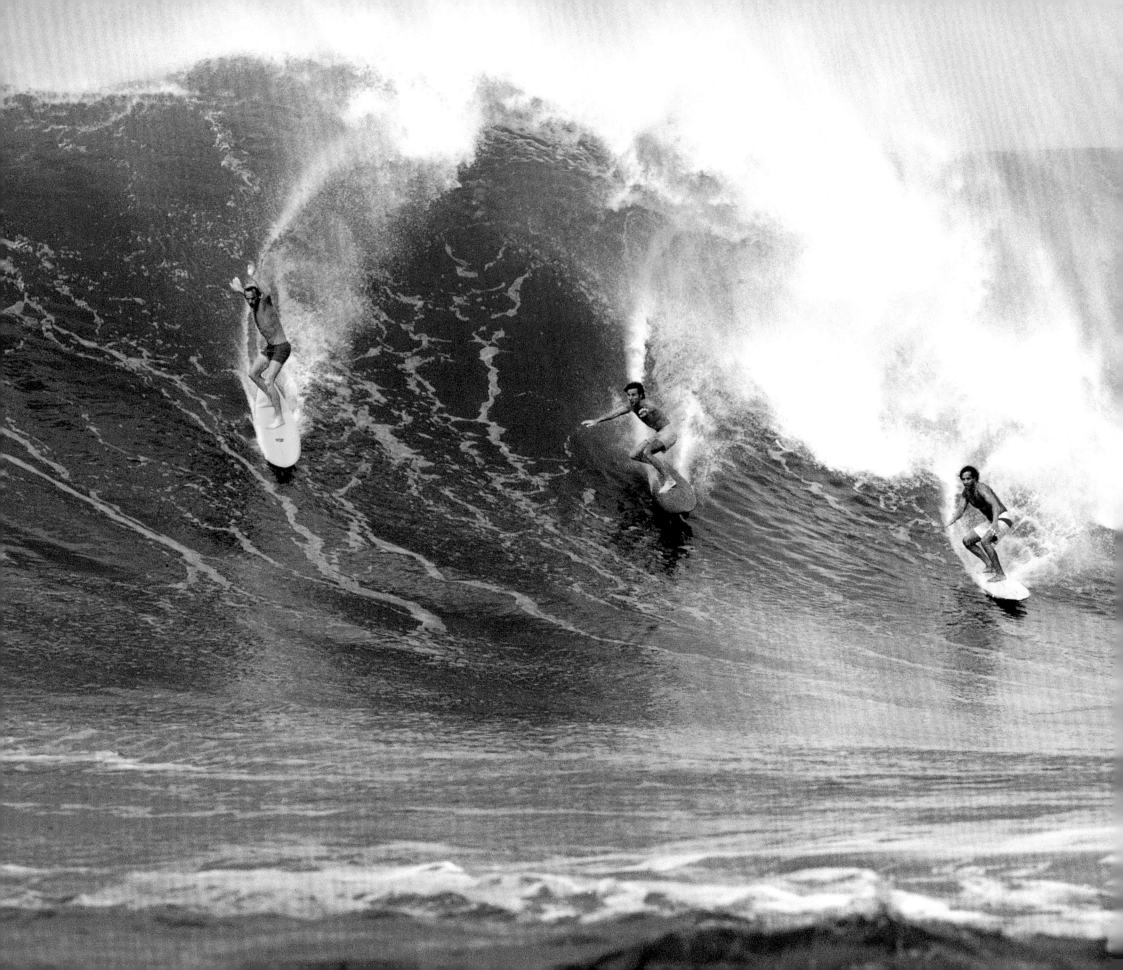

Billy Hamilton, James Jones, Eddie Aikau, Waimea Bay, 1973

Opposite: "The Bay" in its day was the Mt. Everest of surfing. Now surfers use jet skis to tow into waves three times this size.

Gegenüber: „The Bay" war einst der Mt. Everest des Surfens. Heute benutzen Surfer Jet-Skis, um sich in dreimal so hohe Wellen ziehen zu lassen.

Page ci-contre: « The Bay » était considéré en son temps comme l'Everest du surf. Aujourd'hui, les surfeurs utilisent des jets-skis pour grimper au sommet de vagues trois fois plus hautes que celle-ci.

Eddie Aikau, Sunset Beach, 1967

Below: Aikau taking the big drop during the Duke Classic. Note the vignette effect from the Century 1000 lens used by surf photographers of the time.

Unten: Aikau nimmt einen steilen Drop beim Duke Classic. Hier sieht man die Abdunklung an den Ecken, verursacht von dem Century 1000-Objektiv, das damalige Surffotografen verwendeten.

Ci-dessous: Eddie Aikau exécutant un *big drop* pendant les épreuves de la Duke Classic. On remarquera l'effet « vignette » dû à l'objectif Century 1000 utilisé par les photographes de surf de l'époque.

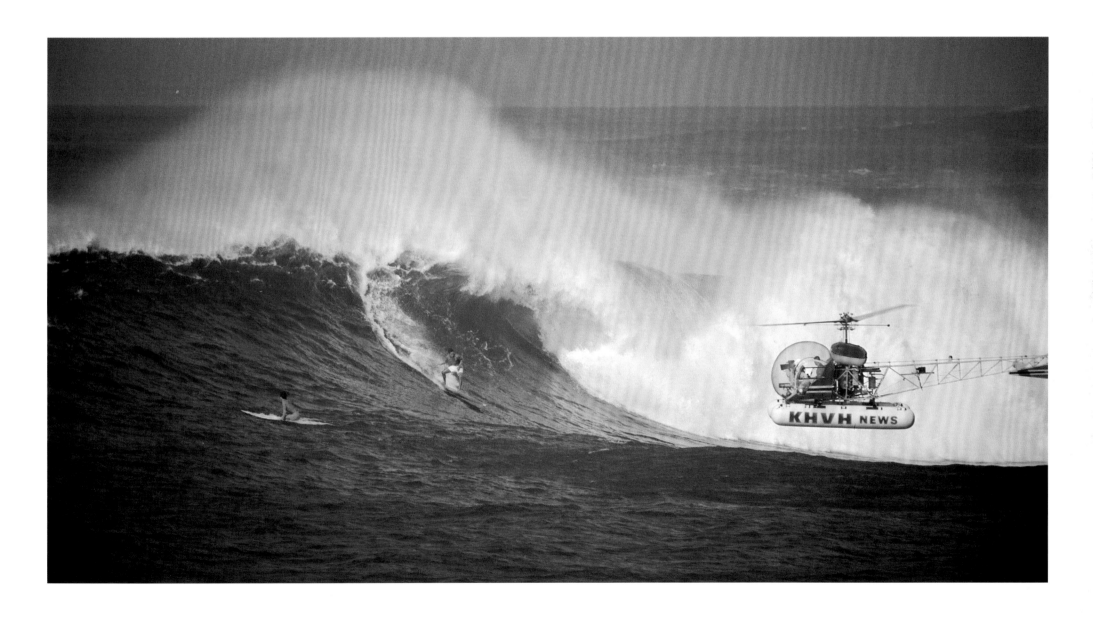

Pipeline, circa 1972

Opposite: There are huge days when there is no exit from Pipeline except up.

Gegenüber: Es gibt Tage mit so hohen Wellen, dass der einzige Ausweg aus der Pipeline durch die Luft führt.

Page ci-contre: Certains jours de gros swell, la seule issue pour échapper aux monstres de Pipeline passe par les airs.

Waimea Bay, circa 1968

Below: Left to right, unidentified, Mike Doyle, Eddie Aikau.

Unten: Von links nach rechts: unbekannt, Mike Doyle, Eddie Aikau.

Ci-dessous: De gauche à droite: non identifié, Mike Doyle et Eddie Aikau.

Ehukai Beach, 1977

Page 226: A small beach crowd watching the Pipeline Masters contest. These days, there are thousands of viewers and hundreds of telephotos on the beach.

Seite 226: Eine kleine Zuschauermenge beobachtet den Pipeline Masters Wettbewerb. Heute gibt es Tausende von Zuschauern und Hunderte von Teleobjektiven am Strand.

Page 226: Attroupement de curieux sur la plage pendant les épreuves des Pipeline Masters. Aujourd'hui, l'événement sportif attire des milliers de spectateurs et des centaines photographes équipés de téléobjectifs.

Makaha, 1965

Page 227: The Makaha Championships queen. The annual contest, started in 1954, was the unofficial world championship until the early sixties.

Seite 227: Die Königin der Makaha Championships. Der seit 1954 jährlich stattfindende Wettbewerb war bis in die frühen Sechziger die inoffizielle Weltmeisterschaft.

Page 227: L'héroïne du championnat de Makaha. La prestigieuse compétition annuelle dont la première édition remonte à 1954, conserva jusqu'au début des années 1960 le statut de championnat du monde non officiel.

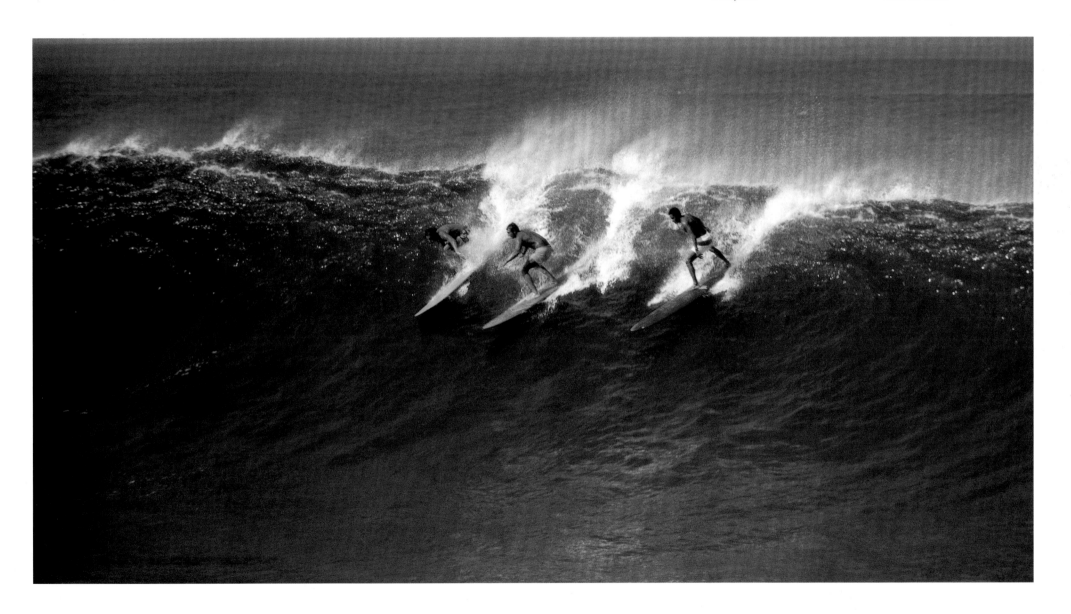

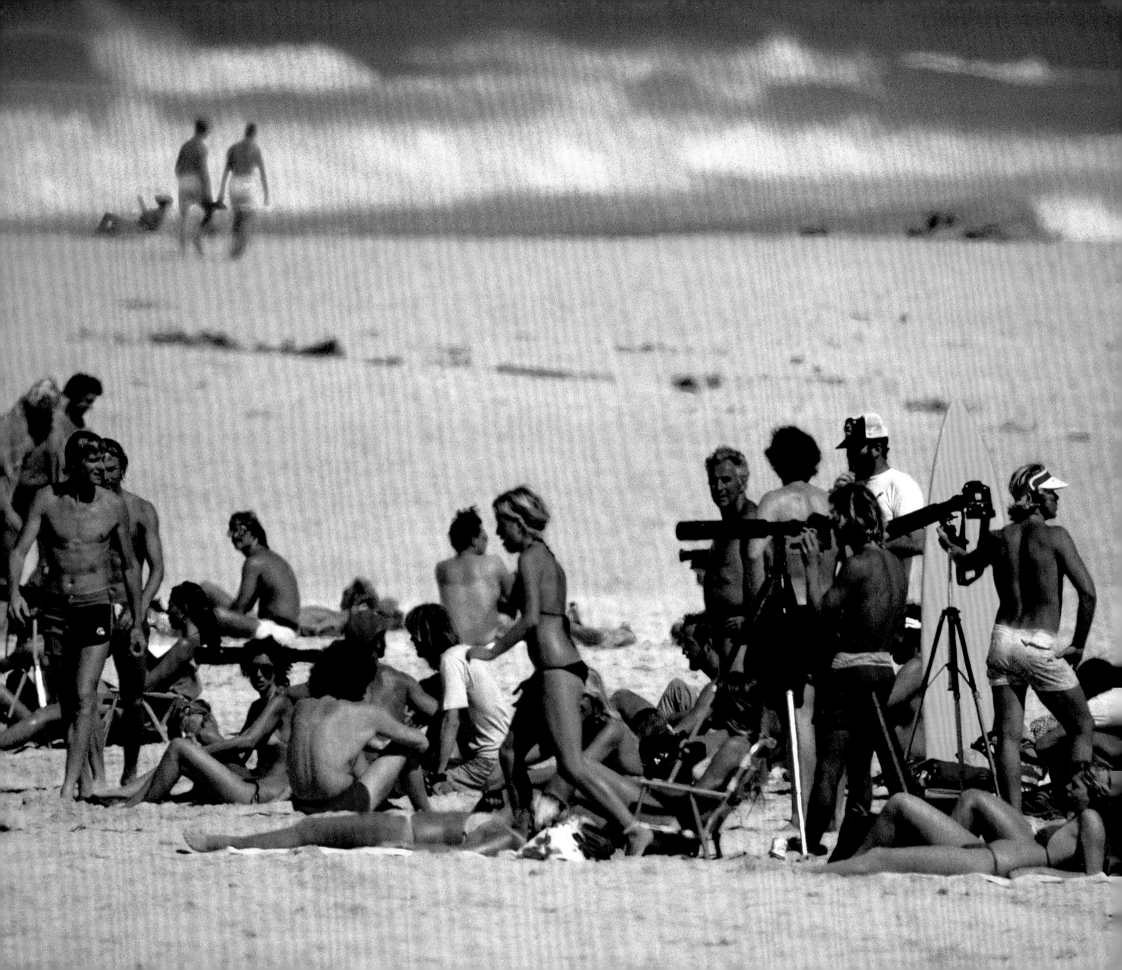

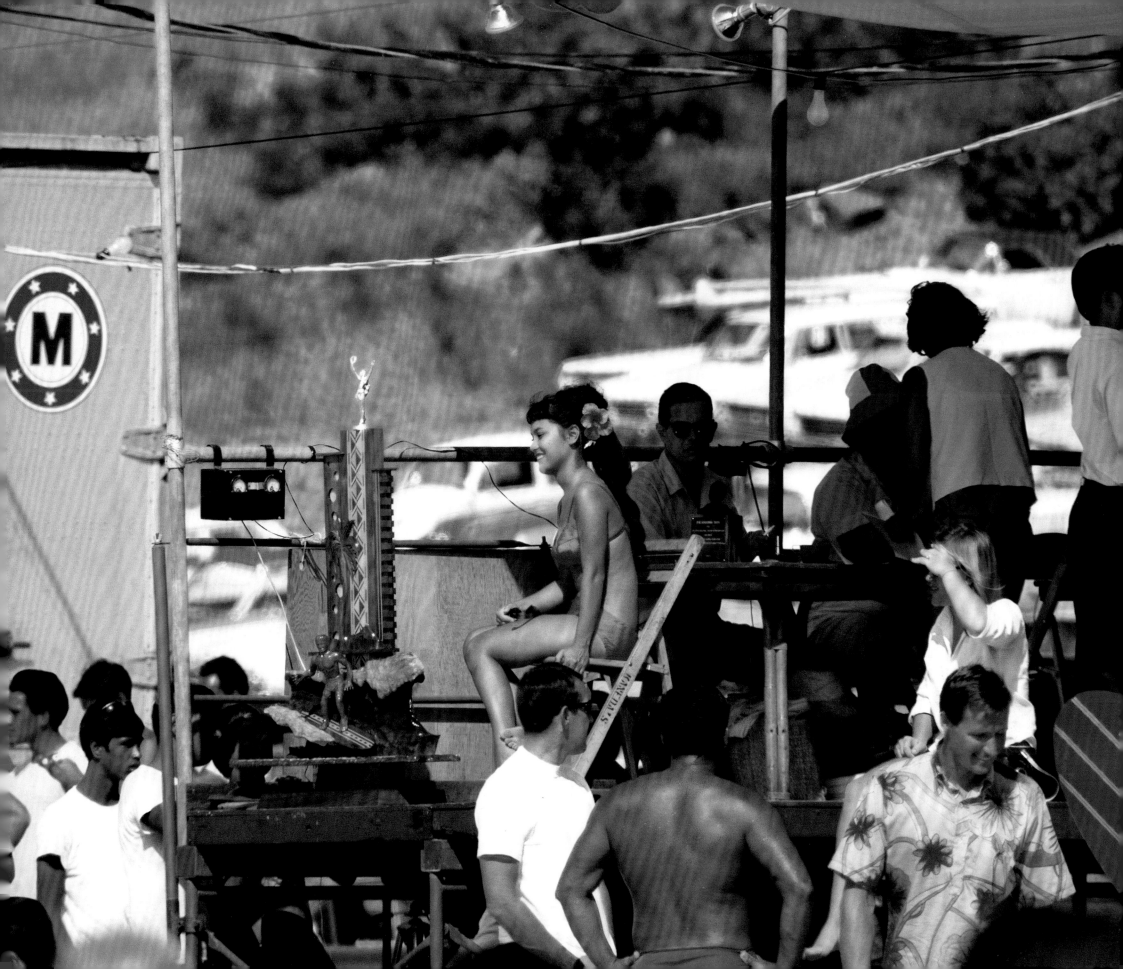

Sunset Beach, 1968

Right: Duke Classic contestants just prior to their heats. Left to right, Mike Doyle, Rick Grigg, Fred Hemmings, Felipe Pomar.

Rechts: Teilnehmer des Duke Classic direkt vor ihren Heats. Von links nach rechts: Mike Doyle, Rick Grigg, Fred Hemmings, Felipe Pomar.

Ci-contre: Concurrents de la Duke Classic quelques instants avant leurs *heats*. De gauche à droite: Mike Doyle, Rick Grigg, Fred Hemmings et Felipe Pomar.

Sunset Beach, 1968

Opposite: Greg Noll surf team all-stars, left to right, Rick Grigg, Fred Hemmings, Felipe Pomar, Greg Noll.

Gegenüber: Die Stars des Greg-Noll-Surfteams, von links nach rechts: Rick Grigg, Fred Hemmings, Felipe Pomar, Greg Noll.

Page ci-contre: Le plateau de stars de l'équipe de Greg Noll. De gauche à droite: Rick Grigg, Fred Hemmings, Felipe Pomar et Greg Noll.

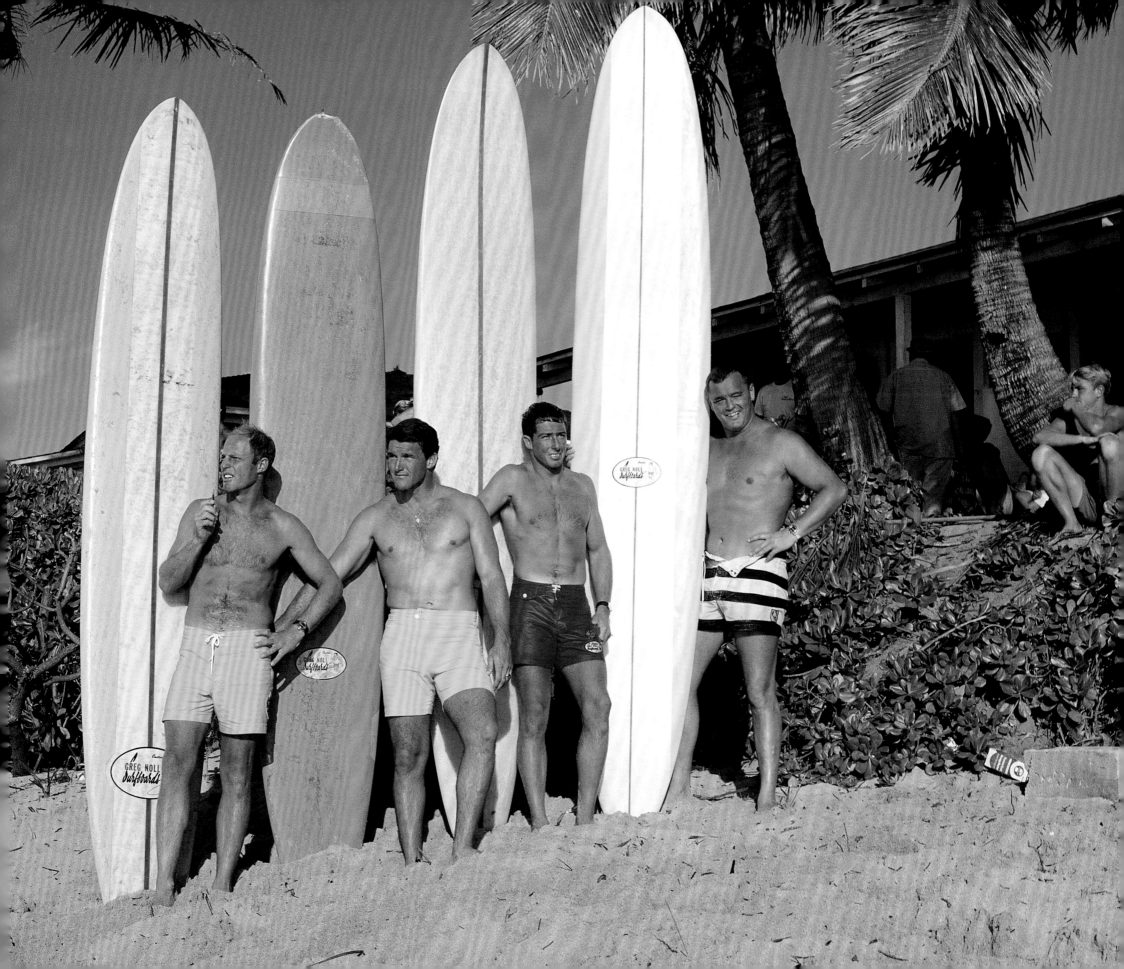

Pipeline, 1980

Below: The annual Pipeline Masters contest, founded as a professional event in 1971, has been held in waves from two to twenty feet.

Unten: Der jährlich stattfindende Pipeline Masters Contest, 1971 als Profi-Wettbewerb gegründet, hat schon in Wellen von einen halben bis zu sechs Metern Höhe stattgefunden.

Ci-dessous: Lors des épreuves des Pipeline Masters, rendez-vous annuel incontournable du circuit professionnel depuis 1971, les surfeurs affrontent des vagues d'un demi-mètre à six mètres de haut.

Pipeline, 1975

Opposite: One water photographer compared the narrow Pipeline channel to being on the sidelines of the Super Bowl—and then having the Super Bowl fall on you.

Gegenüber: Ein Wasserfotograf verglich den schmalen Tunnel der Pipeline mit dem Gefühl, das ein Spieler beim Super Bowl nahe der Seitenlinie haben muss – als ob das Stadion einem über dem Kopf zusammenbricht.

Page ci-contre: Un photographe aquatique a décrit un jour en ces termes la passe étroite de Pipeline: «C'est un peu comme si vous vous promeniez sur la ligne de touche pendant le Super Bowl et que tout à coup le stade s'effondrait sur votre tête!»

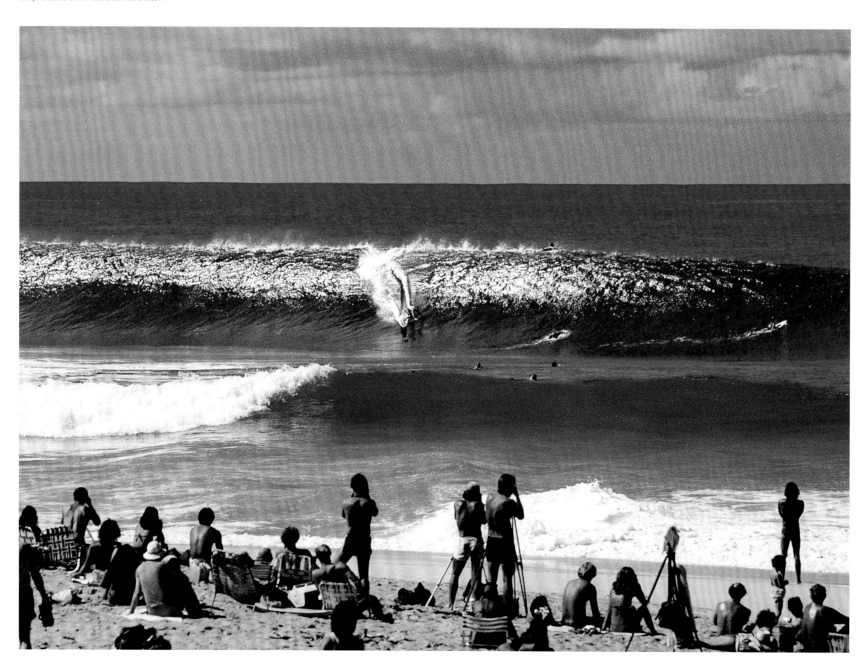

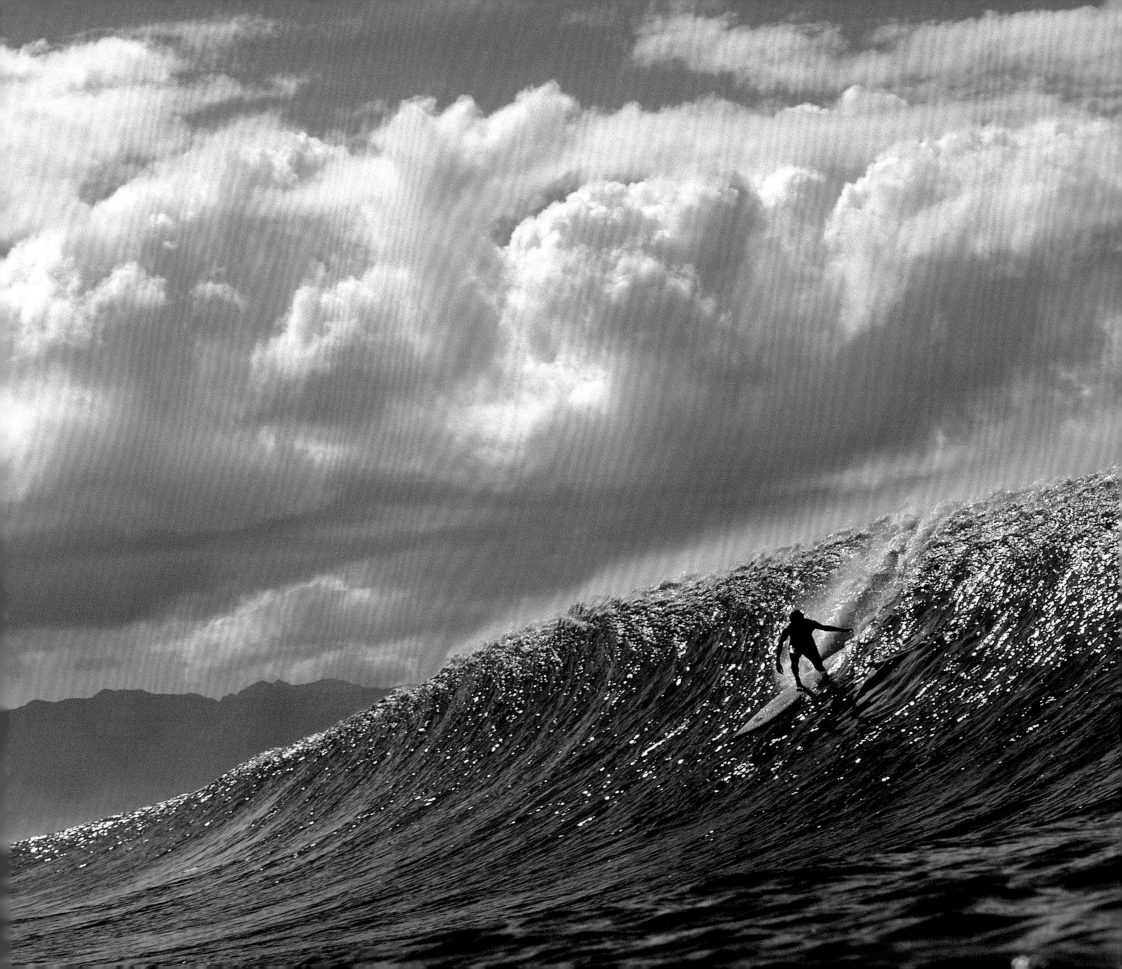

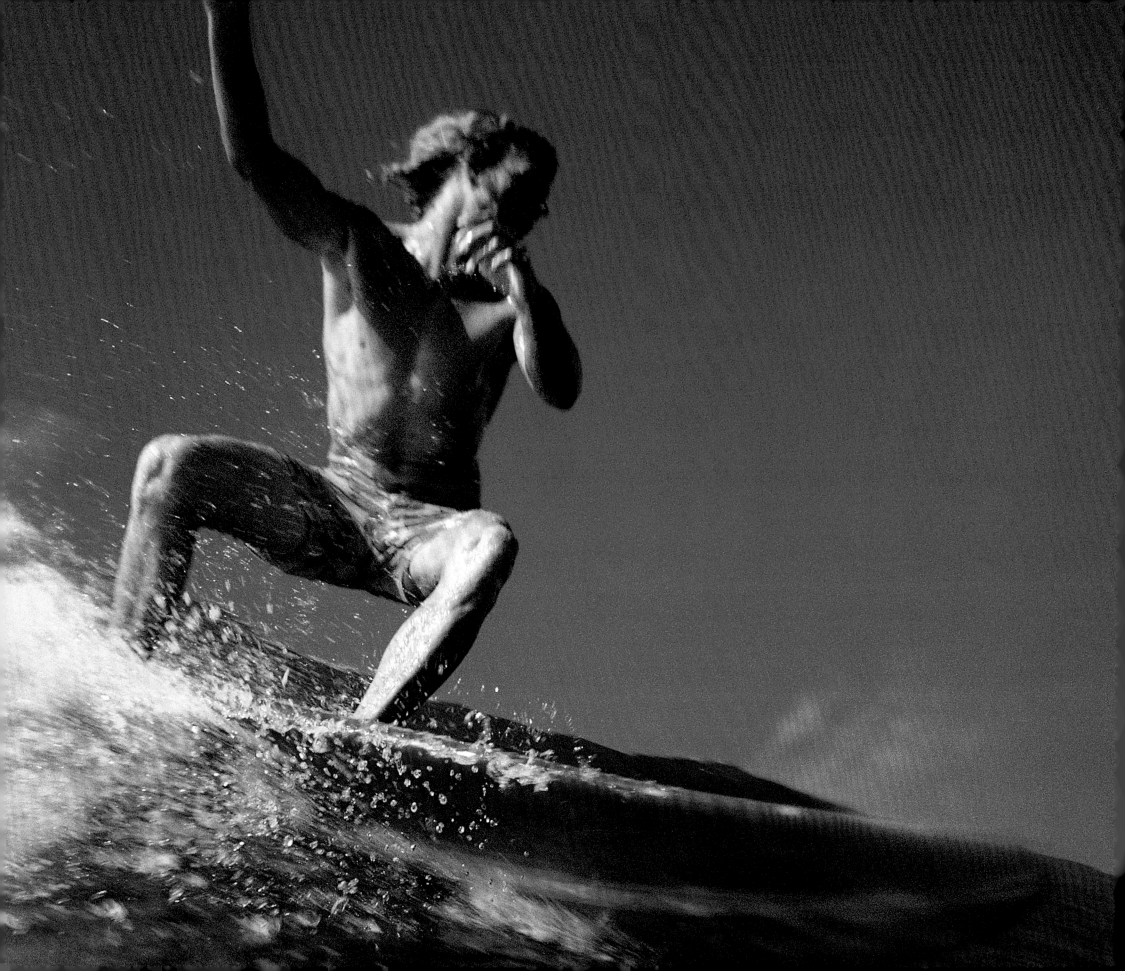

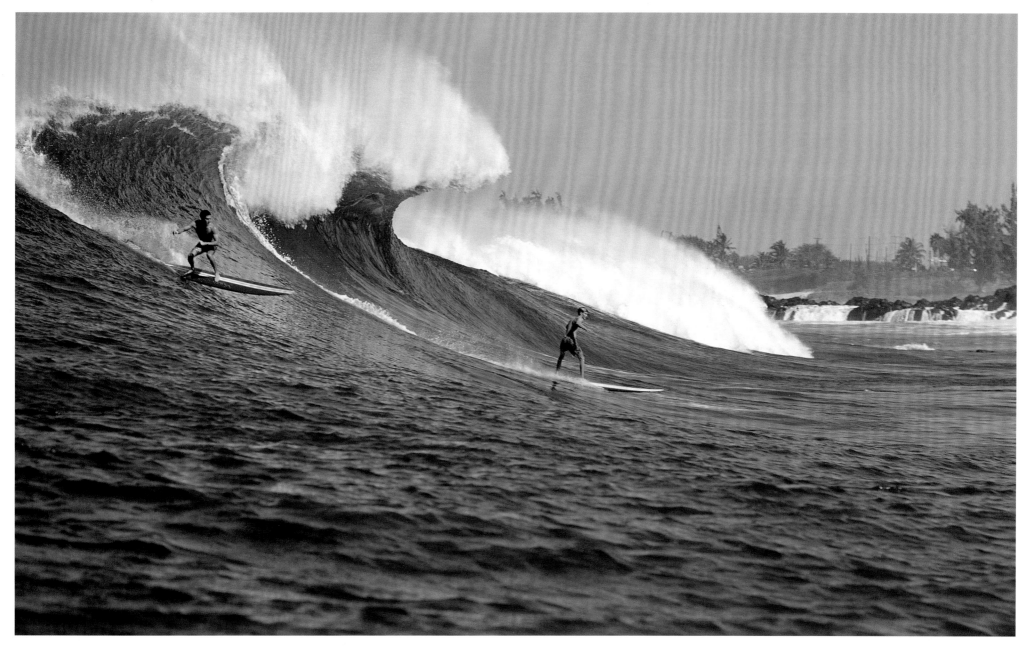

Gerry Lopez, Pipeline, 1972

Below. Unten. Ci-dessous.

Jackie Dunn, Pipeline, 1972

Opposite: Dunn, an underground but vastly respected seventies Pipeline master.

Gegenüber: Dunn, ein wenig angepasster, aber in den Siebzigerjahren sehr angesehener Meister der Pipeline.

Page ci-Contre: Jackie Dunn, un surfeur de Pipeline extrêmement respecté pour ses exploits dans les années 1970, était aussi un anticonformiste.

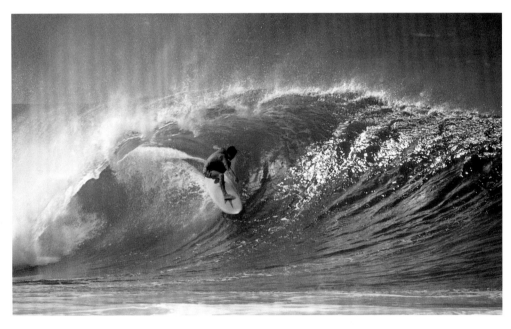

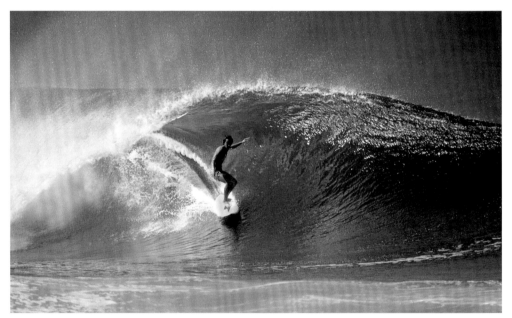

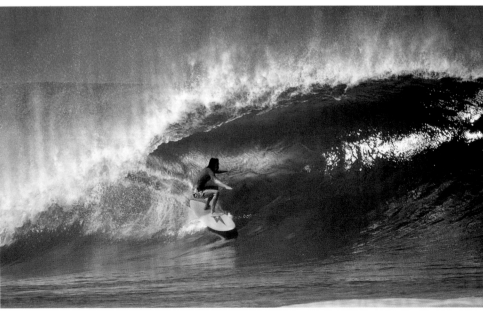

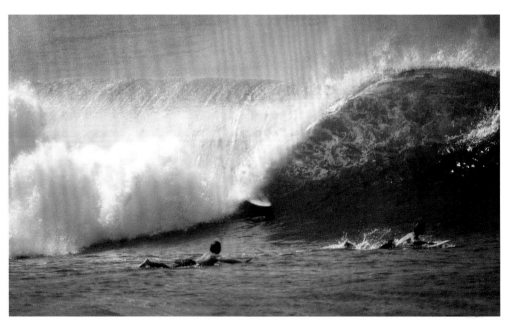

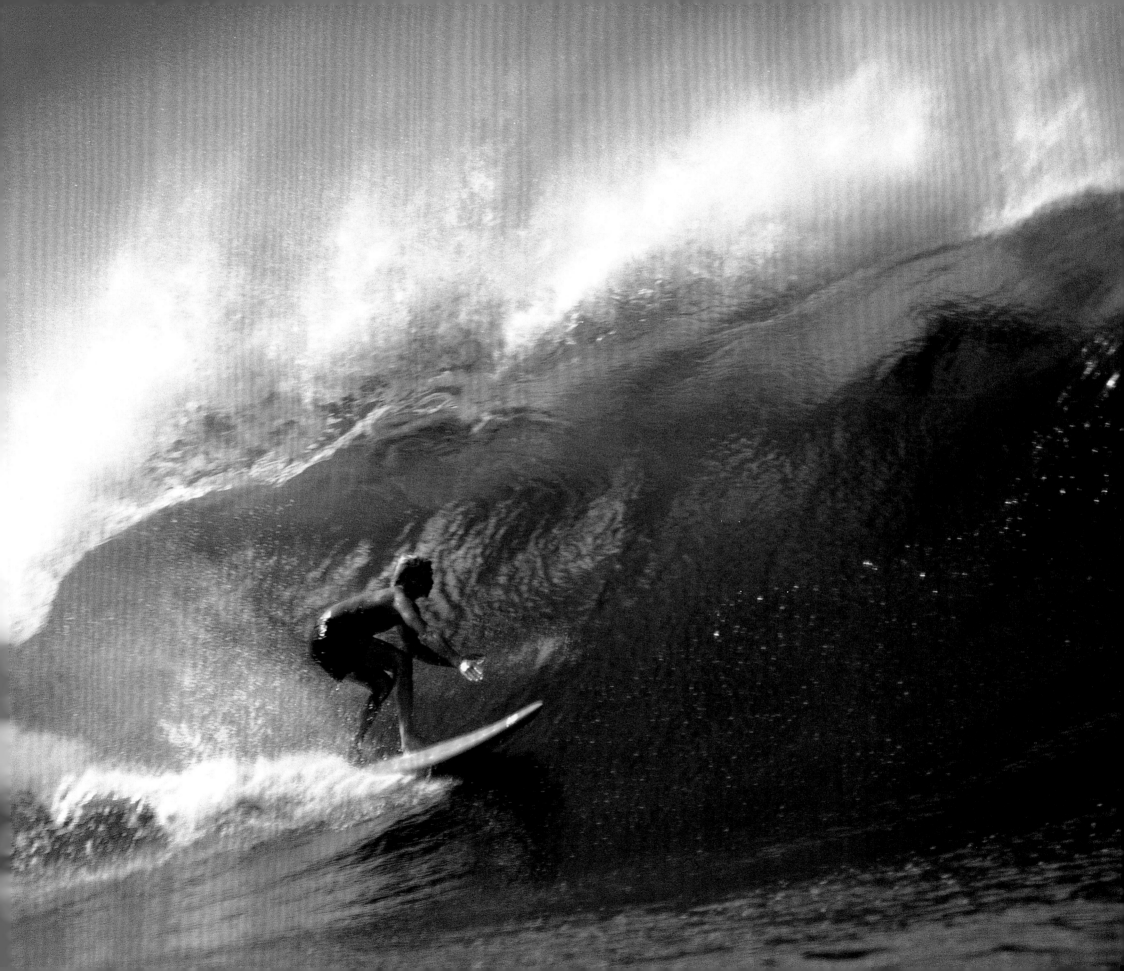

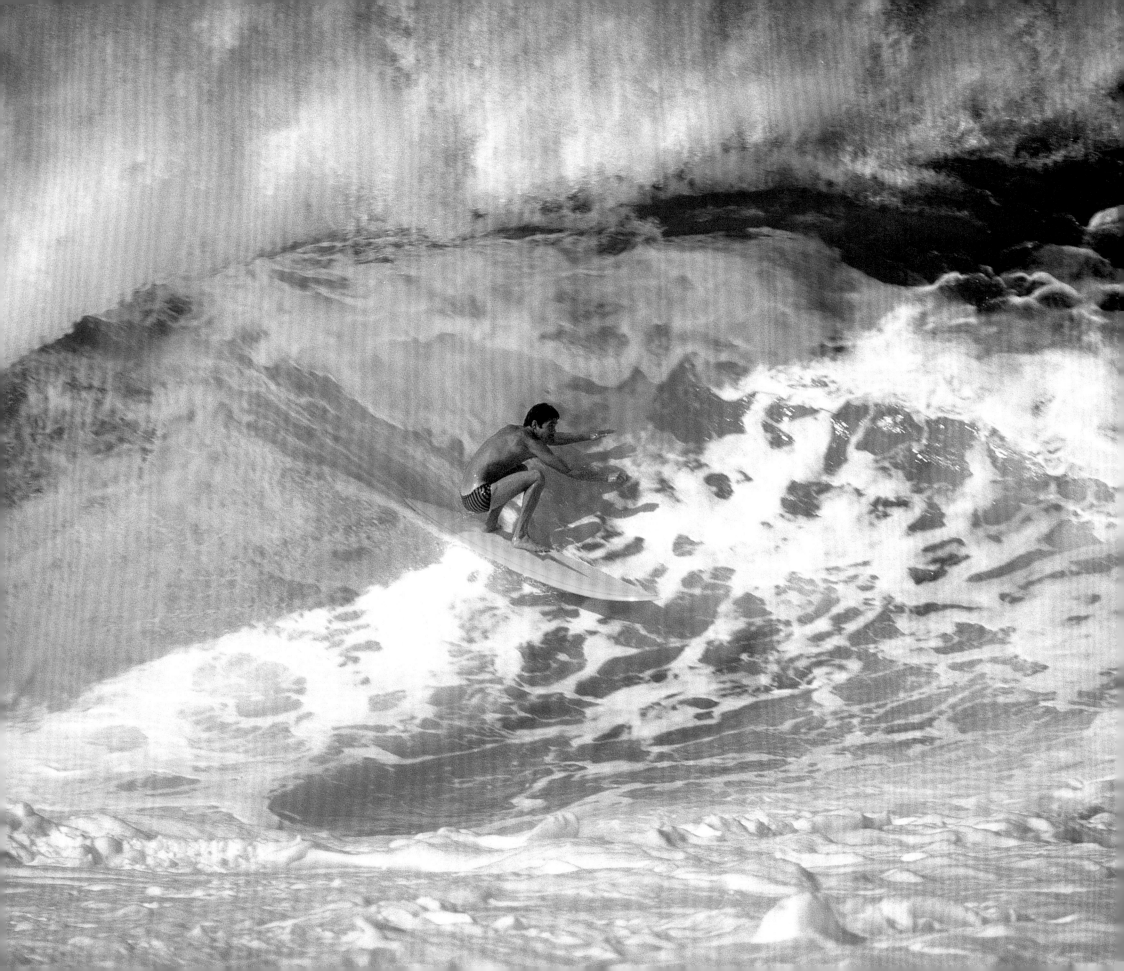

Gerry Lopez, Pipeline, 1974

Opposite: Lopez was the reigning "Mr. Pipeline" in the early seventies. He once described riding the thundering tubes as a "cakewalk."

Gegenüber: Lopez war in den frühen Siebzigern der amtierende „Mr. Pipeline". Er beschrieb den Ritt durch den donnernden Tunnel einmal als „Kinderspiel".

Page ci-contre: Au début des années 1970, Gerry Lopez – « Mister Pipeline » – régnait en maître sur ce redoutable spot. Surfer ses tubes vrombissants était pour lui une « promenade de santé ».

Pipeline, circa 1965

Below: Until Dick Brewer and a handful of other shapers designed special shortboards for Hawaiian wave power, surfers took their chances, and often failed, at Pipeline.

Unten: Bevor Dick Brewer und eine Hand voll weiterer Shaper spezielle Shortboards für die gewaltigen hawaiianischen Wellen entwarfen, versuchten zwar viele Surfer ihr Glück in der Pipeline, scheiterten aber häufig.

Ci-dessous: Dick Brewer et une poignée d'autres shapers ont conçu des shortboards spéciales pour venir à bout des monstres de Hawaï. Avant eux, la plupart des tentatives se soldaient par l'échec.

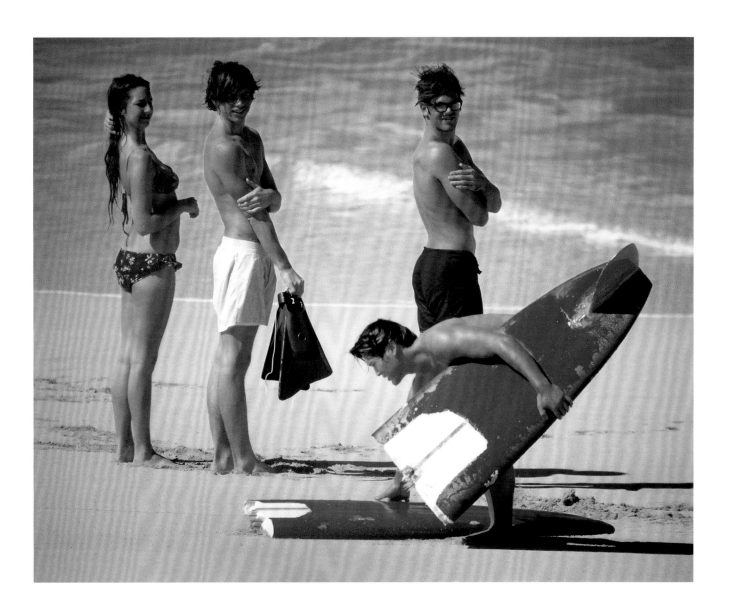

Log Cabins, North Shore, 1973

Below: The view from Grannis's rented beach house on the North Shore. Grannis says his sons were up every morning checking out the surf.

Unten: Aussicht aus dem Strandhaus, das sich Grannis am North Shore mietete. Grannis sagt, seine Söhne waren jeden Morgen früh auf, um die Wellen zu begutachten.

Ci-dessous: Vue depuis la maison de plage louée par LeRoy Grannis sur le North Shore. Il affirmait que ses fils se levaient très tôt chaque matin pour guetter la vague.

Makaha, circa 1968

Opposite. Gegenüber. Page ci-contre.

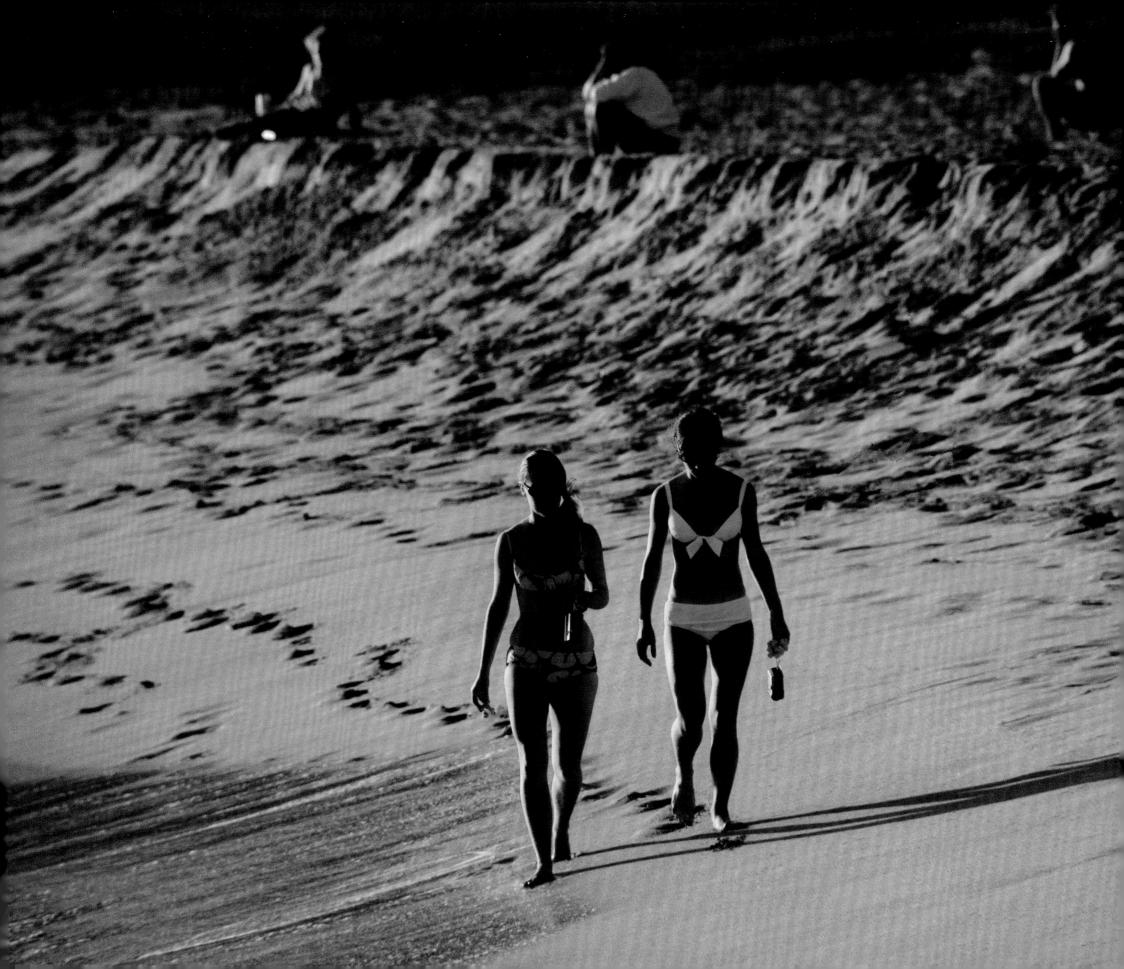

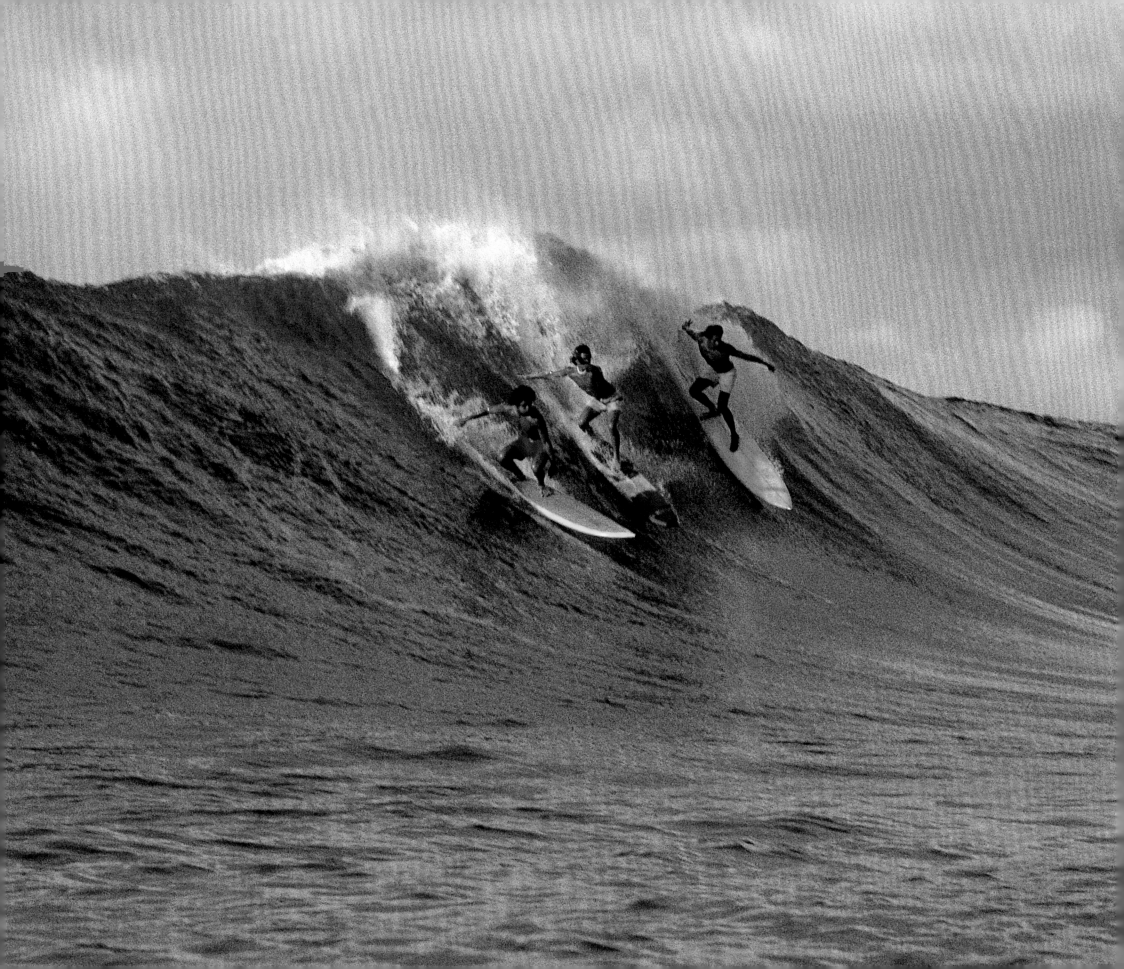

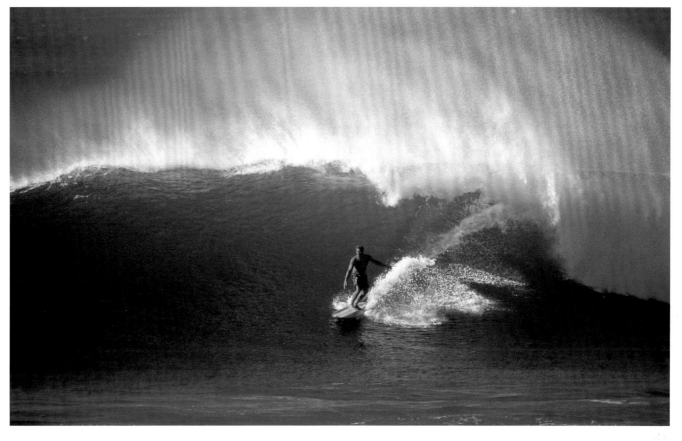

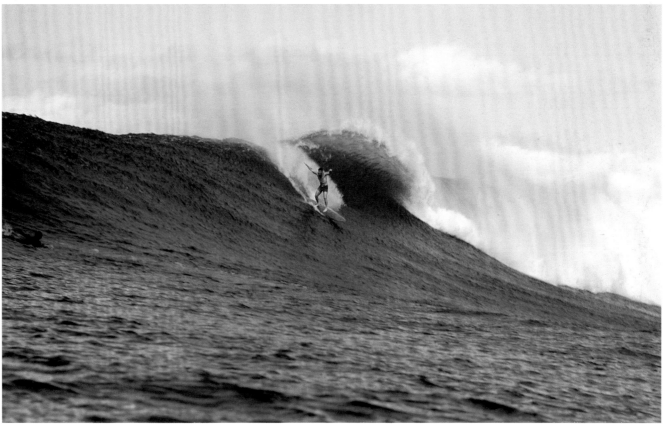

Waimea Bay, circa 1972

Opposite: Left to right, Larry Bertleman, Reno Abellira, Clyde Aikau.

Gegenüber. Von links nach rechts: Larry Bertleman, Reno Abellira, Clyde Aikau.

Page ci-contre. De gauche à droite: Larry Bertleman, Reno Abellira, Clyde Aikau.

Buffalo Keaulana, Sunset Beach, 1965

Left, above: Keaulana, known for his shaggy red hair, is the unofficial "Mayor of Makaha." His sons Brian and Rusty are world-class surfers and watermen.

Links oben: Keaulana, berühmt für seine zotteligen roten Haare, ist der inoffizielle „Bürgermeister von Makaha". Seine Söhne Brian und Rusty sind Weltklassesurfer und Wassersportler.

Ci-contre, en haut: Buffalo Keaulana, réputé pour sa chevelure rousse hirsute, était officieusement considéré comme le « maire de Makaha ». Ses fils Brian et Rusty jouissent d'une renommée mondiale dans le milieu des sports aquatiques… et du surf.

Fred Hemmings, Waimea, 1967

Left, below: Hemmings was part of the conservative North Shore old guard that was left behind by the psychedelic vanguard. "They were rock 'n' rollers," he said, "while I tried to waltz with waves."

Links unten: Hemmings gehörte zur konservativen alten Schule des North Shore, die von der psychedelischen Avantgarde überholt wurde. „Das waren Rock'n'Roller", sagte er. „Ich wollte mit den Wellen Walzer tanzen."

Ci-contre, en bas: Fred Hemmings faisait partie de la vieille école du surf du North Shore qui fut balayée par la vague de l'avant-garde psychédélique. « La mode était au rock 'n' roll, tandis que moi, je m'exerçais encore à danser la valse avec les vagues », confia-t-il un jour.

241

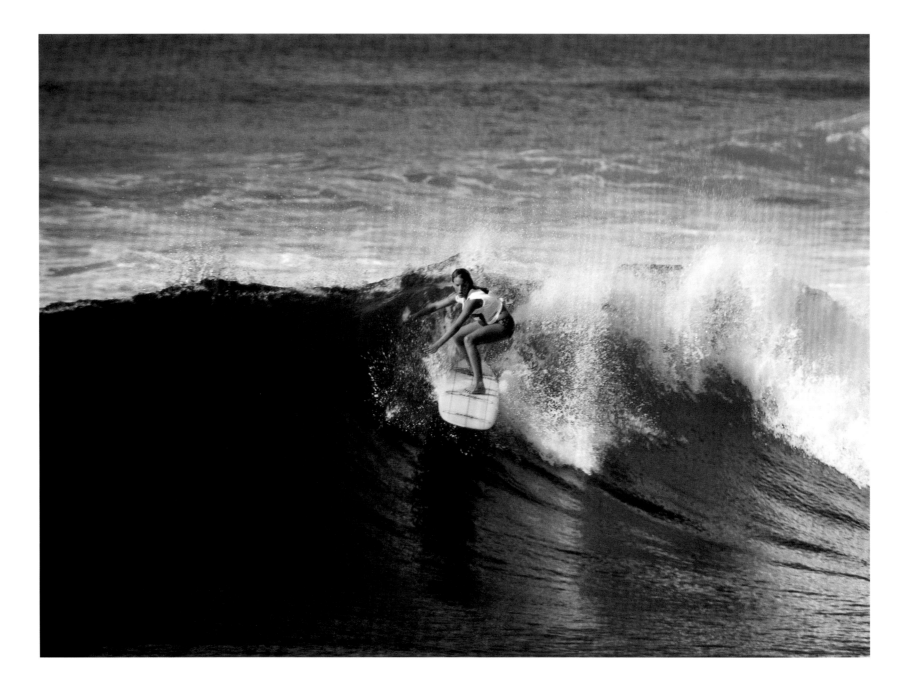

Dale Dahlin, Haleiwa, 1977

Dahlin, one of the North Shore's best
female surfers, was known as "Mrs.
Haleiwa." Her son Kanoa is a world-class
longboarder.

Dahlin, eine der besten Surferinnen der
North Shore, war als „Mrs. Haleiwa"
bekannt. Ihr Sohn Kanoa ist ein Welt-
klasse-Longboarder.

Dale Dahlin, qui fut l'une des meilleures
surfeuses du North Shore, était surnom-
mée « Mrs. Haleiwa ». Son fis Kanoa est un
longboarder de renommée mondiale.

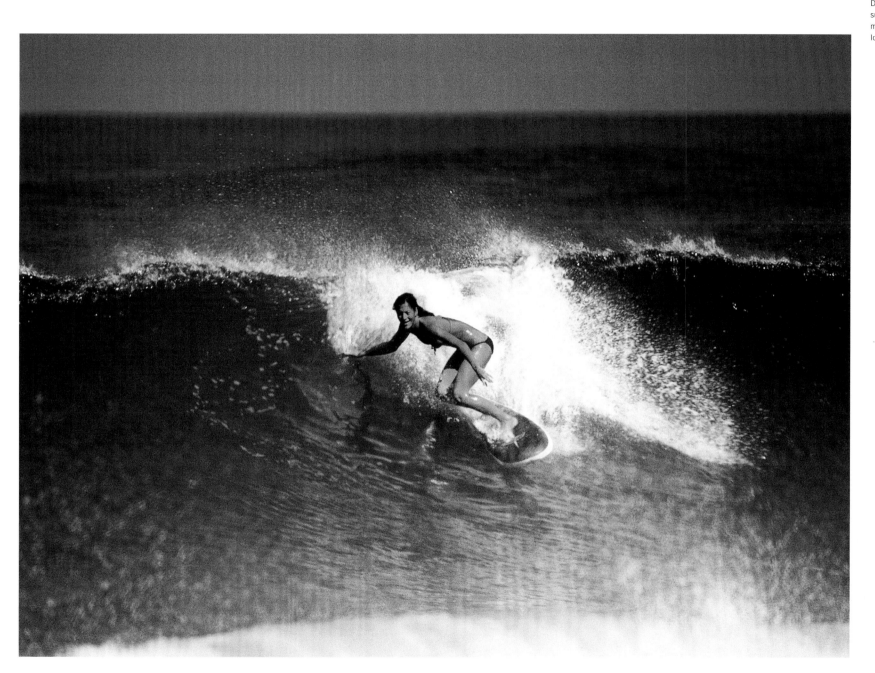

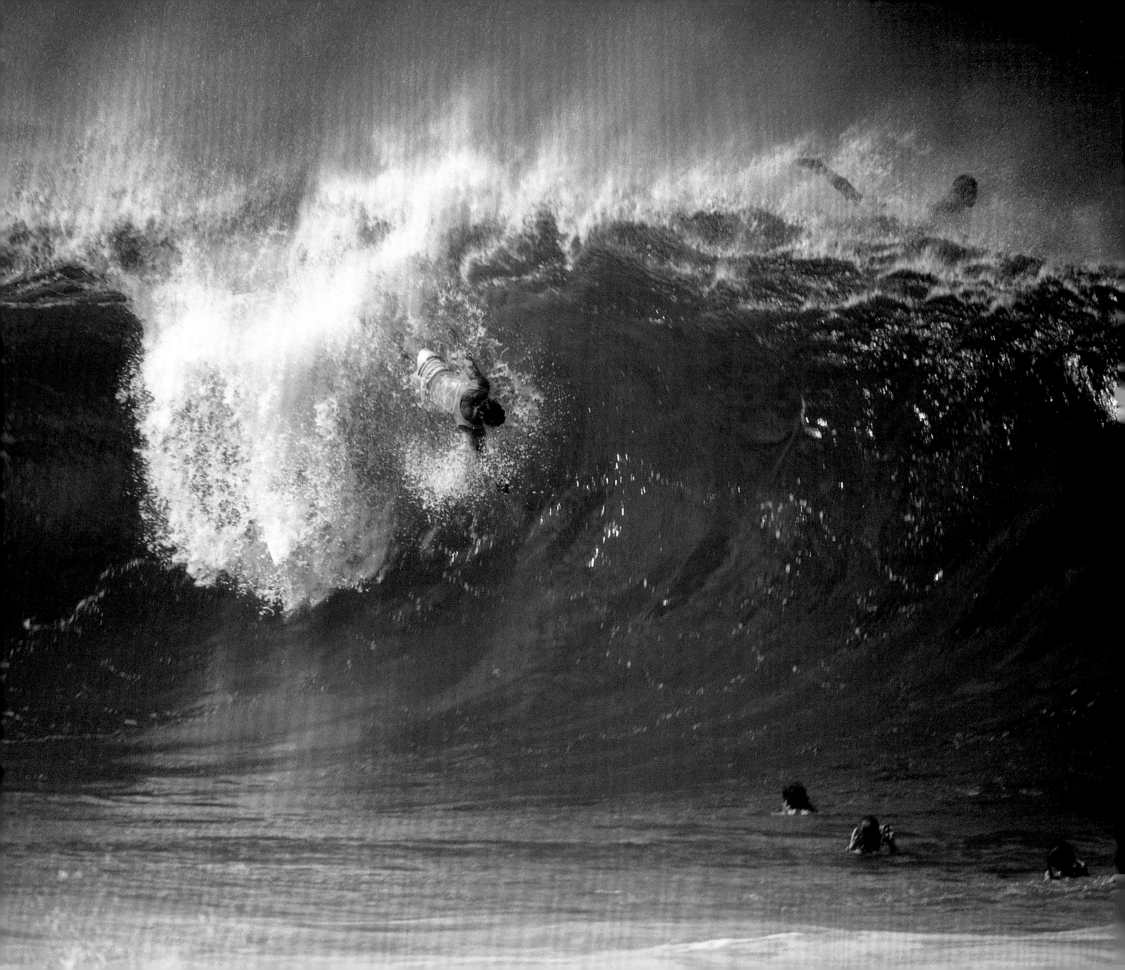

Pipeline, 1981

Opposite. Gegenüber. Page ci-contre.

Sean Ross, Pipeline, 1980

Below left: Ross is shown riding a paipo board, the ancient precursor to the modern bodyboard and the earliest form of board surfing.

Unten links: Ross surft hier auf einem Paipo Board, dem uralten Vorläufer des modernen Bodyboards und die früheste Form des Surfens.

Ci-dessous, à gauche: Sean Ross chevauchant un *paipo board*, l'ancêtre du bodyboard moderne qui fut aussi la planche des tout premiers surfeurs de l'histoire.

Sean Ross, Pipeline, 1977

Below right. Unten rechts. Ci-dessous, à droite.

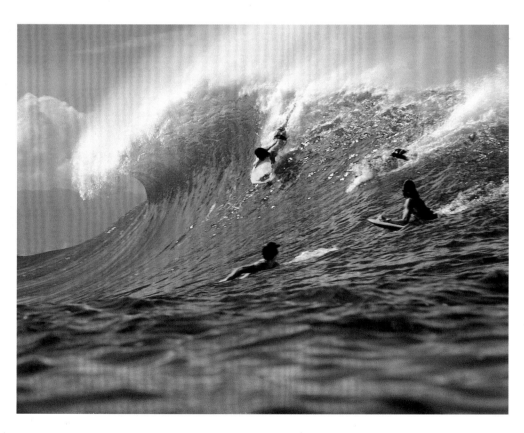

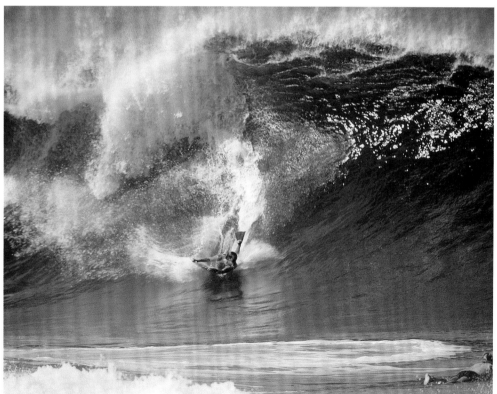

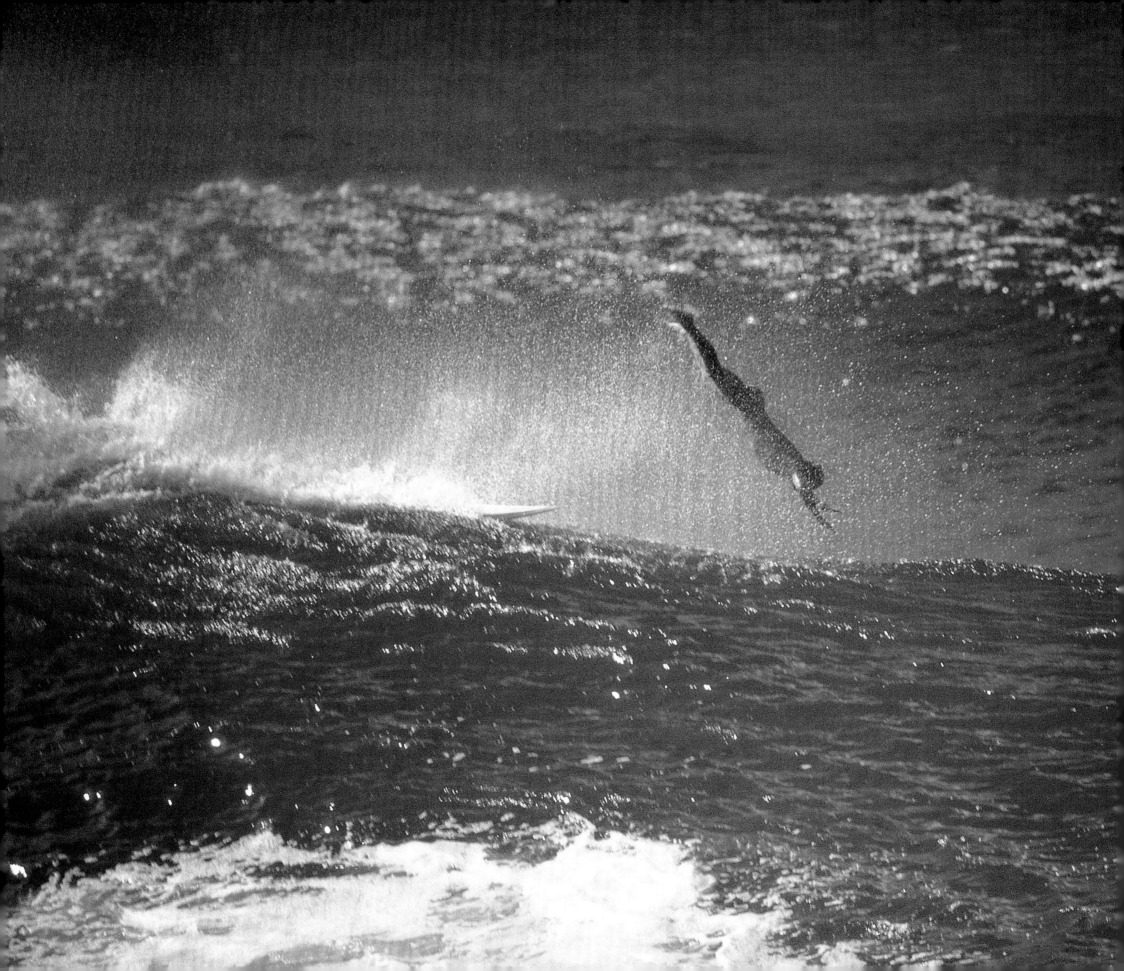

Pipeline, 1980

Opposite: Pre-leash Pipeline ejection.

Gegenüber: Sturz aus der Pipeline ohne Leash.

Ci-contre: Un surfeur sans *leash* se fait éjecter par une vague de Pipeline.

Rocky Point, 1977

Below. Unten. Ci-dessous.

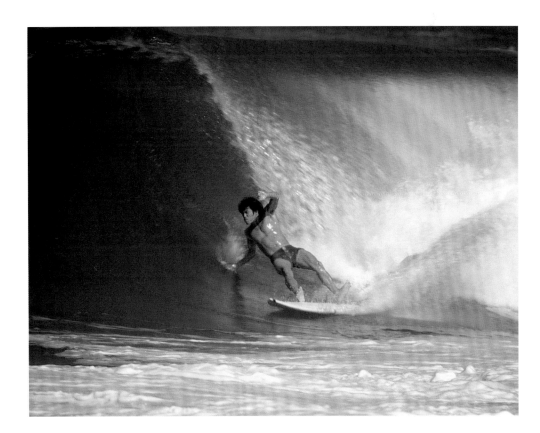

Pipeline, 1970

Below. Unten. Ci-dessous.

Pipeline, 1970

Opposite: This surfer has successfully made the drop and is setting up for the tube.

Gegenüber: Dieser Surfer hat den Start gemeistert und wappnet sich für den Kanal.

Page ci-contre: Drop réussi pour ce surfeur qui s'apprête à enchaîner sur un tube.

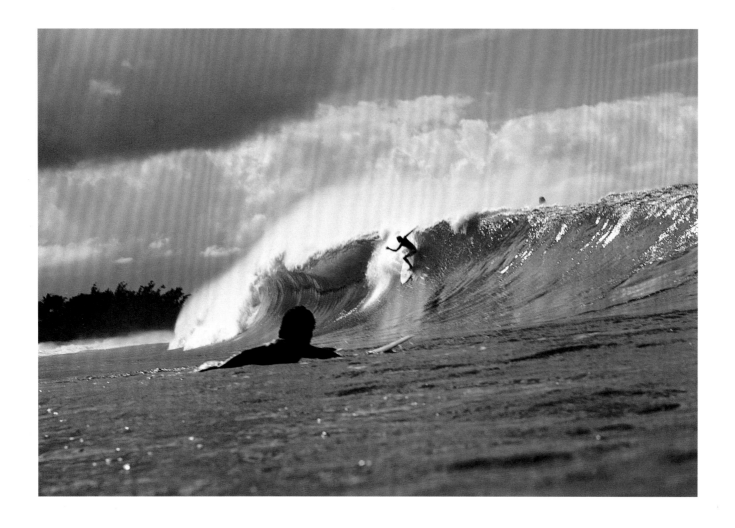

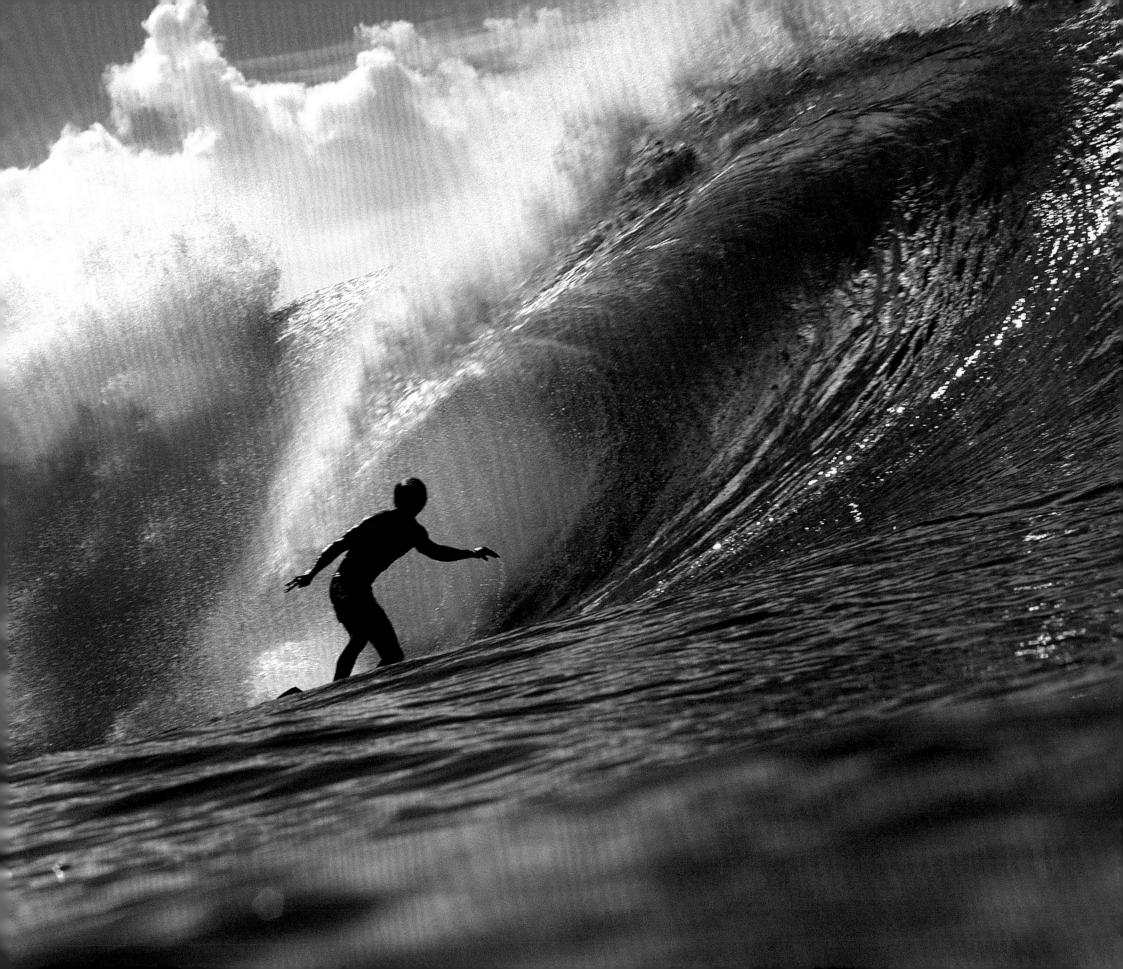

Pipeline, 1971

Below: By dropping in on the surfer farther back on the wave, the one in front has forced him into a bad, even dangerous, position.

Unten: Durch Abdrängen hat der vordere Surfer den anderen in eine schlechte, sogar gefährliche Position gebracht.

Ci-dessous: Le second surfeur (planche jaune), gêné par le premier qui vient de lui barrer la route, se retrouve dans une position délicate, voire dangereuse.

Pipeline, 1977

Opposite: Small, fun Pipeline. This surfer sets up for a "head dip."

Gegenüber: Kleine, witzige Pipeline. Dieser Surfer setzt zum „Head Dip" an.

Page ci-contre: Petit pipeline plutôt amusant. Ce surfeur s'apprête à exécuter un « head dip ».

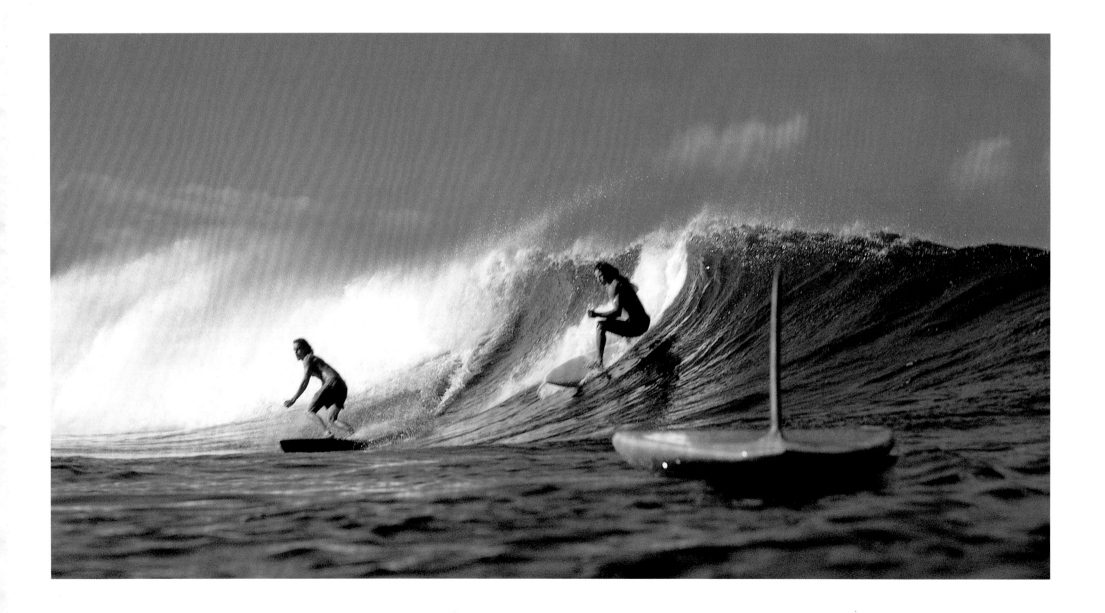

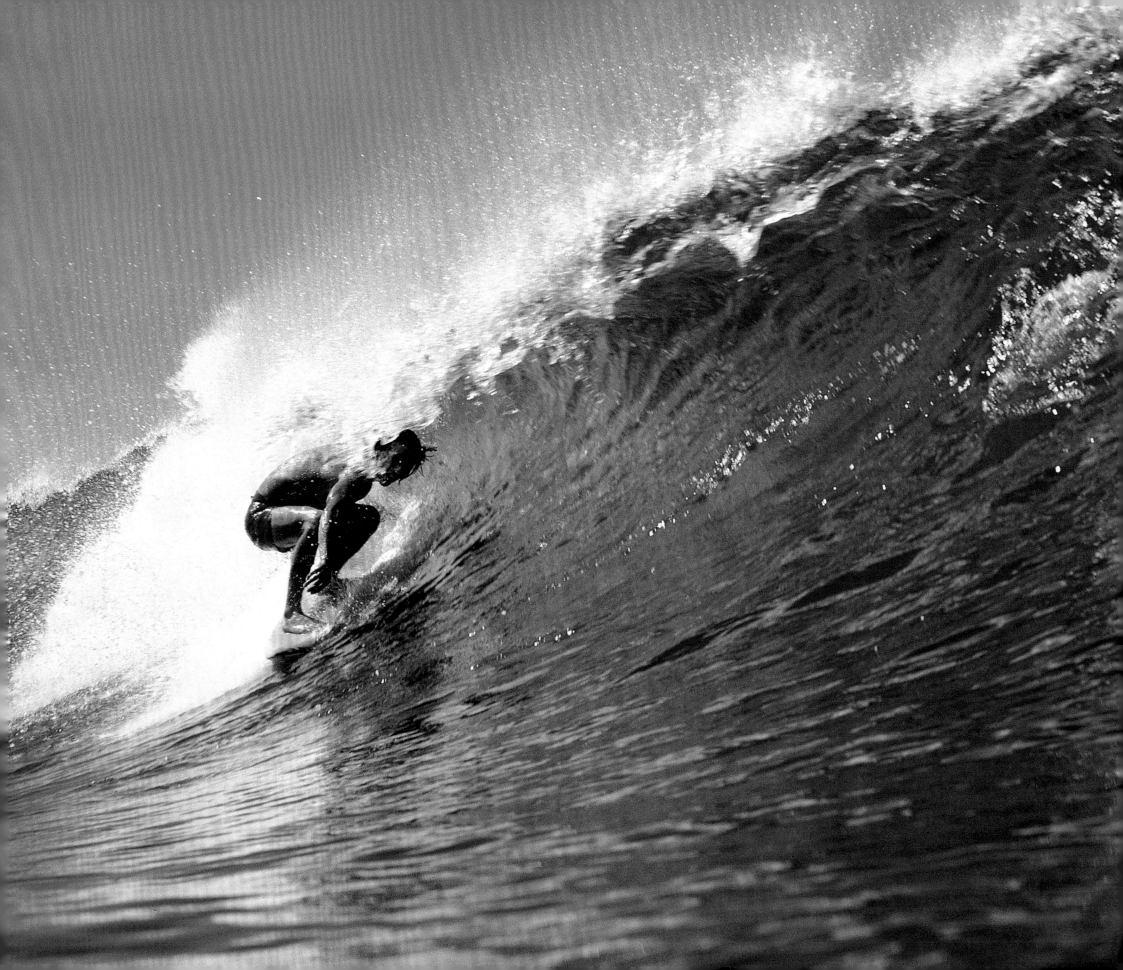

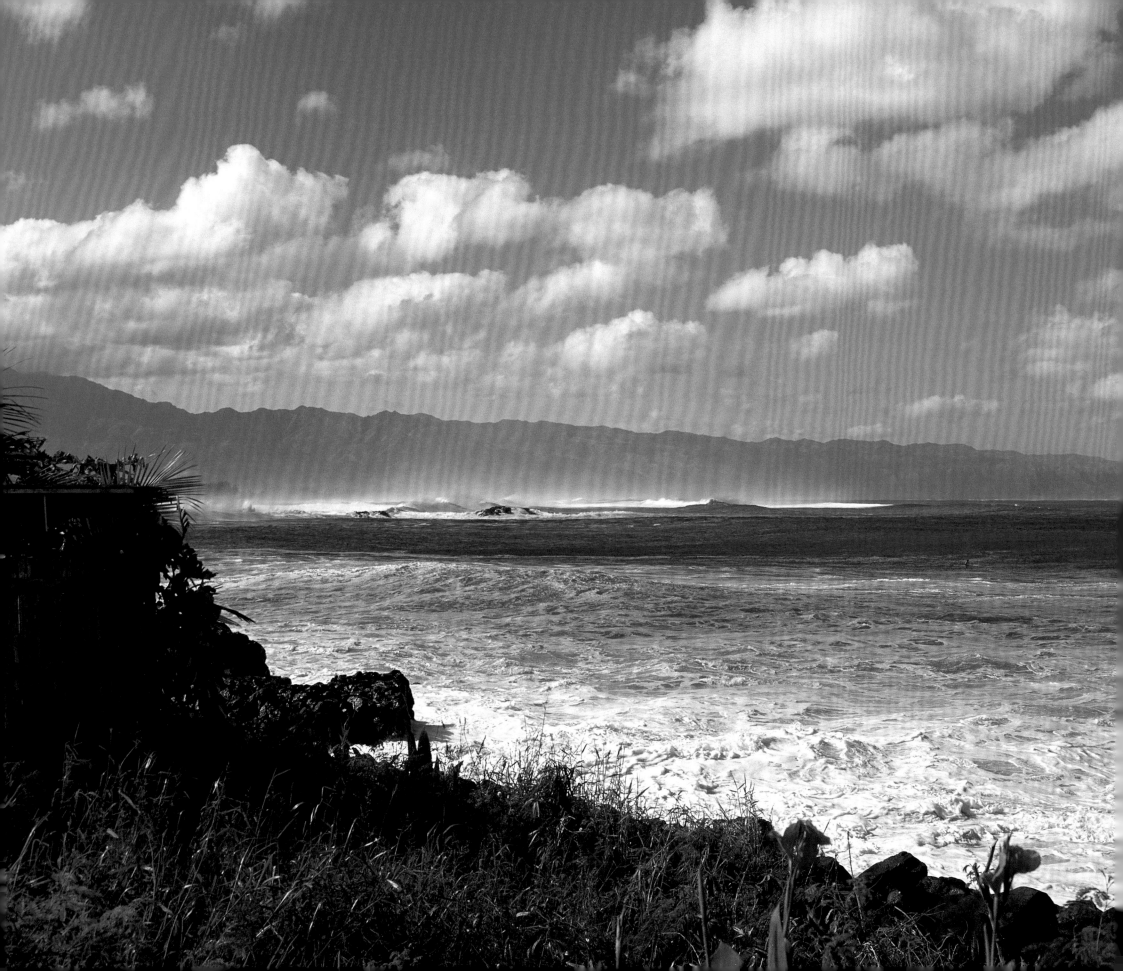

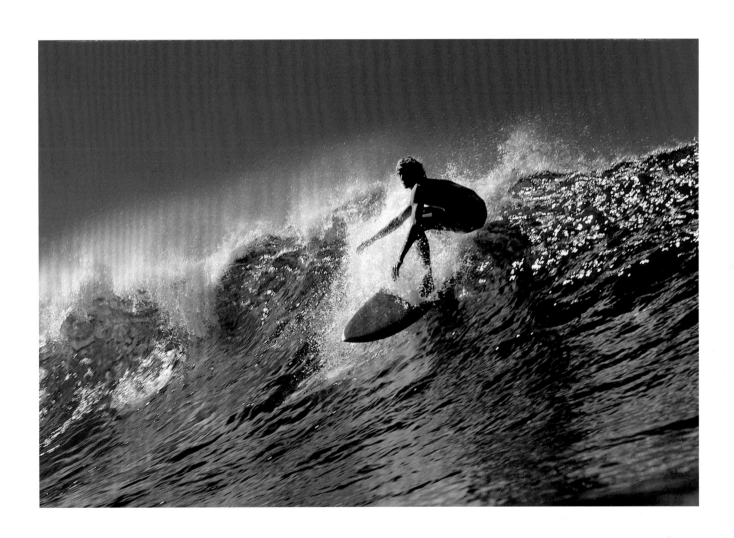

Waimea Bay, 1967

A view of the bay from the ruins of an ancient *he'iau*, or temple.

Aussicht auf die Bucht von der Ruine eines alten *he'iau* oder Tempels aus.

Vue sur la baie depuis les ruines d'un ancien *he'iau* (temple).

Pupukea, 1970

Sunset over Kaena Point. The ancient Hawaiians believed that Kaena is where dead souls walked over the Rainbow Bridge to the afterlife.

Sonnenuntergang über Kaena Point. Früher glaubten die Hawaiianer, dass in Kaena die Seelen der Verstorbenen über die Regenbogenbrücke ins Jenseits gehen.

Coucher de soleil sur Kaena Point. Dans la croyance des anciens Hawaïens, Kaena est le lieu où les âmes défuntes traversent le Pont Arc-en-Ciel pour rejoindre l'au-delà.

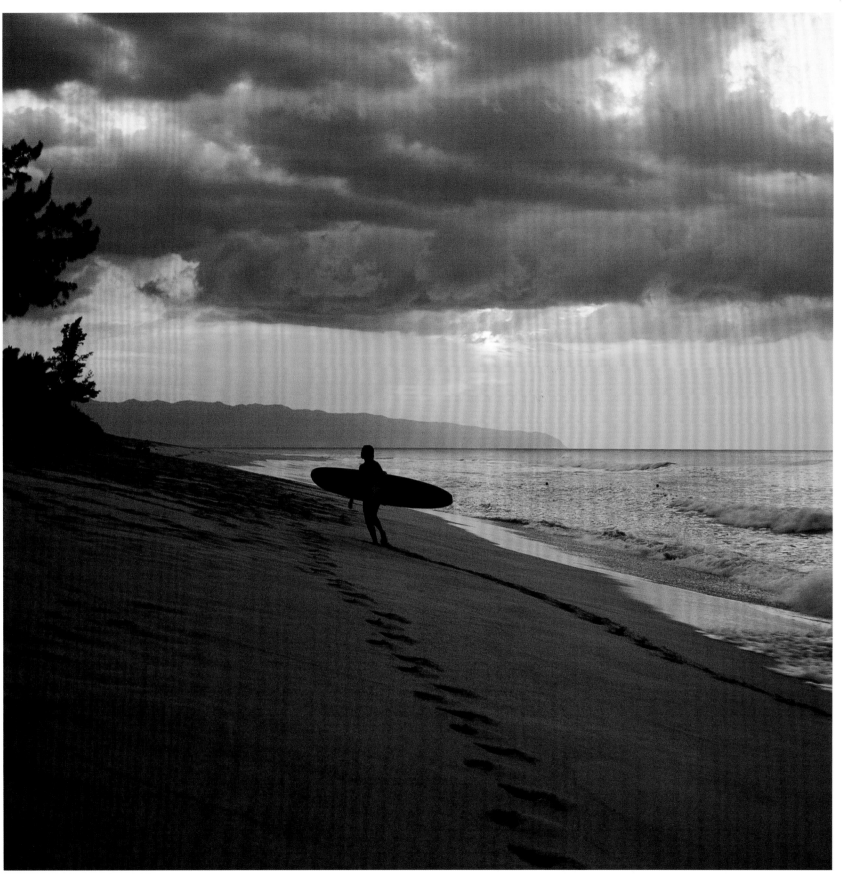

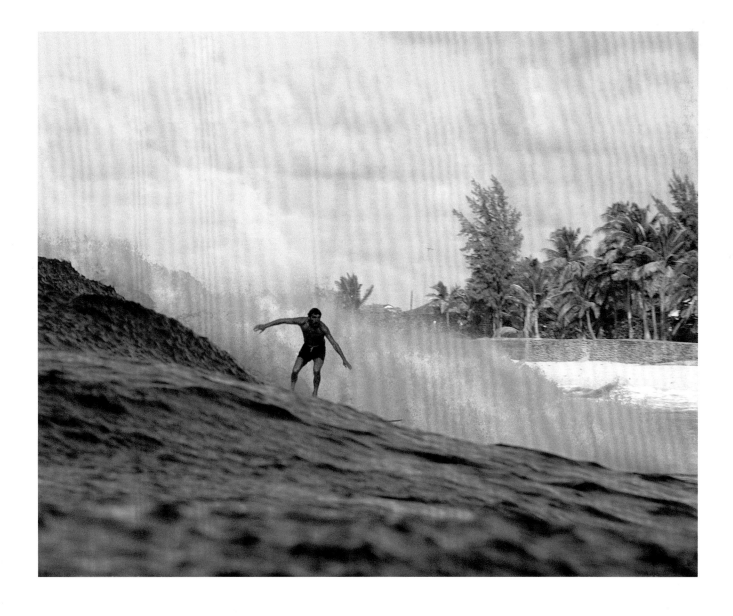

Sunset Beach, 1972

Below: Judges' stand at the Duke Classic. Big-wave specialist James "Booby" Jones won this year.

Unten: Punktrichterstand beim Duke Classic. In diesem Jahr gewann der Big-Wave-Spezialist James „Booby" Jones.

Ci-dessous: Podium du jury de la Duke Classic. Cette année-là, la victoire est remportée par le spécialiste du *big-wave riding* James « Booby » Jones.

Makaha, 1965

Opposite: Founded in 1954, the annual Makaha event was the unofficial world championship until the early sixties.

Gegenüber: Der seit 1954 jährlich stattfindende Wettbewerb in Makaha war bis in die frühen Sechziger die inoffizielle Weltmeisterschaft.

Page ci-contre: Lancée en 1954, la rencontre annuelle de Makaha a conservé le statut de championnat du monde non officiel jusqu'au début des années 1960.

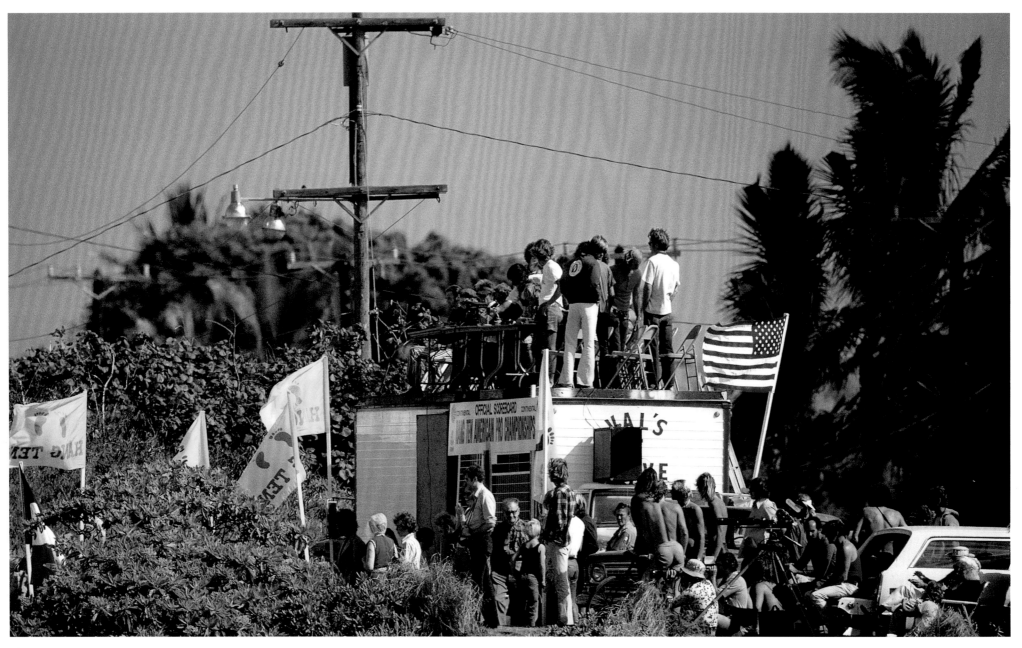

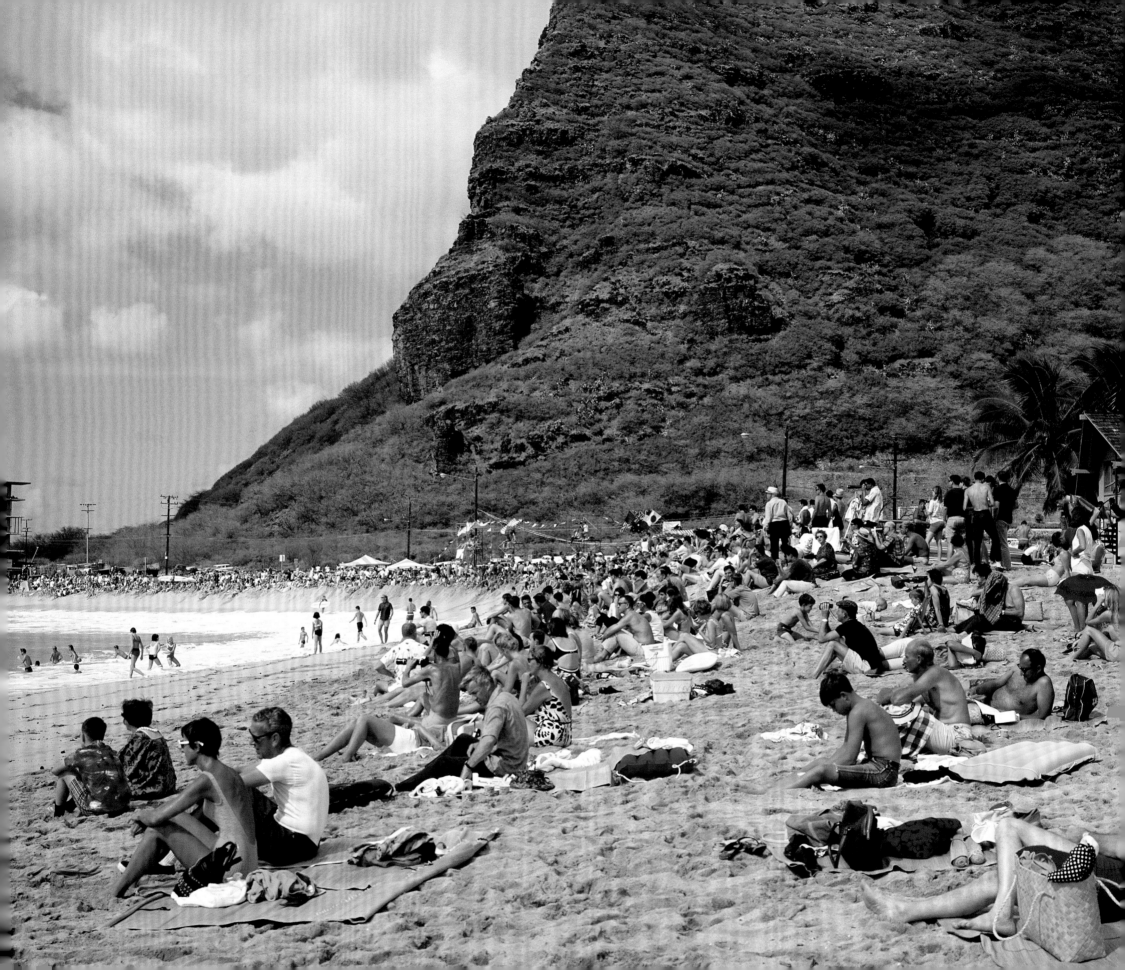

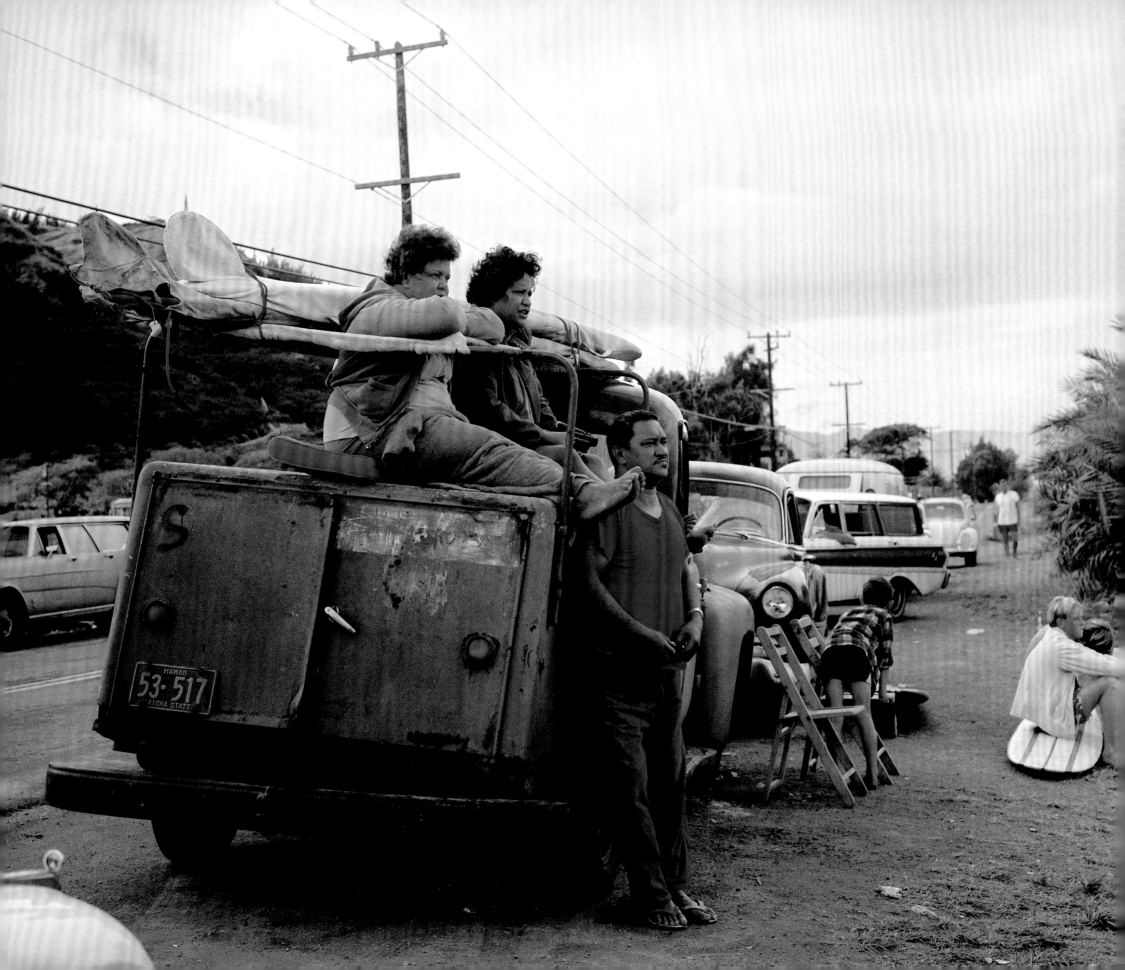

Aikau Family, Sunset Beach, 1967

Pipeline, circa 1972

Opposite: Myra, Mama, and Sol Aikau watching Eddie compete in the third Duke Classic. Eddie won the contest in 1977, and died three months later.

Below. Unten. Ci-dessous.

Gegenüber: Myra, Mama und Sol Aikau sehen Eddie beim dritten Duke Classic zu. Eddie gewann den Wettbewerb 1977 und starb drei Monate später.

Page ci-contre: Myra, Mama et Sol Aikau suivent les exploits d'Eddie lors de la troisième édition de la Duke Classic. Dix ans plus tard, Eddie Aikau remportera la compétition trois mois avant de mourir dans des circonstances tragiques.

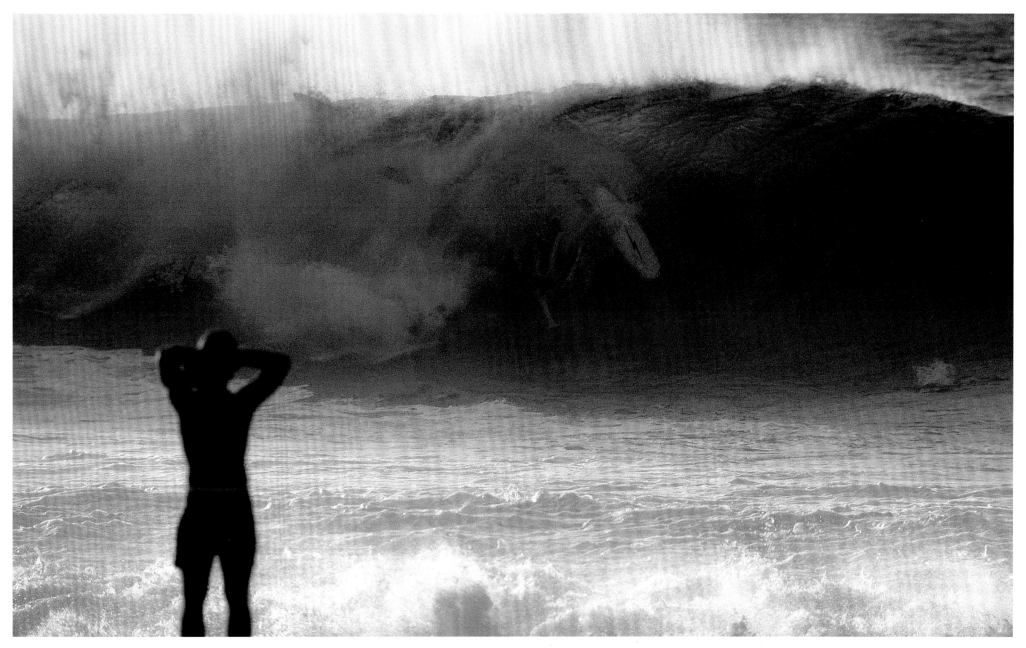

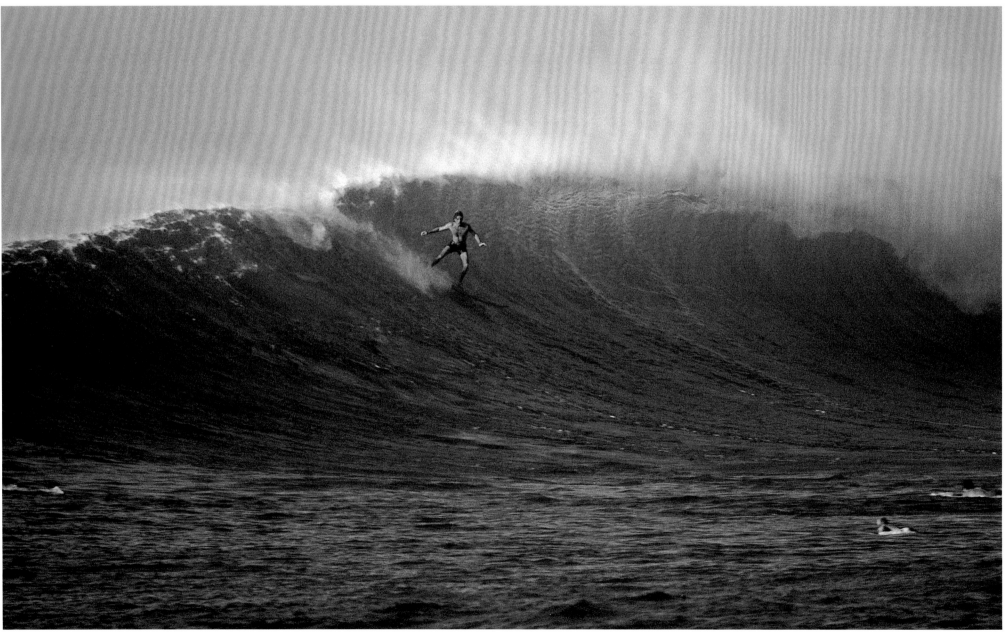

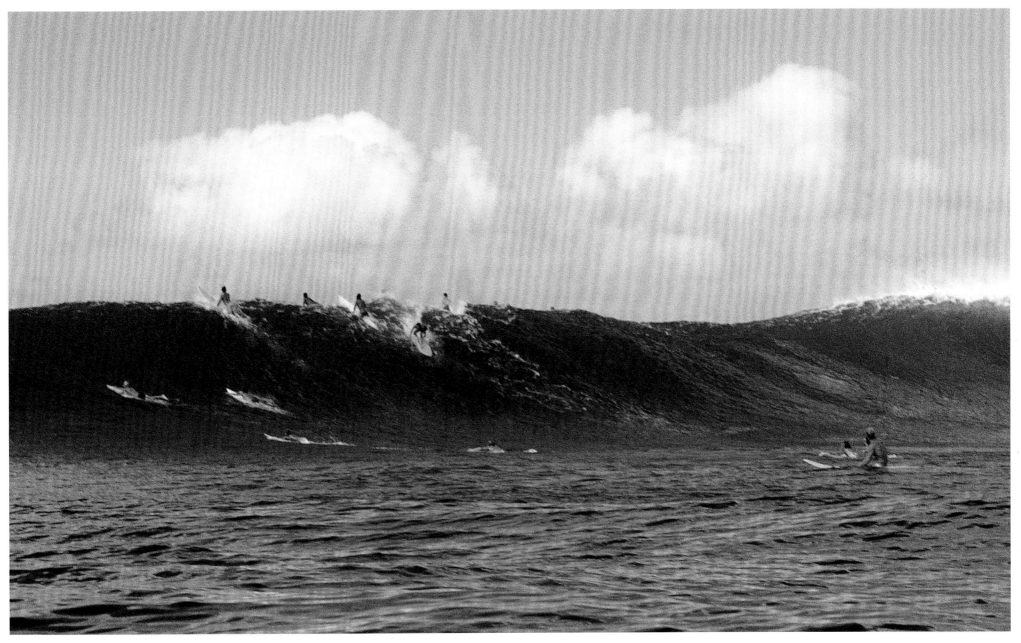

Mark Richards, Pipeline, 1982

Although a four-time world champion and a 1980 Pipeline Masters winner, the Australian Richards said he never liked surfing Pipeline.

Obwohl er vierfacher Weltmeister und Sieger bei den 1980er Pipeline Masters war, sagte der Australier Richards, dass er die Pipeline nicht gern surfe.

Malgré ses quatre titres de champion du monde et sa victoire aux Pipeline Masters en 1980, l'Australien Mark Richards a affirmé qu'il n'avait jamais aimé surfer Pipeline.

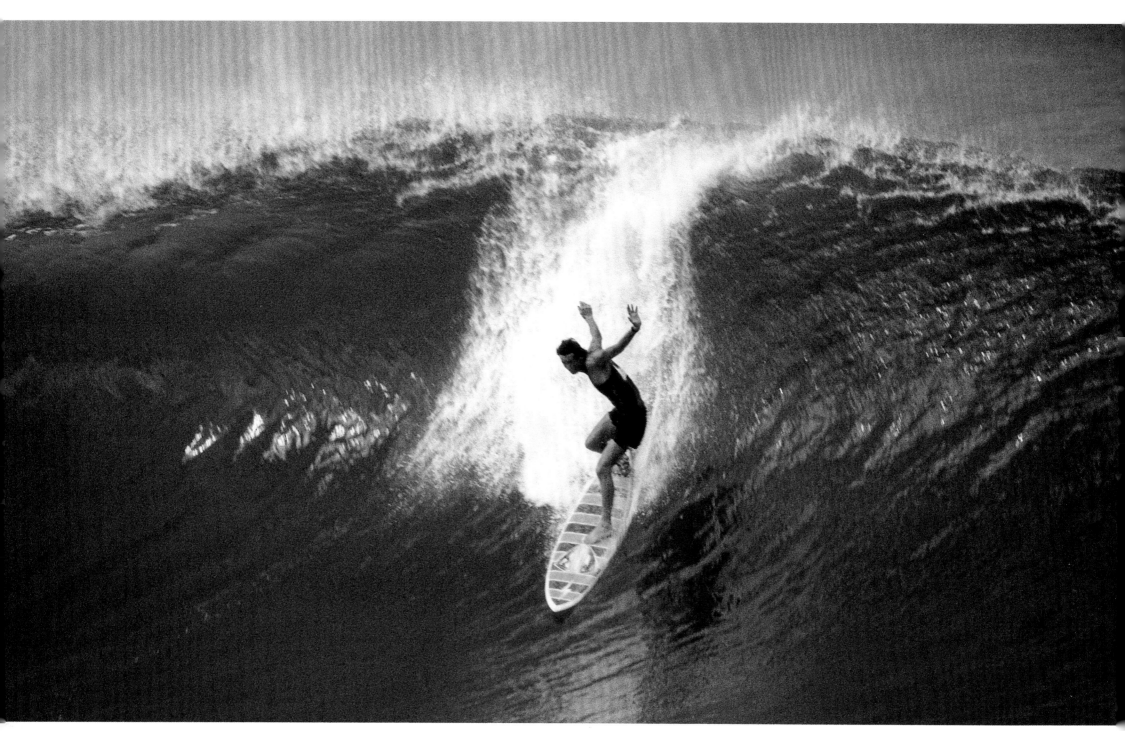

Shaun Tomson, Pipeline, 1977

South African Shaun "the Prawn" Tomson was renowned for his radical tuberiding and his aristocratic bearing. He was a winning pro for fourteen years.

Der Südafrikaner Shaun „The Prawn" Tomson war bekannt für seine radikale Art des Tuberiding und seine aristokratische Haltung. Er nahm vierzehn Jahre lang erfolgreich an Wettkämpfen teil.

Le Sud-Africain Shaun « The Prawn » Tomson était réputé pour son *tube riding* radical et son port aristocratique. Sa carrière professionnelle fut jalonnée de titres pendant quatorze années.

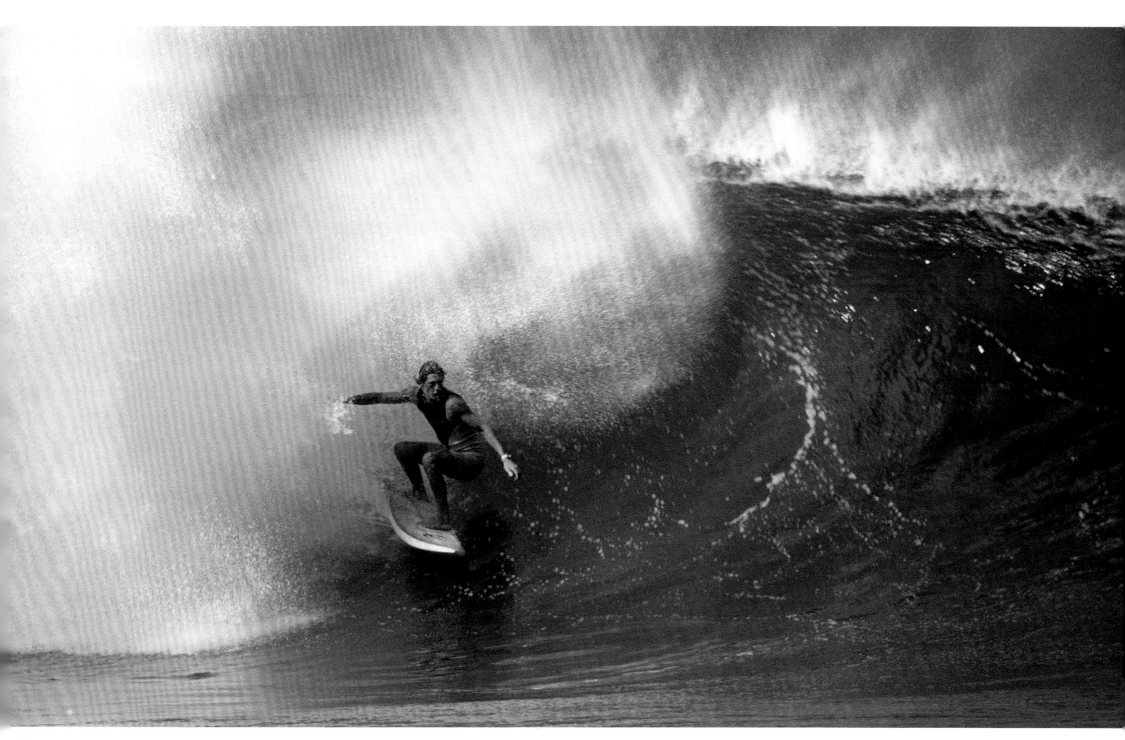

Haleiwa, 1972

Below. Unten. Ci-dessous.

James Jones, Velzyland, North Shore, 1974

Opposite: Filmmaker Bruce Brown named Velzyland in honor of boardmaker Dale Velzy, who sponsored his first movie, *Slippery When Wet*, in 1958.

Gegenüber: Der Filmemacher Bruce Brown benannte Velzyland nach dem Board-Hersteller Dale Velzy, der 1958 seinen ersten Film *Slippery When Wet* sponserte.

Page ci-contre: Le réalisateur Bruce Brown fut baptisé « Velzyland » en l'honneur du shaper Dale Velzy qui sponsorisa son premier film, *Slippery When Wet*, en 1958.

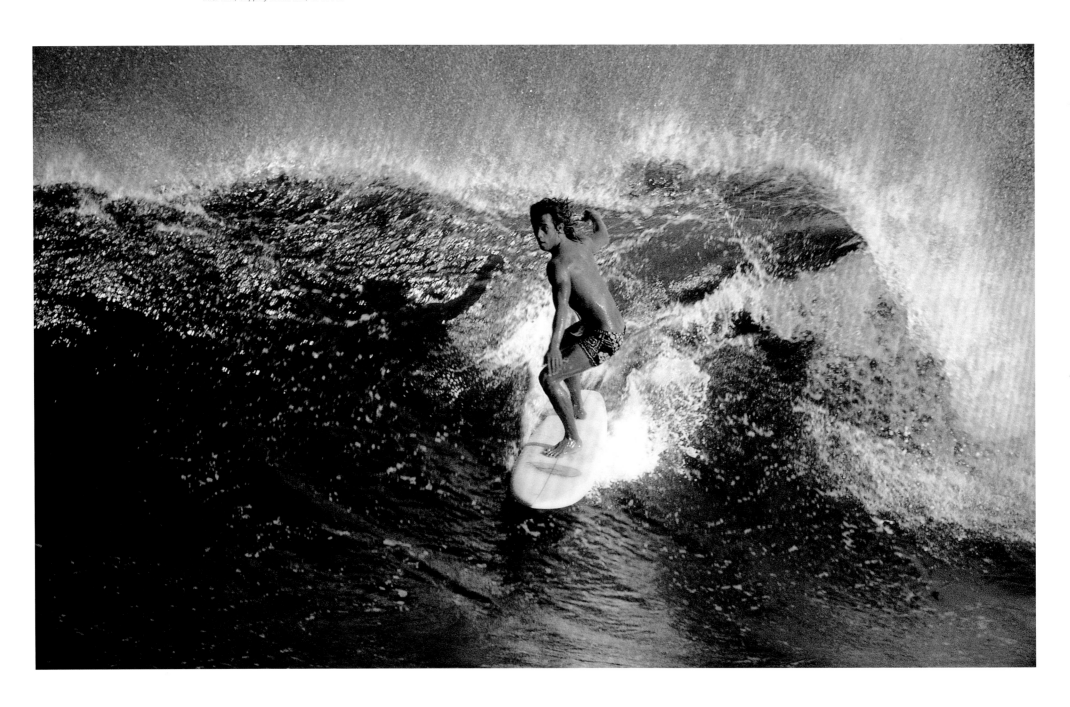

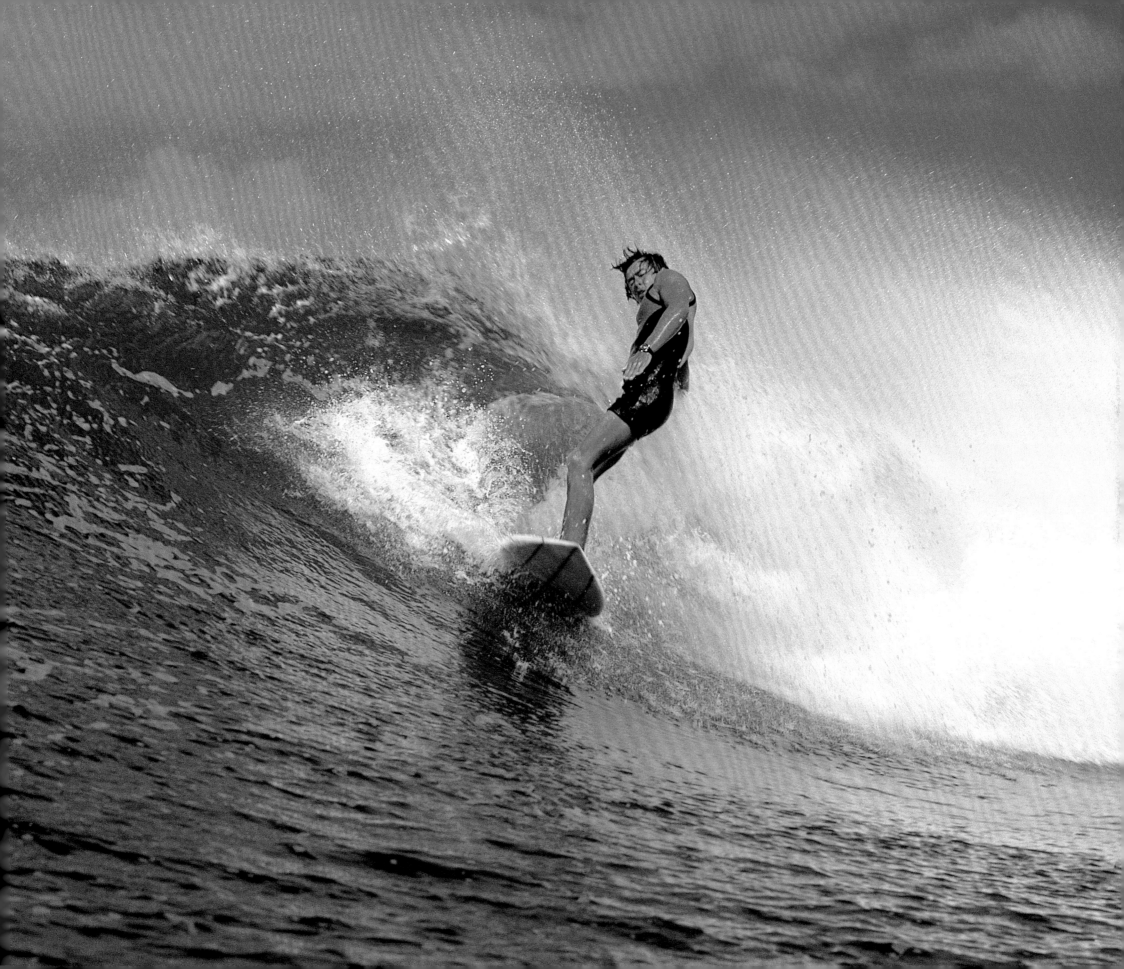

Fred Hemmings, Pipeline, 1964

Below: Often the first sound you hear on the North Shore during a big swell is an ambulance siren's howl.

Unten: Oft ist das erste Geräusch, das man bei einem großen Swell am North Shore hört, die heulende Sirene eines Krankenwagens.

Ci-dessous: Les premiers sons que vous entendez les jours de gros swell sur les plages du North Shore sont souvent les hurlements des sirènes d'ambulances.

Semifinalists, Duke Classic, Sunset Beach, 1969

Opposite: Left to right, Mike Doyle, Ryan Dotson, Felipe Pomar, Nat Young, Ben Aipa, Jock Sutherland, unidentified.

Gegenüber: Von links nach rechts: Mike Doyle, Ryan Dotson, Felipe Pomar, Nat Young, Ben Aipa, Jock Sutherland, unbekannt.

Page ci-contre: De gauche à droite: Mike Doyle, Ryan Dotson, Felipe Pomar, Nat Young, Ben Aipa, Jock Sutherland et non identifié.

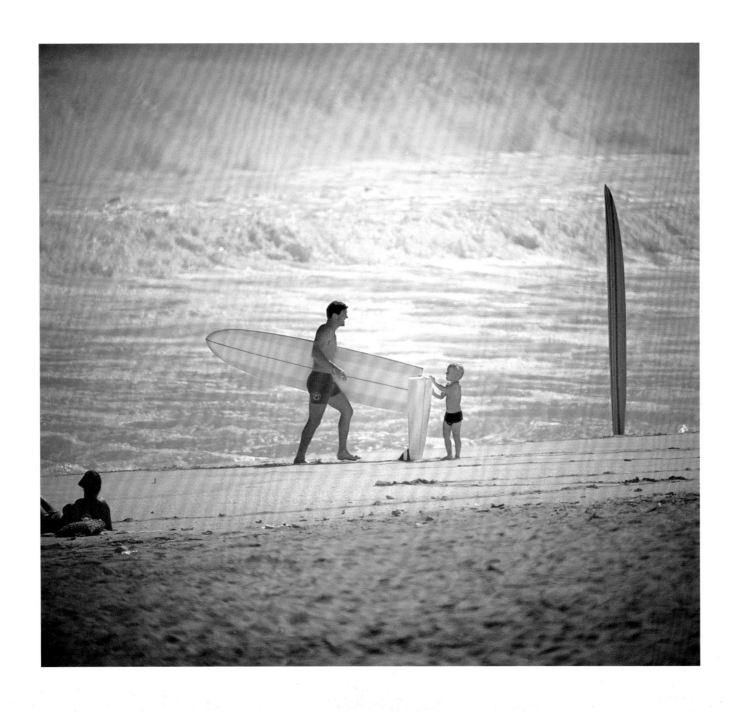

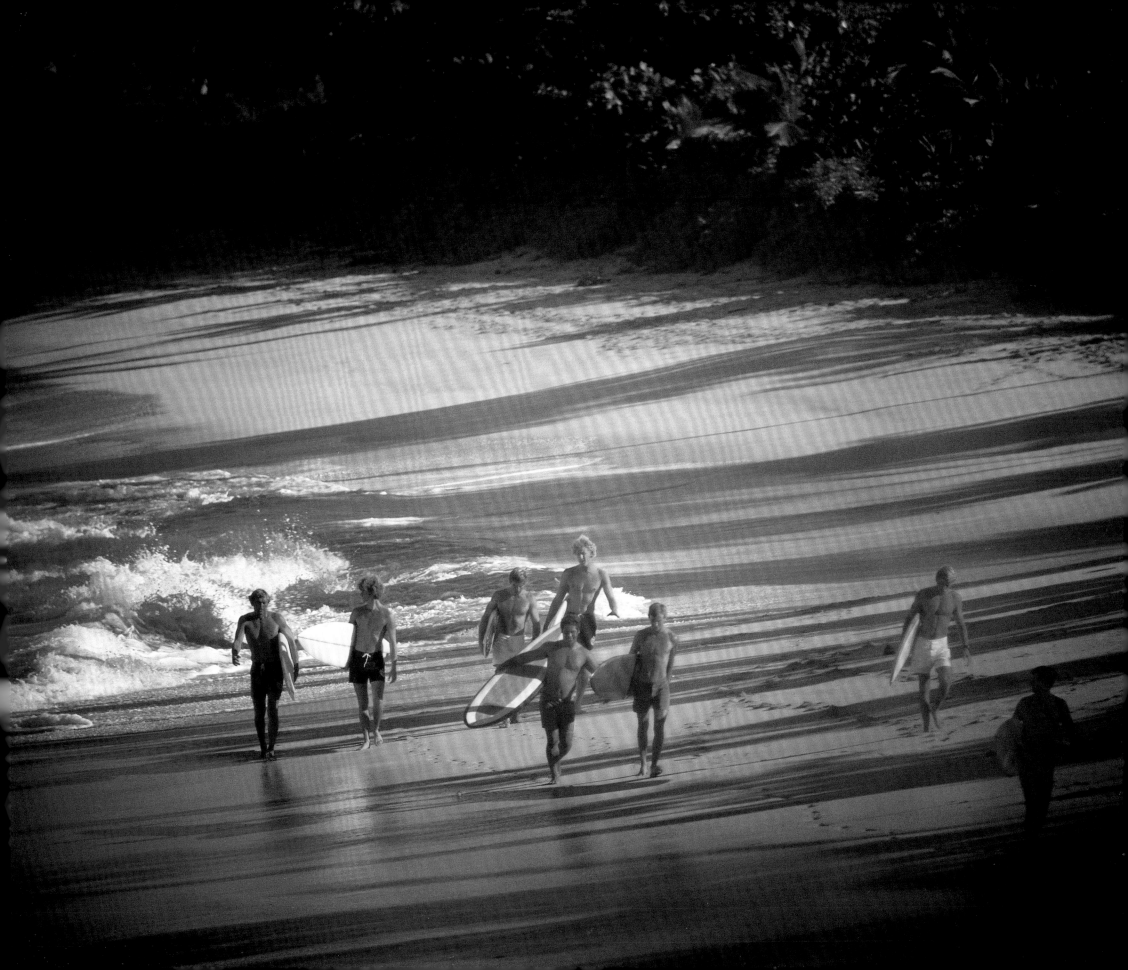

Pipeline, circa 1972

Below. Unten. Ci-dessous.

Ehukai Beach, 1969

Opposite: The "Swell of '69" was considered the swell of the century, with monster waves of up to sixty feet slamming the Hawaiian Islands and causing millions of dollars in damage.

Gegenüber: Der „Swell von '69" galt als Swell des Jahrhunderts, gigantische, bis zu zwanzig Meter hohe Wellen peitschten auf die hawaiianischen Inseln ein und verursachten Schäden in Millionenhöhe.

Page ci-contre: Le «Swell de 1969» restera dans les annales comme la houle du siècle. Cette année-là, des vagues géantes de plus de vingt mètres balayèrent l'archipel hawaïen et provoquèrent plusieurs millions de dollars de dégâts.

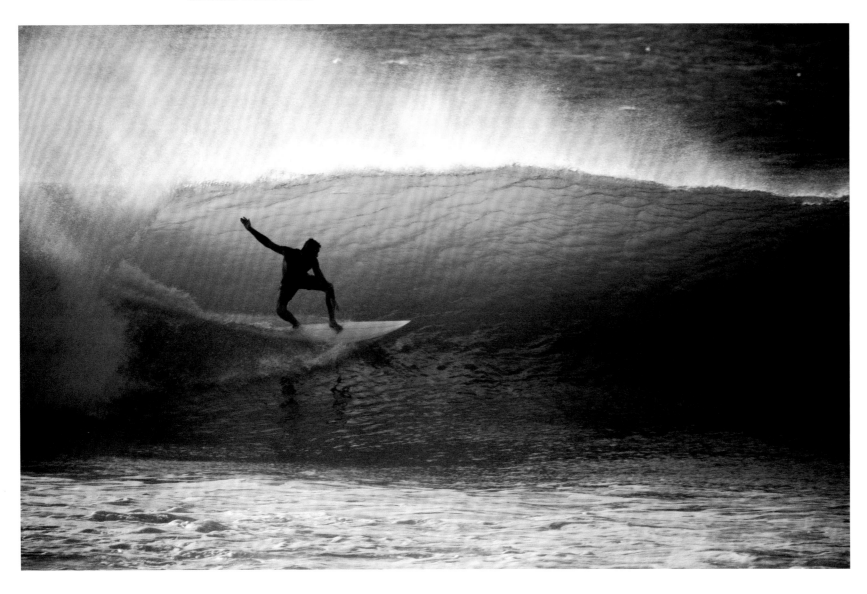

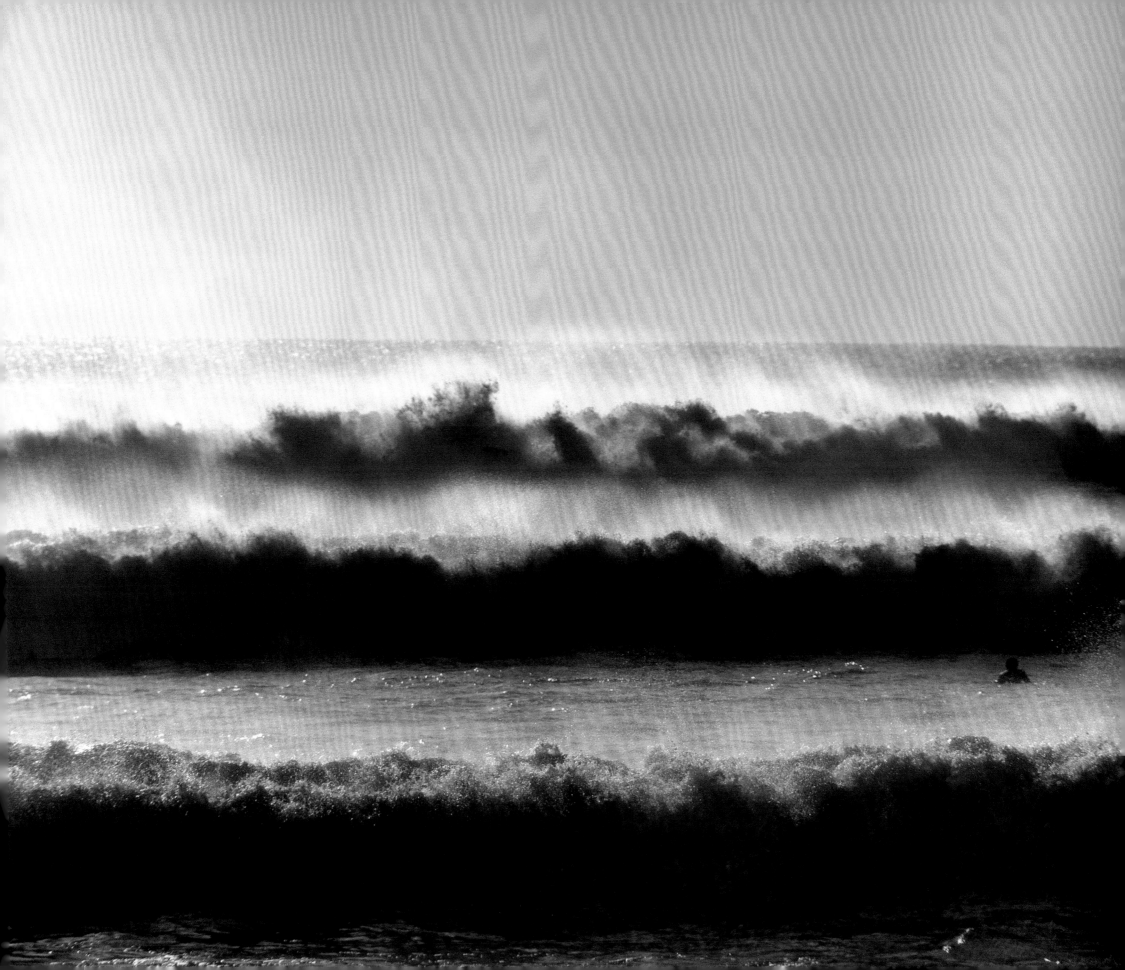

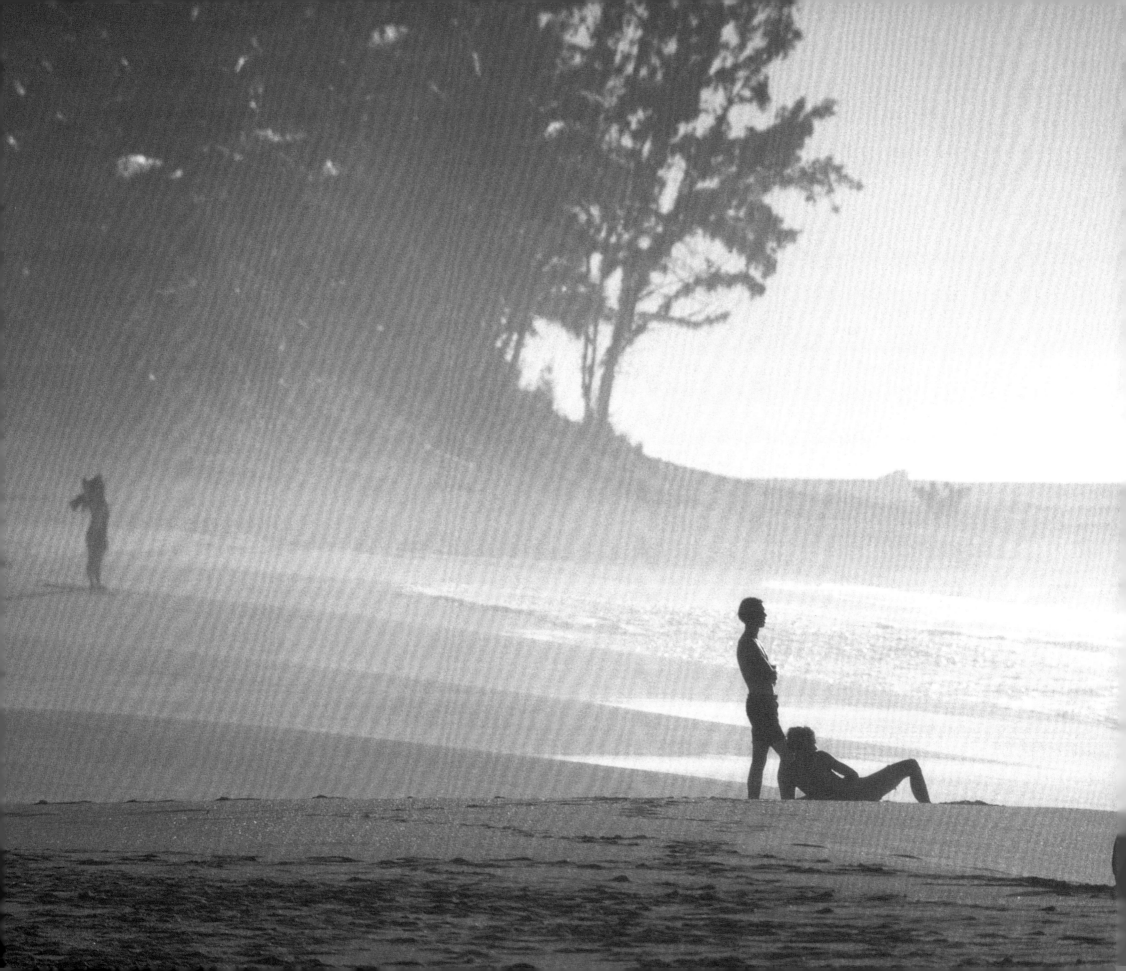

Rocky Point, 1972

Opposite. Gegenüber. Ci-contre.

Makaha, circa 1975

Below. Unten. Ci-dessous.

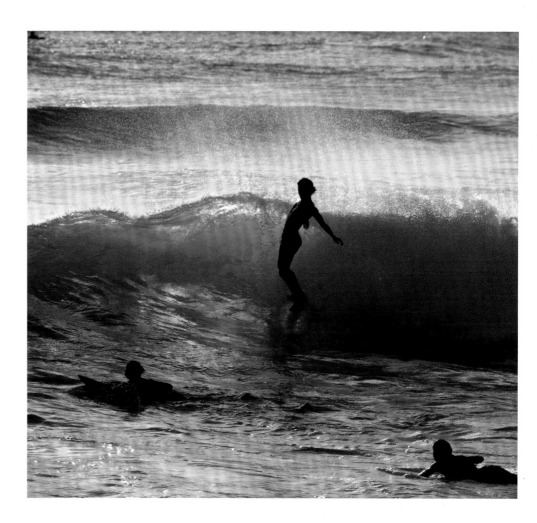

Captions: Opening Sequence

Jock Sutherland, Pipeline, Hawaii, 1966

Page 1: The Hawaiian-born Sutherland pioneered tuberiding in the early sixties on Oahu's North Shore.

Seite 1: Der auf Hawaii geborene Sutherland war Anfang der Sechziger der erste Tuberider am North Shore von Oahu.

Page 1 : Au début des années 1960, le Hawaïen Jock Sutherland se distingue comme le pionnier du *tube riding* sur le North Shore, la côte nord de l'île d'Oahu.

Surf Photos by Grannis Sticker, 1963

Page 3: "Granny's" famous stickers, designed by Stuart Lough, are now collectors' items. Grannis still gives one out to everyone he meets.

Seite 3: Die berühmten Aufkleber von „Granny", entworfen von Stuart Lough, sind heute Sammlerstücke. Grannis verteilt sie noch immer an jeden, den er trifft.

Page 3 : Les fameux stickers de « Granny » réalisés par Stuart Lough sont devenus des collectors. Grannis continue de les distribuer généreusement autour de lui.

Malibu, California, 1967

Page 4: At Malibu's infamous "Pit" during the Summer of Love, an impromptu hair-cutting session draws a crowd.

Seite 4: Im berüchtigten „Pit" von Malibu im Sommer der Liebe: Eine Menschenmenge versammelt sich bei einer spontanen Haarschneide-Aktion.

Page 4 : Pendant le « Summer of Love », un salon de coiffure improvisé attire les curieux sur la plage de Malibu, près du « Puits de l'enfer ».

22nd Street, Hermosa Beach, California, 1963

Page 9. Seite 9. Page 9.

Malibu, California, 1965

Pages 10–11: "The 'Bu" in full Sunday glory during a late spring swell. Today, on a good day, there might be more than 150 surfers out jockeying for an empty wave at Malibu.

Seiten 10–11: Malibu, auch „The 'Bu" genannt, an einem herrlichen Sonntag mit einem Spätfrühlings-Swell. Heute kann man in Malibu an einem guten Tag über 150 Surfer beobachten, die im Wasser auf eine freie Welle warten.

Pages 10–11 : Swell idéal à « The 'Bu » par un beau dimanche de fin de printemps. Aujourd'hui, à Malibu, les « jours de gros » peuvent attirer plus de 150 surfers prêts à en découdre pour être les premiers sur les vagues « libres ».

Phil Edwards, Haleiwa, Hawaii, 1962

Page 12: Edwards, "the Guayule Kid" from Oceanside, California, was a visionary surfer once voted the best in the world for his radical power and grace.

Seite 12: Edwards, „The Guayule Kid" aus Oceanside in Kalifornien, war ein bahnbrechender Wellenreiter, der für seine Energie und Anmut zum besten Surfer der Welt gewählt wurde.

Page 12 : Phil Edwards, surnommé « The Guayule Kid » d'après la localité dont il est originaire, près d'Oceanside en Californie, était un surfeur visionnaire. Sa puissance et sa grâce hors pair lui ont valu le titre de meilleur surfeur du monde.

Makaha, Hawaii, 1962

Page 13: A classic forties-era woody flanked by a crew of young surfers between heats at the Makaha Championships. Left to right, unidentified, Ivan Vanetta, Frank Grannis, Paul Strauch, Candy Calhoun, Robin Calhoun.

Seite 13: Ein toller alter Ford Woody aus den Vierzigerjahren mit einer Gruppe junger Surfer zwischen den Heats bei den Makaha Championships. Von links nach rechts: unbekannt, Ivan Vanetta, Frank Grannis, Paul Strauch, Candy Calhoun, Robin Calhoun.

Page 13 : Une équipe de jeunes surfeurs pose devant un Ford Woody typique des années 1940 entre deux heats de la prestigieuse compétition de Makaha. De gauche à droite : Ivan Vanetta, Frank Grannis, Paul Strauch, Candy Calhoun et Robin Calhoun.

San Onofre, California, 1963

Pages 14–15: With its wide beaches, grass shacks, and long, rolling waves, San Onofre is called "California's Waikiki."

Seiten 14–15: Die breiten Strände, strohgedeckten Hütten und langen, gleitenden Wellen trugen San Onofre den Titel „Waikiki von Kalifornien" ein.

Pages 14–15 : Avec ses vastes plages, ses cabanons à toit de paille et ses longues vagues déferlantes, San Onofre est surnommé le « Waikiki californien ».

Palos Verdes Cove, California, 1967

Page 16: Backlit late afternoon on the trail down to Palos Verdes Cove.

Seite 16: Der Weg hinunter in die Bucht von Palos Verdes im spätnachmittäglichen Gegenlicht.

Page 16 : Soleil aveuglant de fin d'après-midi sur le chemin côtier qui mène à la plage de Palos Verdes Coves.

Dewey Weber, 22nd Street, Hermosa Beach, California, 1964

Page 17: Weber, "the Little Man on Wheels," was considered the archetypal sixties "hotdogger" for his speedy footwork and flashy style.

Seite 17: Weber, „Der kleine Mann auf Rädern", galt dank seiner schnellen Beinarbeit und seines auffälligen Stils als einer der archetypischen „Hotdogger" der Sechziger.

Page 17 : Dewey Weber, dit « Le Petit Bonhomme à roulettes », est considéré comme le modèle des « hotdoggers » des années 1960 en raison de la vivacité de son jeu de jambes et de son style exubérant.

Waimea Bay, Hawaii, 1967

Pages 18–19: Greg Noll, Eddie Aikau (red board), Bobby Cloutier (diving). This photo won third place in a 1970 *LIFE* magazine photo contest.

Seiten 18–19: Greg Noll, Eddie Aikau (rotes Brett), Bobby Cloutier (beim Sprung). Dieses Foto erhielt 1970 den dritten Platz bei einem Fotowettbewerb der Zeitschrift *LIFE*.

Pages 18–19 : Greg Noll, Eddie Aikau (planche rouge) et Bobby Cloutier (en train de plonger). Ce cliché remportera le troisième prix d'un concours photographique organisé en 1970 par le magazine *LIFE*.

Midget Farrelly, Makaha, Hawaii, 1968

Page 276: Bernard "Midget" Farrelly, inaugural world champ in 1964, timelessly bridging the eras.

Seite 276: Bernard „Midget" Farrelly, der erste Weltmeister von 1964, verbindet die verschiedenen Auffassungen der Surfkultur.

Page 276 : Bernard « Midget » Farrelly, qui remporta le premier titre officiel de champion du monde en 1964, a traversé les grandes époques du surf avec une constance impressionnante.

Bibliography

Barrett, Bradley Wayne. *Grannis: Surfing's Golden Age, 1960–1969*. San Clemente: Surfer's Journal, 1998.

Doyle, Mike and Steve Sorenson. *Morning Glass: The Adventures of Legendary Waterman Mike Doyle*. Three Rivers: Manzanita Press, 1993.

George, Sam. *The Perfect Day: 40 Years of* Surfer *Magazine*. San Francisco: Chronicle Books, 2001.

Lueras, Leonard. *Surfing, the Ultimate Pleasure*. New York: Workman Publishing, 1984.

Jenkins, Bruce. *North Shore Chronicles: Big-Wave Surfing in Hawaii*. Berkeley: North Atlantic Books, 1990.

Kampion, Drew. *Stoked: A History of Surf Culture*. Santa Monica: General Publishing Group, 1997.

Noll, Greg, and Andrea Gabbard. *Da Bull: Life Over the Edge*. Berkeley: North Atlantic Books, 1989.

Stecyk, Craig, and David Carson. *Surf Culture: The Art History of Surfing*. Laguna Beach: Ginko Press, 2002.

Stecyk, Craig, Drew Kampion, and Steve Pezman. *Dora Lives: The Authorized Story of Miki Dora*. New York: D.A.P./T.Adler Books, 2005.

Warshaw, Matt. *The Encyclopedia of Surfing*. Orlando: Harcourt, Inc., 2003.

Wright, Bank. *Surfing California; A Complete Guide to the California Coast*. Redondo Beach: Mañana Publishing, 1973.

Acknowledgments

The author would like to thank: Steve Pezman, Brad Barrett, Matt Warshaw, Art Brewer, Randy Rarick, Gerry Lopez, Drew Kampion, Bernie Baker, Jon Close, Robert Lindkvist, Greg MacGillivray, Mickey Muñoz, Mike Doyle, Bruce Gabrielson, Huntington Beach Surf Club, Janet Duckworth, Marilyn Barilotti, Nina Wiener, Kate Soto, Jim Heimann, and LeRoy Grannis.

—Steve Barilotti, San Diego, Calif., 2005

From the editor: My sincere thanks go to all who contributed to creating this book. First and foremost to Granny, who was on board with the project from the beginning, and was gracious and trusting in the handling of his original material. It was a wonderful experience to work with a legend who transported me back in time with his tales and images. He is deserving of this long overdue international recognition, and I am proud to have been able to make this book a reality. It has also been a pleasure to get to know his wife Katie, who has provided Granny with companionship, support, and a fruitful life amidst the waves.

My support team at TASCHEN America has allowed me to concentrate on the creative aspects of this project, knowing that all the minute details would be handled. My heartfelt thanks to: Nina Wiener, the glue that holds everything together and the driving force at TASCHEN America; Kate Soto, who wouldn't let me off the hook with her meticulous editing and ability to wrap things up; Morgan Slade, who seamlessly worked production wonders here in the U.S.; interns Amy Francis and Valerie Palmer, who spent hours logging the photographs and fact-checking the text. Thanks as well to the team at TASCHEN's headquarters in Cologne—Florian Kobler and Stefan Klatte—for putting all the finishing touches on the book and keeping us on track.

My gratitude also goes to designer and surfer Paul Mussa, a trusted friend for over thirty years who created a clean and cool masterpiece without whining too much; surfer and writer Steve Barilotti, who deftly put into words what I was thinking and submitted with nary a complaint to add, delete, add, delete; Janet Duckworth, an artist of an editor who really made the manuscript snap; Anna Skinner for her greased lightning proofreading job; Tom Adler, the master of all that is surf; Steve Pezman for his insightful suggestions; Craig Stecyk for his blunt force trauma to the head; Benjamin Trigano, who knows a winner when he sees one; Matt Warshaw, a beacon in the world of surf writing; and to Mr. Taschen who was as captivated as I was with Granny's work and gave the green light to a winner of a project. Gut gemacht, Blödmann!

And lastly to all those who surf or wish they could and are mesmerized by the power of nature and those who capture its stoke.

—Jim Heimann, Los Angeles, Calif., 2005

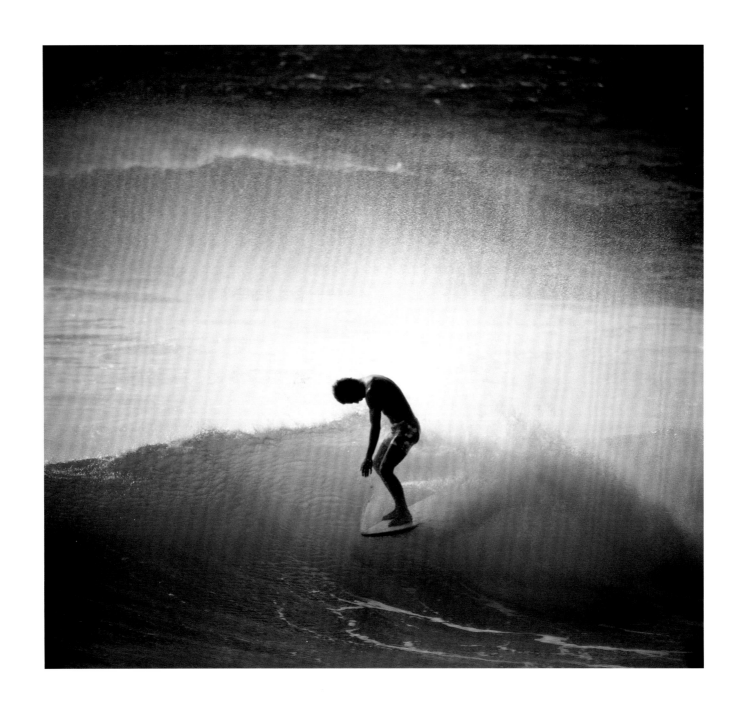